100 Best Paintings in New York

Deanna Macdonald is an art historian, journalist and author of *Art for Travellers: Prague* and the forthcoming *100 Best Paintings in Paris*. She has taught art history at McGill University in Montreal. Like many others, she loves New York.

Geoffrey Smith is a publisher. He spent a post-graduate year studying at the Courtauld Institute of Art in London and has been an enthusiastic museum visitor for more years than he cares to admit. He has visited New York many times and is the author of *100 Best Paintings in London*.

100 Best Paintings in New York

Deanna Macdonald
and Geoffrey Smith

CHASTLETON
An imprint of Arris Publishing Ltd
Gloucestershire

To Matthew DM

For Roland, Lucian and Gabriel
and for Victoria with special thanks GS

Other books by the same authors
Deanna Macdonald
Art for Travellers: Prague

Geoffrey Smith
100 Best Paintings in London

Both published by Chastleton Travel
(an imprint of Arris Publishing Ltd)

First published in Great Britain in 2008 by
CHASTLETON TRAVEL
An imprint of Arris Publishing Ltd
12 Adlestrop, Moreton in Marsh
Gloucestershire GL56 0YN
www.arrisbooks.com

The front cover shows details from:
Gustav Klimt (1862-1918) *Adele Bloch-Bauer I*, 1907; Oil, silver, and gold on canvas, Neue Galerie New York (This acquisition made available in part through the generosity of the heirs of the Estates of Ferdinand and Adele Bloch-Bauer); Franz Marc *Yellow Cow* (*Gelbe Kuh*), 1911, Oil on canvas, 140.5 x 189.2 cm (55 3/8 x 74 1/2 inches) Solomon R. Guggenheim Museum, New York, Solomon R. Guggenheim Founding Collection 49.1210; Pierre-Auguste Renoir *Madame Georges Charpentier and her Children* 1878 © Metropolitan Museum of Art, New York, USA / The Bridgeman Art Library; Jean-Antoine Watteau, *Mezzetin* c.1718-20 (oil on canvas) © Metropolitan Museum of Art, New York, USA/ The Bridgeman Art Library

ISBN 978 1 905214 35 8

Printed and bound in China

Telephone: 01608 659328
Visit our website at www.arrisbooks.com
or email us at info@arrisbooks.com

Contents

Introduction

New York is one of the world's great art cities. From medieval masters to cutting-edge contemporary works, New York has it all, which can be both thrilling and overwhelming. With the *100 Best Paintings in New York* we have created an overview of what we think are the 100 best paintings in the city, telling you where to find them and what they are all about. Whether you are a visitor to New York or a long-time resident, an art aficionado or a first-time museum-goer, this guide can help you figure out what to see and where to see it. Divided by museum the book will direct you to some of the greatest works found in celebrated and breathtakingly large museums such as the Metropolitan Museum of Art, as well as inspire you to visit some lesser visited but nevertheless fascinating collections, such as the Museum of the Hispanic Society of America.

This book is also designed a bit like a crash course in art history which you can read anywhere, including when you are standing in front of the painting. If you have ever looked at a work of art – be it by Botticelli or Vermeer or Rothko – and wondered 'what's that all about'? this is the guide for you. Art always tells a story. It is about a place in time, an artist, a patron, and also the person or idea depicted. It can make you stare in amazement or feel happy or sad. It can make you ask questions about places and people you have never known or contemplated or the beauty of something as quotidian as an apple. With this book we have tried to reveal some of these stories, to give the reader an understanding of the painting – who painted it? Why? When? For whom? – and, hopefully, to inspire you to find out more.

The book is arranged by museum and within each museum section the paintings are listed chronologically. Two pages are devoted to each work of art. Beneath the color reproduction is a detailed essay about the painting, discussing the artist, subject, style and historical context. Following this are a selected list of contemporary works (to give the reader a sense of what was happening in the art world at the same time) as well as a biographical chronology about the artist's life and career.

Of course this is by no means a comprehensive list of painting in New York – the Museum of Modern Art alone has over 150,000 paintings, drawings and sculptures. There are countless independent galleries with ever-changing exhibitions all around the city, which fall outside the scope of this book. All paintings selected are from museums with permanent collections. The reader should be warned that works of art are often removed from display

for restoration or to be loaned to other museums. Also, some museums, such as the Guggenheim and the Whitney, frequently change what they have on display. With this in mind, we have tried for the most part to choose paintings that are likely to be on display and that the reader will be able to see. And, of course, 'best' is a highly subjective word – your 100 best paintings will no doubt be different from ours. However we hope this book will act as an inspiration for anyone interested in art or history or simply in New York City and then to go out and see some of the best art, not only in New York, but in the world.

List of Paintings by Artist

The Brooklyn Museum, housed in a 560,000-square-foot Beaux-Arts building, is one of the oldest and largest art museums in the country. Its permanent collections range from Ancient Egyptian masterpieces to contemporary art, and represent a wide range of cultures. Only a 30-minute subway ride from midtown Manhattan, with its own newly renovated subway station, the museum is part of a complex of 19th-century parks and gardens that also includes Prospect Park, the Brooklyn Botanic Garden, and the Prospect Park Zoo.

Brooklyn Museum

200 Eastern Parkway
Brooklyn, New York 11238-6052
Tel: 718-638-5000
www.brooklynmuseum.org

Opening Hours

10.00am – 5.00pm Wednesday to Friday
11.00am – 6.00pm Saturday and Sunday
11.00am – 11.00pm First Saturday of each month
Closed Monday and Tuesday. Closed Thanksgiving, Christmas and New Year's Day

Admission

$8 suggested contribution; $4 adults 62 and over and students.

How To Get There

Subway: 2 and 3 train to Eastern Parkway / Brooklyn Museum.
Buses: B71 stops in front of the museum; also B41 and B69 to Grand Army Plaza or B48 to Franklin Avenue and Eastern Parkway.

Access for the Disabled

Museum entrances are wheelchair accessible. Complimentary wheelchairs may be borrowed at the coat check on the first floor. Wheelchair-accessible restrooms are located on the first and third floors.

Brooklyn Museum Shop

The Brooklyn Museum Shop offers gifts from a collection of engaging artistic, ethnic, and historical products.

10.30am – 5.30pm Wednesday to Friday
11.00am – 6.00pm Saturday and Sunday
11.00am – 11.00pm First Saturday of each month
Closed Monday and Tuesday

Georgia O'Keeffe

Ram's Head, White Hollyhock – Hills **1935**

Brooklyn Museum

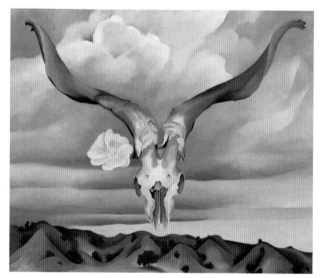

From her first visit to New Mexico in 1917, O'Keeffe was hooked. 'I loved it immediately', she recalled. 'From then on I was always on my way back'. However it wouldn't be until 1929 that she would begin regularly to spend her summers painting in New Mexico. By that date the Wisconsin-born O'Keeffe was already a celebrated artist in New York. As part of the avant-garde circles around her partner, photographer Alfred Stieglitz, O'Keeffe was renowned for her strikingly sensual flowers and views of New York. Her work had already been the subject of a retrospective at the Brooklyn Museum in 1927. However it was the enigmatic beauty of New Mexico that would come to dominate her art and her life.

At first, O'Keeffe found it hard to do justice to New Mexico's majestic landscape. She explored numerous motifs based on the culture and traditions of the region: adobe Spanish mission churches, trees, crosses, etc. But what fascinated her most was the land itself. In 1934 she fell in love with the area around Ghost Ranch north of Taos with its views of the raw cliffs and rain-eroded hills of the Chama River Valley. She would return again and again to the area, eventually buying a house nearby. With its array of color, the barren desert landscape offered all she needed to inspire her to paint: 'All the earth colors of the painter's palette are out there in the many miles of badlands. The light Naples yellow through the ochers – orange and red and purple earth – even the soft earth greens.'

She became fascinated by the hills and mesas that in the dazzling desert light never seemed to get any nearer however far one walked. Said O'Keeffe: 'I had looked out on the hills for weeks and painted them again and again – had climbed and ridden them – so beautifully soft, so difficult …' It is these inscrutable hills dotted with desert brush that feature at the base of this painting. Floating above, like some magnificent bird of prey, is a desert-bleached ram's skull accompanied by a single white and yellow hollyhock, all set against a stormy gray sky.

It was after her second or third trip to New Mexico that O'Keeffe brought back to New York a variety of cattle and wild animal skulls and bones she found in the desert. 'I have picked flowers where I found them – have picked up sea shells and rocks and pieces of wood … When I found the beautiful white bones on the desert I picked them up and took them home too … I have used these things to say what is to me the wilderness and wonder of the world as I live in it'. O'Keeffe included these bones in many of her works and often juxtaposed skulls with artificial flowers like those used in traditional New Mexican culture. While many thought her skulls were about death and resurrection, O'Keeffe felt they were more about life: 'The bones seem to cut sharply to the center of something that is keenly alive … even though it is vast and empty and untouchable – and knows no kindness with all its beauty'.

O'Keeffe enjoyed creating unexpected juxtapositions and here the mixture of the land, skull and flower creates a mysterious, almost surreal aura. Though realistically portrayed, the objects hover between time and space. Each element of the composition is complete and detailed with its own perspective and must be registered as an independent entity by the viewer, reflecting O'Keeffe's interest in the objective beauty of objects. The result is an image of meditative stillness that is almost closer to still life than to landscape. As with all her subjects, this work resonates with expressive color, innate sensuality and an affinity to nature. While some have called her art Surrealistic, O'Keeffe didn't agree: 'Often, a picture just gets into my head without me having the least idea how it got there. But I am much more down-to-earth than people give me credit for.' *DM*

Contemporary Works

1935	Pierre Bonnard: *Dining Room in the Garden*, New York, Guggenheim Museum
1936	Salvador Daii: *Soft Construction with Boiled Beans: Premonitions of Civil War*, Philadelphia Museum of Art

Georgia O'Keeffe

1887	Born at Sun Prairie, Wisconsin.
1902	The O'Keeffe family move to Williamsburg, Virginia.
1905	Attends the school at the Art Institute of Chicago.
1907	Studies with William Merritt Chase at the Art Students League in New York.
1908	Works as a freelance commercial artist in Chicago and then a primary school teacher in Texas.
1912	Attends a summer school at the University of Virginia where she is introduced to the ideas of Arthur W. Dow. She becomes a teaching assistant expounding this system of art education.
1914	Returns to New York to work with Dow. While there she sees work by Picasso, Braque and other European avant-garde artists.
1916	Alfred Stieglitz sees some of her drawings and exhibits them at the 291 gallery.
1918	Stieglitz promises financial support. O'Keeffe moves permanently to New York where Stieglitz provides her with lodgings.
1924	Stieglitz and O'Keeffe are married following his divorce from his first wife. Her earliest close up flower paintings date from this time.
1929	She begins to spend her summers painting in New Mexico.
1932	O'Keeffe suffers a nervous breakdown and does not paint for over a year.
1934	Visits Ghost Ranch near Abiquiu for the first time.
1943	The Chicago Art Institute mounts a one-woman show of her work.
1946	Alfred Stieglitz dies.
1949	O'Keeffe moves permanently to Abiquiu near Santa Fe.
1971	She begins to lose her sight but learns to make pottery by touch.
1987	Dies in Santa Fe.

A visit to this wonderful museum is a must – do not miss it. Some effort is required to get there (at least from Midtown Manhattan) but this makes the experience even more rewarding when you eventually arrive.

The Cloisters is a branch of the Metropolitan Museum of Art devoted to the art and architecture of medieval Europe. It was assembled from architectural elements, both domestic and religious, that date from the 12th to the 15th century. The building and its cloistered gardens – located in Fort Tryon Park in Upper Manhattan – are treasures in themselves, effectively part of the collection which houses sculpture, tapestries, illuminated manuscripts, goldsmiths' and silversmiths' work, paintings, stained glass, enamels, and ivories.

The Cloisters which opened in 1938, gets its name from the portions of five medieval French cloisters—Saint-Michel-de-Cuxa, Saint-Guilhem-le-Désert, Bonnefont-en-Comminges, Trie-en-Bigorre, and Froville—that were incorporated into the modern museum building. The result is not a copy of any particular medieval structure but an ensemble of spaces, rooms, and gardens that provide a harmonious and evocative setting in which visitors can experience the rich tradition of medieval artistic production.

The Cloisters (a branch of the Metropolitan Museum)

Fort Tryon Park
New York, New York 10040
Tel: (recorded information) 212-923-3700
www.metmuseum.org

Opening Hours

9.30am – 4.45pm Tuesday to Sunday (November – February)
9.30am – 5.15pm Tuesday to Sunday (March – October)
Closed Mondays; also closed Thanksgiving, Christmas Day and New Year's Day

Admission

$20 recommended for adults; $15 recommended for senior citizens (65 and over); $10 recommended for students. Children under 12 are free.

How To Get There

Bus: From the main Metropolitan Museum: At Madison Avenue and 83rd Street, take M4 bus directly to the last stop (Fort Tryon Park – The Cloisters).

Subway: Take the A train to 190th Street, exit station by elevator, and walk north along Margaret Corbin Drive for approximately 10 minutes.

Access for the Disabled

A van is available to assist wheelchair users and other visitors with mobility impairments to enter the museum. The Cloisters has some limited access for visitors with mobility impairments. Call 212-650-2211 for more information and to make arrangements. Wheelchairs are available to borrow free of charge.

Met Store

There is a branch of the Met Store at The Cloisters stocking publications and reproductions produced by the museum, as well as other books and merchandise, with an emphasis on the art of the Middle Ages.

Robert Campin

The Annunciation Triptych (Mérode Altarpiece) *c*1425

The Cloisters

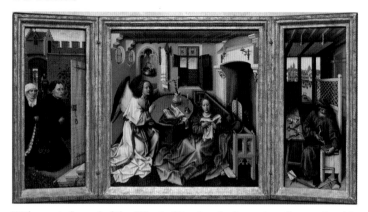

The central panel of the Mérode Altarpiece invites us into the comfortable confines of an early 15th century northern European bourgeois domestic interior. A curiously large bench extends the whole length of the room, its back blocking off the fireplace. Lounging on the floor, her elbow propped against the bench, the Virgin Mary (enveloped in a voluminous robe – each crease of drapery carefully modeled) is immersed in her reading of the Bible, seemingly oblivious to the import of the moment. The angel Gabriel has entered the room with a commendable lack of fanfare, perhaps through the door which opens into the left wing of the triptych. His right hand is already raised in a gesture of benefaction so he will make his presence known in the next second or two. Indeed his divine mission is very close to completion for we can see above his wings the tiny figure of a child (representing the fully formed body and soul of Jesus) transported through the circular window along a beam of light. The minuscule figure carries a cross, a bleak reminder of Christ's eventual destiny.

The room seems to be jammed full and yet there are only two occupants and two major items of furniture. This claustrophobia has been caused by the unnaturally abrupt perspectival recession used by Campin inducing in us the feeling that we are seeing things from a bird's eye view with the floor and the table sloping towards us. It can't be long, we feel, before the vase, candlestick and book slide from the table into the lap of the Virgin. However, Campin was at the forefront of the new naturalism in Netherlandish art, not only in his experiments with perspective and his use of oil as a medium for his pigments but also in his wonderfully meticulous representation of everyday objects – many of which are introduced in order to elucidate the Christian message.

Lilies are usually present in any representation of the Annunciation – they are an ancient symbol of fecundity but in the Christian tradition they became associated with the Virgin Mary, their white color (echoed here in the cloth she is holding) alluding to her purity and chastity. Here Campin has positioned three lilies very centrally in a vase on the table. One flower is still in bud and it has been suggested that this may refer to the incipient arrival of Jesus in fetal form, thus completing the Trinity. Next to the vase stands a candlestick, the flame very recently extinguished, a diminutive plume of smoke rising from the still hot wick. This would seem to be

a reference to St Bridget's idea that the worldly light emitted by the flame is no match for the divine radiance associated with the arrival of Christ.

Waiting in the wings – in this case the left wing – the donor and his wife kneel at the half open door, awed to be in the presence of such exalted company. He can be identified as Pieter Ingelbrecht from the coat of arms which appears in the window of the Virgin's chamber. He married Gretgin Schrinmechers at some point in the 1420s – her name can be translated as 'Carpenter' which forms a nice equivalence with Joseph's depiction in the opposite wing.

Joseph is in his workshop surrounded by the tools of his trade, heedless of the events depicted in the rest of the triptych. Joseph, rarely represented at the Annunciation, is here shown drilling holes in a piece of wood – possibly the top for a footwarmer. However, of more interest, we can see that he has also been manufacturing mousetraps, one of which is on display – no doubt for sale – on a shelf projecting into the town square. These prosaic objects have provided lots of fun for scholars as the symbolism surrounding them seems to be many layered. Suffice it to say that the mouse was associated with the Devil, one reason being that it infested and devoured food, so St Joseph, in making a device for the destruction of mice, is symbolically victorious over the Devil. St Augustine also maintained that the marriage of Mary to Joseph only took place as a cover for the birth of the son of God, in order to deceive the Devil in the same way that the mouse is fooled by the bait in a trap. So the husband of the Virgin (who is shown in other roughly contemporary works as a rather pathetic stooge) is engaged in important work ensnaring Satan.

Until fairly recently scholarly opinion was split as to the attribution of a body of work which was variously ascribed to The Master of Flémalle, The Master of Mérode and Robert Campin. Most authorities now accept that the work of the two masters should now be attributed to Campin: and we can see in this beautiful Annunciation (one of the earliest to be set in a domestic interior rather than an ecclesiastical context) why Campin's groundbreaking work was so important as the jumping off point for van Eyck and the Netherlandish masters of the 15th century. *GS*

Contemporary Works

| 1423 | Gentile da Fabriano: *Adoration of the Magi*, Florence, Galleria degli Uffizi |
| 1425 | Masaccio: *The Holy Trinity, Florence*, Santa Maria Novella |

Robert Campin

Probably born between 1375 and 1379

1405-6	Recorded as a painter in Tournai.
1410	Becomes a citizen of Tournai. We can probably therefore conclude that Campin was not born in the town.
1423	Becomes Dean of the painters guild and following a revolt against aristocratic rule, he is also a member the Committee of Six, which oversees the finances of Tournai.
1427	Four apprentices are listed as being employed in his workshop including a Rogelet de Pasture who has been identified as Rogier van der Weyden.
1428	He is employed by the municipality on a mural (now destroyed) in the Halle des Jurez in Tournai.
1429	After the democratically elected town government is crushed in 1428, Campin refuses to give evidence against its former leaders. He is fined and required to undertake a pilgrimage to Provence.
1432	Campin is charged with immorality as he has been living with a woman other than his wife. He is sentenced to banishment for one year but the Countess of Hainault intercedes and the sentence is commuted to a fine.
1444	Dies in Tournai.

Housed in the New York mansion built by Henry Clay Frick (1849–1919), one of America's most successful industrialists, the collection houses masterpieces of Western painting, sculpture, and decorative art, displayed in a serene and intimate setting. The galleries are arranged for the most part without regard to period or national origin, in the same way that Mr Frick enjoyed the art he loved.

Both the mansion and the works in it serve as a monument to one of America's greatest art collectors. Built in 1913–14 from designs by the firm Carrère and Hastings, the house is set back from Fifth Avenue by an elevated garden.

Since Mr Frick's death in 1919, the collection has expanded both its physical dimensions and its holdings. Approximately one-third of the pictures have been acquired since then, and the building has been enlarged twice – in 1931–35 and 1977. At the Frick, visitors stroll from the airy, lighthearted Fragonard Room, named for that artist's large wall paintings of *The Progress of Love* and furnished with exceptional 18th-century French furniture and Sèvres porcelain, to the more austere atmosphere of the Living Hall, filled with masterpieces by Holbein, Titian, El Greco, and Bellini. Passing through the Library, rich with Italian bronzes and Chinese porcelain vases, one arrives at Mr Frick's long West Gallery, hung with celebrated canvases including landscapes by Constable, Ruisdael, and Corot and portraits by Rembrandt and Velázquez. Vermeer's *Mistress and Maid*, the last painting Mr Frick bought, is one of three pictures by that artist in the collection, while Piero della Francesca's image of St John the Evangelist, dominating the Enamel Room, is the only large painting by Piero in the United States. The East Gallery, adorned with works by Degas, Goya, Turner, Van Dyck, Claude Lorrain, Whistler, and others, usually concludes a visit to the galleries and leads visitors to the serene space of the Garden Court, where they pause beneath the skylight, surrounded by greenery and the gentle sounds of the fountain.

The Frick Collection

1 East 70th Street
New York, New York 10021
Tel: 212-288-0700
www.frick.org

Opening Hours

10.00am – 6.00pm Tuesday through Saturday
11.00am – 5.00pm Sundays
Closed Mondays and holidays

Admission

$15 adults; $10 senior citizens (62 and over); $5 students with valid identification. On Sundays, pay what you wish from 11.00am to 1.00pm. The price of admission includes the ArtPhone audio guide.

How To Get There

Subway: No. 6 train to Sixty-eighth Street.
Buses: M1 – M4 southbound on Fifth Avenue, northbound on Madison Avenue.

Access for the Disabled

The museum is fully accessible to visitors who use wheelchairs or walkers. (The museum also has wheelchairs available for visitors on a first-come / first-served basis.) The wheelchair ramp is just to the left of the main entrance of the museum on 70th Street, through a gate labeled 'Service and Office Entrance.' Open the gate or call for assistance using the call box located to the left of the gate, and proceed down the ramp to the basement Receiving Room. The security staff will assist visitors in wheelchairs from the Receiving Room to the ground floor galleries via an elevator. An elevator is also available for visitors needing assistance from the ground floor to the lower level special exhibition galleries. A fully accessible rest room is located on the ground floor.

Shop

Open Tues – Sat 10.00am to 5.45pm, Sunday 11.00am to 4.45pm

Duccio di Buoninsegna

The Temptation of Christ on the Mountain **1308–11**

The Frick Collection

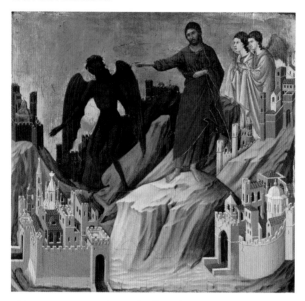

Acontemporary chronicle describes a grand procession in Siena on 9 June, 1311, when this painting – part of Duccio's masterful *Maestà* altarpiece – was carried from the artist's workshop on the outskirts of the city to the cathedral, where it was placed at the main altar.

> '… the shops were shut and the Bishop conducted a great and devout company of priests and friars in solemn procession, accompanied by the nine signori, and all the officers of the commune, and all the people, and one after the other the worthiest with lighted candles in their hands took places near the picture; and behind came the women and children with great devotion. And they accompanied the picture up to the Duomo, making the procession around the Campo, as is the custom, all the bells ringing joyously, out of reverence for so noble a picture…'

Duccio had spent three long years on his *Maestà*: his contract had stipulated that the painting should be entirely by his hand and he must work without interruption, accepting no other jobs until it was finished.

The altarpiece was commissioned by the city of Siena and was dedicated to the Virgin, the city's patron saint, making the work a celebration of both religious devotion and civic pride. It was comprised of a huge central panel of the Virgin and Child in Majesty (*Maestà*) with saints and angels topped by numerous smaller panels depicting the Apostles and the life of the Virgin. Below was a predella with scenes from the birth and infancy of Christ. The Frick *Temptation*, however, comes from the back of the altarpiece that illustrated the life and Passion of Christ. It was one of several pieces sold after the altarpiece

was dismembered and removed from the cathedral in 1771. (Though some pieces have been lost, the majority of the altarpiece can be seen today in Siena cathedral.)

Though clearly underappreciated in the 1770s (when the Gothic style was out of fashion), in Duccio's own time and for generations afterward, the brilliant hues and vivid narrative of his *Maestà* would be a touchstone for Sienese artists. The altarpiece marked a milestone in Western art and this little panel displays why. In it, a resolute Christ, dressed in regal red and blue, rejects the devil, a scowling, winged grey monster, who had offered Christ 'all the kingdoms of the world' if He will worship him (Matthew 4:8–11). The offered kingdoms are depicted like crenellated Lego-sized cities, far out of proportion with the large figures. The contemporary viewer would have understood this disproportion (which was a typical medieval painting technique) as reflective, not of naturalistic scale, but rather of the values inherent in the story: that is, earthly splendor is nothing compared to the glory of God.

But it is Duccio's characteristic lyricism and expressive color as well as his synthesis of traditional and contemporary techniques and formats that truly sets his work apart. Though employing a rigid, Byzantine-influenced format, Duccio infuses the story with emotion and energy, much like his contemporary Giotto was doing in Florence; note Christ's solemn, sorrowful expression and the quiet forcefulness of his gestures. The contemporary viewer might even see a bit of their own home, Siena, in the city's colorful spires and towers, whose detail and precision recalls contemporary northern European art. Duccio's innovations were immediately appreciated; another contemporary chronicler called the *Maestà* 'the most beautiful picture ever seen and made.' *DM*

Contemporary Works

*c*1310	Giotto: *Ognissanti Madonna*, Florence, Galleria degli Uffizi
1317	Simone Martini: *St Louis of Toulouse Crowning Robert of Anjou King of Naples*, Naples, Museo di Capodimonte

Duccio di Buoninsegna

1278	First recorded as painting 12 coffers for the Commune of Siena.
1285	Duccio agrees to paint a Madonna and Child with Angels (*Maestà*) commissioned by Società di S Maria Virginis, now known as the Rucellai Madonna.
1302	Duccio is paid for an untraced *Maestà* to be installed in the Palazzo Publico in Siena.
1311	A huge *Maestà* five meters high, painted by Duccio is ceremonially installed in Siena Cathedral.
1318 or 19	Duccio dies before 3 August 1319.

Jan van Eyck

Virgin and Child with Saints and Donor **early 1440s**

The Frick Collection

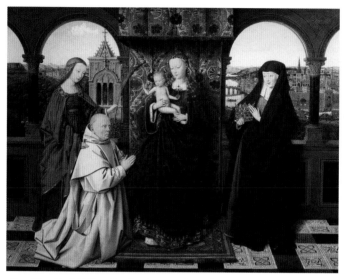

J an Vos (d. 1462), a Carthusian monk and prior of the Charterhouse of
Genadedal near Bruges, commissioned this painting around 1441 from
van Eyck. Though it is thought to be one of van Eyck's last paintings and
may have been finished by his workshop, it nonetheless demonstrates the
painterly skills that made van Eyck famous.

Vos had himself included in the picture kneeling in worship before the
Virgin and Child. He wears a white monk's robe and his piercing gaze meets
the Virgin's, a sign to all viewers of his privileged relationship with the holy
family, reinforced by the blessing he receives from the long-limbed, naked
Christ Child. The Virgin and Child are both blonde, as they are in most northern
European art, and Mary is regally attired standing beneath a brocade canopy
– inscribed AVE GRA[TIA] PLE[N]A (Hail [Mary] full of grace) – and on an
imported carpet laid on a decorative tile floor. This sumptuous detail reflects
both the material wealth of 15th-century Netherlandish society and van Eyck's
exceptional mimetic skill.

Famed for his pictorial illusionism, van Eyck is often credited with the
invention of oil painting; i.e. using oil to bind pigment as opposed to the
less versatile tempera, or egg. However, oil was in fact used as early as the
12th century; but it was van Eyck's virtuoso usage of the medium that helped
to popularize it. He loved to amaze the viewer with details of microscopic
verisimilitude and with a startling naturalism that conveyed the experience of
everyday life – note, for example, the fine pattern of the carpet or the lines of
Vos' face. Playing with the effects of light on various surfaces – note the jewels
on the Virgin's hem – van Eyck tried to break the barrier between the pictorial
space and the viewer's, inviting the onlooker into the image.

The inclusion of popular saints also appealed to a contemporary audience.
It is a pretty St Barbara who presents Vos to the Virgin and Child. She holds a

martyr's palm and her attribute, the tower where she was imprisoned for her Christianity, rises behind her. A statue of the god Mars stands in the tower window; a reference to Barbara as the patron saint of soldiers. On the other side is St Elizabeth of Hungary who holds the crown she gave up to be a nun. Why were these two particular saints included? The saints chosen for such a donor painting were usually associated somehow with the donor. St Elizabeth may be included because she was the patron saint of the Duchess of Burgundy, a supporter of Carthusian monasteries, and St Barbara could be connected with Vos's youthful membership in the Teutonic Order, a religious foundation with military ties.

All figures are framed before an ornate arcade which opens to a detailed background, which allowed van Eyck to show off his mastery of perspective and insert an element of genre: note the figures sitting in the cart and boat. Though many scholars have tried to identify the city represented, this view, like most of van Eyck's panoramas, is almost certainly imaginary, a composite of van Eyck's notion of an ideal city.

Images such as this were often used as aids in private devotion. Van Eyck's mix of naturalism and precision creates a sense of absolute stillness – you could hear a pin drop – that at the same time crackles with an energy which was no doubt a potent inspiration for the worshipper. *DM*

Contemporary Works

1435–40	Rogier van der Weyden: *St Luke Portraying the Virgin*, Boston, Museum of Fine Arts
1444	Konrad Witz: *Miraculous Draught of Fishes*, Geneva, Musée d'Art et d'Histoire
*c*1445	Domenico Veneziano: *Santa Lucia Altarpiece (Virgin and Child with Saints)*, Florence, Galleria degli Uffizi

Jan van Eyck

*c*1390–5	A birth date for Jan van Eyck is unknown but he was probably born about 1390 or perhaps a little later, almost certainly in the town of Maaseick.
1422–5	Jan, already a master, is recorded as court painter to John of Bavaria, Count of Holland working on decorative schemes for his palace in The Hague.
1425	On 19 May Jan is in Bruges where he enters the service of Philip the Good, Duke of Burgundy as painter and *valet de chambre*.
1426–7	Jan is in Lille, probably painting the walls of the ducal palace. He also seems to have undertaken two secret missions for the duke at this time.
1428–9	Jan is part of a Burgundian embassy which travels to Portugal in order to negotiate for the hand of Isabella, daughter of John I. Jan paints the Infanta's (untraced) portrait.
1431	Settles in Bruges where he works on completing the *Ghent Altarpiece*, left incomplete by his deceased brother Hubert.
1432	Jan buys a house in Bruges.
1434	Jan's first son is born. The Duke of Burgundy is his godfather.
1436	Duke Philip sends Jan on a secret mission to a 'distant land,' possibly the Holy Land.
1441	Jan dies on 9 July in Bruges.

Piero della Francesca

The Frick Collection

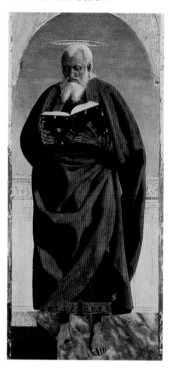

Piero della Francesca, one of the most innovative artists of the 15th century, worked for some of the most powerful figures in Italy, from Frederico de Montefeltro, the Duke of Urbino, to Pope Nicolas V in Rome. Yet Piero always maintained links with his hometown of Borgo Sansepolcro in Tuscany, where in 1454 he accepted a commission to paint a polyptych for the high altar of the church of S. Agostino. His patron was one Angelo de Giovanni di Simone d'Angelo who initiated the project to fulfill the wishes of his late brother, Simone, and Simone's wife, Giovanna, to make a donation to the church for the spiritual benefit of the donors and their family.

This type of religious commission was common among the wealthy mercantile and aristocratic classes. For the devout, such a gift helped guarantee their place in heaven; and, on a more secular level, commissioning an altarpiece for a church was a sanctioned method to display not only the donors' piety but also their status and wealth (a useful function in Renaissance Italy where sumptuary laws frequently forbade overt public displays of riches). And no doubt, particularly for the small town, d'Angelo family, it was a mark of honor to hire such an illustrious artist as Piero.

The contract stipulated that Piero should include 'images, figures, pictures and ornaments.' Unfortunately, the central portion of the altarpiece is lost, but four side panels with standing saints – St Michael the Archangel (National Gallery, London), St Augustine (Museu Nacional de Arte Antiga, Lisbon), St

Nicholas of Tolentino (Museo Poldi-Pezzoli, Milan), and this painting, thought to be St John the Evangelist – have survived. The figure has no identifying attributes but is thought to be St John as he was the patron saint of the donor's father and Simone's wife.

Busy with other commissions, Piero took 15 years to complete the altarpiece (a record of his payment is dated 1469). Still, despite his commitments to other more illustrious and, no doubt, demanding patrons, Piero endowed the Sansepolcro altarpiece with the same contemplative precision and mesmerizing stillness of all his works.

The elderly saint stands reading, draped in red and crowned with a golden halo. The cool color palette and balanced order give the figure a restrained elegance, while his ruddy feet, hands and aged face add an earthy quality. It is a precise balance of a naturalism derived from Netherlandish art with the clearly defined volumes and accurate perspective of the art of classical antiquity. Piero, like many in Renaissance Italy, was fascinated by Greco-Roman antiquity; to emulate the style and works of the Ancients was seen as a way of returning to a grandeur that was felt to have been lost during the 'middle ages,' that is, from the end of antiquity to their own time. This classical influence is evident not only in Piero's crisp linear perspective (the artist was fascinated with geometry and mathematics and would write several treatises on the subjects in later life) but also in the saint's costume and background: note the marble floor and applied columns, capitals and entablature.

Exactly where Piero learned all this is unknown; his early life and training remain a mystery. He is first recorded in 1439 working in Florence with Domenico Veneziano. Subsequently he received commissions for frescos, altarpieces and portraits throughout central Italy. But other than that, we have only his art. **DM**

Contemporary Works

1455	Enguerrand Quarton: *The Avignon Pietà*, Paris, Musée du Louvre
c1460	Rogier van der Weyden: *Francesco d'Este*, New York Metropolitan Museum
1461	Benozzo Gozzoli: *Journey of the Magi*, Florence, Galleria degli Uffizi

Piero della Francesca

c1418	Born in Borgo Sansepolcro, near Arezzo in eastern Tuscany.
1439 – 40	Piero works with Domenico Veneziano in Florence on frescoes for the church of Sant'Egidio which are now lost. While in Florence he witnesses a visit by the Byzantine emperor John VIII Paleologus.
1442	He is back in Borgo Sansepolcro, where he is a candidate for a position on the Town Council.
1445	A contract is signed commissioning Piero to produce a polyptych of the *Madonna della Misericordia* for the Compagnia della Misericordia in Borgo.
1449–51	Works for Sigismondo Malatesta in Rimini and the Este family in Ferrara.
1452	Piero begins the fresco cycle of the *Legend of the True Cross* in the church of San Francesco in Arezzo.
1458-9	Piero is in Rome working on frescoes (now lost) in the Vatican but is also engaged in *The Resurrection* and the unfinished *Madonna della Misericordia*, both in Borgo.
1460–70	Works in Borgo, Arezzo and Perugia.
1469	Stays in Urbino with Giovanni Santi, the father of Raphael.
1474–8	He is again in Urbino working for Federico da Montefeltro.
After 1478	Spends most of his time in Borgo Sansepolcro; it is at this time that he produces his treatises on perspective.
1492	Dies and is buried at Borgo Sansepolcro.

Giovanni Bellini

St Francis in the Desert

The Frick Collection

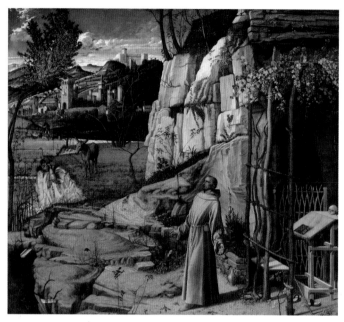

Francis was born Giovanni di Bernardone, the son of a wealthy textile merchant. In his early 20s he famously repudiated his earthly wealth to live the life of a devout ascetic, becoming an itinerant dressed in rags. In 1209, having attracted a small group of adherents, he traveled to Rome and was given an audience with Pope Innocent III who gave his permission for the creation of the Franciscan order of Friars.

On his return in 1221 from a pilgrimage to the Holy Land, faced with dissension within the order, which had grown exponentially, Francis abjured his leadership and returned to the contemplative life. A few years before, a nobleman had given Francis land on the Tuscan mountain known as La Verna in the province of Arezzo and it was while fasting and praying here in 1224 that legend records he received the Stigmata – lesions resembling the five principal wounds inflicted on Christ during His crucifixion.

Bellini has depicted Francis standing as though receiving the Stigmata although, unlike other representations of the same subject, we cannot see the vision of the crucified Christ hovering above him on seraphim wings nor are there any visible 'rays' indicating the transfer of the wounds to his hands and feet. Rather Bellini has sought to symbolize this event in a much more subtle way by illuminating Francis and his immediate surroundings with an unnatural light emanating from a hidden source to the left which mesmerizes the saintly friar, lights up the rock face and the tree to the top left and which casts strong shadows behind Francis and the objects in his study.

But there is another layer of significance which Bellini has built into his iconography. Early Franciscan writers compared Mount La Verna to the desert

described in the Book of Exodus and they made a further connection between what happened to Francis on La Verna and the communication between God and Moses on Mount Sinai. So Bellini has constructed a landscape which reflects these associations. St Francis does indeed inhabit a barren, desert-like outcrop but within a more benign landscape which conforms to that of eastern Tuscany.

However this is not quite the isolated mountainous retreat which the real Francis endured – his makeshift study has been constructed not far from a rather beautiful city. It has been suggested that this represents the Heavenly Jerusalem to which Francis will gain entry through his chosen life as an ascetic. The cave also connects Francis with St Jerome, the first saintly hermit, but his discarded pattens left within his study are a further reference to Moses (and God's command that Moses should 'put off the shoes from thy feet for the place whereon thou standest is holy ground') as is the water spout which drains the rocky outcrop and which refers to the fountain that Moses miraculously called forth from the stony wilderness of Sinai.

Some scholars have acclaimed this picture as the greatest Renaissance painting on show in New York and it is hard to argue with that opinion. It is filled with the most marvelous detail. The ethereal light picks out plants, such as the yellow mullein behind Francis, animals and birds, including a heron, a donkey and a memorable rabbit emerging hesitantly from its burrow near to St Francis's right sleeve, as well as the peculiar Mantegnesque rock formations which guard the saint's retreat. The brown and ocher colors of the foreground are balanced by a wonderfully lustrous blue sky – Bellini was a master when it came to depicting the sky but surely this is one of his most splendid, a progenitor of all those later Venetian skies created by Titian and Veronese.

Beneath it all in the lower left hand corner a piece of parchment is caught on some dead branches; a closer look reveals that it is inscribed Joannes Bellinus. *GS*

Contemporary Works

c1480	Hugo van der Goes: *Dormition of the Virgin*, Bruges, Groeningemuseum
	Sandro Botticelli: *Primavera*, Florence, Galleria degli Uffizi
1480–89	Hans Memling: *The Annunciation*, New York, Metropolitan Museum

Giovanni Bellini

1431–6?	Born in Venice, the son of the painter Jacopo Bellini.
1453	Giovanni's sister Nicolosia marries Andrea Mantegna.
1459	By this date he has his own house in Venice and is probably working as an independent artist although still helping his father and brother Gentile with some commissions.
1474	Completes portrait of Jörg Fugger using oil painting technique.
1475	Antonello da Messina visits Venice, influencing Bellini especially in regard to his use of oil paint.
1470s	Probably travels to Pesaro in connection with a commission, the only journey he ever makes outside the Veneto.
1479	Starts work on a series of scenes from Venetian history in the Doge's Palace. Continued to contribute to this cycle (now destroyed) for four decades.
1506	Dürer is in Venice and writes that Giovanni Bellini is the only Venetian artist to treat him in a friendly manner.
1516	Dies in Venice.

Hans Holbein the Younger

Sir Thomas More 1527

The Frick Collection

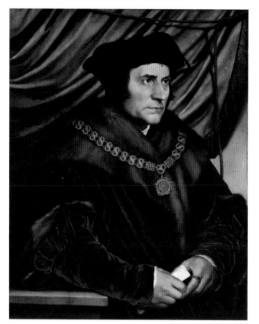

 n 1524 Holbein painted a portrait of the great humanist scholar Desiderius
Erasmus, now in the Louvre. Both painter and subject were then living in
the Swiss city of Basel, one of the intellectual powerhouses of Europe. But
soon afterwards both Holbein and Erasmus (an accomplished fence sitter
during the testing early years of the Reformation), had decided to quit the
town which had been beset by Protestant agitation and iconoclastic riots.
So late in 1526 Holbein, leaving his wife and small children, headed for
Antwerp and then on to London where, armed with a letter of introduction
from Erasmus, he joined the household of Sir Thomas More in 1527.

More, a close friend of Erasmus, was a successful lawyer and politician, he
was elected to parliament in 1504 and by 1517 had become a royal councilor
to Henry VIII. His humanist political work *Utopia* had been published in 1516
which took the form of discussions on the best form of government. In 1521 he
had received a knighthood; two years later he became Speaker of the Commons
and in 1525 he was appointed Chancellor of the Duchy of Lancaster.

So by 1527, when this magnificent portrait was painted, More was a
statesman of some importance (soon to rise even further in the king's favor).
And it is as a statesman rather than a scholar that Holbein has portrayed him,
expensively robed with his chain of office arranged over his ample fur collar.
More sits in three-quarter profile, his head framed against a green curtain, his
expression intense and determined – one might almost say severe. He was
canonized in 1935 and subsequent biographical writings have perhaps colored
our perception of him as a 'man for all seasons,' a saintly figure caught in the
monstrous machinations of a tyrannical king; but here we are in the company

of another Thomas More, an implacable royal advisor who had pressed that same king for more draconian measures in pursuance of the persecution of heretics.

Holbein's amazing ability to render in paint the precise tactile quality of such materials as fur, velvet and silk is demonstrated to the full in this picture – he pulls out all the stops. One can feel the weight of the heavy garment on More's shoulders and the pressure of his golden chain as it settles into the fur. We can see how the fur parts (in the way that only fur does) as the pelt is turned in around his neck and we can only marvel at the miraculous way he has conjured that luminous quality of the velvet used for More's cuffs. All this is accentuated by Holbein's subtle use of light and shadows to produce an uncanny sense of volume and presence – the feeling that the reality of Thomas More is palpable, right down to the stubble on his chin.

More's steady ascent continued after this portrait was completed when, in 1529, he succeeded Cardinal Wolsey as Lord Chancellor. But three years later he resigned when he found himself unable to concur with the king on the matter of his divorce from Catherine of Aragon. In 1534 More refused to swear an oath accepting the legitimacy of an altered succession in favor of Anne Boleyn's children and also repudiating the supremacy of the pope. He was committed to the Tower of London in April 1534 and executed in July 1535. *GS*

Contemporary Works

1527	Jan Gossaert: *Danaë*, Munich, Alte Pinakothek
1527/8?	Parmigianino: *The Conversion of St Paul*, Vienna, Kunsthistorisches Museum
1528	Pontormo: *Deposition*, Florence, S Felicita

Hans Holbein the Younger

1497–8	Born in Augsburg. Date of birth uncertain. Holbein came from a family of artists, his father and uncle were also accomplished painters.
1517	Holbein is working in Lucerne with his father and possibly visits Italy.
1519	He becomes a master in the Basel guild of painters.
1521	He is commissioned to paint murals on the theme of Justice for the Council Chamber at Basel.
1523	Paints several portraits of Erasmus.
1524	Visits France.
1526	Holbein leaves Basel and travels via Antwerp to London armed with a letter of introduction from Erasmus to Sir Thomas More.
1527	Paints this portrait of Sir Thomas More and other friends of Erasmus.
1528	Returns to Basel.
1530	Completes the murals in the Council Chamber at Basel.
1532	Returns to England where he found that More was out of favor.
1533	Holbein gains the patronage of the Hanseatic merchants of the Steel yard and through them he probably meets Thomas Cromwell who may have been instrumental in obtaining for him the commission for *The Ambassadors*.
1536	First recorded as the king's painter. He is salaried but retains a private clientele.
1537	Paints a portrait of Jane Seymour.
1538	Commissioned to paint prospective brides for the king, including the portrait of Christina of Denmark now in the National Gallery, London. Makes a brief visit to Basel while traveling for these commissions.
1543	Dies in London.

Titian

Pietro Aretino

The Frick Collection

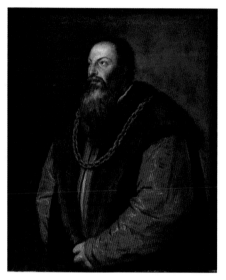

As Titian has vividly portrayed in this painting, Pietro Aretino was a larger than life figure, a poet, dramatist, critic and pornographer, who often transgressed the boundaries of propriety. Born in Arezzo in southeastern Tuscany, the son of a shoemaker, he received very little formal education but on moving to Perugia at about the age of 18 it seems that he may have trained for a short while as a painter. By 1517 he was in Rome where his considerable talents as a satirist catapulted him to fame but also generated a coterie of influential enemies. As for his friends, he counted Michelangelo, Raphael and Sebastiano del Piombo amongst them.

In 1524 another friend, the engraver Marcantonio Raimondi, was imprisoned as a result of the appearance of a set of 16 of his engravings (after drawings by Giulio Romano) showing different sexual positions. This spurred Aretino to publish his *sonetti lussuriosi* (lewd sonnets) which were accompanied by another set of Raimondi's prints. It was a show of defiance which, together with his continued scurrilous attacks on the powerful, made it impossible for him to stay in Rome, and to avoid imprisonment he left the city and eventually settled in Venice where he remained for the rest of his life.

In Venice he began writing letters on innumerable subjects, usually written with an eye to publication. Over 600 of these epistles can be described as art criticism including one dated 1545 in which he analyzes Michelangelo's recently completed *Last Judgement* and astoundingly – considering the reasons for his departure from Rome – accuses him of impropriety for representing saints in the nude. But these letters were also the vehicles for continued satirical attacks and (the other side of the coin) obsequious flattery and through these means he amassed considerable wealth, receiving gifts from popes and kings who wished to encourage the latter and avoid the former. Two popes proffered knighthoods upon him and Francis I of France gave him a gold chain similar

to the one he is wearing in this portrait (which can be seen in another Titian portrait of him now in the Pitti Palace, Florence). All this puts into context the hubristically grandiose appellation he gave himself – *flagello dei principe* (scourge of princes).

On his arrival in Venice (around 1527) Aretino soon became acquainted with the great artists then working in that great maritime city. He commissioned family portraits and mythological scenes for his house from Tintoretto and Titian became a close friend. At about this time, in 1530, Titian attracted the interest of the Emperor Charles V who was so enamored with his talent that three years later he bestowed on him the title of Count Palatine and Knight of the Golden Spur. Charles's commissions represented the apogee of Titian's fame and success and at first they took the form of portraits, a genre which was evolving at this time (due in no small measure to Titian) away from the head and shoulders format typical of the 15th century towards more expansive half length and full length paintings.

In this later portrait of Aretino Titian presents his friend bedecked in satin and fur, one of his gold chains adding to the impression of a successful, worldly man, solid, purposeful, focused, the eyes conveying the menace of the implacable satirist, the sumptuous clothing signifying the fruits of the opportunistic propagandist – the two sides of the 'scourge of rinces'. *GS*

Contemporary Works

1551	Pieter Aertsen: *Butcher's Stall*, Uppsala, University Collection
1552	Giovanni Battista Moroni: *Gian Lodovico Madruzzo*, Chicago, Art Institute
1553	Jacopo Tintoretto: *Lorenzo Sornaro*, Vienna, Kunsthistorisches Museum

Titian

1485–90	The date of Titian's birth in Pieve di Cadore is much disputed by scholars. Arrives in Venice as a child.
1508	According to Vasari, Titian works with Giorgione on exterior frescoes for the headquarters of the German merchants in Venice.
1516	Stays in Ferrara at the ducal castle for a month as the guest of the Duke of Ferrara. Meets Fra Bartolommeo.
1518	The huge, seven-meter tall *Assumption of the Virgin* is installed in the church of S Maria Gloriosa dei Frari in Venice.
1519	Titian is in Mantua.
1526	Completes another altarpiece for the Frari church in Venice.
1530	First meeting with the Holy Roman Emperor, Charles V. Titian's wife dies.
1533	Titian is created Count Palatine of the Golden Spur by Charles V.
1543	Titian is in Bologna where he paints a portrait of Pope Paul III.
1546	Visits Rome and meets Michelangelo. Paints *Pope Paul III with his grandsons*.
1547	Charles V summons Titian to join him in Augsburg. Paints the equestrian portrait of Charles V at the Battle of Mühlberg. Charles's sister Queen Mary of Hungary, regent of the Netherlands, commissions large decorative paintings for her château in the Low Countries.
1548	Executes portraits of Ferdinand I, King of Bohemia and Hungary at Innsbruck.
1550	Travels again to Augsburg where he is commissioned by the future Philip II of Spain to paint a series of religious and erotic, classical subjects (poesie) to be sent at intervals from Venice to Spain.
1560s	His famous 'late' style is characterized by very loose handling of paint outlining forms which are dissolved by light.
1573	Commences his last masterpiece, the *Pietà*.
1576	Dies in Venice.

Agnolo Bronzino

Portrait of Lodovico Capponi **1550 – 5**

The Frick Collection

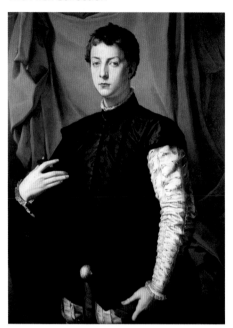

Although you wouldn't immediately know it from his proud, aristocratic air, at about the time this portrait was painted Lodovico Capponi (b. 1533) was madly in love. A page at the Medici court in Florence, in the mid-1550s Lodovico fell in love with a girl whom Duke Cosimo de Medici had intended for one of his cousins. Refused permission to marry, the couple nevertheless remained devoted to each other for three years when, suddenly, the Duke relented with the stipulation that they marry within 24 hours. One can imagine it was a joyous, if rushed, event.

Agnolo di Cosimo di Mariano, called Bronzino, was the court painter of Duke Cosimo and the foremost portraitist in Florence. He also painted religious and allegorical subjects as well as decorations for Medici festivities (perhaps even Ludovico's long awaited wedding) but it is his startlingly crisp portraits, such as this one, for which he is most renowned.

For Bronzino (and for the ducal court), a portrait was a mask. It was not intended to reveal the sitter's character, but to convey the subject's status, sophistication, and self-possession. He depicts young Ludovico almost as a symbol of the Capponi family, wearing his family's armorial colors – black and white. With cool detachment, the young man stands before vivid green drapery that highlights his soft boyish skin and fashionable figure. In keeping with Bronzino's Mannerist style, his body is elongated and his fingers expressive, or 'mannered.'

Mannerism emphasized complexity and virtuosity over naturalism. The style originated in Italy in the 1520s with artists who, inspired by the late works of Michelangelo and Raphael, began to emphasize tension and instability in

composition rather than the balance and clarity of earlier Renaissance painting. Bronzino, part of the second generation of Mannerists, liked to lengthen bodies, flatten pictorial space and use vibrant color to create an air of intellectual and aristocratic elegance. The portraits he made at the Medici court express his extraordinary technical skill and refined execution.

Bronzino liked to focus on the sensations of the material world; here he makes the silks look tactile, the ruffs crisp, hair freshly cut. The surface is finished in such meticulous detail that there is almost no trace of brushstrokes. Even Ludovico's prominent codpiece – which was a widely popular feature of men's fashion at the time, a stylish conceit of masculine virility – adds to his courtly image. (Not all ages, shared this opinion; in the 19th century the codpiece was considered obscene and was temporarily painted over.)

As part of the Medici court, Bronzino must have known of Ludovico's love affair and he may allude to it with the cameo that the sitter holds and partially conceals with his finger. The image is hidden but the cameo's inscription is legible: *sorte* (fate), a meaningful allusion to the twists of fortune and love. Was this painted during the three-year wait? Did Bronzino give this serious young man's expression a hint of sadness because of his thwarted romance? We can only speculate. **DM**

Contemporary Works

1551	Titian: *Elector John Frederick of Saxony*, Vienna, Kunsthistorisches Museum
1551–2	Giovanni Battista Moroni: *Gian Lodovico Madruzzo*, Chicago, Art Institute
c1555	Paolo Veronese: *The Anointment of David*, Vienna, Kunsthistorisches Museum

Agnolo Bronzino

1503	Born near Florence.
1520's	Works with the Florentine Mannerist Pontormo on a number of commissions in and around Florence.
1530	Works in Pesaro.
1532	Returns to Florence where he paints a number of altarpieces
1537	Bronzino becomes a member of the Compagnia di S Luca, the artists' guild.
1539	Becomes court painter to Cosimo I, Duke of Florence, a post which he kept until his death. As well as executing portraits and frescos he also designed tapestries and wrote poetry.
1572	Dies in Florence.

Paolo Veronese

The Choice Between Virtue and Vice

The Frick Collection

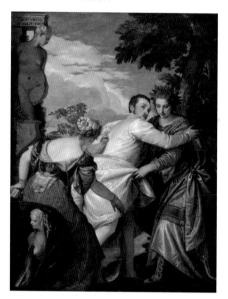

Veronese, a painter famed for his color, illusionism and pageantry, can exert a surprisingly profound influence. Art critic John Ruskin (1819–1900) wrote of a Sunday in 1858 when his 'evangelical beliefs were put away' after seeing a particularly luscious Veronese in Turin; from that moment he realized that 'to be a first-rate painter, you mustn't be pious – but rather a little wicked and entirely a man of the world.'

This is an apt appraisal of Veronese, one of the most important painters of 16th-century Venice, whose paintings revolve around beauty and the pleasures of the flesh, even when depicting moralizing tales. His luminous color is designed to delight and his fabrics are so sensuous, clothing can seem as alluring as nudity. Yet his work is underlined with a subtle intelligence and rigor, which lifts it high above mere decorativeness.

His pictures often depict the worldly, festival atmosphere of 16th-century Venice, including this one. At first glance the colorful costumes and flurry of action suggest a light-hearted scene but it quickly becomes evident that something is not right. Is the man's leg bloody? Is that fear in his eyes? Does the beautiful blonde in blue and orange have claws?

Yes to all, as this is an allegory of Virtue and Vice, most probably a variant on the Choice of Hercules, a popular theme in Renaissance art. In it, the young Hercules finds himself at a crossroads where he must decide between a life of ease and pleasure (Vice) or a challenging lifelong ascent that will eventually lead to true happiness (Virtue). In typical Veronese fashion, the characters are not in classical dress but rather in 16th-century Venetian costumes. Dressed in gold-trimmed white satin, Hercules is a contemporary gentleman (some have even suggested that it is a self-portrait of Veronese) and he must choose between two young women.

One is modestly dressed in a green gown and her serious face is crowned with a laurel wreath. The other woman, though her back is to the viewer, is clearly the more beautiful of the two, with golden hair, lilywhite shoulders and a sumptuous dress. She holds a pack of playing cards, an indicator of the variability of fortune as well as a reference to a life of idleness and play. She leans on a marble Sphinx – an emblem of lust in the Renaissance – with a knife against its chest; both allude to death. If it wasn't already obvious that she is Vice, then her pointed claws, which Veronese highlights with a daub of white and red, give it away. Hercules, already bleeding from tarrying too long with Vice, wisely turns to the protective arms of Virtue.

The motto *Honor et virtus post mortem floret* (Honor and virtue flourish after death) written on a classical statue in the background, reinforces the moral. Yet the image, like most Veroneses, appeals to the senses with its opulent bravura and lush hues, suggesting that though he may run to Virtue now, the young man, like Ruskin, may have a change of heart.

This picture was one of five Veroneses in the collection of Emperor Rudolf II in Prague. A theory suggests the paintings were commissioned for Rudolf's coronation in 1576, but this is uncertain. After a colorful history – including being stolen by invading Swedish troops in 1648 – this painting (along with the *Allegory of Wisdom and Strength*) entered the Frick collection in 1912. *DM*

Contemporary Works

1575–80	Jacopo Tintoretto: *Christ at the Sea of Galilee*, Washington, National Gallery of Art
1577	El Greco: *The Assumption of the Virgin*, Chicago, Art Institute
1581	Nicholas Hilliard: *Sir Frances Drake*, Vienna, Kunsthistorisches Museum

Paolo Veronese

1528	Born in Verona, the son of a stonecutter.
1541	Veronese is recorded as being apprenticed to Antonio Badile.
1551	Completes a commission for an altarpiece in the Giustiniani Chapel within the Venetian church S Francesco della Vigna.
1552	Works in Mantua on a fresco in the cathedral.
1553	Moves to live in Venice. Begins work on decorations for rooms within the Doge's Palace which establish his reputation.
1560	Visits Rome.
c1561	Works on frescoes for the newly finished Villa Barbaro designed by Andrea Palladio at Maser in the Veneto.
1562	Begins work on the vast banquet picture *Wedding at Cana* for the refectory of S Giorgio Maggiore in Venice.
1566	Returns to Verona. Marries Elena Badile, the daughter of his first master. Works on two altarpieces in the city.
1573	Completes the monumental *Feast in the House of Levi* for the refectory of Santi Giovanni e Paulo in Venice.
1574	A fire in the Doge's Palace brings further commissions for Veronese.
1579	Veronese and Francesco Bassano jointly win a competition for the execution of a huge *Paradise* in the Sala del Maggior Consiglio in the Doge's Palace. The commission was never undertaken. Tintoretto eventually completes the picture.
1588	Dies in Venice.

Anthony van Dyck

The Frick Collection

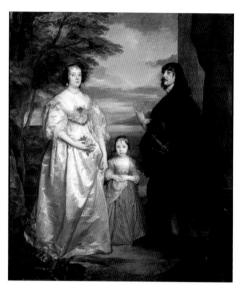

By accepting King Charles I's invitation to England in 1632, Antwerp-born and trained Anthony van Dyck set in motion a long tradition of portrait painting in the British Isles. One of the greatest Flemish artists of the 17th century, van Dyck was a brilliant portraitist and his paintings of the king and the nobility between 1632 and 1641 inspired artists for the next 150 years and effectively created the enduring image of the Stuart court, of which this painting is a sterling example.

A group portrait featuring elegantly arranged figures in a romantic countryside – like all good Flemish painters van Dyck was also a sensitive landscapist – was typical of the artist's late English period (as a 20-year-old he had briefly come to England to work for James I). Pictured are James Stanley, seventh Earl of Derby (1607–51), his wife Charlotte de la Trémoille (1599–1664) and one of their daughters, captured in aristocratic ease before the Civil Wars (1642–51) engulfed the British Isles and overturned their world.

With brilliant brushwork and seeming effortlessness, van Dyck envelopes each figure in luxurious fabric and lace. The earl, stylishly attired in black, gracefully motions to an island in the background, most likely representing the Isle of Man, of which the Derbys were hereditary sovereigns. The countess is his counterpart in white, dripping with jewels and ringlets. But it is the little girl (whose name is sadly unrecorded) who steals the limelight. In her vibrant orange gown – an allusion to the family's descent from the House of Orange – she is like a little ball of barely restrained energy with her pressed lips, direct stare and neatly folded hands. Van Dyck was one of the best child portraitists ever and here one can sense a childish mix of curiosity and a desire to run off to play.

However, van Dyck's portrait is primarily about the aspirations of the adults

and of their aristocratic society. He creates figures of matchless elegance, natural dignity and of unquestioned authority and high culture. In this image, like others, he flatteringly elongated the subjects and portrayed them from below to enhance their stature. The sitters seem at once grand and human, a style of formal portraiture that remains the picture of blue-blooded nobility and gentlemanly ease today. Unsurprisingly van Dyck was eagerly sought after by society; so much so that he needed a workshop full of assistants who would do things like paint the costumes of his sitters arranged on dummies.

This artistic record of the Stuart court's defiantly aristocratic bearing and cult of courtly refinement takes on a poignant aspect when considered in light of subsequent history. The earl and his wife were ardent Royalists. During the civil war, the earl, who prior to the war was a writer of history and devotional works, fought valiantly for Charles I, as did the countess, who was renowned for her vigorous defense of the family's country seat, Lathom House, during a three month siege. Despite their efforts, the earl was captured and executed by Commonwealth forces in 1651. The countess, however, lived to see the restoration of the Stuart crown. *DM*

Contemporary Works

1636	Nicolas Poussin: *A Dance to the Music of Time*, London, Wallace Collection
1639	Peter Paul Rubens: *Rubens, His Wife Helena Fourment and their Son*, New York, Metropolitan Museum
1640	Georges de la Tour: *Boy Blowing on a Lamp*, Dijon, Musée des Beaux-Arts

Anthony van Dyck

1599	Born in Antwerp, the seventh child of a textile merchant.
1609	Becomes a pupil of the Dean of the Antwerp Guild of St Luke.
1617	His father becomes bankrupt.
1618	Registered as a master of the Guild of St Luke.
1618–19	He is working in Rubens' studio.
1620	Partly in order to avoid paying for his father's debts, van Dyck sets up his own independent studio in Antwerp, but later in the year he is in London.
1621	Van Dyck receives £100 from James I in recompense for 'special services.' In March he returns to Antwerp. In October he leaves for Genoa.
1622	He is in Rome. Then travels to Venice and Mantua, painting a number of portraits, some of traveling English aristocrats, as he went.
1623	Visits Turin, Florence and Bologna, then travels back to Rome where he paints more portraits. Meets Sir Kenelm Digby, a future English patron.
1624	He is in Palermo completing commissions from the Viceroy of Sicily.
1627	Returns to Antwerp where he paints religous subjects and portraits.
1630	Becomes painter to the court of Infanta Isabella in Brussels but remains resident in Antwerp.
1632	After spending the previous winter in The Hague, van Dyck travels to London receiving a knighthood from Charles I.
1634	In Antwerp attending to business and is elected Dean of the Guild of St Luke.
1635	Returns to England.
1637	Van Dyck is paid £1,200 by Charles I for 'certaine pictures.'
1639	Marries Mary Ruthven, a member of the queen's retinue.
1640	Visits Flanders; then travels to Paris in the hope of prestigious commissions for the Louvre.
1641	Dies in London eight days after his wife gives birth to their daughter Justiniana.

Claude Lorrain

The Sermon on the Mount

c1656

The Frick Collection

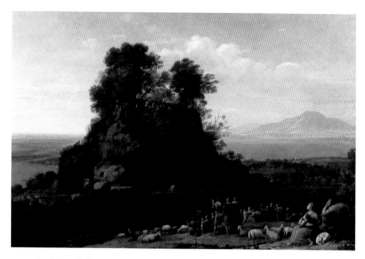

'And there followed him great multitudes … And seeing the multitudes, he went up into the mountain: and when he had sat down, his disciples came unto him. And he … taught them, saying "Blessed are the poor in spirit: for theirs is the kingdom of heaven …" … And it came to pass, when Jesus ended these words, the multitudes were astonished at his teaching.' **Matthew 4:25, 5: 1-3 and 7: 28**

Christ, robed in blue and flanked by the Twelve Apostles is shown seated at the summit of a rocky hill against a backdrop of trees. The 'multitudes' are gathered around the base of this sylvan outcrop but although groups can be seen in the middle distance to left and right, Claude has hardly gone out of his way to exaggerate the size of the assembly. As the momentous pronouncements are carried on the gentle breeze some of those present can be seen to react to their import; but life carries on – sheep graze, a dog sleeps, small sailing boats ply distant calm waters.

Behind the knoll we can see an epic landscape bathed in an ethereal light. To the right a mountain dominates the scene and a large body of water fills the middle distance. It seems that the central hill might obscure an important geographical feature because the vista to the left, where a river meanders toward the horizon amidst verdant countryside, appears to be set at an appreciably lower altitude than the balancing space to the right. What Claude has done here is to present us with a compressed version of the geography of the Holy Land – the distant mountain represents Mount Lebanon rising above the Sea of Galilee; to the left, we see (nearest to us) the Dead Sea and the river Jordan – all transported from the sun-baked Levant to the more temperate climes of the Roman campagna, the model for all Claudian landscapes.

Within Claude's *oeuvre* this is a most unusual painting. Commissioned by François Bosquet, Bishop of Montpellier, it is one of his largest canvases and it was the first in which he constructed a pictorial topography to tie in with

his chosen subject matter. On the reverse of one of the five sketches he made for this painting he drew a map noting the salient geographical features of Palestine.

But it doesn't matter what part of the world this painting purports to represent. Claude is really representing a state of mind – a nostalgia for a lost idyll, whether it be biblical or (more usually) classical. He is a master of the idealized landscape, suffused with a magical luminosity, where human kind is at one with nature – an integral part of a world of unimaginable felicity in which simple, contented lives are led in surroundings of bounteous beauty. *GS*

Contemporary Works

1655	Rembrandt: *The Flayed Ox (The Carcass of Beef)*, Paris, Musée du Louvre
	Nicolas Poussin: *Saints Peter and John Healing the Lame Man*, New York, Metropolitan Museum
1656	Diego Velázquez: *Las Meninas*, Madrid, Museo Nacional del Prado

Claude Lorrain

1604–5	Born Claude Gellée in Chamagne, a small village near Nancy in the duchy of Lorraine. His date of birth remains a matter of debate despite his tomb in Rome being inscribed with the year 1600.
1617	He probably travels to Rome at about this time.
1618	Arrives in Naples on or after this date. He later studies painting under Agostino Tassi in Rome.
1625	Returns to Lorraine where he works on some frescoes for the Carmelite church in Nancy which are now destroyed.
1626–7	Returns to Rome, where he takes up permanent residence.
1633	Becomes a member of the Accademia di S. Luca. His reputation grows.
1635 or 6	Prompted by the appearance of a number of forgeries, Claude begins his 'Liber Veritatis' – a large book containing 195 drawings recording the great majority of his paintings before they left his studio.
1637	His fame results in a commission to paint *Seaport* (now in Alnwick Castle, Northumberland) for Pope Urban VIII.
1658	Claude becomes guardian of a young girl, Agnès who may have been his illegitimate daughter (he never married).
1662	Jean Gellée, a nephew, comes to Rome to live in the artist's household.
1679	Another nephew arrives to live with Claude.
1682	Dies in Rome.

Rembrandt

The Frick Collection

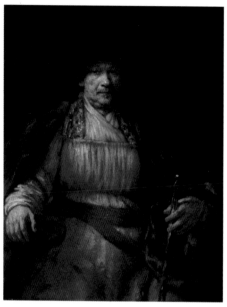

On July 14th 1656 Rembrandt applied to the High Court of Holland for *cessio bonorum* – a voluntary surrender of goods to creditors. A few days later an inventory of his effects was drawn up which illustrated part of the problem – lavish spending on a splendid collection of art – a collection which he had amassed to some extent as an investment but the sale of which could not save him from bankruptcy.

Biographers of Rembrandt writing at around the turn of the 19th century and into the 20th, created a romantic vision of Rembrandt after his bankruptcy as a lonely and forgotten genius. It is true that his financial situation never really recovered after 1656 but recent research has established that he was far from forgotten. Indeed, in 1667, towards the end of Rembrandt's life, he received a visit from Cosimo de' Medici, later the Grand Duke of Tuscany, who was visiting the Netherlands on his Grand Tour. Cosimo met numerous artists and visited 15 in their studios but when writing his travel journal he only referred to three as 'famoso,' Rembrandt being one of them.

Rembrandt produced more than 40 self portraits during his life – a surviving quantity unique in the history of western art. One might ask why he painted so many. Perhaps the most important reason is that there was a thriving market for paintings of famous men and it seems that self portraits were especially collectable in that they were both a representation of a famed individual and at the same time an example of the reason for that fame. It is known that two of his self portraits were in royal collections during his lifetime.

So this self portrait, painted two years after the crisis in his financial affairs may be seen as an example of the way that he continued to trade on his fame. It is the largest of all the self portraits and one of the most impressive – the life size

figure is seated magisterially – his bulk accentuated by the swathes of exotic garb. His left hand (his right hand in reality, transposed via the intervention of the mirror), cursorily painted (as in most self portraits, because of the difficulty in depicting the hand which is engaged in the act of painting), holds a cane with a silver top. The painting is realized in a typically free style; creases, in particular on the right sleeve, are often indicated with single strokes of the brush.

He is dressed (as so often in his other self portraits) in 16th-century clothes, which he seems to have collected. A brocade scarf is tucked within a yellow jerkin with a low horizontal neckline, typical of the early 16th century, made of indeterminate material. A red sash encompasses an ample waist and on his head sits a dark, large brimmed hat. This exotic ensemble imparts an oriental feel to the painting.

But it is the head and eyes to which the viewer's attention constantly returns. As our gaze plays on the profoundly sympathetic features of Rembrandt's face, we realize that his eyes, even though partially shaded by the brim of the hat, and formed by nothing more than paint, seem to be engaged in a two-way relationship with us – they seem to search for the very soul of the beholder – to burn into one's psyche. And it is this quality, the mysterious facility of the late self portraits, to speak directly to us across the centuries – to speak of the common experience of a shared humanity which makes them one of the crowning achievements of western art. *GS*

Contemporary Works

1658	Pieter der Hooch: *The Courtyard of a House in Delft*, London, National Gallery
1659	Diego Velázquez: *Infanta Margarita Teresa in a Blue Dress*, Vienna, Kunsthistorisches Museum

Rembrandt

1606	Rembrandt Harmensz van Rijn is born in July, the son of a miller in Leiden.
1620	He enrolls at Leiden University at the age of 14.
1622	Starts a three year apprenticeship with the painter Jacob Isaacz van Swanenburgh.
1625	He spends about six months in Amsterdam studying with Pieter Lastman. Then returns to Leiden to establish himself as an independent artist .
1628	Rembrandt takes on his first pupil – the 14-year-old Gerrit Dou.
1631	Moves to Amsterdam – lives with the art dealer Hendrick van Uylenburgh.
1634	Marries Saskia van Uylenburgh, Hendrick's niece.
1639	Now an acclaimed artist, Rembrandt buys the house next door to Hendrick van Uylenburgh for 13,000 guilders.
1641	Rembrandt and Saskia's son Titus is born.
1642	Rembrandt finishes *The Night Watch*. Saskia dies of tuberculosis. Geertje Dircz is employed as a nurse for Titus, soon becoming Rembrandt's mistress.
c1647	A new servant, Hendrickje Stoffels is employed and replaces Geertje as his mistress.
1649	Geertje sues Rembrandt for breach of a promise to marry her.
1650	Rembrandt instigates legal proceedings which end with Geertje being committed to a house of correction in Gouda.
1654	Hendrickje gives birth out of wedlock to a daughter, Cornelia.
1656	Rembrandt declares himself insolvent. An inventory of his belongings and art collection is made.
1658	His collection and house are auctioned.
1660	Employed by a business in the joint names of Hendrickje and Titus.
1663	Hendrickje dies.
1668	Titus marries in February but dies in September leaving a pregnant wife.
1669	Titus's daughter Titia is born. Rembrandt dies and is buried in a rented grave in the Westerkirk.

François Boucher

A Lady on her Day Bed (Madame Boucher) **1743**

The Frick Collection

Boucher is famed for his development of the mature Rococo; a style wildly admired at the time and as strongly criticized as it fell from favor. Rejecting rule and order in favor of the natural and light-hearted, the Rococo was all the rage in 1730s France; but by the 1760s it was being criticized as superficial and decadent. Denis Diderot famously wrote of Boucher in his review of the 1761 Salon, '*Cet homme a tout – excepté la vérité*' (That man is capable of everything – except the truth). However, all did not share Diderot's opinion: Boucher had a wide-ranging clientele, from bourgeois collectors to Madame de Pompadour, and four years after Diderot's biting review he was named first painter to King Louis XV and director of the Académie.

And indeed, few could deny the appeal of works like this pretty portrait most likely of Boucher's wife, Marie-Jeanne Buseau (1716–after 1786). Madame Boucher frequently appeared in her husband's paintings as the model for a goddess or a queen but rarely as herself. When this was painted, she was 27 years old, a mother of three and had been married for ten years.

Pertly propped up on a chaise-longue she looks as if she might have just woken from a mid-afternoon nap. Charmingly *déshabillé*, her voluminous dress is bunched up around her revealing a shapely ankle and stylish high-heeled slippers. Pink bows set off her pale skin and rosy cheeks, one of which she leans coquettishly into a soft hand. It is a candid image of a much-loved wife and as well as a compendium of the Rococo style: glossy surfaces, a high-toned palette favoring blues and pinks, a playful grace and lightness and a sentimental, vaguely erotic tone.

It is also a glimpse into the Bouchers' new apartment on the Rue de Grenelle-

Saint-Honoré where they had moved a year before. The joys of domesticity were also a popular theme of the Rococo and the image's easy-going, almost teasing tone suggests a happy home-life. The Oriental porcelain figurine and tea service on the hanging *étagère* reflect the Bouchers' taste for chinoiserie, which was so à la mode in the 18th century. The luxurious wall coverings and the gold watch on the wall suggest a measure of financial success, as does the fashionable dishevelment of the room: crumpled papers, a ball of yarn on the floor, a cloth tossed on the footstool. Madame Boucher, like the fine ladies Boucher worked for, was clearly not concerned with tidiness. For this reason and because Boucher borrowed the picture's composition from famous depictions of Venus by the likes of Giorgione and Titian, this painting has been nicknamed the 'Untidy Venus.'

Though his pretty, playful art would suggest a sybaritic character, Boucher's output was prolific and he often worked 12 hours a day; he in fact died at the age of 67 in his studio in the Louvre. His children followed in his footsteps: his two daughters married his students, the artists Deshays and Baudouin, and a son, Juste-Nathan, would specialize in drawing architectural fantasies. And despite her leisurely depiction here, Madame Boucher was an artist herself and in later life painted miniature reproductions of her husband's more popular pictures and made engravings after his drawings. *DM*

Contemporary Works

1742	Giovanni Battista Tiepolo: *Rinaldo Enchanted by Armida*, Chicago, Art Institute
1743	William Hogarth: *Marriage à la Mode (six scenes)*, London, National Gallery
1744	Jean-Siméon Chardin: *Grace Before a Meal*, Saint Petersburg, Hermitage

François Boucher

1703	Born in Paris.
1723	Wins the Prix de Rome but is unable to undertake the three years study in Rome as the necessary funds are diverted to court favorites.
c1723–28	Works as an illustrator for the engraver and publisher Jean-François Cars.
1728	Travels independently to Italy. In Rome he finds lodgings at the Académie de France. Unlike most artists visiting Rome, he seems to have preferred to study the work of baroque masters rather than Michelangelo and Raphael.
c1731	Returns to Paris having visited Naples, Venice and Bologna. Resumes activities as a book illustrator.
1733	Marries Marie-Jeanne Buseau.
1734	Boucher is 'received' at the Académie Royale.
1735	Receives his first royal commission for four large paintings for the Chambre de la Reine at Versailles.
1736	Produces his first tapestry designs. Tapestry is instrumental in the dissemination of Boucher's style throughout Europe.
1742	In addition to producing stage designs and working on tapestry cartoons for the Beauvais works, he also exhibits some of his most famous pictures such as *Diana after the Bath* and *Leda and the Swan*.
1743	Produces stage designs and costumes for *L'Ambigu de la Folie* produced by the Théàtre de la Foire.
1747	The king's principal mistress, the Marquise de Pompadour, becomes Boucher's most enthusiastic patron.
1755	Appointed Inspector of Works at the Gobelins tapestry factory.
1765	Boucher is appointed First Painter to the king and is elected Director of the Académie Royale.
1770	Dies in Paris.

Joshua Reynolds

General John Burgoyne *c*1766

The Frick Collection

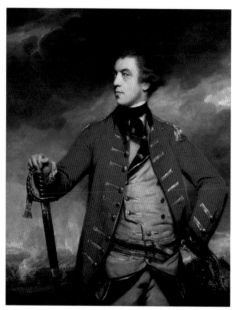

Though Reynolds portrays him as the consummate military leader, John Burgoyne (1722–92) has the misfortune to be primarily remembered as the British commander who surrendered to American forces in 1777 at Saratoga, a loss many consider the turning point of the American Revolution. But Burgoyne was a multifaceted character; a Member of Parliament as well as an actor, playwright, dandy and gambler, he was known in his day as Gentleman Johnny. His life story reads like a romantic novel.

At 21, he eloped with his best friend's sister. Her father, Lord Strange, gave her a modest dowry and cut her off. Deep in debt, the couple left for the continent where Burgoyne learned of the European 'light dragoons', – versatile, all-purpose mounted troops then unknown in England. He later submitted a plan to create such a force and in 1759 founded the 16th Light Dragoons. He went on to build an illustrious career, making his name in the Portuguese campaign of 1762.

It was most likely Burgoyne's senior officer, Count La Lippe, who commissioned this portrait as a memento of their victory in Portugal. Reynolds' ledger for May 1766 notes a sitting by a General Burgoyne and so this picture is believed to date from that year; moreover, Burgoyne's uniform is that of the 16th Light Dragoons as it was worn until that month.

Reynolds, known for his keen sense of what pose or gesture was appropriate for his sitter, were they society ladies, kings or soldiers, depicts Burgoyne as the ultimate 18th-century English hero. He cuts a dashing figure silhouetted before a tumultuous sky and battlefield, a composition that would become a classic type of Romantic portraiture. With cool command, Burgoyne looks imperiously off into the distance to what can only be a glorious future. His stance, one arm akimbo and the other on his sword, is inspired by a tradition

of male military portraits dating from the Italian Renaissance.

Reynolds would have acquainted himself with such works during a sojourn in Italy from 1749–52. Returning to London, he became the most celebrated portraitist of his day. A literary type (as compared to his more intuitive rival Gainsborough who reportedly 'detested to read'), his friends included Oliver Goldsmith, David Garrick, Angelica Kaufmann, Dr Johnson and James Boswell, who dedicated his *Life of Johnson* to Reynolds. A great networker, he was never short of clients: in 1759 alone, he recorded over 150 sitters. Unsurprisingly, he often used workshop assistants to help complete drapery and backgrounds. His portraits from the 1760s, such as this one, have an especially imaginative flair without ever forgetting the sitter's need for a fashionable and flattering likeness. Just two years after this portrait he was elected as the first President of the Royal Academy and would become an influential theorist and teacher as well as principal painter to King George III.

Burgoyne's future however would be a bit bumpier. Elected to parliament in 1761, promoted to major-general in 1772, he also began a literary career and had considerable success with a play, *Maid of the Oaks*, staged in London by David Garrick in 1775. But then, in 1776, the American Revolution erupted, the same year his wife died. Burgoyne was first sent to Boston and later, in September 1777, he led a disastrous attack from Quebec into upstate New York and ended up surrendering at Saratoga. Ridiculed for his questionable leadership and pomposity, his military and political career floundered. He found some success in his last years writing comic operas and plays and had four illegitimate children with his mistress, opera singer Susan Caufield. **DM**

Contemporary Works

1764–5	Jean-Honoré Fragonard: *Le petit parc*, London, Wallace Collection
1766	George Stubbs: *Turf, with Jockey Up, at Newmarket*, New Haven, Yale Center for British Art

Joshua Reynolds

1723	Born at Plympton St Maurice in Devon, the son of the headmaster of Plympton Grammar School.
1740	Decides to become a painter. Apprenticed to Thomas Hudson in London.
1743	Reynolds cuts short his apprenticeship, working independently in London and Devon.
1749	Sails to Italy with his friend Commodore Augustus Keppel.
1750	Reynolds lives in Rome for two years.
1752	Visits Florence, Bologna, Naples, Venice and Paris before returning to London.
1753	Sets up his own studio in London quickly becoming successful and establishing himself in society circles.
1756	Meets and becomes friendly with Dr Johnson.
1759	Reynolds is elected a governor of the Foundling Hospital.
1764	Founds the Literary Club. Becomes seriously ill but recovers.
1766	He is elected as a member of the Society of Dilettanti.
1768	The Royal Academy is founded and Reynolds is elected as first President.
1769	Delivers the first of his *Discourses*. Knighted by George III.
1773	Elected Mayor of Plympton.
1778	The first seven *Discourses* are published.
1782	Suffers a stroke which affects his eyesight.
1784	Appointed principal painter to the king.
1785	Visits Brussels, Antwerp and Ghent.
1789	His eyesight begins to fail.
1790	Makes his last appearance at the Royal Academy.
1792	Dies in London.

Jean-Honoré Fragonard

The Progress of Love: The Meeting 1771–3

The Frick Collection

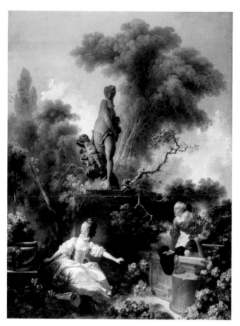

W hat could American robber barons Henry Clay Frick and J. Pierpont Morgan and famed courtesan Madame du Barry, mistress of Louis XV, all have in common? Why, their taste in art, of course.

Around 1771, Madame du Barry commissioned celebrated Rococo artist Fragonard to create a decorative cycle for a new pavilion in the garden of her château at Louveciennes. However, when the four canvases of *The Progress of Love* were delivered the following year, she rejected them in favor of another series in the new 'antique' style by Joseph-Marie Vien. Fragonard ended up keeping the paintings until 1790, when he retired for a year to his native town of Grasse and installed them there in a cousin's house.

Fast forward a century or so and the cycle was purchased first by Morgan for his London home and after Morgan died in 1913, Frick acquired it for a whopping $750,000. He then paid over a million more to create the perfect Rococo drawing room for them in his Fifth Avenue home, where they remain today.

The cycle, set in lush gardens full of mythological statuary, follows two lovers through various facets of romance: *The Pursuit*, *The Meeting*, *The Lover Crowned*, and *Love Letters*. The concept borrows from the tradition of Watteau's *fêtes galantes* and from the pastoral paintings of François Boucher (with whom Fragonard once worked). But it is Fragonard's fluid style full of the exuberance and curiosity of the French Enlightenment that makes this cycle one of the outstanding achievements of 18th-century French decorative painting.

In this image, the lovers – an earnest young man climbing up a ladder and a willowy girl with flowers in her hair and plunging *décolletage* – meet, presumably in secret. Their somewhat exaggerated poses are clearly inspired

by contemporary theater and ballet; both look off-stage, so to speak, as if fearful they will be found out. Fragonard builds this dramatic tension in a painterly love triangle formed by the couple and the statue of Venus taking Cupid's quiver of arrows that towers above them. Critics have made much of the upward thrust of the trees – is the couple's desire so evident that even the trees appear aroused? Perhaps the way the trees split behind the statue is intended to let the viewer know that the resolution of their love is not yet sure? However by the next panel, *The Lover Crowned*, their union is certain.

Despite its somewhat staged nature, the scene is spontaneous and sweet without being saccharine. Like the best of Fragonard's work, the painting is playful yet sincere, filled with erotic possibilities. These rustic protagonists in billowing silks have nothing to do with realism or classical rigor but embody the carefree pastoral charm of the Rococo and pre-Revolutionary French art.

Why did Madame du Barry reject such a delightful cycle? Was the earnest lover too indiscreet an allusion to her own, Louis XV? Some have suggested the paintings simply didn't fit in the room for which they were intended. Or perhaps Fragonard's Rococo exuberance didn't match the cool Neo-Classical design of her new pavilion by innovatory architect Claude-Nicolas Ledoux? In fact, by the 1770s the heyday of the Rococo was over. After the Revolution (in which Madame du Barry lost her head), Fragonard tried to remake his style to fit the new Neo-Classical taste but without success; he died almost forgotten in 1806. *DM*

Contemporary Works

| 1773 | Angelica Kauffmann: *Lord John Simpson*, Vienna, Belvedere |
| | John Singleton Copley: *Mrs John Winthrop*, New York, Metropolitan Museum of Art |

Jean-Honoré Fragonard

1732	Born in Grasse, Provence, the son of a haberdasher.
1738	The family moves to Paris.
c1749	After spending some time as the pupil of Jean-Siméon Chardin he enters the studio of François Boucher.
1752	Wins the Prix de Rome.
1756	Arrives in Rome.
1758	Meets the French painter Hubert Robert.
1760	Spends the summer at the Villa d'Este as the guest of the Abbé de Saint-Non, Robert's patron.
1761	Travels with the Abbé de Saint-Non and Robert on a tour of Italy.
1765	Fragonard becomes a member of the Académie Royale. His presentation piece for the Académie, *Coresus Sacrifices Himself to Save Callirhoe* is a great success when exhibited at the Salon and is purchased for the Crown.
1769	Marries Marie-Anne Gérard.
1770	His fashionable status is confirmed when he is commissioned by Mme du Barry to produce decorations entitled *The Progress of Love* for her pavilion at Louveciennes.
1773	Tours Italy visiting Rome again.
1774	Visits Naples, continuing to Vienna, Prague and Germany.
1789	Moves back to live in Grasse.
1792	Returns to Paris. He manages to negotiate the French Revolution without imprisonment but his style is deeply out of step with the Neo-Classical vogue which accompanies it.
1794	Jacques-Louis David uses his influence to recommend that Fragonard be appointed a member of the Conservatoire des Arts.
1795	Becomes President of the Conservatoire des Arts with responsibility for the new national museum in the Louvre.
1806	Dies in Paris in obscurity.

Thomas Gainsborough

The Frick Collection

In Fanny Burney's bestselling novel, *Evelina, the History of a Young Lady's Entrance into the World* (1778), the innocent young heroine loses her way in a public pleasure garden and finds herself in the compromising company of ladies of the night. Gainsborough's London was full of such ambiguous social situations. A new vogue for public places of entertainment – theaters, assembly rooms, parks, etc – among everyone from the aristocracy to the *demi-monde* meant that the respectable and disreputable often overlapped.

It is this world that is hinted at in *The Mall*, referring to the tree-lined walkway in the park of St James's Palace, which was a popular place for an elegant stroll. It was also where many prostitutes practiced their trade; James Boswell wrote of his frequent sexual encounters in the park in the 1760s.

Gainsborough's London residence, Schomberg House, was nearby in Pall Mall and he would have had many opportunities to observe the mixing of London society on the leafy Mall. The composition is unique for Gainsborough, who was best known as a portraitist, and was clearly inspired – as several contemporary critics noted – by the *fêtes galantes* of Watteau.

It depicts numerous ladies (and a token male in uniform) gliding through a bucolic landscape, evidence of Gainsborough's abilities as a landscape painter and to his pioneering interest in the picturesque. As a young painter, Gainsborough had been inspired by Dutch landscape artists and might have made that his specialty if portraiture had not been so much more lucrative a business.

The women are rosy-cheeked (or is it rouge?) and depicted like exotic birds of paradise. The feathery foliage and rhythmic design inspired a contemporary to remark that the painting was 'all aflutter, like a lady's fan.' Another claimed

that Gainsborough composed the scene partly from dolls and a model of the park.

Considering the artist's long career as a portraitist, it is unsurprising that some have suggested the figures are portraits: the central group of ladies are perhaps the daughters of King George III and the background figure under the tree to the right might be Gainsborough himself, though these claims are unsubstantiated. It might also simply be a representation of the see-and-be-seen atmosphere of the Mall; almost all the ladies glance curiously at their fellow strollers.

This was, after all, a world Gainsborough knew well. A skilled draftsman and natural painter with a fluid, assured technique and a sharp eye for a beautiful woman, Gainsborough was in great demand among the Georgian *cognoscenti*. He was both celebrated and chastised in the press for his chic portrayals of fashionable women, were they countesses or courtesans. Gainsborough's women were painstakingly elegant, luxuriously dressed, either wandering in wild landscapes or posing by classical ruins – it is near impossible, without titles, to tell a duchess from an actress.

But this ambiguity was clearly part of the age, and he was no less admired for it. After Gainsborough's death, Sir Joshua Reynolds, his contemporary and fierce rival, said: 'If ever a nation should produce genius sufficient to acquire to us the honorable distinction of an English school, the name of Gainsborough will be transmitted to posterity, in the history of Art, among the very first of that rising name.' *DM*

Contemporary Works

1782	Joshua Reynolds: *Colonel Banastre Tarleton*, London, National Gallery
1783	Marie-Louise-Elisabeth Vigée-Lebrun: *Portrait of the Duchesse de Polignac*, Waddesdon Manor, Buckinghamshire, England
1784	Jacques-Louis David: *The Oath of the Horatii*, Paris, Musée du Louvre

Thomas Gainsborough

1727	Born in Sudbury, Suffolk.
1733	Gainsborough's father, a clothier, is declared bankrupt.
c1740	Trains in London with a French artist named Gravelot. Possibly works with Francis Hayman decorating supper-boxes at Vauxhall pleasure gardens.
1746	Marries Margaret Burr (July).
1748	His father dies and he returns to Sudbury.
1752	Moves to Ipswich.
1759	Finds it difficult to make a living in Ipswich and consequently moves to Bath.
1768	Founder member of the Royal Academy.
1774	Gainsborough moves with his family to London.
1784	Quarrels with the Royal Academy over the issue of where to hang some of his portraits of royalty.
1788	Dies in London.

John Constable

The Frick Collection

In 1798 John Constable met Dr John Fisher who was rector of Langham in Suffolk near to Constable's family home. His friendship with the Fisher family blossomed and Constable was invited to Windsor in 1802 where Fisher was canon. In 1807 John Fisher, who was a favorite of George III, was appointed Bishop of Salisbury and four years later Constable stayed for several weeks as a guest in the bishop's palace. Here he met the bishop's nephew, another John who was also ordained in 1812 and who became Constable's closest friend and confidant. In 1816 the younger Fisher officiated at Constable's wedding to Maria Bicknell.

In 1820 Constable was back in Salisbury for an extended visit which resulted in a commission for a view of Salisbury Cathedral from Bishop Fisher. This painting (now in the Victoria and Albert Museum in London) was eventually exhibited at the Royal Academy in 1823 and received positive reviews, although Constable seems to have found its execution to be somewhat arduous. In a letter to the younger Fisher he wrote:

> 'My Cathedral looks very well. Indeed I got through that job uncommonly well considering how much I dreaded it… It was the most difficult subject in landscape I ever had upon my easel. I have not flinched at the work, of the windows, Buttresses etc., etc.'.

However, all was not entirely well at the bishop's residence where the inclusion in the picture of dark clouds looming above the cathedral were not to the prelate's liking. Consequently Constable was asked to take 'another peep or two at the view of our Cathedral' and was eventually commissioned to repeat the composition with the hope that this time he 'would but leave out his black

clouds.' The painter duly responded by producing this painting, similar in most respects but with white clouds and a warmer blue sky.

The graceful thrust of the cathedral spire (the tallest in Britain) soars into this unthreatening sky framed and complemented by trademark Constable trees – realized with unsurpassed skill. The complex architecture of the great church sits perfectly within the English pastoral idyll which surrounds it; the uninterrupted greensward of the close providing the perfect foil for the predominantly vertical emphasis of the 13th-century Gothic structure.

To the left, the bishop and his wife have stopped momentarily to admire the view, the bishop using his walking stick in order to direct his wife's attention to one or two interesting architectural elements. Ahead of them, in the middle distance, one can see the figure of a young lady – presumably their daughter (who was the intended recipient of this painting – as a wedding gift).

Apart from his personal connections with Salisbury, the subject of this picture chimes with Constable's conservative political views. He saw the church, together with parliament, as the twin pillars upholding Britain's social and political stability (then under attack from strident political pressures unleashed by the Industrial Revolution). This picture, together with other famous examples of his *oeuvre* (such as the *Hay Wain*), can be seen as paradigms, as exemplars, not just of a beautiful, peaceful and quintessentially English landscape but of the immutable order of British society, a stasis which Constable held dear. *GS*

Contemporary Works

1825	Samuel Palmer: *Rest on the Flight into Egypt*, Oxford, Ashmolean Museum
1826	Jean-Auguste-Dominique Ingres: *Oedipus and the Sphinx*, London, National Gallery
	Jean-Baptiste-Camille Corot: *The Forum Seen from the Farnese Gardens*, Paris, Musée du Louvre

John Constable

1776	Born at East Bergholt in Suffolk the son of a gentleman farmer who also had a milling business.
1796	Meets Sir George Beaumont who owns Claude Lorrain's *Landscape with Hagar and the Angel*, a painting which inspires the young Constable to pursue his artistic ambitions.
1799	Begins his studies at the Royal Academy Schools.
1802	Exhibited at the Royal Academy for the first time.
1806	Visits the Lake District.
1809	Falls in love with Maria Bicknell, granddaughter of the rector of East Bergholt but her family disapproves.
1811	Visits Salisbury, staying with the bishop, Dr John Fisher.
1816	The death of his father brings some financial security and despite her family's opposition Constable marries Maria. In December they settle in London.
1819	Constable rents a house in the London suburb of Hampstead, prompted by Maria's illness with tuberculosis. Becomes an ARA.
1820	Visits Salisbury and sketches in the surrounding countryside.
1824	Wins a gold medal at the Paris Salon.
1828	Maria dies of tuberculosis leaving seven children.
1829	Belatedly becomes a full member of the Royal Academy.
1837	Dies at Hampstead.

Jean-Auguste-Dominique Ingres

Comtesse d'Haussonville 1845

The Frick Collection

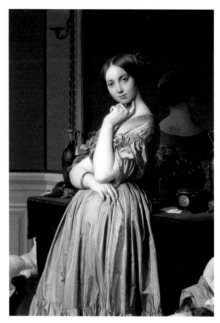

'A portrait of a woman! Nothing in the world is more difficult, it can't be done … It's enough to make one weep.' – **Ingres**

A perfectionist, Ingres surpassed even his teacher Jacques-Louis David in his painstaking attention to detail and finish. A painting was not done until he was satisfied and clients could wait for years for their portrait: the young comtesse depicted here had to wait three as Ingres made endless studies and drawings.

For an artist famed for his portraits, Ingres surprisingly claimed not to like them; he felt portraiture to be a lesser art form, a necessary evil to pay the bills. Despite this assertion, Ingres' contemporary Charles Baudelaire wrote: 'M. Ingres is never so happy nor so powerful as when his genius comes to grips with the feminine charms of a young beauty.'

This beauty was Louise (1818–82), Princesse de Broglie, Comtesse d'Haussonville, the granddaughter of Madame de Staël. She was known for her liberal opinions, active social life and as the author of several books, including a biography of Byron. She clearly had a bit of the Byronic spirit herself for her memoirs are filled with statements like,'I was destined to beguile, to attract, to seduce and in the final reckoning to cause suffering in all those who sought their happiness in me.' A contemporary called her 'the girl with eyes like smouldering embers.' In this portrait she is in her mid-twenties, a mother of three.

Ingres depicts her standing in her fashionable boudoir, leaning with a studied casualness against a blue velvet upholstered mantelpiece, which matches wonderfully the paler blue of her dress. The mantel is cluttered with flowers and porcelains and several 'props,' items for which Ingres asked his sitter to

help set the scene. There are opera glasses and visitors' cards, some with their corners turned down (it was common practice in refined circles to pay daily social visits and leave cards; if the person visited was absent, the card was left with its corner folded), which suggest Louise has just arrived home, perhaps from the opera. A shawl thrown over a chair arm reinforces the impression.

Though her heavy-lidded gaze is focused on the viewer, her expression has been described as distant, even vacant; this however may reflect her character. 'The life of the imagination was for me larger than real life', she wrote in her memoirs; 'I lived in a dream'.

A mirror reflects the tortoiseshell comb and ribbon in Louise's fashionable glossy hair and the finger she places on her round, impossibly creamy chin. However, the angle of the reflection is incorrect and the artist would not see Louise's finger in the mirror.

Despite their fine detail and near photographic clarity, Ingres' portraits often feel a bit odd, as he preferred to paint what he thought looked best, regardless of reality; for instance, Louise's disproportionately large right arm seems to extend from her chest instead of her shoulder. When first shown, critics thought she looked as if she had no muscle or bone. However, according to Ingres, the finished work 'aroused a storm of approval among her family and friends.' A contemporary even suggested that the artist, 'must have been in love to paint such a portrait.' Whether 65-year-old Ingres was enamored will never be known, however, one person definitely was; when Louise died her husband immediately left their home and ordered a copy of this work to keep with him always (Louise had bequeathed the original to her daughter). *DM*

Contemporary Works

1844	J.M.W. Turner: *Rain, Steam and Speed*, London, National Gallery
1845	Adolf von Menzel: *Garden of Prince Albrecht's Palace in Berlin*, Berlin, Staatliche Museen

Jean-Auguste-Dominique Ingres

1780	Born in Montauban near Toulouse, the son of a painter and sculptor.
1797	After receiving instruction from his father and attending the academy at Toulouse, he enters the studio of David in Paris.
1801	Wins the Prix de Rome.
1806	Travels to Rome to take up his position at the Académie de France.
1808	Sends two paintings back to Paris but their reception is unenthusiastic.
1813	Completes commissions for the Napoleonic administration in Rome. Marries Madeleine Chapelle.
1815	The fall of the Napoleonic regime in Italy sharply reduces commissions.
1819	Further submissions to the Paris Salon are greeted with little interest.
1820	Moves to Florence.
1824	*Entry into Paris of the Future Charles V* and the *Vow of Louis XIII* are exhibited at the Salon and are received favorably.
1825	Ingres is awarded the Cross of the Légion d'Honneur. Opens a studio in Paris taking in students.
1834	Again disappointed by the reception of a painting at the Salon, Ingres leaves Paris to become director of the Académie de France in Rome.
1840	*Antiochus and Stratonice*, started in 1807 is delivered to the Duc d'Orléans in Paris. When exhibited, the picture is greeted with acclaim.
1841	Returns to Paris.
1849	Ingres becomes vice-president of the École des Beaux-Arts. In July his wife Madeleine dies. Ingres is devastated and ceases to work for some time.
1852	His spirits are raised by his second marriage to Delphine Ramel.
1867	Dies in Paris.

Jean-Baptiste-Camille Corot

The Boatman of Mortefontaine
c1865–70

The Frick Collection

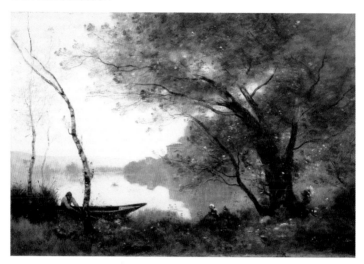

In November 1825 Corot, following the well trodden path of the young painter, traveled to Italy where he stayed for over two years. This first stay in Rome (he later returned for two more extended visits) provided him with his life's inspiration and set the classicizing tone for his later work. He produced numerous sketches in and around Rome many of which he used in later years as the basis for his timeless visions of a blissful Arcadia. He occupies a position between his fellow countryman Claude Lorrain (who lived most of his life in Rome and also used the Roman *campagnia* as a model for his own version of Elysium) and the Impressionists, for some of whom he was a father figure.

Indeed, no artist of the previous generation had a more significant influence on the Impressionists than Corot. Famous for his generosity and kindliness towards younger artists or those experiencing hard times, he offered advice and help to all with Pissarro and Berthe Morisot in particular benefiting from his benevolence. In terms of working method he anticipated the Impressionists in his practice of working out of doors. His *plein-air* paintings, in contrast to his more 'finished' studio output, were usually restricted in size and, similar to later Impressionist works, are characterized by free and rapid brushstrokes. The high regard in which Corot was held by the Impressionists can be judged by Edgar Degas' comment that 'he anticipated everything'. Claude Monet went even further, maintaining that 'There is only one master here – Corot. We are nothing compared to him, nothing'.

This appreciation was shared by patrons and collectors who, after Baudelaire began to champion his work in 1846, flocked to buy his paintings. During his lifetime he exhibited over 100 paintings at the Salon but he always retained his renowned modesty and generosity of spirit, on one occasion helping his ailing fellow artist Daumier to buy a house.

The Boatman of Mortefontaine is typical of Corot's later output in that even

though it was inspired by the park of Mortefontaine outside Paris, the painting is, in the main, an imaginary construct. The elements of its composition are almost identical to *Souvenir de Mortefontaine* in the Louvre, but in this painting a temple appears in the hazy middle distance across the lake where there is none in the Louvre painting. Corot uses some of his favorite motifs, a tranquil body of water, a leaning birch tree and a willow with diaphanous foliage, all enveloped in a hushed and breathless atmosphere, redolent of delightful summer languor. His range of color is limited to grays, yellows and greens, his primary interest being in the manipulation of tonal values and the creation of a very special soft light which pervades his late landscapes engendering a dreamlike ambience. *GS*

Contemporary Works

1865	Dante Gabriel Rossetti: *The Blue Bower*, Birmingham, Barber Institute of Fine Arts
1866	Édouard Manet: *Woman with a Parrot*, New York, Metropolitan Museum
	Winslow Homer: *Prisoners from the Front*, New York, Metropolitan Museum
1870	John Everett Millais: *The Boyhood of Raleigh*, London, Tate

Jean-Baptiste-Camille Corot

1796	Born in Paris.
1822	After an apprenticeship with a draper Corot's family agree to help him financially in his chosen course as a painter.
1825	Leaves for an extended stay in Italy.
1827	While living in Rome Corot submits two canvases to the Salon – both are accepted.
1828	Returns to France.
1834	Visits Italy.
1837	The Duc d'Orléans buys one of Corot's pictures.
1840	The French state purchases a painting for the museum in Metz.
1843	Corot is again in Italy.
1846	Baudelaire writes approvingly of Corot's work.
1849	Corot is elected to the Salon jury on which he sits frequently, often using his status to help young artists.
1851	Louis-Napoleon (later Napoleon III) buys *Morning, Dance of the Nymphs* from the Salon.
1852	Meets Charles-François Daubigny.
1854	Visits the Low Countries.
1862	Corot's pictures are exhibited at the International Exhibition in London. He paints with Courbet in the Saintonge.
1865	Napoleon III buys *Souvenir de Marcoussis* for his private collection.
1866	Attacks of gout prevent him from traveling as much as in the past.
1871	Remains in Paris during the siege. Gives a large sum of money to the poor of Paris.
1875	Dies in Paris.

James Abbott McNeill Whistler

Symphony in Flesh Color and Pink: Portrait of Mrs Frances Leyland 1872–3

The Frick Collection

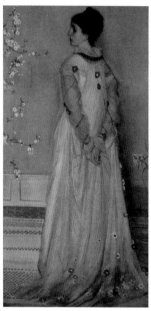

Frances Dawson married Frederick Leyland in 1855. Her husband had joined a Liverpool shipping company as an apprentice rising rapidly to become a partner in the firm, amassing a fortune and taking control of the business in 1872. In 1867 part of his wealth had been used to buy Speke Hall near Liverpool, and two years later a grand house in London. His affluence also enabled him to collect Italian Renaissance art and Pre-Raphaelite paintings, especially from Dante Gabriel Rossetti. It was Rossetti who introduced Whistler to Leyland.

In 1871 Leyland commissioned Whistler to paint his wife's portrait. Whistler made many visits to Speke Hall in pursuit, it seems, of a stubbornly illusive ideal. Interviewed many years later, Frances Leyland remembered that she often thought the painting to be very nearly finished only to find at her next appointment that Whistler had scraped it down and was starting again. While this was not altogether unusual behavior – he had done much the same while painting the companion portrait of her husband – it does seem that this painting represents an extreme example of Whistler's perfectionist tendencies. There may, however, have been other reasons for his wish to string out the process …

In 1876 Whistler began to work on another project for F.R. Leyland. Even though the shipping magnate had not received delivery of either his wife's or his own portrait, the errant artist was engaged to repaint the hall and staircase at Leyland's London house. Whistler took it upon himself to extend his remit and redecorate the dining room as well – which became known as the Peacock Room. This proved to be a turning point in their relationship – Leyland was outraged by the size of the bill and by Whistler's presumption. However there was another reason for the abrupt souring of relations. Leyland had become aware of the warmth of

feeling between his wife and the person who had recently spent so long in her company. There seems little doubt as to the real nature of their liaison. Whistler wrote to her in 1875 after yet another visit to Speke Hall that he was unable to give her 'the faintest notion of my real happiness and enjoyment as your "guest" (Whistler's quotes)'. Leyland now wrote to Whistler that 'It is clear that I cannot expect from you the ordinary conduct of a gentleman. If I find you in her society again I will publicly horsewhip you.' In 1879 Mr and Mrs Leyland separated.

The portrait which emerged from this turmoil is strikingly beautiful. The pose is unusual; Frances Leyland, her hands clasped lightly behind her, stands with her back towards the viewer but turns her head so that it is in profile. She wears a diaphanous confection designed by the artist – an overdress of pink chiffon cascades to the floor from a brown yoke which sits on her shoulders. White chiffon is used for the undergarment covering her shoulders – her arms are sheathed in a see-through gauze decorated with brown and light pink spirals. Rosettes and flowers are scattered on this wondrous garment, concentrating at the bottom as the dress meets the floor. We can still see the *pentimenti*, especially around the shoulders and upper arms – the telltale signs of numerous reworkings and the reason for all those false dawns noted by Frances Leyland.

The background and dado complement the colors of the dress exactly to create a typical Whistlerian composition using a very limited but effective palette to create a harmonious whole. Whistler used musical titles for his work precisely in order to emphasize that he was more interested in the creation of harmony of color and mood than mere representational verisimilitude. The cherry blossom intruding from the left and the somewhat flat picture space also reminds us that Whistler was a passionate devotee of everything Japanese which reinforced his interest in the purely decorative above the slavishly descriptive. *GS*

Contemporary Works

1872	Dante Gabriel Rossetti: *Veronica Veronese*, Wilmington, Delaware Art Museum
1873	Claude Monet: *Impression Sunrise*, Paris, Musée Marmottan

James Abbott McNeill Whistler

1834	Born in Lowell, Massachusetts, the son of a railway engineer.
1843	His family moves to the Russian capital, St Petersburg.
1848	Lives with his stepsister in England. Attends lectures at the Royal Academy.
1849	Returns to the USA after his father's death.
1851	Enters West Point Military Academy.
1854	Dismissed from West Point after failing his chemistry examination.
1855	Determined to become an artist he leaves America for France.
1856	Attends Charles Gleyre's studio in Paris.
1859	Moves to London taking rooms at Wapping.
1861	*Symphony in White No. 1: The White Girl* is rejected by the Royal Academy.
1863	*The White Girl* hangs with *Déjeuner sur l'herbe* at the Salon des Refusés. Moves from Wapping to Chelsea. His mother moves to live with him.
1866	Travels to Chile.
1872	*Arrangement in Grey and Black; Portrait of the Artist's Mother* is exhibited at the Royal Academy.
1877	*Nocturne in Black and Gold: the Falling Rocket* is exhibited at the Grosvenor Gallery. Ruskin writes to *The Times*. Whistler sues for libel.
1878	Whistler wins his libel case but is awarded a farthing in damages.
1879	Facing huge legal costs, Whistler is declared bankrupt losing his newly constructed house. He destroys work rather than see it go to creditors.
1888	Marries Beatrice Godwin.
1896	Beatrice dies after a two-year fight against cancer.
1903	Whistler dies in London.

During the thirties the wealthy American industrialist Solomon R. Guggenheim began to collect modern art by artists such as Vasily Kandinsky, Paul Klee, and Marc Chagall. In 1943 Guggenheim commissioned Frank Lloyd Wright to design a permanent structure to house the growing collection. The same year the Solomon R. Guggenheim Foundation (founded in 1937) acquired land between East 88th and 89th Streets on Fifth Avenue.

Construction began in 1956 and the museum opened in 1959, six months after Wright's death. The highly distinctive building is a modernist symphony of spiraling forms. Circularity is the leitmotif, from the rotunda to the inlaid design of the terrazzo floors.

Today the permanent collection is comprised of the Guggenheim collection, the Justin K. Thannhauser collection featuring many Impressionist, Post-Impressionist and early modern artists, as well as recent acquisitions by the Guggenheim Foundation.

Guggenheim Museum

1071 Fifth Avenue at 89th Street
New York, New York 10128-0173
Tel: 212-423-3500
www.guggenheim.org/new_york_index.shtml

Opening Hours

10.00am – 5.45pm Saturday to Wednesday
10.00am – 7.45pm Friday
Closed Thursday

Admission

$18 adults; $15 senior citizens (65 and over) and students with valid ID.
On Friday evening tickets are purchased on a 'Pay What You Wish' basis.

How To Get There

Subway: 4, 5, or 6 train to 86th Street. Walk west on 86th Street, turn right
at Fifth Avenue and proceed north to 88th Street.

Buses: M1 – M4 southbound on Fifth Avenue, northbound on Madison
Avenue.

Access for the Disabled

The museum is wheelchair accessible except for the High Gallery, which
is at the top of the first ramp and accessible by two low stairs. Wheelchairs
are available free of charge but are not available in advance.

Museum Store

9.30am – 6.15pm Saturday to Wednesday
9.30am – 8.30pm Friday
11.00am – 6.00pm Thursday

Museum Café

9.30am – 3.00pm Saturday to Wednesday
9.30am – 3.00pm Thursday and Friday

Édouard Vuillard

Place Vintimille **1908**

Guggenheim Museum

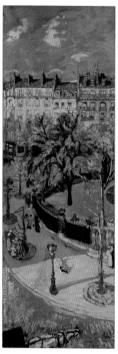

Vuillard never married and lived with his mother until her death at a number of addresses in Paris. In 1908 they moved into an apartment on the fourth floor of 26 rue de Calais in the Batignolles district in the north of Paris where they were to live for over 25 years.

The Batignolles area will always be associated with the birth of Impressionism a generation before – the Café Guerbois at 11 Grande rue des Batignolles was the regular meeting place of the artists who would form the core of the Impressionists but who were at the time known as the Batignolles group and many of them had lived in the area. Édouard Vuillard's work was therefore part of a tradition of urban painting in the area and in these two paintings we can see that he is following in the footsteps of such painters as Monet and Pissarro who both produced many paintings of the Paris boulevards from the vantage point of the upper floor of an apartment block.

These two panels show the view of Place Vintimille (now renamed Place Adolphe-Max) from Vuillard's flat. They are part of a commission for four panels from the playwright Henry Bernstein showing views of the square and rue de Vintimille which were to join four paintings by Vuillard, depicting street scenes in the Passy area of Paris, that Bernstein had purchased in 1908. The right hand panel shows Place Vintimille in overcast, rainy conditions while in the left hand painting a bright shaft of sunlight illuminates the foreground and highlights the facades of the buildings on the far side of the square. It seems that a trip with his close friend Pierre Bonnard to see Claude Monet at Giverny may have

inspired Vuillard to take up the challenge of creating a series of pictures of the same motif under changing conditions of light.

The pictures have a flat, opaque quality resulting from Vuillard's preference during most of his life for the use of distemper over oil paint and for cardboard (a very absorbent base) or board over canvas. Distemper – notoriously difficult to work with – is a water-based medium which is mixed with glue giving a fast drying time. Vuillard found it to be conducive to his methods for producing large decorative panels but after about 1900 he used distemper for most of his output of whatever type. Its rapid drying properties allowed Vuillard to build up layers of paint in some areas of his compositions (while leaving other parts in a relatively unworked state).

Vuillard first exhibited with the Nabis in 1900 and he maintained friendships with a number of former members of the group, most especially Ker-Xavier Roussel and Bonnard throughout his life. The philosophy of the group was neatly summed up by Maurice Denis in his famous definition of painting as 'a flat surface covered with colors assembled in a certain order' and in many ways Vuillard continued to adhere to this approach throughout his career. *GS*

Contemporary Works

| 1908 | Piet Mondrian: *The Red Tree*, The Hague, Gemeentemuseum |
| | Gustav Klimt: *The Kiss*, Vienna, Belvedere |

Édouard Vuillard

1868	Vuillard is born at Cuiseaux, Saône-et-Loire.
1877	The family move to Paris.
1885	After leaving school Vuillard attends the studio of Diogène Maillart in Paris.
1886	Attends the Académie Julian.
1887	Passes the entrance examination for the École des Beaux-Arts.
1889	He is encouraged by his friend Maurice Denis, to join the brotherhood of the Nabis.
1893	Vuillard is a founder member of the Théâtre de l'Oeuvre company designing costumes and programs and painting scenery.
1894	Commissioned by the wealthy Alexandre Natanson to paint decorative panels for his dining room.
1895	Meets Jos and Lucy Hessel. Lucy would later become a close friend and favored model.
1897	The dealer Ambroise Vollard commissions a series of lithographs from Vuillard on the theme of landscapes and interiors.
1899	Travels to London with his friend Bonnard.
1900	Shows 11 paintings at the first exhibition of the Nabis group.
1901	Travels to Spain with Bonnard.
1903	Travels with Thadée and Misia Natanson to Vienna to visit the 16th Vienna Secession.
1908	Travels to England and on to Scotland with the Hessels.
1913	Accompanies Bonnard to Hamburg.
1914	Vuillard is called up for war service as a railway patrolman.
1917	Serves as a war artist.
1928	Vuillard's mother (with whom he is still living) dies.
1937	Elected to the Institut de France. Works on murals for the headquarters of the League of Nations in Geneva.
1938	A major retrospective of his work is staged in Paris.
1940	Dies at La Baule near Saint-Nazaire.

Franz Marc

Yellow Cow 1911

Guggenheim Museum

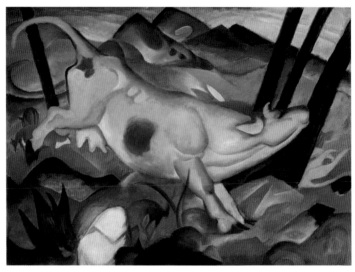

Late in 1915 the German Chief of the General Staff, General Erich von Falkenhayn, made the decision to attack French forces at Verdun. On February 21st 1916 the attack was launched and the ensuing battle, which lasted most of that year is considered to be one of the most terrible in the annals of armed conflict. Both sides, locked in a blinkered strategic stalemate, committed huge numbers of troops in a remorselessly bloody struggle of attrition resulting in a relentless tide of casualties. One of those slaughtered on the hills surrounding Verdun was Franz Marc.

Marc was born in Munich and most of his short life was lived in or around that city which at this time was a leading center for the visual arts. In 1896 Vasily Kandinsky had moved from Russia to Munich, forsaking a career in law in favor of studying art. Marc met Kandinsky in 1910 and a year later, frustrated by the conservatism of elements within a society of artists to which both belonged (the *Neue Künstlervereinigung*), they resigned and formed a new grouping which they called *Der Blaue Reiter* (The Blue Rider). Kandinsky explained that the name grew from their shared enthusiasm both for the color blue and the imagery surrounding horses and riding – but there may have been more complex reasons behind the choice of name, perhaps including underlying associations with Germanic traditions of Christian warrior knights.

Furthermore, Marc explained in a letter to his friend and fellow painter August Macke that 'Blue is the male principle, astringent and spiritual'. He went on to state that 'Yellow is the female principle, gentle, gay and sensual. Red is matter, brutal and heavy and always the color to be opposed and overcome by the other two'. These ideas about color were combined with Marc's intense sensibility for the natural world to produce lyrical paintings such as *Yellow Cow*. The mystical importance that Marc felt for nature is summed up in a letter of 1908:

I am trying to intensify my ability to sense the organic rhythm that beats in all things, to develop a pantheistic sympathy for the trembling flow of blood in nature, in trees, in animals, in air – I am trying to make a picture of it … with colors which make a mockery of the old kind of studio picture.

The central figure of a remarkably graceful cow is, according to Marc's color theories, symbolic of femininity. The animal cavorts in a Fauvist landscape dominated by red and orange hues with triangular blue mountains set into a sky of magenta and lemon. It has been suggested that the cow could be a reference to his wife Maria (given her knowledge of his love of animals we can assume that she forgave him) and that the blue mountains are a symbolic 'portrait' of himself.

Not a surprising self-portrait for a man who studied philosophy and religion and looked to nature for artistic inspiration and with the hope of spiritual redemption. Marc believed that nature, and especially animals, possessed a godliness that man had long ago lost. 'People with their lack of piety … never touched my true feelings,' he wrote in 1915. 'But animals with their virginal sense of life awakened all that was good in me.' *GS*

Contemporary Works

1911	Umberto Boccioni: *The City Rises*, New York, MOMA
	Georges Braque: *The Portuguese*, Basel, Kunstmuseum
	Fernand Léger: *La Noce*, Paris, Musée National d'Art Moderne - Centre Georges Pompidou

Franz Marc

1880	Franz Marc is born in Munich.
1900	Having initially resolved to study theology and philosophy, Marc decides to become a painter. He studies at the Academy of Fine Arts in Munich.
1902	During the summer, Marc works at Kochel in Bavaria.
1903	Visits Paris. On his return he curtails his studies at the Academy.
1906	Marc accompanies his brother Paul on a trip to Greece.
1907	During a brief stay in Paris Marc is inspired by the paintings of Gauguin and van Gogh.
1908	Spends the summer in Bavaria where his deep affinity with animals becomes more marked.
1910	Develops a close friendship with Auguste Macke. Macke's uncle Bernhard Koehler funds both artists. This enables Marc to move from Munich to Sindelsdorf in Upper Bavaria. Meets Vasily Kandinsky and Alexei Jawlensky.
1911	An exhibition of Marc's work is held at Galerie Thannhauser in Munich. Kandinsky and Marc are instrumental in founding *Der Blaue Reiter* group. First exhibition of the group at Galerie Thannhauser.
1912	In May *Der Blaue Reiter Almanac* is published, edited by Marc and Kandinsky. It is recognized as a seminal manifesto. Marc and Auguste Macke visit Robert Delaunay in Paris.
1914	Registers as a volunteer at the outbreak of war.
1916	Marc is killed during the battle of Verdun.

Faith Ringgold

Tar Beach **1988**

Guggenheim Museum

Filled with vibrant color and whimsy, *Tar Beach* is the first story quilt in Ringgold's series entitled *Women on a Bridge*. It depicts the story of Cassie Louise Lightfoot, a spirited eight-year-old girl who on a summer night in Harlem in 1939 can suddenly fly. The text surrounding the image tells her tale: 'I will always remember when the stars fell down around me and lifted me up above the George Washington Bridge.' In the foreground we see Cassie's family up on 'tar beach' – the roof of her family apartment building – playing cards after a picnic of fried chicken, roasted peanuts, watermelon and beer while Cassie and her little brother look up at the stars. Cassie pictures herself soaring and sure enough, in the background, Cassie can be seen flying through the night sky above the George Washington Bridge, which, the text recounts, her father helped build and whose lights she dreams of wearing as a necklace. The text also tells how she soars over and dreams of giving her father the union building that denied him membership because he is black. 'Sleeping on Tar Beach was magical,' says Cassie, '. . . only eight years old and in the third grade and I can fly. That means I am free to go wherever I want to for the rest of my life'.

For Ringgold, this imaginary flight through the urban sky symbolizes the desire for freedom and self-possession. Speaking about the 'Woman on a Bridge' series, Ringgold has said: 'My women, are actually flying; they are just free, totally. They take their liberation by confronting this huge masculine icon – the bridge.' The image is a mix of autobiography, fiction, literature and African-American history and captures the euphoria of a children's dream while reminding the viewer of the social injustices of the adult world.

It is these injustices that Ringgold often addresses in her work. A civil rights activist in the 1960s and 70s, she demonstrated against the exclusion of women and black artists by museums like the Whitney and MOMA and was among the first artists to depict the life of black women and the gulf between the white American dream and black American reality. Her early work was in performance and painting on a traditional stretched canvas but by the early 1970s she began to use unstretched acrylic canvas with lush cloth borders like Buddhist *thanka* paintings. She worked with her mother, a designer and dressmaker, who told her tales of their slave ancestors who made quilts for plantation owners. Inspired, Ringgold began to incorporate quilting into her artwork.

The story quilt was a traditional American craft associated with women's communal work that also has roots in African culture, and revived among feminist artists in the 1970s seeking to reclaim traditional arts and handicrafts as valid artistic expressions and to challenge to the often narrow definition of 'high art.' This image is comprised of a central painted canvas bordered with printed, painted, quilted, and pieced cloth. The medium imparts a naïve, folk-art quality, which Ringgold employs to emphasize narrative over style. Here, the medium becomes part of the message.

While Ringgold's early work was about political agitation, her later works, like *Tar Beach*, seek to challenge racial and gender stereotypes by presenting empowered, optimistic images of black female heroines, like Cassie. Ringgold tells us 'My process is designed to give us "colored folks" and women a taste of the American dream close up. Since the facts don't do that too often, I decided to make it up.' *DM*

Contemporary Works

1988	Gerhard Richter: *11.4.88*, New York, MOMA
	Robert Mapplethorpe: *Self Portrait* (Photograph), New York, Guggenheim Museum
	Roy Lichtenstein: *Bauhaus Stairway*, New York, MOMA

Faith Ringgold

1930	Born Faith Willi Jones in Harlem, New York.
1955	Gains a degree from the City University of New York. Teaches art at schools in New York.
1959	Completes her masters degree.
1967	Ringgold's first one-woman show at the Spectrum Gallery in New York.
1968 – 70	She is involved in demonstrations against the exclusion of black and women artists from certain New York museums.
1970	Arrested for desecrating the American flag.
1971	Co-founds 'Where We At,' an African-American women artists group.
1973	She resigns from her post as a school teacher to devote more time to her painting.
1976	Makes her first visit to West Africa.
1984	Becomes a professor at the University of California, San Diego.
1991	*Tar Beach* is adapted by Ringgold into a popular children's book.

The Hispanic Society of America, located on Audubon Terrace, Broadway, provides a free museum and reference library for the study of the arts and cultures of Spain, Portugal, and Latin America.

The Hispanic Society of America was founded on May 18, 1904, by Archer Milton Huntington (1870 – 1955) and it first opened its doors in 1908 at the Beaux-Arts building on Audubon Terrace that still serves as its home. Under Huntington's supervision, the Hispanic Society published more than 200 monographs by the Society's curators and internationally noted scholars on virtually all facets of Hispanic culture.

The Society Museum offers a comprehensive survey of Spanish painting and drawing from the Middle Ages to the present, with particular strengths in the Spanish Golden Age (1550-1700), the 19th century, and the early 20th century. The collection comprises over 800 paintings and more than 6,000 watercolors and drawings.

The Hispanic Society of America

613 West 155th Street
New York, New York 10032
Tel: 212-926-2234
www.hispanicsociety.org

Opening Hours

10.00am – 4.30pm Tuesday to Saturday
1.00pm – 4.00pm Sunday
Closed Mondays. Also major holidays (please see website)

Admission

Free.

How To Get There

The entrance to The Hispanic Society of America is located on Broadway between 155th and 156th Streets.

Subway: Number 1 to Broadway and 157th Street

Buses: M4 or M5 to Broadway and 155th Street

Access for the Disabled

Future plans include 100 per cent wheelchair accessibility, but at present handicapped access is extremely limited. Telephone 212-926-2234, ext. 209, to discuss possible ways to address any special needs.

Gift Shop

Books, postcards and other publications by the Hispanic Society are available at the gift shop located in the Sorolla Room.

Please note that The Hispanic Society does not have a cafeteria but the surrounding neighborhood has an extensive selection of Spanish and Latin American restaurants.

Francisco de Goya

Duchess of Alba

The Hispanic Society of America

María del Pilar Teresa Cayetena de Silva Álvarez de Toledo, 13th Duchess of Alba (1762-1802), was, after Queen María Luisa, the first lady of Spain. She was also considered one of the most beautiful and captivating women of her day. British traveler Lady Holland wrote that she had it all: 'beauty, popularity, grace, riches and nobility.' She was worshipped, envied and the subject of endless gossip. It was said that men traveled to Spain just to catch a glimpse of her, and that Goya too fell for her charms.

Goya first painted the duchess in 1795 and around the same time he wrote to a friend: 'the Alba woman … yesterday came to the studio to make me paint her face, and she got her way; I certainly enjoy it more than painting on canvas, and I still have to do a full-length portrait of her.' After her husband's death in 1796, the duchess invited Goya to her estate in Andalusia where he stayed for several months and completed this painting.

At the time, Goya was Spain's leading painter, despite being completely deaf since an illness five years earlier. Over his long career he worked for four successive monarchies, but his early light-hearted Rococo style would slowly transform after his illness to a distinctively dark, pessimistic vision that looked forward to 19th-century Romanticism and Realism. Goya was in many ways the last old master and the first artist of the modern world; and this portrait teeters somewhere between the two.

Goya's had three principal influences: the elegant, fluid style of Velázquez; Rembrandt's honest, insightful portraits; and nature itself. In this work he also displays his knowledge of contemporary British portraiture, particularly the full-length female portraits by artists like Gainsborough and Reynolds. However,

instead of placing his sitter in a bucolic landscape, the duchess stands before the dry Andalusian landscape of her own lands in Southern Spain.

With a confidence that borders on bravado, the duchess stands arm akimbo, one foot forward. Proud and poised, she requires no props to reveal her status and forceful character. She looks directly at the viewer with dark Bette Davis eyes, rosy lips, bushy eyebrows and a large beauty mark (considered a symbol of a passionate nature) next to her right eye. Like many Goya portraits, the face is finely executed and stands out from the more freely painted style of her surroundings and dress.

Wearing a black skirt and lace mantilla with a shimmering golden blouse and red sash underneath, she is dressed as a 'maja' – a peasant woman, a style that reflected both her character and politics. This style was considered fashionable, daring and sexy when worn by an aristocrat; all adjectives that well suited the duchess. She was also a leading figure of a faction that promoted the traditions of Old Spain in opposition to the popularity of the ideas and fashions of the French Enlightenment and Revolution in Spanish society.

On her hand she wears two rings: upon one is written 'Alba'; on the second 'Goya'. The same finger points to the words, traced in the sand, 'Sólo Goya' (Only Goya). The 'Sólo' was at some point painted over and was only discovered in 1960 during restoration, adding to the endless speculation about the relationship between the duchess and Goya.

Were they lovers? She was 35, in mourning; Goya was 51, deaf, often saturnine and in poor health. The duchess remained a beauty; Goya was both brilliant and successful. There are also informal drawings from this period of a woman very much like the duchess in various states of deshabillé: did she pose for him? Or did Goya simply use her dark beauty as a prototype? Perhaps it was Goya who was smitten and 'Only Goya' was his fantasy, rather than reality. Whatever the case, the duchess never took possession of this portrait and Goya kept it until his death. *DM*

Contemporary Works

| 1796 | Antoine-Jean Gros: *Napoleon at Arcole*, Paris, Musée du Louvre |
| 1799 | Jacques-Louis David: *Mme de Verninac*, Paris, Musée du Louvre |

Francisco de Goya

1746	Born in Fuendetodos in Aragon.
1771	Goya travels to Rome after studying in Saragossa.
1773	Marries Josefa Bayeu, the sister of his mentors, Francisco and Ramón Bayeu.
1774	Moves to work under Francisco Bayeu in Madrid.
1780	Elected to the Real Academia de Belles Artes de S Fernando in Madrid.
1786	Goya is appointed Painter to the king.
1792	Falls ill while visiting Cádiz, leaving him profoundly deaf.
1793	Returns to Madrid in a weakened state.
1796	Stays in Andalusia as the guest of the Duchess of Alba.
1799	Publishes a series of 80 satirical aquatints known as the *Caprichos*.
1800	Spends the spring working on the group painting of the family of Carlos IV.
1808	The French invade. Carlos IV abdicates. Goya records the horrors of the siege of Saragossa.
1809	Joseph Bonaparte is installed on the Spanish throne.
1810	Goya begins the print series *Disasters of War* based on his Saragossa sketches.
1812	Goya's wife dies. He paints portraits of the Earl (later Duke) of Wellington.
1814	The ferociously reactionary Fernando VII is restored to the Spanish throne.
1819 – 20	Buys a property near Madrid which he decorates with the 'Black Paintings'.
1824	Horrified by the wave of terror unleashed by Fernando, Goya leaves Spain.
1828	Dies in Bordeaux.

The Metropolitan Museum of Art was founded in 1870 by a culturally-minded group of New York businessmen, financiers, art patrons, artists and others. The museum's original painting collection included 174 donated works by European greats, such as Poussin, Tieoplo and Guardi and numerous Flemish and Dutch masters. Through further donations and astute purchases (for example, in 1910 the museum was the first public institution to accept works by Matisse) the collection grew and by the early 20th century, the Metropolitan was one of the world's great art museums. Today the Met's collections span from antiquity to the present and include one of the world's best collections of Impressionist and Post-Impressionist art as well as five of the fewer than 40 known works by Vermeer. The American Wing holds the most comprehensive collection of American art in the world. Plus the museum continues to be among the world's most important art collectors, regularly adding everything from old masters to contemporary works to its vast holdings.

Since 1880, the Metropolitan Museum has been located on the east side of Central Park, though its original Gothic-Revival building has been greatly expanded in size since then to house its ever-growing collection of art, sculpture, architecture and *objets d'art* from around the world. The present facade and entrance on Fifth Avenue were completed in 1926. The Robert Lehman Wing was added in 1975, the Sackler Wing in 1978, the American Wing in 1980, the Michael C. Rockefeller Wing in 1982 and the Lila Acheson Wallace Wing in 1987. In June 1998, the Arts of Korea gallery opened to the public, completing a major suite of galleries devoted to the arts of Asia. In October 1999 the renovated Ancient Near Eastern Galleries reopened. Most recently, in April 2007, after 15 years of planning and $220 million, the Metropolitan unveiled its newly renovated Greek and Roman galleries, featuring 50,000 square feet of galleries set around a spectacular two-story-high, sky-lit, Roman-style courtyard, complete with burbling fountain.

The Metropolitan Museum of Art

1000 Fifth Avenue at 82nd Street
New York, New York 10028-0198
Tel: 212-650-2251
www.metmuseum.org

Opening Hours

9.30am – 5.30pm Tuesday, Wednesday, Thursday and Sunday
9.30am – 9.00pm Friday and Saturday
Closed Mondays except some national holidays (please see website).

Admission

$20 recommended for adults; $15 recommended for senior citizens (65 and over); $10 recommended for students. Children 12 or under are free.

How To Get There

Subway: From the East Side take the 6 train to 86th Street and walk three blocks west to Fifth Avenue. From the West Side take the 1 train to 86th Street then the M86 crosstown bus across Central Park to Fifth Avenue.

Buses: M1, M2, M3 or M4 southbound on Fifth Avenue, northbound on Madison Avenue.

Access for the Disabled

Street-level entrances are at Fifth Avenue and 81st Street and at the Museum Parking Garage at Fifth Avenue and 80th Street. Wheelchairs are available free of charge at coatcheck areas on a first-come, first-serve basis. The museum is accessible to wheelchair users.

Met Store

Located off the Great Hall and in several other convenient locations throughout the building, the Met Store features publications and reproductions produced by the museum, as well as other books and merchandise related to the permanent collection and special exhibitions.

Giotto di Bondone

The Epiphany *c*1320

The Metropolitan Museum of Art

*Once Cimabue thought to hold the field
as painter; Giotto now is all the rage,
dimming the luster of the other's fame.*
Dante, *Divine Comedy*

Dante, like most of his contemporaries, was an admirer of Giotto. Even Pope Boniface VIII (according to Vasari) thought 'that Giotto surpassed all other painters.' Credited in his own time with reviving the art of painting after centuries of decline, today Giotto is considered the founder of Renaissance painting. This small panel painted around 1320 demonstrates why.

Originally part of a series of paintings depicting the life of Christ (of which six others are known and are in other collections), it may have been part of one of four altarpieces by Giotto recorded in the Franciscan church of Santa Croce in Florence; the same church where Giotto was commissioned to decorate the chapels of two wealthy banking families, the Bardi and the Peruzzi, around 1320 or earlier.

It depicts two related but separate events of the Epiphany (that is, the revelation of Christ as divine to humankind): the arrival of the three kings and the annunciation of Christ's birth to the shepherds. Giotto combines the images to show both the exalted and the humble being told of Christ's birth; a facet of the story the Franciscans, who advocated a life of poverty, liked to emphasize. In fact the two shepherds in the upper left corner are depicted in contemporary Franciscan brown robes and tonsure.

Giotto precisely organizes the pictorial space like a stepped stage upon which the characters interact. The stable is no more than an awning and the manger a wooden feed box but they serve to frame the action. The figures,

solid and fully formed beneath folds of drapery, are also supple and active: note the angels who urgently swoop and pray as they do in Giotto's celebrated Arena Chapel in Padua. This movement and perspective was a radical change from the static Byzantine compositions common at the time.

But perhaps Giotto's greatest innovation was to infuse the narrative with human emotion: no one had ever depicted a magus removing his crown and picking up the Christ Child like a doting old grandfather. His individualized figures exchange intense glances, full of feeling: all three kings gaze compassionately at the baby; an awe-struck shepherd looks to a joyful angel; Mary watches them all with sorrow and tenderness. Giotto translated remote history into tangible, moving events and Western art was never the same.

The brilliant colors are composed of costly pigments imported from the East. The most sought-after was ultramarine (literally, 'overseas'), a blue mineral extracted from the semiprecious stone, lapis lazuli. More expensive than pure gold and before the 19th century found only in northeastern Afghanistan, this precious blue was employed only for the most glorious subjects, such as the Virgin. Ironically, ultramarine darkens over time, and Giotto's reclining Virgin now wears black.

Why would such an expensive painting be made for a monastery that preached poverty? The answer reflects the complex mix of theology and secular concerns at the time. Medieval theology saw wealth as an impediment to salvation ('It is easier for a camel to pass through the eye of a needle, than for a rich man to enter into the kingdom of heaven'; Matthew 19:24), a sentiment echoed in Florence's numerous sumptuary laws regulating any type of extravagant display. However, wealth devoted to the glory of God was different; Giotto's beautiful, eloquent images were meant to inspire and teach the faithful (remembering that most of the population was illiterate). Religious patronage was also a way for the rich to make amends for their lavish lifestyles with a bit of Christian charity, not to mention an opportunity to display publicly their status and prosperity without censure. *DM*

Contemporary Works

1311	Duccio di Buoninsegna: *Maestà*, Siena, Museo dell'Opera del Duomo
1326	Simone Martini: *Saint Andrew*, New York, Metropolitan Museum

Giotto di Bondone

1266–75	Giotto was probably born at some time between 1266 and the early 1270s at Vespignano near Florence.
1301	Giotto is recorded as a house owner in Florence.
1303–6	Giotto paints the frescoes in the Arena Chapel in Padua.
1309	A document mentioning Giotto regarding a joint debt owed by him and an inhabitant of Assisi, suggests that Giotto has lived in Assisi prior to this date. His authorship of the St Francis fresco cycle in the Upper Church in Assisi is disputed. It is possible that Giotto played some part in making the frescoes, probably earlier in the decade.
1311–14	Possible dates when Giotto may have worked on frescoes in Santa Croce church in Florence.
c1320	Probable date for the completion of frescoes in Santa Croce.
1328	Giotto travels to Naples to work for Robert I, King of Naples, decorating his chapel.
1334	Giotto has returned to Florence where he is named as Chief of Works for the construction of the cathedral.
1335	Travels to Milan to work for Azzo Visconti.
1336	Probable return to Florence.
1337	Dies in Florence.

Fra Filippo Lippi

Portrait of a Woman with a Man at a Casement **c1440**

The Metropolitan Museum of Art

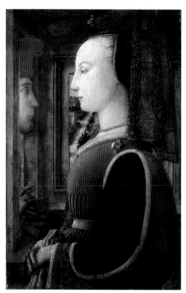

Often a portrait reveals more than just the sitter's physiognomy. This double portrait, thought to have been painted for the betrothal or wedding (in 1436) of Lorenzo di Ranieri Scolari (1407–1478) and his bride, Angiola di Bernardo Sapiti, reveals as much about the society that made it as the individual subjects.

Lorenzo appears to be looking through a window into the room where Angiola stands in rigid profile. Dressed in sumptuous fabrics and jewels, with pale hair and skin as luminous as the pearls she wears, the woman is by far the dominant figure. Yet the picture is not really about her.

A young patrician girl in 15th-century Florence usually had two possible courses in life: become a nun or a wife. She was expected to be modest, chaste and obedient to her father and when married, to her husband. Her life was lived within a domestic sphere and her wedding was one of the few times she appeared in public. The composition of this picture reflects this closely regulated life.

And indeed, Angiola is depicted a bit like a pearl herself, a jewel encased in an elegant room; she is the embodiment of the womanly ideals of beauty and virtue. Although betrothed, the couple's gazes do not meet; lowered or averted eyes were a sign of a woman's modesty and obeisance; to meet a man's eyes would be seen as wanton. Upon marriage, a woman became part of her husband's household, as indicated here by the inclusion of only the Scolari coat of arms, upon which Lorenzo rests in his hands. Angiola sports only one motto: *lealt* (loyalty) embroidered at the edge of her sleeve.

Typical of Fra Filippo's style, both figures are elegantly solid with simplified facial features but elaborately detailed jewels and attire. A 1480 commentary noted that, 'Fra Filippo Lippi was gracious and ornate and exceedingly skillful;

he was very good at compositions and at variety, at coloring, relief, and in ornaments of every kind.' This attention to material surfaces appealed to many important patrons, from the Scolari to the Medici, as art in 15th-century Tuscany was about conspicuous consumption, intended to show off wealth and possessions. Lippi also incorporates topographical detail in the buildings and gardens seen through the window (a technique he probably learned from Flemish art). It is almost as if the artist were documenting the Scolari family possessions: jewels, property and virtuous wife.

The innovative Fra Filippo Lippi was one of the first artists to excel at the profile portrait – this image is thought to be the first double portrait in Italian art, one of the first set in an interior and one of the first to depict a woman. Derived from imperial images on classical coins, the format would remain the standard for female portraits for decades (there are about 40 female Renaissance profile portraits that survive today), perhaps as it was perfectly suited for an emblematic display of female virtue, family honor and wealth.

The restrictive societal mores represented in this work were not something the artist followed himself. Though a Carmelite friar (Fra) from the age of 14, Lippi was not suited for religious life. He was involved in numerous scandals, the most notorious in 1456 when he abducted a nun, Lucrezia Buti, from the convent in Prato where he was chaplain. However, with the help of one of his patrons, Cosimo de Medici, both were relieved of their vows. They married and had a son, Filippino, who became as successful a painter as his father, training in Filippo's workshop along with another star of the next generation, Botticelli. *DM*

Contemporary Works

1436	Jan van Eyck: *Madonna with Canon van der Paele*, Bruges, Groeningemuseum
1436–40	Fra Angelico: *Descent from the Cross*, Florence, San Marco
*c*1440	Rogier van der Weyden: *The Crucifixion*, Vienna, Kunsthistorisches Museum

Fra Filippo Lippi

*c*1406	Born in Florence.
1421	Takes monastic vows at the Convent of the Carmine in Florence; subsequently trains as a painter at the monastery.
1420s	First works created; influenced by Masaccio and Masolino, who are working on frescoes in the Brancacci chapel in Church of the Carmine in the 1420s.
1428	Named sub-prior of the Carmelite convent in Siena.
*c*1434	Recorded working as an artist in Padua.
1437	Returns to Florence, becoming one of city's leading artists.
1456	According to Vasari's *Lives of the Artists*, while in Prato (near Florence) for a commission, Fra Filippo abducts a nun, Lucrezia Buti, with whom he has a son, Filippino.
1461	With the help of his patron, Cosimo de Medici, Fra Filippo and Lucrezia Buti are released from their religious vows and marry.
1469	Dies in Spoleto, where he had been working on a fresco cycle for the cathedral with his son, Filippino. Reflecting his status as an artist, he is buried in the cathedral.

Giovanni di Paolo

The Creation and the World and the Expulsion from Paradise

The Metropolitan Museum of Art: Robert Lehman Collection

This extraordinary panel depicts the two central themes of the book of Genesis – the Creation and the expulsion of Adam and Eve from Paradise. It originally formed part of a predella for an altarpiece which was situated in the church of San Domenico in Siena, as did Giovanni's representation of Paradise also in the Metropolitan collection.

The left half of the painting shows God creating the universe – a fascinating representation of the medieval view of celestial space. The Earth is shown as a 'mappomondo' in the center of concentric circular bands which represent various layers within the medieval conception of the cosmos. The rocky and barren Earth is surrounded by the blue-green of the oceans, then a ring of fire, a blue stratum of air, a layer representing the movement of the planets around the Earth, including the Sun, and eventually an outer skin containing the stars symbolized by the signs of the Zodiac.

Within the ether, outside this construct, God is piloted through the heavens by a squadron of azure cherubim in close formation. Golden rays emanate from His halo, a visual reference to the power of His will. His gaze is directed towards the events taking place in the other part of the composition as His right hand penetrates the circular cosmos pointing at the arid Earth and indicating that this is the destination of Adam and Eve, after their fall from grace.

To the right of the mesmeric roundel we see the moment of the expulsion as an (unusually naked) angel physically thrusts Adam from the scene. This is taking place against a verdant backdrop of serried trees bearing golden apples and a lush meadow supporting an abundance of flowers and small, unthreatening animals. Beneath this grassy sward the four rivers of Paradise issue forth, ultimately finding their way to the four geographical directions, symbolizing according to John Pope-Hennessy, 'the four virtues by which

man will eventually be saved, and, thence the Four Gospels, announcing this salvation to Christendom.' This message is given further emphasis by the presence of strawberries and lilies, symbolic attributes of the Virgin Mary, seen as the second Eve, heralding salvation through the sacrifice of her son.

This picture was probably completed about 1445 – at a time when artists such as Domenico Veneziano, Andrea del Castagno and Piero della Francesca, working in Florence and Tuscany, had mastered the mysteries of perspective, and the representation of volume and space (and a full 20 years after Masaccio had completed his illusionistic fresco of the Trinity in the church of Santa Maria Novella in Florence). A glimpse at the map will confirm that Florence and Siena are close neighbors, and yet Giovanni seems either to have been oblivious to these developments or to have ignored them, preferring instead to work in the tradition of earlier Sienese masters.

However, influences from outside the city walls of Siena did make themselves felt in the form of a polyptych painted by the great Gentile da Fabriano for the Sienese guild of notaries in 1425. Gentile, a contemporary of Masaccio, was a master of the florid late gothic style which has come to be known as International Gothic and which is characterized by elegant and flowing drapery and the realistic depiction of detail. This style flourished at the same time as Masaccio and others were forging a new art. In this painting we can see that Giovanni has melded this late gothic approach (note the sinuous, slightly elongated bodies and the detailed representation of flowers and animals in the expulsion) with the conservative traditions of Sienese art to produce a work of great power and vitality. *GS*

Contemporary Works

1440–45	Rogier van der Weyden: *Triptych of the Seven Sacraments*, Antwerp, Kroninklijk Museum
	Jean Fouquet: *The Court Jester Gonella*, Vienna, Kunsthistorisches Museum
1446	Petrus Christus: *Portrait of a Carthusian*. New York, Metropolitan Museum

Giovanni di Paolo

c1399	Born in Siena.
1417	Giovanni receives payment for miniatures in a Book of Hours commissioned by a Milanese professor of law.
1420	Receives payments for two untraced paintings, both for religious houses in Siena. This suggests Giovanni is an established artist by this date.
Early 1420s	Paints four altarpieces for S. Domenico, Siena.
1428	Joins the painters' guild in Siena.
1438-44	Works on illustrations for Dante's *Divine Comedy*.
1441	He is appointed the rector of the Sienese painters' guild.
1449	Completes an altarpiece commissioned for the church of S. Maria della Scalla in Siena.
1463	Paints an altarpiece for the cathedral at Pienza.
1475	Produces his last dated work – an altarpiece for the church of S. Silvestro di Staggia in Siena.
1482	Dies in Siena.

Petrus Christus

The Metropolitan Museum of Art: Robert Lehman Collection

St Eligius was born to an influential family in the French town of Limoges in about AD 588. His first calling may have been as a farrier but he later established himself as a goldsmith. He left Limoges and traveled north to work for the royal treasury where he came to the attention of the Merovingian king Clothaire II. It seems that Clothaire came to value him as much for his abilities as an advisor as for his skill as a goldsmith, and on the king's death in 629, his successor Dagobert confirmed Eligius as his chief councilor. In 641 he was made bishop of Noyon-Tournai and was conspicuous in his efforts to convert his mainly pagan flock. He was also notably assiduous as a founder of monasteries and churches. His cult was widespread in France (and indeed in much of Europe due to his adoption as patron saint of goldsmiths, blacksmiths and farriers) but became particularly strong in the area centered on the Flemish cities of Tournai, Courtrai, Antwerp, Ghent and Bruges.

Petrus Christus has depicted St Eligius seated at a bench in his goldsmith's workshop surrounded by his tools and retail stock, including rings, a piece of coral, ewers and other liturgical objects. Standing behind him are an elegantly dressed young couple; the young woman wears a magnificent brocade dress which attests to her wealth as does the gentleman's fur lined tunic and gold chain. The purpose of their visit is evident because Eligius, while holding his balance in one hand, grasps a gold wedding ring in his other. We are given another clue in the bridal girdle which is conspicuously arrayed on the goldsmith's bench.

Propped against the reveal of the shop front (for we are indeed viewing the goldsmith and his clients from the street, the bench forming a sales counter similar to the way St Joseph displays his wares in the right hand panel

of the Mérode Altarpiece – see page 20) we see a prominently displayed convex mirror. We can clearly see the reflection of the market square and two fashionably dressed men within it (does one represent the viewer?). One of these gentlemen is carrying a falcon, perhaps showing him to be a member of those idle classes who can afford such pastimes, in marked contrast to the solidly bourgeois virtues of diligent enterprise exhibited by St Eligius. The mirror performs another function – it serves to aid the illusion that we, the viewers, are part of the action, an impression enhanced by the way that the artist has positioned his protagonists in close proximity to the picture plane, and the way that the girdle is positioned on the bench, spilling over into the viewer's space.

The painting was commissioned by the goldsmiths' guild of Bruges - essentially it is an advertisement for their services and indeed some scholars have interpreted it as the first secular painting in Netherlandish art, questioning whether the seated figure should really be equated with St Eligius at all, but should rather be seen as a likeness of one of the members of the guild. Whichever way one wishes to interpret the piece, there is no doubt as to its charm. Petrus Christus was an admirer and follower of Jan van Eyck as can be seen in the way that he has lavished such effort on the minutest details of this painting. Furthermore, the convex mirror is an obvious quotation from *The Arnolfini Portrait* by van Eyck now in the National Gallery, London (see *100 Best Paintings in London*). It used to be thought that Christus was a pupil of the great man but scholars now believe that there was in fact little or no personal contact between the two. Be that as it may, Christus was a worthy successor to van Eyck's legacy. *GS*

Contemporary Works

1449–50	Andrea del Castagno: *Assumption of the Virgin with SS Miniato and Julian*, Berlin, Gemäldergalerie
c1450	Stefan Lochner: *Virgin of the Rose Bower*, Cologne, Wallraf-Richartz Museum
c1450–51	Piero della Francesca: *Portrait of Sigismondo Malatesta*, Paris, Musée du Louvre

Petrus Christus

c1410	Born in Baerle-Duc (Baarle-Hertog) in the South Netherlands.
1444	Resident in Bruges. Buys citizenship to enable him to become a painter.
1462	Becomes a member of the Confraternity of the Dry Tree.
1463	He is paid for the construction of a Tree of Jesse.
1472	He is the representative of the painters' guild in a dispute with another painter.
1472 or 3	Dies in Bruges.

Hans Memling

The Metropolitan Museum of Art

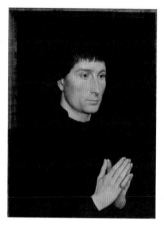 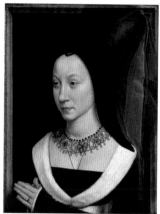

Not only are these pictures two of Memling's finest portraits but the male likeness portrays one of the most important and influential patrons of the arts during the latter half of the 15th century. They are also emblematic of the close business and cultural links which existed between the Netherlands and Italy.

Tommaso Portinari arrived in Bruges from his native Florence around the year 1440, in order to take up a position in a branch of the Medici bank which had been established in that city. For the next 25 years he worked in junior positions, all the while assiduously cultivating contacts and even gaining some influence in the Burgundian court. His ambition led him to lobby the Medici for preferment and in 1465 he was appointed as manager of the Bruges branch. Tommaso was now able to use his much improved status to greatly advance his parallel career in the Burgundian court where he became an advisor to two dukes of Burgundy. Needless to say, pecuniary advantages also came his way, which is more than can be said for his employers. Portinari's promotion proved to be disastrous for the Medici bank – Tommaso saw fit to approve large and very risky loans to Duke Charles the Bold but when the duke defaulted on repayments (as was the way with so many princely debts) the Medici were forced to declare the branch bankrupt in 1478. Tommaso was recalled to Florence but was back in the Netherlands in 1480 attempting to recover some of the money.

Just before the consequences of Portinari's poor judgement became all to painfully apparent, he commissioned an altarpiece of the Adoration of the Shepherds from the Ghent painter Hugo van der Goes which proved to be one of the greatest and most influential works of art ever produced in the Netherlands. The huge triptych now known as the Portinari Altarpiece was installed in the Portinari chapel in the church of St Egidio in Florence where Hugo's masterful use of oil paint exercised a considerable influence on Florentine artists.

Hans Memling hailed from a small town on the River Main near the German

city of Mainz. In 1465 he was registered as a resident of Bruges where he probably moved after having worked in the studio of Rogier van der Weyden (who died in 1464). Shortly after his arrival he received a commission from Portinari's predecessor as head of the Medici bank, Angelo Tani, for a large triptych of the Last Judgment. (Unfortunately this was captured by Hanseatic pirates whilst in transit to Italy and it has resided in Gdansk – Danzig – ever since.) Memling seems to have continued to attract rich clients. By 1480 he was one of the wealthiest men in Bruges.

This pair of portraits was probably painted to celebrate the marriage of Tommaso to Maria Baroncelli in 1470. Originally the two panels may have been the wings flanking a central panel depicting the Virgin and Child. Unusually, Memling has not included a pastoral scene as background for these paintings. His exquisite, distant landscapes seen in the margins of portraits and triptychs alike (seen to perfection in the very beautiful *Portrait of a Man* in the Frick Collection) were justly celebrated, and when a number of works found their way to Italy they influenced such painters as Perugino and through him Raphael.

Here, the dark backgrounds tend to concentrate one's attention on the physiognomy of the faces and incidentally on the skill of the artist. Maria's jewelry provides an outlet for some ostentation, otherwise a hushed austerity holds the stage. The serenity and stillness which pervades all Memling's work is here in abundance but Memling also softens; a degree of idealized license seems to have been used in these portraits as a comparison between them and the likenesses of the same couple which appear in the wings of the Portinari Altarpiece will show. This might be seen as one of the reasons behind Memling's popularity as a portraitist. *GS*

Contemporary Works

1470	Dieric Bouts, *Christ Crowned with Thorns*, London, National Gallery
c1470	Jacopo Pollaiuolo: *Madonna and Child*, Saint Petersburg, Hermitage
1472–4	Piero della Francesca: *Madonna with the Duke of Urbino (Montefeltro Altarpiece)*, Milan, Pinacoteca di Brera

Hans Memling

1430–40	Born in Seligenstandt in Germany.
1465	Becomes a citizen of Bruges.
1474	Admitted to the Confraternity of Our Lady in the Snow in Bruges, all members of which were either wealthy or aristocratic.
1479	Completes his largest commission, *The Mystic Marriage of St Catherine*, for the hospital of St Jan in Bruges.
1481	Memling, together with over 200 other citizens of Bruges, is repaid money lent to support war against France. He is one of the wealthiest citizens in the town.
1487	Memling's wife dies.
1489	He completes the *Shrine of St Ursula* – a Gothic reliquary made of carved wood with eight paintings decorating the sides.
1491	Memling receives a commission for a triptych for Lübeck cathedral in Germany.
1492	Completes a commission for a large altarpiece (most of which is now lost) for the abbey of Nájera in Spain.
1494	Dies in Bruges.

Carlo Crivelli

Madonna and Child **c1480**

The Metropolitan Museum of Art

A porcelain Madonna, clad in a sumptuous cope of blue and gold brocade, stands behind a parapet steadying her infant with unfeasibly elegant hands. The child is clutching a goldfinch (perhaps a mite too tightly) and is sitting on a soft cushion. The Virgin is shown against a backcloth held aloft by uncertain means and she is flanked by some outsized fruit which may have been trained to grow on the same indeterminate structure from which the cloth hangs. Her halo and that of the Christ child are encrusted with jewels and are given the charmingly corporeal reality of expensive dinner plates rather than the more ethereal quality favored by many of Crivelli's contemporaries. In the middle distance we can see an exquisitely rendered forest landscape, the equal of those produced by the Netherlandish masters of such peripheral settings.

To the left of the gold cloth upon which the holy child's cushion sits, Crivelli has painted a *trompe-l'oeil* fly complete with tiny shadow – it looks as if has just alighted on the parapet, or maybe the painting. No doubt the artist has included this in order to impress us with the extent of his talent but it is also there as a symbol of torment (because of its irritating buzzing) and destruction (connected as it is with putrefaction) and was therefore associated with Christ's Passion. This stark message, reminding us of the nature of Christ's final earthly days at the same time as presenting us with the innocent child, is reinforced by the melancholy demeanor of his mother as well as the presence of the goldfinch whose bright red head was thought to remind the faithful of the blood which issued from Christ's head when crowned with thorns; it also fed on thistles – a plant that was associated with those same spiny thorns.

The prominently displayed fruit (the depiction of which was a Crivelli specialty) also carries a symbolic charge. The apple refers of course to the Fall of Man after Eve picked the forbidden fruit from the tree of knowledge. The cucumber, much coarser than modern varieties, also symbolized sin (as a result of its ability to reproduce with speed) but through some theological contortions stemming from a passage in the book of Isaiah ('And the daughter of Zion is … like a lodge in a cucumber field') became associated with the Virgin as a paragon of virtue surrounded by iniquity.

Venetian by birth but influenced by the hard-edged, wiry style of Mantegna and by the Paduan school, Crivelli was one of a kind. After being arraigned in Venice for having committed adultery with the wife of a sailor, leading to a short spell in prison, he spent most of his life in the cultural backwaters of Venetian Dalmatia and the Italian territories on the opposite shore of the Adriatic collectively known as the Marches.

In his love of ornamentation and detail he perhaps looks back to earlier masters such as Gentile da Fabriano and Pisanello. Like them he employed such outdated but wonderfully decorative techniques as the creation of raised areas of gesso beneath the paint surface to enhance three dimensional effects, sometimes embedding colored glass to represent jewels. Another stylistic trademark can be seen here in Crivelli's representation of the hair of the infant Jesus – beautifully arranged in linear locks – and the deeply creased cloth falling from the Virgin's headgear. All this contributes to a delightful personal canon which includes some of the most distinctive paintings of the Italian Renaissance. *GS*

Contemporary Works

*c*1480	Sandro Botticelli: *Allegory of Spring (Primavera)*, Florence, Galleria degli Uffizi
	Hugo van der Goes: *Dormition of the Virgin*, Bruges, Groeningemuseum
1482	Pietro Perugino: *The Delivery of the Keys*, Vatican, Sistine Chapel

Carlo Crivelli

1430–5?	Born, probably in Venice.
1457	After legal action brought in Venice, Crivelli is imprisoned for six months and fined for adultery with a sailor's wife.
1465	He is recorded as living in the Venetian city of Zara on the Dalmatian coast (now Zadar, Croatia).
1468	Crivelli is working in Fermo in the Marches.
1478	He buys a house near the cathedral in Ascoli Piceno where he now seems to be based.
1486	Paints the *Annunciation*, now in the National Gallery, London for the Annunziata church in Ascoli.
1490	Crivelli is knighted by Prince Ferrante of Capua.
1495	Dies in Ascoli Piceno (3 September).

Sandro Botticelli

The Annunciation c1485

The Metropolitan Museum of Art: Robert Lehman Collection

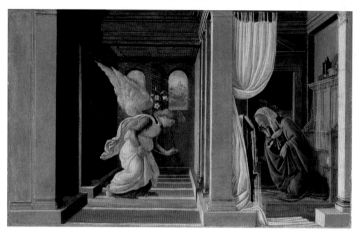

We are witnessing one of the most solemn moments in the Christian story. An angel has appeared with a message from heaven; the recipient of that message, and of God's will, kneels. The world holds its breath – the instant draws out into a timeless lacuna, filled with silence, pregnant with momentous consequences.

The cool austerity of the imposing classical architecture enhances the mood of solemnity and wonder, engendering a feeling of ordered peace. This sense of order is underpinned by the precision with which Botticelli has locked the components of his architectural caprice into a mathematically rigorous perspectival system. No hint of decoration relieves the formality of the outer vestibule and although the color scheme throughout maintains and underlines the sober serenity of the piece, the Virgin is allowed a few furnishings within her sanctum to mitigate the asceticism of her surroundings. A white curtain, echoing Gabriel's apparel, is gathered and fastened for the day; red cushions, mirroring the terracotta floors of the antechamber, adorn her bench (the same color is used again for the covers of two books which balance atop the entablature of the settle).

The angel Gabriel has approached through a gap in the colonnade although he could just as easily have materialized within the room without any need to observe the physical constraints of our earthly realm. He bows, and is in the process of kneeling, hitching up his voluminous robe to enable such a maneuver. He holds a splendid stem of lilies – the white flowers match the angelic wings and garb but the real reason for their presence is to remind us, through the purity of their ivory whiteness, of the innocence and virtue of Mary.

Gabriel has delivered his speech. 'Hail, thou that art highly favored, the Lord is with thee … thou shalt conceive in thy womb, and bring forth a son, and shalt call his name Jesus.' Mary's perplexed response that she 'know(s) not a man' has been countered by the angel, telling her that 'The Holy Ghost shall come upon thee' and it is this momentous event which is recorded here as a

stream of divine light enters the outer colonnade speeding above the kneeling angel into the inner chamber, illuminating (and impregnating) the Virgin as she kneels submissively.

Today, Botticelli is rightly one of the most popular artists of the Italian Renaissance and this wonderful jewel of a painting is a good example of why he is held in such high regard. However, this was not always the case. During his lifetime his reputation as one of the greatest painters in Italy was assured. But the achievements of the High Renaissance were soon to eclipse his standing and it was not until the last half of the 19th century that renewed appreciation among scholars, with Walter Pater and Bernard Berenson in the vanguard, led to a rehabilitation. In part this was due to a 19th century revival of interest in humanism at the Medici court where, in line with the intellectual tastes of the time, Botticelli was noted for the iconographic complexity of some of his pieces. But in this picture he shows us that he is also a consummate master of profoundly moving simplicity. *GS*

Contemporary Works

1483	Domenico Ghirlandaio: *The Vocation of St Peter and St Andrew*, Vatican, Sistine Chapel
1485	Leonardo da Vinci: *The Virgin of the Rocks*, Paris, Musée du Louvre
1486	Carlo Crivelli: *The Annunciation with Saint Emidius*, London, National Gallery

Sandro Botticelli

1444 or 5	Born in Florence.
1460s	Receives his initial training with Fra Filippo Lippi.
1470	First mentioned as an independent master.
1472	Enters the Compagnia di S. Luca (the painters' guild) in Florence.
1474	Works on a fresco in the cathedral at Pisa (destroyed in 1583).
1478	Paints *Primavera*, the first of his great mythological pictures.
1481	Botticelli travels to Rome where (together with Ghirlandaio, Perugino and Signorelli) he is employed by Pope Sixtus IV on the fresco decoration of the walls of the newly completed Sistine Chapel.
1482	Back in Florence, engaged in a number of commissions.
1484	Completes *Birth of Venus*.
1489	The Dominican friar Girolamo Savonarola arrives in Florence and denounces (among other things) the practice of painting images of holy personages in contemporary fashion. Botticelli becomes a devotee of the sect.
1498	Savonarola is burned at the stake for heresy.
1500	Completes the *Mystic Nativity* (in the National Gallery in London) which illustrates a considerable change in style from the serenity of his work in the 1480s, brought about to a large extent by recent religious upheaval.
1510	Dies in Florence (May 17th).

Jean Hey

Portrait of Margaret of Austria **c1490**

The Metropolitan Museum of Art: Robert Lehman Collection

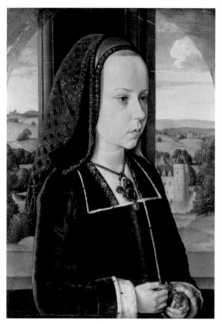

The daughter of Habsburg Emperor Maximilian I and Mary of Burgundy, Margaret of Austria (1480–1530) would marry three times by the age of 21. She was successively, queen of France, infanta of Spain and duchess of Savoy. Finally, a widow at 24, she refused to marry again and was instead appointed as governor of the Burgundian Netherlands, where she had been born, and which she ruled until her death. Known for her intelligence and diplomatic skill, she would act as a confidante and advisor to two emperors, helping to create the Habsburg Empire that covered much of Europe and the New World. She was also a great patron of the arts: her court introduced Italian Renaissance styles to the Low Countries, her collections included everything from works by Dürer to Aztec treasures and she created a magnificent church and monastery in Brou, Savoy, to house her equally spectacular mausoleum.

Much of this lay far in the future when French court painter, Jean Hey (sometimes called the 'Master of Moulins'), painted this portrait of 'la petite reine', as 11-year-old 'Marguerite' was then known. She had been married, as part of a peace treaty, in 1483 to the French dauphin Charles (1470–98), who soon after the marriage became King Charles VIII and the three-year-old Margaret, queen. Though the marriage would not be consummated until she reached puberty, she was raised and educated as the French queen. Her historian recorded that 'she was always lavishly cared for, magnificently dressed and attended to by 90 to 100 noble ladies.'

The border of her dress collar contains the initials C and M, probably referring to her marriage. The shells on the trim of her head covering reflect

the arms of the House of Bourbon, while the fleur-de-lis of her pendant is a symbol of France. Despite these clues, over the centuries the sitter's identity was lost and when the picture first came on the art market in the late 19th century, the portrait was thought to be Margaret's Spanish sister in-law, Juana la Loca painted by Hans Holbein. However, Margaret's appearance – heavy-lidded eyes, blonde hair and prominent Habsburg lower lip – clearly mirrors other known portraits of her. And with its lush fabrics, translucent flesh and unidealized features, the style of the portrait is typical of Hey, a Flemish-trained painter who worked frequently for the Valois.

Margaret's jewel-encrusted pendant also has a pelican, a symbol of Christian charity: in Christian legend, the pelican pierced its own breast to feed its young, reflecting the sacrifice of Christ. Like a drop of blood, a large ruby hangs below it, followed by a pearl, a symbol of purity. All reflect the virtues expected of a queen: to care selflessly for the heirs and subjects of France. The portrait was originally the left side of a diptych, the other side depicting the Virgin and Child; as Margaret holds her rosary and looks to the right, the whole image would have been of a virtuous and pious young queen at private devotion.

In 1491, not long after this portrait was painted, Charles VIII repudiated Margaret and married Anne of Brittany – this again was a political, not love, match. Humiliated, 11-year-old Margaret was kept at the French court for another year as a bargaining chip in the negotiations for her return to her father: She had come to France with a large dowry including parts of Burgundy which the French were more reluctant to return than Margaret herself. She was sent back to her family in 1492 but never forgot this slight and would consider the French her life-long enemies. *DM*

Contemporary Works

1480–90	Hieronymus Bosch: *Christ Carrying the Cross*, Vienna, Kunsthistorisches Museum
*c*1490	Vittore Carpaccio: *Hunting on the Lagoon*, Malibu, J. Paul Getty Museum
	Luca Signorelli: *Portrait of Niccolo Vitelli*, Birmingham, Barber Institute of Fine Arts

Jean Hey

*c*1480 – 1580	Active as a painter. Little is known of his life; he worked for the Valois court in France and his name suggests he or his parents were originally from the Low Countries. He has been identified as the Master of Moulins.
1494	An *Ecce Homo* is signed with his name and dated.

Piero di Cosimo

A Hunting Scene *c*1500

The Metropolitan Museum of Art

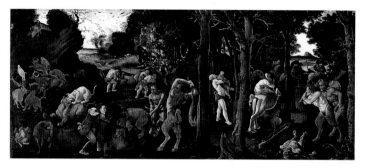

> ... *living more like a wild beast than a man. He would never have his*
> *rooms swept, eat just when he felt hungry, would not have his garden*
> *dug or the fruit trees pruned, but let the vines grow and their branches*
> *trail on the ground, and seemed to find pleasure in seeing everything as*
> *wild as his own nature ... in all his works there is a spirit very different from*
> *that of others, and a certain subtlety in investigating nature regardless*
> *of time or fatigue, only for his own pleasure. And indeed it could not be*
> *otherwise, for, enamored of nature, he cared not for his own comfort ...*
> Giorgio Vasari, *Lives of the Artists*

The dimensions of this painting suggest that it was a *spalliera*, a panel which either formed the backrest of a bench or the backboard of a *cassone* (a large chest) most often produced on the occasion of a wedding. Many painters created such works for Florentine patrons towards the end of the 15th century and into the 16th when they were fashionable items – one famous example is Botticelli's depiction of Venus and Mars (in the National Gallery, London) which was probably made for the influential Vespucci family. However Piero di Cosimo seems to have specialized in this niche market as a number of examples by him have survived including *A Hunting Scene* and *The Return from the Hunt* (also in the Metropolitan) which were almost certainly made as a pair, as well as *The Forest Fire* now in the Ashmolean Museum in Oxford (which seems to be related to the two Metropolitan panels although perhaps not painted at the same time) and *A Satyr Mourning over a Nymph* in the National Gallery, London. His choice of subject matter for these works and his treatment of that subject matter was inventive and unconventional (as one would expect from the highly eccentric artist described by Giorgio Vasari in his *Lives of the Artists* as surviving on a diet of nothing more than hard boiled eggs). However, the iconography for *A Hunting Scene* may have been specified by his patron.

The panel is filled with action – almost pandemonium. Satyrs and primitive men are engaged in hunting a great profusion of game. They inhabit a mixed landscape of open countryside and woods with a rocky outcrop to the left. In the middle distance the wood or forest has erupted into flames – which is perhaps responsible for the fortuitous concentration of every type of prey. In any event, men and satyrs are making the most of the situation.

It is probable that this scene is the first in a cycle of works which depict the very beginnings of civilization; Piero, in his masterly rendition of a raging conflagration may be illustrating the fact that the control and harnessing of fire was the first step on the road from barbarism to civilization. One of his sources, no doubt supplied by his patron (probably Francesco del Pugliese), was the Roman poet and philosopher Lucretius whose monumental *De Rerum Natura* (On the Nature of the Universe) contains, in book 5, a vivid description of a forest fire as well as an account of how early man discovered the beneficial uses of fire for warmth and cooking from which flowed the beginnings of a sense of community. Piero, it must be remembered, was producing work for patrons in the most sophisticated and cultured city in Europe. In such rarefied humanist circles, knowledge of, and familiarity with, such texts was taken for granted. *GS*

Contemporary Works

1500	Albrecht Dürer: *Self Portrait*, Munich, Alte Pinakothek
	Giovanni Bellini: *The Madonna of the Meadow*, London, National Gallery
	Hieronymus Bosch: *Ship of Fools*, Paris, Musée du Louvre

Piero di Cosimo

1461 or 2	Born in Florence, the son of a toolmaker.
1480	By this date Piero is apprenticed to Cosimo Rosselli from whom he took his name.
1481	When Rosselli is summoned to Rome Piero accompanies him.
1504	Piero enrolls in the painters' guild in Florence. He is also a member of the committee set up to select a site for Michelangelo's recently completed *David*.
1515	Piero is involved in preparing for the celebrations attendant on the visit of Pope Leo X to Florence.
c1521	Dies in Florence.

Gerard David

Virgin and Child with Four Angels c1510–15

The Metropolitan Museum of Art

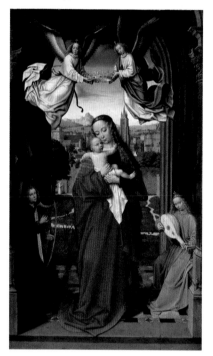

The Virgin Mary stands holding her child in a late Gothic archway as if she were presenting the Christ child to the viewer. She is accompanied by four angels – one plays a harp, another a lute – two hover above the Queen of Heaven holding her crown. Mary is absorbed with her child, her eyes lowered in contemplation of this divine being – her baby – which she clasps tightly to her, temporarily oblivious to our gaze. The child however turns away, balancing himself by grasping a tress of his mother's beautifully crimped hair, and engages the viewer directly, as does the lute-playing angel.

David uses other methods to reinforce our empathy with mother and child – saintly parent and divinity. At the foot of the painting a low step has the effect of marking the boundary between us and the holy company. But, in his efforts to instill our sense of inclusion, he overcomes this necessary demarcation by extending the pictorial space a little further towards the viewer, drawing us in to the drama of the miraculous appearance of God in our midst. The exquisitely rendered scene which can be glimpsed through the doorway, realized with consummate perspectival skill, also creates a believable space within which we can imagine our participation. Especially if you happened to live in Bruges at around the turn of the 16th century, for beyond the walled garden is a recognizable 'portrait' of that city (although a denizen of the town would have been most surprised, had he climbed to the top of the tower shown so prominently behind the Virgin, to have seen a range of craggy mountains in the distance).

In the enclosed garden we can deduce from the presence of the small figure of a member of the Carthusian order against the far wall that the well worn path has been used by monks for exercise and contemplation. His inclusion means that in all probability this painting was commissioned by a member of his order.

Growing in the garden close to the gateway, on either side of the Virgin two plants are flourishing – plants that are very often seen in the paintings of this period in close proximity to Mary. To her left, the iris is a symbol of purity but it also has leaves which were thought to look like a sword thereby chiming with Luke's passage referring to Mary's future sorrows 'Yea and a sword shall pierce through thine own soul.' To her right a columbine grows, a flower which symbolizes the presence of the holy spirit (in the form of a dove, because of the similarity of its name to the Latin for dove, *columba*). It has a further significance as it often produces seven simultaneous blooms which were seen as representing the seven sorrows of the Virgin.

David's refined and beautiful paintings can be seen as the last flowering of the Eykian tradition – he assimilated the styles of the great exponents of the early Northern Renaissance – van Eyck, van der Goes, Memling and Bouts. One might think that things had not moved on too much since the death of van Eyck 70 years before and it is interesting to note that Raphael was working on his great frescoes in the Vatican at about the time David was engaged in producing this little masterpiece. Their difference in style reflects the fact that David and Raphael worked in two very different centers of Renaissance art and produced images that reflected the desires and tastes of their markets and patrons.

There are several notable works by David in New York, at both the Metropolitan Museum and the Frick Collection, however this small work stands out as one of the most exquisite. *GS*

Contemporary Works

1510	Albrecht Altdorfer: *St George Slaying the Dragon*, Munich, Alte Pinakothek
1512	Raphael: *Portrait of Pope Julius II*, London, National Gallery
1515	Matthias Grünewald: *The Isenheim Altarpiece*, Colmar, Musée Unterlinden

Gerard David

c1460	Born in Oudewater near Gouda in the northern Netherlands.
1484	Gerard David is admitted as a member of the Guild of Painters (the Guild of St Luke) in Bruges.
1488	He is appointed as a juror of the painters' guild. Commissioned to produce a large diptych (probably the *Judgment of Cambyses*) for the town hall of Bruges.
1494	Moves to a house in St Jorisstraat near to that of Memling.
1501	Becomes dean of the Guild of St Luke in Bruges.
1502	The *Baptism* triptych is commissioned by Jan de Trompes, the Receiver-general of Flanders.
1507 or 8	David becomes a member of the Brotherhood of the Dry Tree – a religious society many of whose members are from the aristocracy.
1509	David donates his painting of *Virgo inter Virgines* to a Carmelite convent in Bruges.
1515	A 'Master Gerard of Bruges' becomes a member of the Guild of St Luke in Antwerp. This was almost certainly Gerard David who may have spent some time in the city but did not move his home from Bruges.
1520	David is briefly imprisoned as a result of a legal dispute with his assistant Ambrosius Benson.
1523	Dies in Bruges.

Lucas Cranach the Elder

The Judgment of Paris c1528

The Metropolitan Museum of Art

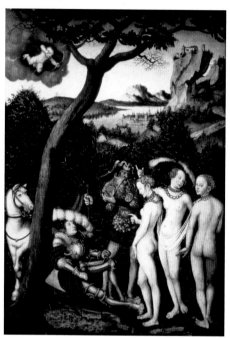

aced with an onerous task foisted on him by Jupiter, Paris made a fateful choice which led directly to the Trojan War. It all started when someone forgot to invite Eris, the goddess of discord, to the wedding of Peleus and Thetis. Angered by this slight she arrived at the banquet and threw a golden apple onto the table. Well-versed, of course, in the petty jealousies which were rife amongst the gods, Eris, in an inspired piece of mischief-making, had inscribed on the apple 'for the fairest.' This instantly had the desired effect when Juno, Minerva and Venus began to quarrel over the prize. In an effort to restore order, Jupiter asked Mercury to take the Apple of Discord to Paris on Mount Ida with instructions that he should be the final arbiter regarding the charms of the three divine contestants.

The three goddesses knew better than to leave things entirely to the whims of a mere mortal and immediately resorted to that tried and tested expedient – bribery. Juno offered to make Paris the ruler of both Europe and Asia; Minerva promised him victory in battle but Venus trumped them by guaranteeing him the love of Helen of Sparta, the most beautiful woman in the world. Paris awarded the apple to Venus and then traveled to Sparta to claim his prize. Helen responded to his advances by eloping with Paris but, needless to say, this did not go down well with her husband King Menelaus who followed them accompanied by a large Greek army. The rest is history (or myth).

Cranach and his workshop painted many versions of *The Judgment of Paris*, a Homeric subject which was well received in the humanist circles in which Cranach moved. A close friend of Luther (they were godfathers to each other's

children) the artist was a central figure in the movement which became known as the Reformation, unleashed when Martin Luther nailed his 95 theses to the door of Wittenberg Palace church only 11 years or so before this painting was produced.

One can't help but think that one reason for the popularity of this subject, and the reason that Cranach and his studio produced so many versions of it, is that it presented an opportunity to produce female nudes of an undoubtedly erotic nature – and of course an opportunity for his clients to enjoy looking at them – at the same time as displaying their classical learning.

Cranach's early paintings of nudes display the influence of Italian models but later, as exemplified in this picture, he developed a personal ideal of female beauty, essentially anti-classical, looking back to late medieval, Gothic, influences (an ideal which is, however, appealing to the modern eye). Here his goddesses have slender waists, small breasts, long legs and betray a Mannerist elongation of the body. The addition of accessories such as jewelry and hats imparts a seductive eroticism, heightened by the suggestive use of a diaphanous scarf.

Paris is shown comfortably seated in a beautiful verdant landscape; a wide river flows past a prosperous town which sits beneath a rocky outcrop – a favorable vantage point for a citadel. He is accoutred in the very finest suit of the latest armor, set off by an extravagant hat, transforming him into a member of the Saxon court. In the centre, Mercury holds a glass sphere – a Germanic substitute for the golden apple. He presents the three captivating contestants, each assuming a different posture, the better to remind the (male) viewer of the charms of the female nude. The central goddess wears a large-brimmed hat which echoes that of Paris; she points towards the figure of Cupid who hovers above Paris, ready to unleash an arrow in her direction. This connection with Cupid identifies her as Venus, the illustrious winner of the contest. *GS*

Contemporary Works

1527	Hans Holbein the Younger: *Sir Thomas More*, New York, Frick Collection
c1528	Parmigianino: *The Conversion of St Paul*, Vienna, Kunsthistorisches Museum
1530	Correggio: *Adoration of the Shepherds*, Dresden, Gemäldegalerie Alte Meister

Lucas Cranach the Elder

1472	Born in Kronach.
1501 or 2	He is working in Vienna.
1504	Cranach is appointed court artist to the Elector of Saxony, Duke Frederick the Wise at Wittenberg.
1508	Duke Frederick grants him a coat of arms featuring a winged serpent, a device he now uses as his signature. Travels to the Netherlands on behalf of the duke.
1519	Designs the earliest surviving propaganda sheet in support of Reformation theology.
1520	Cranach engraves portraits of his friend Martin Luther.
1522	Illustrates the Book of Revelation in the first edition of Luther's translation of the New Testament. Cranach partly underwrites the publication of Luther's translation.
1523	Cranach installs a printing press in his house.
1524	Prints part of Luther's translation of the Old Testament.
1547	With the capture of Duke John Frederick by the forces of Charles V, Cranach loses his position as court painter.
1550	Decides to join the duke in captivity in Augsburg. Continues to paint.
1552	Moves to live with his daughter and son-in-law in Weimar.
1553	Dies at Weimar.

Jacopo Tintoretto

The Miracle of the Loaves and Fishes c1545–50

The Metropolitan Museum of Art

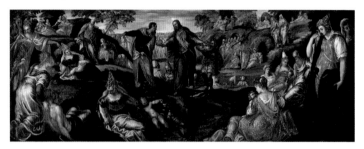

The Bible tells two stories of Christ feeding a multitude with a few loaves and fishes. Tintoretto has here chosen to represent the miracle recounted in John 6:1-14, when Jesus fed a crowd of 5,000 followers with five barley loaves and two fishes. In typical Tintoretto fashion, the artist takes this moving, holy event and turns it into a party.

One of Venice's greatest painters, Tintoretto often infused his imagery with a bit of the festive atmosphere of his city. The multitude is depicted not as a group of the humble early Christians but as an assortment of well-dressed blondes, some cherubim-like babies with a few elderly, white-bearded prophet types thrown in for good measure. The scene resembles a courtly picnic rather than a New Testament parable. The women wear jewels in their hair and few look even remotely hungry. Despite this, Christ stands at the center of this unusual multitude and with exaggerated elegance, takes a loaf from the basket of the young boy who provided the food and gives it to his disciple, Andrew, to distribute. The landscape behind is dotted with the arched openings of tombs and dynamic greenery painted in the same iridescent tones as the figures. It reaches back in the far distance, sprinkled with groups of Christ's followers.

A master of Venetian Mannerism, Tintoretto here employs the style's characteristic complexity, instability and compositional tension to create a sense of restless energy. Almost everybody appears to twist or move in some fashion; even the trees seem animated. Mannerist painters weren't interested in naturalistic representation but in virtuosity and expressiveness. Gestures are theatrical and exaggerated, such as the exchange between Christ and Andrew. Limbs and bodies are unnaturally elongated; note the woman in pink and pearls in the central foreground, whose thigh is as long as the rest of her body. Shimmering, acid color illuminates the figures in an artificial glow. Rejecting the balance and clarity of earlier Renaissance painting, it was a style that appealed to the intellectual and sophisticated circles of Venice.

Painted to be viewed from below, this long rectangular canvas would have been hung high on a wall in, perhaps, a Venetian church or confraternity hall; some scholars have suggested that some of the multitude could depict members of a confraternity. The exact patron is unrecorded but this picture is known to have been made as a companion work to *Christ Washing the Feet of the Disciples* (today in the Art Gallery of Ontario, Toronto).

Tintoretto often took more commissions than he could handle and this

painting, like many of his works, was designed and partially painted by him but completed by his workshop. He was known to paint at breakneck speed, earning himself the nickname *il Furioso*. 'Tintoretto' was also a nickname (his given name was Jacopo Robusti), meaning 'little dyer,' a reference to his father's profession. This humble start did not hinder his success. Legend claims he was apprenticed to Titian but was tossed out for showing up the master. He only once left Venice – for a short stay in Mantua in 1580 – yet his art, including this work, reveals a multitude of influences: the Venetian focus on color and atmosphere; the Florentine sense of form; the well-muscled figures and passionate energy of Michelangelo; the complex human drama and strong emotion of Titian. To this, Tintoretto added his own unique sensibility for sharp color, lighting and unusual perspective. *DM*

Contemporary Works

c1540–50	Bronzino: *An Allegory with Venus and Cupid*, London, National Gallery
1546	Titian: *Pope Paul III and his Grandsons*, Naples, Museo di Capodimonte
1547	Jacopo Bassano: *Adoration of the Shepherds*, London, Royal Collection

Jacopo Tintoretto

1519	Born in Venice, the son of a cloth-dyer, hence his nickname.
1539	After working for a very short time in Titian's workshop, Tintoretto is by this date working as an independent master.
1548	Produces *St Mark Rescuing the Slave* for the Scuola Grande di S. Marco. This painting finally brings recognition in Venice for Tintoretto.
1551	Recorded as a member of the Accademia Pellegrina, a literary academy.
1564–88	Works on decorations for the meeting house of the Scuola Grande di S. Rocco, his masterwork.
1565	Becomes a member of the confraternity of the Scuola Grande di S. Rocco.
1577	After two fires, in 1574 and 1577, damage the Doge's Palace, Tintoretto is commissioned to contribute to the redecorations.
1580	Travels to Mantua regarding a commission for the Gonzaga family. This is his only recorded journey outside Venice.
1592	Again works on important commissions for the Doge's Palace.
1594	Dies in Venice.

Pieter Bruegel the Elder

The Harvesters 1565

The Metropolitan Museum of Art

It is probable that this painting originally once hung in the Antwerp residence of Niclaes Jonghelinck, a prosperous, well-educated merchant. He had commissioned a series of six paintings from Pieter Bruegel, a successful local artist. Jonghelinck knew he was getting a master's work but what he would not have realized is that his new paintings marked a turning point in Western art and that history would judge Bruegel to be one of the greatest artists of 16th-century Europe.

Five of the six paintings, which depict the seasons or times of the year, survive: *Gloomy Day* (early spring), *The Return of the Herd* (autumn) and *Hunters in the Snow* (winter) are today in the Kunsthistorisches Museum, Vienna; *Haymaking* (early summer) is in Nelahozeves Castle, Czech Republic; and this painting, the *Harvesters* (high summer) is now a highlight of the Metropolitan. The painting depicting spring is lost.

Bruegel's chosen subject was a popular one. The seasons were frequently depicted in illuminated manuscript calendars (the *Très Riches Heures* of the Duc de Berry, are a well known example). Most educated Europeans in the 16th-century would have read Virgil's *Georgics*, which celebrated the virtues of a peasant life revolving around nature's cycles. However, Bruegel's picture is not a poetic vision, but is rather reflective of the artist's personal observations and narrative genius.

The entire cycle shows lives lived close to the land. The scenes are not idealized and nor are the individuals who are portrayed as types: an old woman, a strong youth. The people are there to animate a scene of the year's recurring cycles: each year this scene of harvesting repeats itself with different individuals. Bruegel brings out the humanity of the types with meaningful gesture: a hungry young worker slurping down his food; a woman bending over a bundle of wheat suggesting the back-breaking nature of the work;

another so exhausted that he has sprawled out on the ground and fallen asleep, his mouth hanging open – he could be snoring. This is a bountiful harvest but it is nevertheless achieved by strenuous labor.

Gone was the religious pretext for landscape painting. Instead of using landscape as simply the settling for a biblical or mythological story, Bruegel makes nature itself, including human nature, the subject. Bruegel was a humanist and a skilled observer of nature in all forms, including mankind, and in this series, he celebrates nature and man's part in it. These pastoral scenes show the life of Everyman, the work of the year carried out for generations. Bruegel's vision is at once human and universal, with sympathy for mankind and its small part in the eternal rhythm of nature. He mixes the world around him with allegory and popular proverbs giving layers to his imagery.

Little is known of Bruegel's life. He was probably born in 1525. Popular myth has assumed he must have been a peasant but scholars now believe he was a townsman who developed close ties with educated circles. He worked in the Low Countries and around 1552–53 traveled to Italy, where he was influenced by Renaissance compositional techniques and also by humanism. Yet his style remained essentially northern, but with a mix of new and old: he continued the precise realism of the Northern Renaissance and depicted a North European reality yet he approached landscape in a new way, giving nature itself primacy and unifying genre scenes and landscape. His sons, Pieter II (1564–1638) and Jan (1586–1625) continued the successful Bruegel family workshop.

This painting has traveled extensively. In 1594 the entire cycle was purchased by the Antwerp City Council as a gift for Archduke Ernst, the Habsburg governor of the Netherlands, based in Brussels. From there it traveled to Prague to join the vast collections of Rudolf II. It remained in Habsburg hands in Vienna until the early 19th century when it was sold in Paris. It was finally purchased by the Met in 1919. *DM*

Contemporary Works

1563	Paolo Veronese: *Wedding Feast at Cana*, Paris, Musée du Louvre ·
1565	Jacopo Tintoretto: *Crucifixion*, Venice, Scuola di San Rocco
1567	Joachim Beuckelaer: *Market Scene*, Antwerp, Koninklijk Museum

Pieter Bruegel the Elder

1525–30	Probably born in Breda.
before 1550	Bruegel works in the studio of Pieter Coecke van Aelst in Antwerp.
1550	Moves to Mechelen where he enters the studio of Claude Dorizi and works on an altarpiece which is now lost.
1551	Travels to Italy.
1552	Leaves Rome for Calabria and possibly visits Palermo.
1553	Returns to Rome.
1554	Leaves Italy for the Netherlands.
1555	12 prints by Bruegel known as the *Large Landscapes* are published by Hieronymus Cock in Antwerp.
1559	Paints *Netherlandish Proverbs* and *Battle between Carnival and Lent*.
1562	Paints *Fall of the Rebel Angels* and the *Triumph of Death*.
1563	Marries Mayken (Maria?) Coecke, the daughter of Pieter Coecke in Brussels.
1565	Completes *The Seasons* – six pictures commissioned for the house of Niclaes Jonghelinck in Antwerp. Five survive.
1569	Dies in Brussels

El Greco

Portrait of a Cardinal *c*1600

The Metropolitan Museum of Art

E l Greco has always had a curiously modern appeal. In the early 20th century
critic Robert Fry, watching a crowd before an El Greco, noted that they
talked as 'they might talk about some contemporary picture,' as if El Greco was
'an old master who is not merely modern, but actually appears a good many
steps ahead of us, turning back to show us the way.' Modern artists loved
him: it was the Impressionist Mary Cassatt who found this painting for some
New York collectors; painters from Picasso to Franz Marc considered him the
precursor to modern art. And this is how he is still popularly perceived: as a
proto-modernist who anticipated every modern ism to come.

However to appreciate his art we must remember one important point:
El Greco was most certainly not modern. In fact, in his own time, he was
considered old-fashioned, not to mention a bit odd. Trained as an icon painter,
he embraced an almost medieval mysticism and erudite Mannerism when
both were *passé* and Baroque naturalism was all the rage. His artistic vision
was brilliant and unique, but it wasn't *au courant*.

He was almost always an outsider. Born in Venetian-controlled Crete, he came
to Venice at 26, where he transformed his flat post-Byzantine technique by
studying Renaissance masters like Titian, Veronese and Tintoretto. But the use of
perspective didn't bring him clients. In 1570 he left for Rome, where he made the
career-stalling mistake of publicly questioning Michelangelo's talent. Six years
later, after failing to gain the patronage of Philip II in Madrid he ended up in the
former capital of Toledo, then the primate archbishopric of Spain. In this highly
Catholic city, El Greco ('the Greek' as they called him) finally found a sympathetic
audience. El Greco didn't want to paint reality; he wanted to paint a Neo-Platonic

vision of art, a higher realm of the intellect and spirit, and this was just what the pious patrons of Toledo wanted, including this hawkish cardinal.

Rigidly perched on his seat like a bird of prey ready to take flight, the cardinal exudes a rather terrifying authority; which is appropriate as he is thought to be Cardinal Don Fernando Niño de Guevara, who once held the title of Grand Inquisitor. However it should be remembered that this is an ecclesiastical state portrait, which was intended to embody the power and uncompromising religious fervor of the holy office of cardinal, rather than the individual in that position; de Guevara, in fact, was known for his liberal views.

The portrait reveals many of El Greco's Italian influences. The composition - a seated religious figure dressed in red – was already an established format used by Raphael and Titian. It has a Mannerist emphasis on exaggerated forms, hyper-elegance, radical foreshortening and fantastic color. However El Greco imbued these effects with a profound expressiveness that was more than mere Mannerist virtuosity. The picture bristles with tension. The cardinal seems to hover above the ground and his black-rimmed glasses (quite unusual at the time) emphasize his intense sideways stare. One hand clenches the chair arm while the other hand is limp, as if it could not even hold the paper that lies on the floor; following Venetian fashion, El Greco has signed the paper, in Greek: *Domenikos Theotokopoulos / made this*.

The painting's surfaces, particularly the stiff, metallic robes, seem to suggest the flickering light and glow of a Byzantine icon. The cardinal, enveloped under these watery surfaces, seems about to dematerialize; you can imagine him disappearing with a 'poof.' It is like a vision, an image of an almost magical spirituality; more in keeping with the medieval world than the modern.

El Greco was the only Western artist to travel, artistically, from the flat, symbolic world of the Byzantine icon through Renaissance humanism beyond to his own, largely conceptual, form of art. The result of almost incompatible influences on an idiosyncratic talent, he could have emerged in no other time than his own. *DM*

Contemporary Works

c1600	Joos de Momper: *River Landscape with Boar Hunt*, Amsterdam, Rijksmuseum
1601	Caravaggio: *Supper at Emmaus*, London, National Gallery
c1603–4	Annibale Carraci: *The Lamentation*, Vienna, Kunsthistorisches Museum

El Greco

1541	Born near Herakleion (then called Candia) in Crete the son of a tax collector.
1563	It seems that he has become a master painter by this date.
1568	He is recorded as being in Venice by this date. He visits Titian's studio (possibly studying under his guidance).
1570	Travels to Rome, visiting Parma, Verona and Florence on the way.
1572	Becomes a member of the Academy of St Luke in Rome. Opens a workshop.
1577	Travels to Madrid, probably in search of royal commissions for the decoration of the Escorial. Moves on to Toledo.
1581	Philip II commissions *The Martyrdom of St Maurice and the Theban Legion*.
1584	*The Martydom of St Maurice* is rejected by the king.
1588	Completes his masterpiece, the *Burial of Count Orgaz*.
1614	Dies in Toledo.

Georges de la Tour

The Fortune Teller c1630s

The Metropolitan Museum of Art

This painting is full of enigmas relating to its painter, subject and provenance. Signed in Latin in its top right corner 'G. de La Tour Fecit Luneuilla Lothar' (made by G. de la Tour, Lunéville Lorraine), this is one of the few daylight paintings by an artist who specialized in nocturnal scenes. Little is known of him: he seems to have worked mostly for the bourgeoisie and bureaucrats of Lorraine and was successful enough to be given the title of *peintre du roi* (Painter to the King) in 1639. There is no record of his travels, if he made any, but his art reveals the influence of the art of Caravaggio and his followers, including Gerard Honthorst, who were fascinated with the representation of light.

The picaresque subject is also Caravaggesque: a naïve young man duped by a group of thieves. The toothless old woman seems to be haggling with the well-dressed youth over the price of something – she holds a coin, he holds his hand out. But while his suspicious gaze is fixed on her, her three young accomplices rob him. There is no indication of setting, though all wear colorful costumes. Are they in a brothel? Are the robbers gypsies? As it has a theatrical air, could it be a scene from a play, such as the parable of the prodigal son?

But la Tour does not play the scene for comedy or eroticism. Sideways glances, expressive hand gestures and a mix of shadow and crisp daylight create an atmosphere ripe with tension: what will happen next? Details are meticulously rendered; from the patterns on the colorful fabrics to the words AMOR (love) and FIDES (faith) written minutely on the young man's watch chain. Despite the moralizing theme, the artist seems to imbue each character with humanity: the foppish youth seems more naïve than dissolute and there is a sense of sadness and peril about the thieves (punishments for stealing in the 17th century included cutting off an ear, branding or death). The picture seems to warn of the dangers for all in a world of deceit and greed.

It is an exceptional work, which makes it even more surprising that la Tour was forgotten for three centuries until rediscovered by art historians in the 20th century. In 1900 only two paintings by him were known; by 1972 there were 30. This painting first surfaced in 1942. The story goes that a French prisoner of war saw a painting in a book on Georges de la Tour that reminded him of a picture in his uncle's estate in the Loire. After the war, the painting was examined by experts and declared a la Tour. It was put on the market in 1949 and the Louvre was outbid by French art dealer Georges Wildenstein (he paid 7.5 million francs). Wildenstein did not sell the painting until 1960 when the Metropolitan Museum purchased it for an undisclosed, but 'very high sum.' At the time the French Government was furious, as it was unclear how an export license for a French art work was obtained.

None of this is that unusual in the unsettled art market after World War II; however in 1984 an art historian named Christopher Wright published a book claiming that this painting and all of la Tour's pictures set in daylight were forgeries. Wright, who as a young scholar had been involved in la Tour authentications, said that he had been pressured to pronounce the work genuine by powerful figures such as Sir Anthony Blunt, the famed art expert/spy. Wright even suggested that a French restorer (who died in 1954) named Delobre who worked for Wildenstein in the USA had painted them. Many have dismissed Wright's claims, including the Met, but an aura of mystery remains. *DM*

Contemporary Works

1633	Anthony van Dyck: *Queen Henrietta Maria with Sir Jeffrey Hudson and a Monkey*, Washington, National Gallery of Art
1634	Rembrandt: *Saskia as Flora*, Saint Petersburg, Hermitage
1634–5	Diego Velázquez: *The Surrender of Breda*, Madrid, Museo Nacional del Prado

Georges de la Tour

1593	Born in Vic-sur-Seille, Lorraine (eastern France).
1617	La Tour marries Diane Le Nerf.
1620	Moves to live with his wife in Lunéville, where he specializes in religious and genre scenes. He engages an apprentice.
1621	La Tour's son, Etienne is baptized (August 2nd) at Lunéville.
1639	Visits Paris. A document describes him as *peintre du roi* (Painter to the King).
1640s	Receives a number of well paid commissions from the town of Lunéville.
1652	Dies in Lunéville.

Peter Paul Rubens

Rubens, his Wife Helena and their Son late 1630s

The Metropolitan Museum of Art

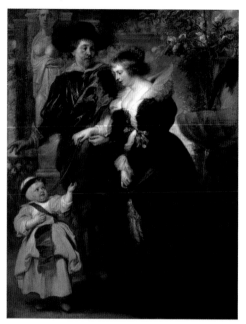

Diplomat, art collector, scholar, businessman, confidant of rulers and intellectuals, fluent in six languages, Rubens was one of the most dynamic men of his age. He was also a brilliant artist, as well as a doting husband and father, as this handsome portrait of Rubens, his second wife, Helena Fourment, and their second son, Peter Paul, reveals.

The couple married on December 6, 1630, when Rubens was 53 and Helena 16. A friend of Rubens wrote a wedding poem for the couple: 'May he who has lived through five decades receive what buds now into first blossom in you; he will grow young again in your arms, maid …' And in many ways he did. The couple had five children and Helena, the youngest daughter of a long-time friend, became Rubens' model and the inspiration for his paintings, particularly those about love and beauty. This portrait captures a bit of Rubens' happiness in his second marriage.

Pictured as a youthful 62, Rubens gazes adoringly, almost with paternal care, at his innocent-looking young wife, who in turn looks to their child. All three are richly and fashionably attired, particularly Helena who has a huge jeweled brooch dangling from her ample bosom. With her buxom form and rosy skin she is the quintessential 'Rubenesque' female.

X-rays have shown that Rubens altered the picture as he painted, shifting the focus from himself as head of the household, to Helena as the perfect wife and mother. She receives loving looks from both husband and son and the scene is filled with symbols of ideal motherhood: the parrot is a symbol of the Virgin Mary and the fountain, caryatid, and garden setting imply fertility, as well as portraying Rubens' own garden in Antwerp.

It is an idyllic image of domestic bliss, marital and filial love, prosperity and elegance, all expressed in Rubens' characteristically exuberant Baroque style full of *joie de vivre*. The style was the product of his varied influences and exceptional talent. After beginning his studies in his native Antwerp, Rubens headed to Italy in 1600 where antiquity, Renaissance masters like Michelangelo and Titian, and contemporaries such as Caravaggio and Giulio Romano, all influenced him. Among the finest draftsmen of all time, Rubens blended his northern European sense of realism with Italy's love of grandeur and monumentality.

After several years as court painter, as well trusted courtier and international diplomat, to the duke of Mantua, he returned to Antwerp in 1608, taking up a similar role for the Habsburg rulers. He rose to unprecedented heights in art and diplomacy. He received commissions from all over Europe and was hailed as 'the Apelles of our age.' He also traveled widely on diplomatic missions and was knighted in 1630 by Charles I of England for his role in brokering a peace treaty between England and Spain. When he died in 1640 – just a year after this painting was completed and Helena was pregnant with their fifth child – he was justly commemorated as 'the most learned painter in the world.'

His influence in the arts lasted long after his death and this painting became the prized possession of successive art connoisseurs: from Habsburg hands, it was presented to the first duke of Marlborough by the city of Brussels in 1704; it then hung at Blenheim Palace until it was purchased by Baron Alphonse de Rothschild in 1884. The painting was donated to the Met in 1981. DM

Contemporary Works

1636	Nicolas Poussin: *A Dance to the Music of Time*, London, Wallace Collection
	Francisco Zurbarán: *St Lawrence*, Saint Petersburg, Hermitage
1638	Anthony van Dyck: *Equestrian Portrait of Charles I*, London, National Gallery

Peter Paul Rubens

1577	Born in Siegen, Westphalia where his father is exiled from Antwerp having had an injudicious affair with the wife of William of Orange.
1578	The family moves to Cologne.
1588	After the death of Rubens' father, his family returns to Antwerp.
1598	Rubens becomes a master in the Antwerp Guild of St Luke.
1600	Travels to Italy where he joins the court of Vincenzo Gonzaga, duke of Mantua. Copies many Renaissance works in the duke's collection.
1602	Rubens is in Rome. Studies the work of Michelangelo and Raphael.
1603	The duke of Mantua sends Rubens to Spain to deliver presents to Philip III.
1604	Returns to Mantua.
1605–6	Rubens is in Genoa where he works on various commissions.
1606–8	Working in Rome again.
1608	Hearing of his mother's death, Rubens returns to Antwerp.
1609	Appointed court painter to Archdukes Albert and Isabella. Starts to receive commissions from all over Europe. Marries Isabella Brant.
1625	Rubens visits Paris on a diplomatic mission for Archduchess Isabella. Meets the duke of Buckingham who commissions two portraits.
1626	His first wife Isabella dies.
1628	In his role as a diplomat Rubens visits Madrid in pursuit of peace between Spain and England. While there he paints *Philip IV on Horseback*.
1629	He is in London pursuing his peace mission. Philip IV appoints him as secretary of the Spanish privy council.
1630	Rubens is knighted by Charles I of England. Marries Hélène Fourment.
1631	Knighted by Philip IV of Spain.
1635	Rubens acquires the estate of Steen near Malines.
1640	Dies in Antwerp.

Diego Velázquez

Juan de Pareja **1650**

The Metropolitan Museum of Art

As the court artist of Philip IV of Spain, Velázquez painted many portraits; but none were quite like this one. In 1649 Velázquez traveled to Italy on the king's behalf to collect works of art for the Alcazar Palace in Madrid. During his extended stay in Rome, the center of the art world at the time, Velázquez painted two portraits of two extremely different men yet both caused a sensation: one was an official portrait of Pope Innocent X (today in the Galeria Doria Pamphili, Rome) and the second was of a much humbler but no less striking subject: Velázquez's assistant, Juan de Pareja (c1610–1670). According to the artist and writer Palomino in his *Life of Velázquez* (1724), when the portrait of Pareja was exhibited at the Pantheon in Rome on March 19, 1650, it was 'applauded by all the painters from different countries, who said that the other pictures in the show were art but this one alone was "truth."'

About 40 years of age in this picture, Pareja was a Sevillian of Moorish descent and a slave, whom Veláquez had inherited from a relative. He had been working in Velázquez's studio since the 1630s and soon after this portrait was made, Pareja was given his freedom. He would stay on in Velázquez's studio, working as a painter. Some of Pareja's art is today found in various collections, including the Prado in Madrid and in the Hermitage in St Petersburg.

Why did Velázquez decide to paint Pareja's portrait? There are several theories. According to Palomino, Velázquez painted his assistant as practise in depicting a head from life before painting the pope. However, the composition bears no resemblance to that of the papal portrait and considering this portrait's penetrating immediacy and brilliant execution, it is hard to image Velázquez considered it a mere exercise.

Velázquez, freed from the more formal structure of state portraiture, here seems focused on painting a person rather than a status; he does not include attributes of the sitter's identity or rank, nor props or drapery to set the stage. Pareja's clothes are the same somber hues as the plain background that serves to highlight his face, which is bathed in light and framed by a white lace collar (finery not usually worn by a servant and which Velázquez must have added for effect). He gazes out at the viewer with startling directness and quiet assurance. The result is a virtuoso portrait of an individual; a masterpiece, depicting Velázquez's assistant (and one suspects, friend) with a dignity no less than that of a king.

Another anecdote related by Palomino suggests another reason Velázquez painted Pareja. Before officially exhibiting the painting, Velázquez, supposedly had Pareja himself carry it around to some influential Roman acquaintances. 'They stood staring at the painted canvas, and then at the original, with admiration and amazement, not knowing which they should address and which would answer them.' With this little bit of theater, which he certainly could not have done with a royal sitter, Velázquez set out to dazzle his contemporaries with his illusionism.

Not that they needed much convincing. Velázquez had been the king's painter and personal friend since he joined his court in 1623 and he was widely celebrated in his own time. As most of his works remained in the royal palaces for which they were made, few people saw them until the Napoleonic wars dispersed some of Velázquez's paintings throughout northern Europe. *Juan de Pareja* remained in Italy in the Ruffo family collection, until sold to an English lord in the late 18th century. Today Velázquez is considered the greatest Spanish painter of his century, perhaps of any century, a status reflected in his extraordinary auction prices: *Juan de Pareja* cost the Met a record $5.5 million in 1970. *DM*

Contemporary Works

1648	Philippe de Champaigne: *The Last Supper*, Paris, Musée du Louvre
c1650	Aelbert Cuyp: *Dordrecht, Sunrise*, New York, Frick Collection

Diego Velázquez

1599	Born in Seville.
1610	Enters the studio of Francisco Pacheco.
1617	Velázquez is licensed to work as an independent painter.
1618	He marries Pacheco's daughter Juana.
1623	Pacheco's good connections with the court result in his entry into the service of Philip IV.
1628	Rubens arrives at the Spanish court representing Charles I of England. He stays for many months and Velázquez is greatly influenced by him.
1629	The king gives him permission to visit Italy and provides him with letters of introduction. He visits Venice, Bologna and Rome.
1630	Velázquez is in Naples.
1631	Returns to Madrid.
1643	He is appointed Ayuda de Cámara.
1649	Velázquez visits Italy again in order to purchase works of art for the king. Visits Milan, Venice, Florence, Bologna Parma and Rome where he paints several influential works including the portrait of Innocent X.
1651	Returns to Spain.
1656	Paints his masterpiece, *Las Meninas*.
1658	Velázquez is granted the title Knight of Santiago.
1660	He organizes the ceremonial meeting on the Franco–Spanish border between Philip IV and Louis XIV during which the French king takes the Infanta María Theresa as his bride. Velázquez becomes ill on his return to Madrid and dies.

Johannes Vermeer

Young Woman with a Water Pitcher **c1662**

The Metropolitan Museum of Art

It is surprising to learn that Vermeer, today one of most widely admired artists in the western world, fell into obscurity after his death. Even in his own lifetime he was not as successful as many of his celebrated contemporaries, such as Rembrandt or Pieter de Hooch. We do not know who his teacher was and, evidently, Vermeer did not have any pupils himself. He did have some success; at one point Vermeer was head of the painters' guild in his home town of Delft and his meticulously detailed paintings fetched high prices. However, he was not prolific (he is believed to have produced only about 45 paintings in his life, mostly for a small circle of Delft patrons) and died in debt; his wife, Catharina Bolnes, and 11 children declared bankrupt the year after his death.

Today 34 authenticated Vermeers survive (a remarkable eight of which are in New York City: five in the Met and three in the Frick), thanks in part to French art critic Théophile Thoré, who wrote a series of articles after visiting Holland in the 1860s in which he championed the long-forgotten artist as a poet of the everyday and a master of 'Realism' (a style in vogue at the time). Suddenly Vermeer was 'rediscovered' and became popular with collectors in Europe and the USA: the masterful *Young Woman with a Water Jug* was the first of 13 Vermeers to enter the United States between 1887 and 1919.

A mature work, it is the last in a group of paintings of single females alone in scenes of absolute compositional rigor that Vermeer painted from the mid-1660s. Like most of his paintings, there is no narrative; rather it depicts a timeless scene of domestic harmony, a 'still-life' world derived from acute observation mixed with conscious design. The exquisitely balanced composition is typically Vermeer: a modestly dressed woman with downward looking eyes is pictured

inside a room occupied in some unspecified domestic activity. Light enters from a window to the left and illuminates the scene in a silvery blue glow. Each object and texture is meticulously depicted, from the woman's starched coif to the plush Turkish carpet that is reflected in the burnished underside of the basin.

Vermeer designed his paintings to explore formal relationships and the effects of color and, in particular, light. He was fascinated by the transforming power of light and shadow and in scenes like this attempted to capture that fleeting second as natural light floods a space; you can almost sense the warmth of the sun on the woman's skin or the shimmer of dust in the air, so precisely does Vermeer render its effects. To the modern eye, Vermeer's use of dramatic perspectives and contrasts in light and texture can appear almost photographic and this has led scholars to suggest Vermeer may have used a camera obscura, an experimental optical device sometimes used by painters to help with perspective and composition. True or not, it detracts nothing from his extraordinary technical ability and painstaking attention to detail.

Vermeer's pictures are often regarded as the culmination of realism in Dutch art. However, it must be remembered that while the objects depicted are indeed startlingly real, the ideals presented are just that: idealized. Domestic scenes were immensely popular in 17th-century Holland and were connected with bourgeois Dutch ideals of the home and female virtue. To be considered a good housekeeper was the height of female accomplishment and moralizing scenes of household concord (as well as discord) were found everywhere from emblem books to art. Many household objects held symbolic significance; for example, a basin and pitcher are symbols of purity, suggesting this young woman's virtue. Images like this one both reflected and reinforced gender roles and offered a comforting scene of a well-run home. Like many of Vermeer's pictures there is also the suggestion of a relationship between the viewer and the scene, as if the spectator were a spellbound voyeur, privileged to be party to an edifying domestic moment. *DM*

Contemporary Works

1661	Rembrandt: *Saint Batholomew*, Malibu, J Paul Getty Museum
	Gerrit Dou: *Old Woman with a Candle*, Cologne, Wallraf-Richartz Museum
1664	Claude Lorrain: *Landscape with Psyche outside the Palace of Cupid (The Enchanted Castle)*, London, National Gallery

Johannes Vermeer

1632	Born in Delft.
1652	Vermeer inherits his father's property which included an inn.
1653	Marries Catherina Bolnes, who is a Catholic, in spite of the initial opposition of his future mother-in-law. Vermeer seems to have converted to Catholicism possibly to mollify his wife's mother. In October he is admitted to the Delft Guild of St Luke as a master.
1662–3	Serves for the first time as *hoofdman* (headman) of the painters' guild.
1670–1	Serves again as *hoofdman*.
1672	Vermeer is summoned to The Hague in order to authenticate the attribution of paintings ascribed to Holbein, Raphael and Titian among others.
1675	Dies in Delft leaving 11 children.
1676	Catherina petitions for bankruptcy.

Jean-Antoine Watteau

Mezzetin

The Metropolitan Museum of Art

The *commedia dell'arte* was a form of improvised theater which originated in Italy in the 16th century but was still popular in much of western Europe two centuries later. Each member of the company was given one 'mask,' or stock character, to play and would act only that part, the basic traits and characteristics of which were immutable. However, within this framework each performance, although subject to a pre-arranged synopsis, was extemporized.

Mezzetin was one such mask, a valet whose amorous pursuits were doomed to eternal failure. His comic adventures were accompanied by much buffoonery and he was the butt of ribaldry and scorn from the rest of the cast. However in this picture we only see the inner sadness which permeates the character – we see him singing as he accompanies himself on the guitar – presumably he sings of the pains of unrequited love for his expression is evocative of mournful longing. Behind him we can see the statue of a woman, her back turned, no doubt echoing the heartless exit of the subject of his plaintive refrain.

The sylvan setting reminds us of the *fêtes galante*, that delightful genre of painting invented by Watteau in which gatherings of the young and fashionable leisured classes are portrayed in languorous pursuit of amorous liaisons within a pastoral landscape, the exquisite perfection of which is only found in dreams. But beneath these celebrations of youth and love, set against the backdrop of perpetual summer, there lurks the faint but definite whiff of melancholy – a realization of the essential transience of youth, laughter and life itself.

Watteau was only too well aware of life's evanescence for at the time he

painted this picture his health (never robust) was failing and he knew that his personal destiny would end in an early consumptive death.

Noted for his caustic tongue and 'difficult' temperament, Watteau nevertheless attracted loyal friends and influential collectors. However, he was always something of an outsider and his portrayal of Mezzetin captures this feeling of alienation and loneliness – whereas in his *fêtes galantes* the pleasurable pastimes of his blessed gatherings are merely tinged with an implied ennui, a subliminal unease, in the case of Mezzetin all felicity has been replaced by a palpable and overt melancholy. As one of his later compositions, it is tempting to see this change of emphasis as indicative of Watteau's mood as his health deteriorated. *GS*

Contemporary Works

1710–15	Giuseppe Maria Crespi: *The Scullery Maid*, Florence, Galleria degli Uffizi
1717	Godfrey Kneller: *Portrait of Joseph Tonson*, London, National Portrait Gallery
1721	Jean-Baptiste Oudry: *Terrace with Dogs and Dead Game*, London, Wallace Collection

Jean-Antoine Watteau

1684	Born at Valenciennes in northern France.
1702	Probable date of Watteau's move to Paris where he is employed in a picture workshop producing devotional and wholesale paintings.
1705	Assists the painter Claude Gillot in the production of paintings illustrating scenes from the theater including the *commedia dell'arte*.
1708	Works with an interior decorator, probably providing paintings which were incorporated into the decorative scheme.
1709	Wins second prize in the Prix de Rome competition. Returns for a short time to Valenciennes.
1717	Admitted to the Académie Royale. His reception piece is *Departure for the Isle of Cythera*.
1719	Visits London possibly in order to consult Richard Mead, a renowned doctor, about his failing health.
1720	Returns to Paris. In poor health, he goes to live with his friend the art dealer Edmé-François Gersaint.
1721	Paints *L'Enseigne de Garsaint* – a shop sign for Gersaint's business. Dies at Nogent sur Marne near Paris.

Jacques-Louis David

Antoine-Laurent Lavoisier and his Wife **1788**

The Metropolitan Museum of Art

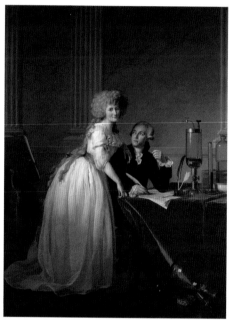

Antoine-Laurent Lavoisier is recognized as the founder of modern chemistry. He was born in Paris in 1743, the son of wealthy parents, both of whom were lawyers, but after a liberal education which included the study of law, it was clear that his interests lay in the field of the natural sciences. He inherited a fortune from his mother but in order to finance his research as well as secure an income, he invested in membership of the Ferme Générale, a consortium which held the contract to collect taxes and customs duties on behalf of the French Crown.

In 1771 Lavoisier married Marie-Anne-Pierrette Paulze, the 14-year-old daughter of a fellow 'fermier.' She was a very talented draftswoman who seems to have studied under David and she later used her skills to illustrate her husband's various treatises. She also learned English and Latin so that she could translate scientific works from those languages in order to assist Lavoisier's studies.

During the 1770s he worked towards a new understanding of combustion discovering the existence of the elements oxygen and nitrogen in the process. In 1783 he demonstrated that water was formed when hydrogen was burned in the presence of oxygen and he went on to establish that oxygen was essential for animal life to flourish. In the same year he collaborated in the publication of a new system of chemical nomenclature.

David shows the great chemist seated at a table covered in red velvet. He has been writing – a quill pen in his hand (probably a reference to his influential work *Traité élémentaire de chimie*) but he stops momentarily to admire his wife who stands next to him, one arm leaning on his shoulder in a gesture of informality as she stares out of the picture to engage the viewer. A shapely

male leg, clad in black, juts out around the red table cloth; it is a rather odd pose – it seems that Lavoisier must have been proud of his elegant legs.

A number of scientific instruments are casually strewn on the table and the floor next to Lavoisier, two of which have been identified as those used in his experiments with gunpowder and in the discovery of oxygen. Behind Marie-Anne, resting on a chair, we can see her artist's portfolio which provides a compositional balance to her husband's instruments. Above them extends a wall, decorated to resemble cool marble, its severity relieved only by irregularly spaced pilasters. The austere grandeur of the room reflects David's neoclassicism but also his preference for unadorned backgrounds so as to focus attention on his sitters.

This splendid double portrait was completed in the cataclysmic year of 1789. The wealthy, urbane scientist and his wife could not foresee the consequences for them, for France and for Europe of the upheavals following the storming of the Bastille on July 14th. Both artist and chemist fell foul of the ensuing political turmoil. Despite Lavoisier's liberal views and the fact that he served the revolutionary government in a number of roles (working on the commission which planned the adoption of the metric system, for example), as the guiding impetus driving the revolution became more and more radical, with the ascent of an extreme Jacobin faction led by Maximilien Robespierre, his former activities as a tax farmer led to his arrest and execution during the Terror of 1794.

Interestingly, Lavoisier's demise coincided with the apogee of David's involvement with revolutionary politics. Early in 1794 David became President of the Convention and it seems he was assiduous in his duties, one of which was the signing of arrest warrants. One wonders if one of these documents related to his erstwhile client, now arraigned as an enemy of the revolution. David himself came perilously close to oblivion later in the year after the fall of Robespierre. He was arrested and imprisoned before being released due to ill health. *GS*

Contemporary Works

| 1785 | Thomas Gainsborough: *Mrs Siddons*, London, National Gallery |
| 1786 | Jean-Baptiste Greuze: *A Visit to the Priest*, Saint Petersburg, Hermitage |

Jacques-Louis David

1748	Born in Paris.
1757	David's father dies of wounds received in a pistol duel.
1766	Enrolls in the Académie Royale.
1775	After winning the Prix de Rome David lives in Rome for five years.
1782	Marries Marguerite-Charlotte Pécoul.
1783	Becomes a full member of the Académie. Birth of his first child.
1784	Works on the *Oath of the Horatii* in Rome. The painting receives much praise.
1790	Joins the Jacobin Club.
1792	Elected to the National Convention joining the 'Mountain' faction.
1793	David votes in favour of the execution of Louis XVI. Serves a term as president of the Jacobin Club. Becomes a member of the Committee of General Security.
1794	Serves a short term as president of the Convention (Jan). Divorces his wife. Organizes the Festival of the Supreme Being. After the fall of Robespierre, David is imprisoned.
1796	Re-marries his wife.
1801	Completes *Bonaparte Crossing the St Bernard Pass*.
1804	Appointed First Painter to the emperor.
1808	David is given a title and a coat of arms.
1816	After the fall of Napoleon, David is exiled as a regicide. Lives in Brussels.
1825	Dies in Brussels.

Thomas Lawrence

Elizabeth Farren, later Countess of Derby　　**1790**

The Metropolitan Museum of Art

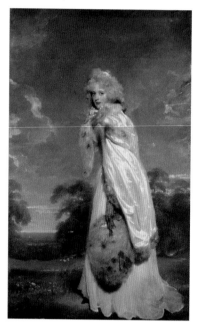

When this painting was exhibited at the Royal Academy in 1790, the subject, Irish actress Elizabeth Farren (c1759–1829), was mortified by its title: *Portrait of an Actress*. One of the most famous performers of her day at the height of her career, she felt *Portrait of a Lady* or at very least, *Portrait of a Celebrated Actress* would have been more suitable. However, the press loved it, enthusing: 'completely Elizabeth Farren; arch, careless, spirited and engaging.'

Farren had made her London debut in 1777 in Oliver Goldsmith's *She Stoops to Conquer* and was soon the toast of Drury Lane; Horace Walpole called her the 'Queen of Comedy'. Her specialty was playing comely, fine ladies; a part she did so well that seven years after this portrait was made, she became one in real life, marrying the 12th earl of Derby.

Lawrence portrays her full of life, capturing a bit of the stage presence that made her a star (and a countess). Towering above the romantically stormy landscape, Farren radiates a swirling energy; at any moment this enchanting creature might turn and run off. With teasing insouciance, she casts an enticing look over her shoulder at the viewer, all rosy lips and dewy dark eyes. Everything about her looks soft to the touch: from her shimmering cape to her plush kid gloves. The flowered-petal trim of her diaphanous gown touches the bottom of the canvas, drawing the viewer's eye up along her form. Her wind-blown powdered hair – tousled hair was all the fashion at the time – is echoed by her dangling fur muff, which Lawrence paints with exuberant but precise strokes. The muff and its blue ribbon have been suggested as a mischievous reference to the blue-blooded earl who commissioned this painting and whom Farren

'dangled' for many years before marrying: a contemporary cartoon by James Gillray depicts the earl, who was by all accounts rather short and squat, in roughly the same shape as Farren's muff.

Despite the portrait's effusive reception, in true star fashion, Farren tried to charm the artist into altering it: 'Mr. Lawrence, you will think me the most troublesome of human beings, but indeed it is not my fault; they tease me to death about this picture; and insist upon my writing you. One says that it is so thin in figure, that you might blow it away – another that it looks broke off in the middle; in short you must make it a little fatter...' Lawrence, however, clearly thought she looked just right and never retouched it. The earl must also have approved as it remained in his family for generations.

Like all of Lawrence's portraits – whether of aristocrats, actors or generals – this image embodies the dashing glamour associated with the Regency period. This coquettish portrait helped – along with a portrait he made the same year of Queen Charlotte, wife of George III – to establish Lawrence as the leading portraitist of his generation. Only two years later the 23-year-old artist – who had been a child prodigy, drawing and selling pastel portraits of tourists at his father's coaching inn – succeeded Reynolds as official painter to the king; just the first step in a stellar career that would bring him a knighthood and presidency of the Royal Academy. *DM*

Contemporary Works

1790	Henry Fuseli: *Titania and Bottom*, London, Tate
1792	Jacques-Louis David: *Madame de Pastoret and her Son*, Chicago, Art Institute
	Francisco Goya: *Don Sebastián Martinez y Pérez*, New York, Metropolitan Museum

Thomas Lawrence

1769	Born in Bristol, the youngest of 16 children.
1770s	Untrained yet precocious, Lawrence gains a reputation for his drawn portraits of visitors to his father's coaching inn at Devizes on the road from London to Bath.
1779	Lawrence's father is declared bankrupt.
1780	His family moves to Bath. He takes art lessons with William Hoare.
1787	Settles in London. Spends three months at the Royal Academy Schools. Sir Joshua Reynolds invites Lawrence to study in his studio.
1789	Exhibits first full-length portrait at the Academy.
1780	Paints a full-length portrait of Queen Charlotte.
1791	Elected an Associate of the Royal Academy.
1792	Succeeds Reynolds as Painter-in-Ordinary to the king.
1793	Begins to take on students and assistants to help keep up with the huge demand for his work.
1794	Becomes a full Academician.
1807	Comes close to bankruptcy caused by late completion of commissions and over generosity to his family.
1814	Commissioned by the Prince Regent to paint the allied heads of state and generals responsible for the defeat of Napoleon.
1815	Lawrence is knighted.
1818	Lawrence travels to Aachen and Vienna in pursuit of the Prince Regent's commission of 1814.
1819	Travels to Rome to paint Pope Pius VII.
1820	He is elected president of the Royal Academy.
1830	Dies in London.

Joseph Mallord William Turner

Venice, from the Porch of the Madonna della Salute **c1835**

The Metropolitan Museum of Art

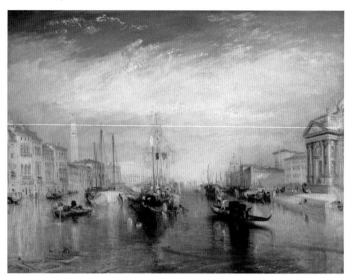

From the outbreak of hostilities between Britain and France in 1793 to the defeat of Napoleonic France at the battle of Waterloo in 1815, British citizens had been unable to travel to continental Europe (except during a brief truce from 1802 to 1803). For a restless character like J.M.W. Turner this must have been frustrating although he made do with ceaseless domestic peregrinations. However, in 1817 Turner toured Belgium, Holland and the Rhineland and two years later he traveled to Italy and made his first visit to Venice. He returned to *la Serenissima* in 1833 and this painting was based on sketches made during this visit.

One can imagine the impact which Venice – a city of canals rising from the sea with the moving reflections of water everywhere – must have had on Turner, the painter of light. His sketchbooks are full of notes to remind him of the precise colors for a particular area of the image, 'Blue – Mass of Light – White – Sky purple – water green – and dark blue.'

The unique properties of Venetian light have been perfectly captured in this picture. The sky is partly occluded by diaphanous cloud which looks as if it is turning to a sea mist at the horizon; but where this breaks Turner has conjured a stunning dark azure blue. The water of the Grand Canal morphs from a similar ultramarine in the middle distance, breaking into a myriad colors in the foreground – greens, golds, muted blues, white highlights. The palaces and churches which line the canal are rendered in blinding whites and darker buff colors, their reflections changing the color of the water beneath them to a mesmerizing mix of white and gold.

The water is home to a curious mix of craft, the central vessel is laden with lobster pots and all manner of fishing gear. Turner is a master of nautical painting, at home with masts and rigging and the paraphernalia of wind-borne ships. But the vessel which catches the eye is the gondola to the right, looking

a little sinister in its black livery. Turner has exaggerated its jet black reflection – a device which he used again to dramatic effect in one of his most famous late paintings, *Burial at Sea*.

Turner was never afraid to 'improve' on the panorama before him and this is precisely what he has done in this composition which is in fact a conflation of two views from two separate vantage points – each side of the canal is seen as though the viewer were standing on the opposite bank. But, as in all his art, what matters is not the exact accuracy of his representation of the subject but the way in which – in his quest to render the fleeting properties of light and in his search for the 'sublime' – he conjures the very soul of a city or a landscape.

GS

Contemporary Works

1834	Paul Delaroche: *The Execution of Lady Jane Grey*, London, National Gallery
1835	Jean-Baptiste-Camille Corot: *Hagar in the Wilderness*, New York, Metropolitan Museum of Art
	Caspar David Friedrich: *Riesengebirge*, Saint Petersburg, Hermitage

Joseph Mallord William Turner

1775	Born in Covent Garden, London, the son of a barber and wig-maker.
1789	He is admitted to the Royal Academy Schools.
1790	At the age of 15 he exhibits a watercolor at the RA.
1796	He is elected as an Associate Member of the Royal Academy.
1799	Rents a house in Harley St which he later buys. He installs his mistress, probably Hannah Danby, nearby.
1800	Turner's mother is committed to the Royal Bethlehem Hospital as a result of her insanity.
1802	Becomes a full Royal Academician at the age of 26. After the Treaty of Amiens, Turner makes his first visit to continental Europe, visiting Paris then Switzerland.
1804	Turner opens his own gallery in Harley St. His mother dies.
1807	Elected Professor of Perspective at the Royal Academy.
1808	Tours the north of England, which he visits many times over the next two decades.
1811	Tours the west of England.
1813	Moves to Solus Lodge, Twickenham, probably built to his own design.
1817	Travels to the battlefield of Waterloo and then to Germany where he sketches in the Rhine gorge before returning to the Low Countries.
1819	Tours Italy, visiting Venice, Rome and Naples.
1821	Tours northern France.
1825	Revisits the Rhineland.
1827–37	Spends much time at Petworth, the home of Lord Egremont, who provides him with a studio.
1828	Returns to Italy and sets up a studio in Rome. His work was not well received.
1829	Turner's father, who had been his constant companion, dies.
1835	Visits Copenhagen, Berlin, Dresden and Vienna.
1843	The first volume of *Modern Painters* by John Ruskin appears, much of it devoted to an impassioned defense of Turner who had been the subject of attacks from a conservative faction at the Royal Academy.
1841–4	Visits Switzerland each year basing himself in Lucerne.
1845	Turner's health is deteriorating.
1846	Turner acquires a small house in Chelsea for Mrs Sophia Booth with whom he had frequently stayed on visits to Margate.
1851	Dies in December at Chelsea in west London.

George Caleb Bingham

Fur Traders Descending the Missouri **c1845**

The Metropolitan Museum of Art

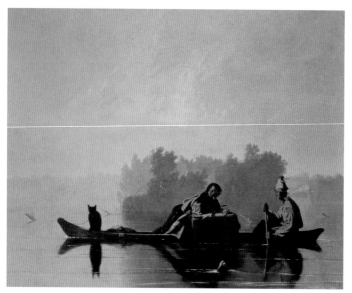

A canoe glides silently on the glassy waters of a great river – low in the water, weighed down by cargo. The oarsman stares fixedly from his seat in the stern, engaging the viewer as though posing for a photograph, although his demeanor is a little confrontational. A youth (the picture's original title tells us that he is the older man's son) sprawls listlessly on the mound of pelts which occupies the center of the craft, perhaps somewhat stupefied by the sultry heat which permeates every corner of the scene. It is this heat and the special nature of the occluded light, which Bingham has conjured so memorably, that almost steals the show. Landscape, river, boat and occupants are all drenched in an enervating, humid luminosity – mist rising from the river shrouds the trees adding to the general mood of languid torpor.

The third figure in this sparse composition adds a charmingly enigmatic note which sticks in the memory. In the boat's prow sits a chained pet fox cub (according to some commentators a bear cub). Its black fur and equally black reflection are set directly below the most luminous area of sky. In another context this black silhouette might impart a markedly uneasy, not to say malevolent quality to the scene, but in this setting any thought of discord somehow seems inappropriate.

The low horizon, the great expanse of water filling the foreground (extending who knows how far beyond the picture's parameters) and the immense sweep of sky somehow reminds us that the dangers of the frontier are always present – Bingham imparts an almost agoraphobic realization of the continent's space, of its echoing vastness and the disparity (in the mid-19th century) between the boundless scale of the natural world and the activities of the few frontiersmen who lived close up to nature. But he also presents us with the American West

as a modern Eden which places this picture firmly in a European tradition – perhaps best exemplified by the paintings of Claude Lorrain – which sought to realize in paint (and maybe in some way to assuage) a deep yearning for an unattainable Arcadia, a world in which a perfect balance between man and nature would result in blissful harmony.

Of course, the search for this chimerical idyll is always doomed to be disappointed and even as Bingham was working on this painting, the way of life it depicts was disappearing as the market for pelts collapsed.

Fur Traders is often cited as an early example of Luminism, a school of artists centered in (but by no means exclusive to) New England who were influenced by painters such as Casper David Friedrich and the Dutch masters of the 17th century. Certainly one can see parallels in this picture with the Dutch painter Aelbert Cuyp who delighted in similar lighting effects – filling a scene with buttery evening light flooding into the picture from an unseen setting sun placed offstage left. But this masterpiece owes so much to its sense of place, preserving a vanished moment in the development of America as it expanded ever westward. *GS*

Contemporary Works

1844	J. M. W. Turner: *Rain, Steam and Speed – The Great Western Railway*, London, National Gallery
1845	Jean-Auguste-Dominique Ingres: *Comtesse d'Haussonville*, New York, Frick Collection
1847	Thomas Couture: *Romans of the Decadence*, Paris, Musée d'Orsay

George Caleb Bingham

1811	Born in Augusta County, Virginia but he is brought up in rural Missouri where he is apprenticed to a cabinet maker.
1834	After teaching himself to draw Bingham begins painting portraits.
1838	Travels to Philadelphia where he studies for a short period at the Pennsylvania Academy of Fine Arts.
1841	Moves to work as a portraitist in Washington DC.
1844	Settles again in Missouri.
1847	The American Art-Union commissions his painting of *Jolly Flatboatmen* (1846) to be engraved. The image is sold to 10,000 subscribers.
1856	Travels to Düsseldorf where he is commissioned to produce a number of historical portraits.
1858	Returns to the USA where he becomes increasingly involved in local Missouri politics.
1879	Dies in Kansas City.

Emanuel Gottlieb Leutze

Washington Crossing the Delaware **1851**

The Metropolitan Museum of Art

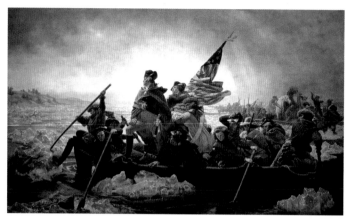

This iconic image of General George Washington leading revolutionary troops across the Delaware River has come to be thought of as a piece of early photojournalism; capturing the courage and fortitude of the Americans as they surprised English and Hessian troops in the Battle of Trenton on December 25, 1776. However many do not realize that the painting was actually executed 74 years after the fact in a studio in Düsseldorf by a 34-year-old German-American artist who wanted to encourage German liberals defeated in the revolutions of 1848 to continue the struggle.

It was a fantastic piece of myth making, using the long-finished American Revolution to inspire another in Europe. When a second copy was sent to America in 1851 it quickly became part of the American vision of the Revolution (the first version was damaged in a fire but was celebrated in Germany nevertheless; it remained in the Bremen Kunsthalle until 1942 when it was destroyed in a British bombing raid). In New York, 50,000 people came to see it; it traveled to Washington, where Congress wanted to buy it for the White House; however it was a New York collector who purchased it for the then-enormous sum of $10,000.

At more than 12 feet high and 21 feet long (378.5 x 647.7 cm) it is today the largest picture in the Metropolitan. To complete it, Leutze recruited American tourists and art students to serve as models and assistants; many posed in period costumes in his Düsseldorf studio for hours on end.

Born in Schwäbisch-Gmünd, Leutze had spent his childhood in Philadelphia, returning to Germany in 1841 to study in Düsseldorf, where he remained for almost 20 years, primarily producing Romantic-styled pictures about American history. He was a 'history painter,' a somewhat deceptive title, considering most history painters took great liberties with historical facts for the sake of composition or drama, as Leutze does here.

In reality, Washington and his men daringly crossed the Delaware at night; Leutze sets it at dawn with a single prophetic star gleaming in the stormy sky. The picture is a flurry of activity: the only element not in motion is General Washington – the calm center of the storm. He stands heroically, though quite

implausibly, in the rocking boat gazing off towards the enemy and victory. Behind him another future president, James Monroe, holds an anachronistic American flag (it was not adopted until many months after the crossing). Around them cluster men of various origins including a Scot in a tartan bonnet, frontiersmen with fur caps, and an African said to represent Prince Whipple, a slave who was emancipated during the war and fought with Washington. The latter's inclusion was significant as Leutze was a strong abolitionist and in 1851 America had yet to abolish slavery.

Leutze depicts the river dangerously peppered with large ice chunks, a setting inspired not so much by reality as by the Romantic winter imagery of artists like Caspar David Friedrich. Some of the soldiers look ill, others scared as the oarsmen struggle to work against the winds and current. Leutze makes the boat improbably small, a technique that heightens the sense of peril. The focus is not on triumph, but on struggle and leadership – without Washington's iron resolution this would be a picture of chaos and inevitable defeat; a lesson Leutze no doubt considered relevant to the liberals of Germany. For in real life, in 1776, the Revolutionaries won that battle at Trenton and the rest, as they say, is history. *DM*

Contemporary Works

1852	Gustave Courbet: *Young Women of the Village Giving Arms to a Cowherd*, New York, Metropolitan Museum of Art
	John Everett Millais: *Ophelia*, London, Tate
1851–3	Jean-Auguste-Dominique Ingres: *Princesse de Broglie*, New York, Metropolitan Museum of Art

Emanuel Gottlieb Leutze

1816	Born in Schwäbisch-Gmünd, Germany.
1825	Emigrates with his family to the US, settling in Philadelphia.
1834	Studies art with John Rubens Smith in Philadelphia.
1841	He is sponsored to travel to Europe. Works with the German painter Karl Friedrich Lessing in Düsseldorf.
1842	Studies in Munich; travels in Italy.
1845	Returns to Düsseldorf where he marries and works as a painter.
1851	Travels to the USA where his *Washington Crossing the Delaware* is enthusiastically received.
1859	Returns to America where he is commissioned by the US Congress to decorate a stairway in the Capitol Building in Washington, DC.
1868	Dies in Washington, DC.

Frederic Edwin Church

The Heart of the Andes

The Metropolitan Museum of Art

In wilderness is the preservation of the world. **Henry David Thoreau (1819–62)**

It was this picture, along with other monumental, 'national' paintings like Leutze's *Washington Crossing the Delaware*, which led to calls for a city art gallery and the founding of the Metropolitan Museum. The passion this painting inspired reflected not only the artist's popularity but the era's fascination with the natural world and a burgeoning interest in travel. It depicts a Romantic vision of a South American landscape, inspired by the artist's second trip to Ecuador in 1857.

Frederic Church was a student of Thomas Cole, founder of the Hudson River School, the first American school of landscape painting that flourished between the mid-1830s and the mid-1870s. Church traveled widely throughout his career – New England, Europe, the Arctic, the Middle East, North Africa and South America – making copious sketches that he would then paint back in his New York studio. Already a success, *The Heart of the Andes* would make him America's most famous painter.

This large work, five and a half feet by nearly ten feet (168.3 x 302.9 cm) was first exhibited in New York in April 1859 and caused a sensation. Exhibited in a darkened room, illuminated by gas flames behind silver reflectors and surrounded by tropical plants, it was like an imaginary trip to the Andes for the city dwellers of New York, most of whom could never dream of traveling to such an exotic place. Nearly 13,000 people paid 25 cents to file by it during its three-week début. It received a similar enthusiastic reception in London that summer and around the US as the painting toured the country over the following years.

People were fascinated not only by the foreign locale but by the nature of the Equatorial Andes, which encompassed every climatic zone from tropical to glacial. Church himself had been inspired to travel to South America by naturalist Alexander von Humbolt's book, *Cosmos*, and the paintings he produced were a synthesis of Humbolt's ideal views on nature and Cole's Hudson River style: a typical 19th-century mix of natural science and Romanticism.

The painting depicts a lush equatorial jungle set against vast dark mountains

receding to majestic, snow-capped peaks. In reality, no single view like this exists. Church took the varied landscapes he had seen and compressed them into one image. While the landscape is presented as a dramatic, idyllic vision, Church nevertheless reproduces natural elements with near botanical accuracy. When first exhibited, visitors were advised to use opera glasses to study the extraordinary detail of the plants, flowers and birds.

On a more spiritual level, nature was seen as an antidote for an ailing industrialized society. Painters like Church and Cole set out to capture the grandeur and vastness of the Americas, reflecting the time's foreboding sense of the encroachment of civilization and the eventual destruction of these landscapes. Thus these paintings often have a nostalgic, sentimental tone and present the North and South American landscape like the last glimpse of an earthly Eden. Church even adds a tiny Ecuadorian couple in the left foreground who kneel before a simple cross, symbolically intertwining nature, religion and salvation. *DM*

Contemporary Works

1857	Jean-François Millet: *The Gleaners*, Paris, Musée du Louvre
1859	Dante Gabriel Rossetti: *Bocca Baciata*, Boston, Museum of Fine Arts
1861	Édouard Manet: *The Spanish Singer*, New York, Metropolitan Museum of Art

Frederic Edwin Church

1826	Frederic Edwin Church is born in Hartford, Connecticut.
1844	Church studies with Thomas Cole.
1847	Settles in New York.
1849	Elected as a member of the National Academy of Design.
1850	First visits Maine, beginning a long association with that state.
1853	Having been inspired by the writings of Alexander von Humbolt, Church travels to South America.
1857	Exhibits *Niagara*, the work that ensured his fame throughout the United States.
1857	Church returns to South America.
1859	*Heart of the Andes* is displayed in New York to great acclaim before touring the USA and Britain.
1860	Buys a farm in Hudson, New York and marries Isabel Carnes.
1865	Visits Jamaica.
1867	Buys land above his farm on which he later builds his home 'Olana'.
1867–9	Tours Europe and the Levant, staying in London on his return journey to study the works of J.M.W. Turner.
1900	Dies in New York, spending the last decades of his life at his home 'Olana'. which affords wonderful views of the Catskills.

Gustave Moreau

Oedipus and the Sphinx 1864

The Metropolitan Museum of Art

The tale of Oedipus has most of the classic ingredients one would expect of one of the Greek myths: tragedy, cruelty, mistaken identity, mysterious monsters, and, underlying it all, a Delphic prophecy wreaking a terrible burden on the hero.

Oedipus was the son of King Laius of Thebes and his queen, Jocasta. He was abandoned on a mountain as a new-born baby by his father who had heard a prophecy that his son would kill him. However the baby was found by a shepherd who took him to Corinth where the king of that city raised the child as one of his own. When the oracle at Delphi told Oedipus that he would kill his father and marry his mother, he determined to leave Corinth, oblivious that he had been adopted. While traveling toward Thebes he met a man on a narrow road; a dispute ensued regarding right of way which ended with Oedipus killing the stranger – unwittingly fulfilling the first part of the prophecy as the other party in the altercation was King Laius. Continuing on the road to Thebes, Oedipus encountered the monstrous Sphinx who had held the city in its thrall, patrolling the roads leading to the town, killing any traveler who could not answer a riddle.* The gallant Oedipus solved the riddle and in a despairing rage the Sphinx killed herself. The city, overjoyed to be free of the monster, gave the vacant throne to the heroic newcomer as well as the hand of the widowed queen Jocasta, thereby completing the Delphic prophecy. The couple had four children but when they discovered the truth, Jocasta killed herself and Oedipus blinded himself.

Like Ingres before him, Moreau has chosen to represent the confrontation between Oedipus and the Sphinx and like Ingres he has given us a curiously anodyne monster – her body resembles a cross between a greyhound and

very small female lion, her beautifully painted wings are the size of one of the smaller eagles but her breasts and face are those of a very pretty young woman whose blond hair, carefully coiffured in the latest Parisian style, is held in place by an elegant tiara. No doubt her claws, which may be penetrating the flesh of the naked Oedipus, could cause intense pain but one cannot help wondering if she really represents the necessary physical threat required of a marauding monster, notwithstanding the presence of assorted body parts – the remnants of unlucky travelers who preceded Oedipus – which litter the rocks in the foreground.

However, it is the psychological interchange which is interesting. The Sphinx holds Oedipus in an intense silent stare, as if she is in the process of hypnotizing him. The brooding sky heightens the mysterious tension. Perhaps this is her trick – she doesn't need to use physical might, relying more on the force of her will. She is the paradigm for Moreau's stable of powerful, dangerous females who seem to dominate his languid and somewhat androgynous males.

Moreau spent several years working on this canvas, making many preparatory drawings, a process which was not unusual – his perfectionism meant that he often held on to his compositions, sometimes for decades, constantly re-working them and adding detail. When it was eventually exhibited at the Salon in 1864 *Oedipus and the Sphinx* met with considerable acclaim, winning a medal and the admiration of Prince Napoleon-Jérôme who later purchased it. In short, this painting established Moreau's reputation, and despite a critical reaction against him later in the 1860s and a somewhat reclusive reaction to this criticism on his part, he exerted a considerable influence on later art movements such as Symbolism and Surrealism as well as Neo-Impressionism and Fauvism through his pupil Henri Matisse. *GS*

* What walks on four legs in the morning, on two legs at noon and on three legs in the evening? Man – in infancy he crawls on all fours, when an adult he walks upright on two legs and in old age he needs the support of a stick.

Contemporary Works

| 1864 | Richard Dadd: *The Fairy Feller's Masterstroke*, London, Tate |
| 1865 | James A. M. Whistler: *Harmony in Blue and Silver: Trouville*, Boston, Isabella Stewart Gardner Museum |

Gustave Moreau

1826	Born in Paris.
1849	After studying at the École des Beaux-Arts, Moreau enters for the Prix de Rome but fails to win.
1852	Moreau exhibits a *Pietà* at the Salon.
1857	Travels to Italy to study in Rome, Venice and Florence.
1860	Returns to France.
1864	Wins a medal at the Salon for *Oedipus and the Sphinx*.
1869	The critics attack the works he exhibits at the Salon. After this, his appearances at the Salon are few.
1880	He submits paintings to the Salon for the last time.
1883	He is made an Officier of the Légion d'Honneur.
1884	J.K. Huysmans writes about Moreau's art in a widely read novel, *A Rebours*, which confirms and enhances his fame.
1890	Moreau's mistress Alexandrine Dureux dies.
1892	Appointed professor at the École des Beaux-Arts in Paris where he teaches Henri Matisse and Albert Marquet.
1895	Moreau makes alterations to his Paris home converting it into a museum.
1898	Dies in Paris.

Gustave Courbet

Woman with a Parrot 1866

The Metropolitan Museum of Art

Courbet was no stranger to controversy. He was a man of strong political views which occasionally erupted into activism, in particular during the revolutionary year of 1848 and the Commune in 1871. He was anti-intellectual, anti-clerical and anti-establishment and these socio-political opinions had an impact on the subject matter he chose to depict. All this gained him a reputation as a provocative firebrand but he nevertheless exhibited regularly at the Salon, protected by powerful patrons; indeed at the 1849 Salon he was awarded a gold medal.

However, in contrast to the warm reception afforded to some of his work, Courbet was more than capable of upsetting just about everyone with other canvases; three years before he completed *Woman with a Parrot* he submitted a painting entitled *Return from the Conference* for the notorious 1863 Salon. The jury that year were particularly uncompromising rejecting huge numbers of paintings; the subsequent uproar from spurned artists resulting in the establishment of the Salon des Refusés where rejected paintings were shown. However *Return from the Conference* depicting drunken priests was too much even for the Salon des Refusés to stomach – it was eventually purchased by a devout Catholic who destroyed it.

The critics found plenty to criticize when they were confronted by *Woman with a Parrot* at the 1866 Salon, complaining about the model's 'ungainly pose' and the artist's lack of taste. The principal problem however was the blatant sexuality of the painting in which a young woman can be seen sprawled across a couch, her legs slightly splayed, the tresses of her luxuriant hair spread out against a disarranged white sheet, part of which has, perhaps fortuitously, entwined itself around her upper leg. Most of the sheet has become a tangled heap leading to questions in the mind of the viewer as to how this might have come about. The young woman is diverted by the eponymous parrot whose outstretched wings, revealing its striking plumage, echo the massed locks of her hair.

Why the parrot? As a result of some curious labyrinthine medieval logic (the call of some parrots was thought to resemble the word 'Ave' used by the archangel Gabriel to greet Mary at the Annunciation) the parrot became one of the many attributes of the Virgin. By association the bird later came to be used as a secular companion to women. Their sumptuous and exotic appearance and provenance (and the consequent expense of acquiring one) enhanced their allusive use by some artists as a pointer to those qualities in the sitter. By the 18th century, a bird that had flown its cage came to be associated with a fallen woman. The parrot therefore came to embody both the exotic and the erotic.

So with the parrot, Courbet suggests a daring mix of references, no doubt designed to ruffle the feathers of the Salon committee. However, Courbet's contemporaries loved it: Cézanne apparently kept a photo of it in his wallet and Manet produced his own version of the image. *GS*

Contemporary Works

1865	Ford Maddox Brown: *Work*, Manchester, City Art Gallery
1866	Winslow Homer: *Prisoners from the Front*, New York, Metropolitan Museum of Art
1867	Claude Monet: *Women in the Garden*, Paris, Musée du Louvre

Gustave Courbet

1819	Born at Ornans, Franche-Comté.
1837	After being taught at the Petit Séminaire in Ornans by a pupil of Antoine-Jean Gros, Courbet attends the Collège Royal in Besançon.
1839	Begins his training as a painter in Paris but is soon disillusioned by the academic teaching at the École des Beaux-Arts.
1846	Courbet visits the Netherlands and Belgium. He is influenced by the paintings of Rembrandt and Hals.
1851	Three works (including *Burial at Ornans*) exhibited at the Salon create considerable interest and some shock at the realism of the portrayal of peasants.
1855	Courbet has 11 paintings accepted for the Exposition Universelle but *The Artists Studio* is rejected. Courbet therefore funds his own Pavillon du Réalism near to the official exhibition.
1859	Starts to visit the Normandy coast on painting expeditions.
1868	Two anti-clerical pamphlets by Courbet are published in Brussels.
1870	Courbet refuses the offer of the Cross of the Légion d'Honneur. Establishes a Federation of Artists, calling for freedom against censorship in art. Daumier, Manet and Corot are amongst the members.
1871	During the Commune Courbet is appointed as president of the Commission for the Protection of Artistic Monuments in Paris. After the overthrow of the Commune Courbet is implicated in the demolition of the Vendôme Column and imprisoned.
1873	Faced with the cost of re-erecting the Vendôme Column, Courbet moves into exile in Switzerland to avoid bankruptcy.
1877	Courbet dies of liver disease exacerbated by heavy drinking, at La Tour-de-Peilz near Vevey in Switzerland.

Edward Burne-Jones

Le Chant d'Amour 1868-73

The Metropolitan Museum of Art

Hélas! Je sais un chant d'amour
Triste ou gai, tour à tour

Alas, I know a love song, / Sad or happy, each in turn
Traditional Breton song

In the early summer of 1862 Edward Burne-Jones, accompanied by his wife, traveled to Venice with his mentor John Ruskin who commissioned him to paint copies of a number of Venetian Renaissance works. He returned home via Paris where he saw more Venetian paintings in the Louvre (which he had previously visited in 1855 and 1859). In particular he would have seen there the famous *Concert Champêtre*, then thought to have been the work of Giorgione but now considered to be by his pupil Titian, showing a group of figures in a verdant landscape with a musical theme. His subsequent style was highly influenced by these experiences and in 1865 he produced a Giorgionesque watercolor – a 'prototype' of this painting – which was purchased by William Graham, a wealthy Scottish businessman and Member of Parliament.

Graham became a trusted advisor to Burne-Jones and he also had a tangential influence on the artist's output in that his taste for richly colored romantic compositions ensured that Burne-Jones continued to paint in a 'Venetian' style even when his output had otherwise become more subdued in tone. Graham later commissioned Burne-Jones to paint an enlarged oil version of the 1865 watercolor and this is the painting now owned by the Metropolitan.

It is one of the most ravishingly beautiful paintings produced by Burne-Jones. Three figures are set in an exquisite landscape – a timeless realm of verdant pasture, solid vernacular architecture and lovingly tended garden flowers – an English Arcadia. An ethereal evening light illuminates the scene

triggering memories in us all of those precious transient moments at the waning of a summer day when the world seems at its most serene.

There is no psychological contact between the three protagonists – they are wrapped in their own thoughts – the lovelorn knight's unfocused gaze extends to infinity as does that of the musician (even as her hands are busy depressing keys and controlling the music manuscript against the slight breeze which plays in her hair and Cupid's cloak). Cupid, languorously engaged in working the organ bellows, has his eyes closed. Their wistful demeanor enhances the mood of delicious nostalgia – a yearning for an unattainable domain of blissful tranquility and contentment, or as Burne-Jones put it '… a land no-one can define or remember, only desire.'

Cupid (or perhaps he represents a personification of Love) looks as though he might be lifted straight from a painting by Botticelli. But his shift of rich red echoed in the sleeves of the knight and the foreground display of flowers betray the lingering influence of Giorgione and Titian. The knight's armor however is pure Burne-Jones – a fabulous conflation of late medieval craftsmanship and highly romanticized personal invention. The splendid ivory gown of the musician and the intense ultramarine cushion upon which she kneels provide the perfect foil for the flanking concentrations of red – the inclusion of a beautifully painted blue iris picked out against the knight's metallic chain mail chimes in with the cushion as do the curious wings of Cupid.

The unresolved nature of the piece ensures that we weave our own thoughts and imaginings into his world, a world which Burne-Jones said was 'a beautiful romantic dream of something that never was, never will be – in a light better than any light ever shone…' He never ceased to search for this land through his art for he said it was 'too beautiful not to be true.' *GS*

Contemporary Works

1869	Pierre-Auguste Renoir: *La Grenouillère*, Stockholm, Nationalmuseum
1871	Edgar Degas: *The Rehearsal*, Glasgow, Burrell Collection
1872	Paul Cézanne: *House of the Hanged Man*, Paris, Musée d'Orsay

Edward Burne-Jones

1833	Born in Birmingham, his mother dies shortly after his birth.
1853	Begins his studies at Exeter College, Oxford, destined for the church. Meets William Morris.
1855	After a tour of French cathedrals and inspired by Ruskin's writings, Burne-Jones and Morris decide to follow artistic vocations.
1856	Meets Dante Gabriel Rossetti. Settles in London.
1857	Collaborates with Rossetti and others in decorating the Oxford Union.
1859	Visits Italy.
1860	Marries Georgiana Macdonald.
1861	Burne-Jones is involved in the founding of Morris, Marshall, Faulkner & Co. being particularly involved in the design of stained glass windows.
1862	Visits Italy again with Ruskin.
1871	Visits Florence, Pisa, Orvieto, Rome etc.
1873	Again in Italy.
1877	Exhibits eight pictures at the opening exhibition of the Grosvenor Gallery. They are a great critical success.
1878	Gives evidence in support of Ruskin in the case brought by Whistler against Ruskin. Enjoys success exhibiting his work in Paris.
1890	The 'Briar Rose' paintings are exhibited at Agnew's to general acclaim.
1894	Created a baronet.
1898	Dies at Fulham in London.

Edgar Degas

Dance Class 1874

The Metropolitan Museum of Art

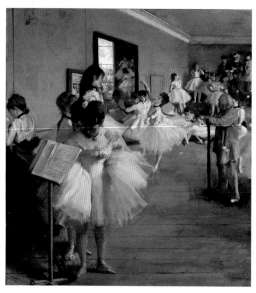

Though he was one of the group's founders and core members, Degas never liked to be called an 'Impressionist.' He preferred 'Realist' or 'Independent,' a distinction that reflected his background and artistic vision. From a wealthy Parisian family, his father recognized his talent early and gave his son encouragement and a first-rate education. Young Degas copied Old Masters in the Louvre, trained under one of Ingres' students at the prestigious École des Beaux-Arts and spent years studying in Italy.

However by the mid-1860s he turned from lofty Salon themes (the Salon was the official art showcase, promoting conventional painting often on historical, religious and mythological subjects) to the modern subjects favored by the Impressionists, depicting the experience of living in contemporary society. However, unlike most other Impressionists, Degas' work continued to emphasize composition and drawing (rather than color and atmosphere) and he rarely painted outdoors. Degas favored scenes in theaters and interiors illuminated by artificial light, which he used to clarify the contours of his figures. Fascinated by movement, he painted over 600 ballet scenes, mostly rehearsals or backstage views, the first around 1873.

Though painted a few years earlier, this painting was first shown at the Impressionist exhibition in Paris in 1876 and depicts some 21 dancers as they wait their turn to be evaluated by the ballet master Jules Perrot. Four stage mothers are on hand to watch. Degas had never witnessed such an examination and instead invented the composition from numerous drawings executed in his studio while dancers posed for him. The painting was not intended as a composite portrait but rather as a study of moving bodies and the physicality of the dancers using contorted poses and unexpected vantage points.

From a distance the dancers with their white tutus and pink satin shoes

seem to fit into conventional ideals of grace and female beauty. However, up close, Degas depicts a harsher reality: hard work, sweat and boredom. Note the blunt concentration of the girl adjusting her dress in the left foreground; the decidedly plain face of the dancer doing a pirouette; the folded arms and slouch of a seated girl. They are not Swan Lake-like gazelles but uneducated, working class girls, the 'Montmartre types' with snub noses and stocky, immature bodies that Degas painted so often. These dancers are not concerned with artistic expression or beauty but with making a living.

Like many of his contemporaries, Degas was greatly influenced by Japanese art, newly fashionable in the West since the reopening of trade with Japan in 1854. The inventive compositions, unexpected views, asymmetrical framing and abrupt cut-offs of Japanese prints were considered very modern and Degas incorporated their techniques into his painting. (Degas would also have observed similar cut-offs and unusual framing in the 16th-century Italian Mannerists he studied in Italy.) In this picture, the viewer has an oblique prospect deep into the rehearsal room and out to the rooftops of Paris, which are seen through a window reflected in a mirror on the opposite wall. On either side figures are cut off as if in a snapshot (an anachronistic comparison as the same techniques would not influence photography until the 1880s). A masterly composition, it is unsurprising that Degas' fellow Impressionist and friend, Mary Cassatt claimed that, in this painting, Degas surpassed Vermeer. And indeed there is as much Old Master as Impressionist in this work. Degas himself wrote, 'I assure you that no art was ever less spontaneous than mine. What I do is the result of reflection and study of the great masters; of inspiration, spontaneity, temperament … I know nothing.' **DM**

Contemporary Works

1873 Claude Monet: *Impression: Sunrise*, Paris, Musée Marmottan
1874 James A. M. Whistler: *Nocturne in Black and Gold: the Falling Rocket*, Detroit, Institute of Arts

Edgar Degas

1834 Born in Paris, the eldest son of a banker.
1854 Instructed in the studio of Louis Lamothe who had been a pupil of Ingres.
1855 Attends the École des Beaux-Arts.
1856 Begins a long visit to Italy staying with members of his extended family in Naples and Florence. He also visits Rome for long periods.
1859 After a trip to Siena and Pisa, Degas returns to Paris.
1862 Meets Manet while engaged in copying paintings in the Louvre.
1865 Exhibits the *Misfortunes of the City of Orléans* at the Salon.
1870 Degas enlists in the National Guard (during the Franco-Prussian War).
1872 Travels to New Orleans where members of his family are engaged in the cotton trade.
1874 Degas exhibits ten works at the independent show which later becomes known as the First Impressionist Exhibition.
1876 Shows 24 works at the Second Impressionist Exhibition.
1879 At the Fourth Impressionist Exhibition Degas has 20 paintings on show.
1881 At the Sixth Impressionist Exhibition his wax sculpture of a *Little Dancer aged Fourteen* causes uproar with critics suggesting it ought to be in an anthropology museum rather than an art show.
1886 Increasingly at odds with many of his former Impressionist friends he sends only ten works to the last group exhibition.
1894 The Dreyfus affair (Degas was fiercely anti-Dreyfusard) leads gradually to the loss of a number of friends.
1912 Degas endures failing eyesight and poor health.
1917 Dies in Paris.

Édouard Manet

Boating 1874

The Metropolitan Museum of Art

Édouard Manet had almost reached the age of 40 in 1872 without having sold more than a couple of paintings. He had gained notoriety during the 1860s with paintings such as *Déjeuner sur l'herbe* and *Olympia* both of which had provoked furiously venomous reviews. But he doggedly continued to submit paintings for consideration by the Salon jury in subsequent years despite enduring constant abuse from reviewers, occasional rejection by the jury and precious little interest from prospective buyers.

However, in January 1872 his fortunes were transformed when the dealer Paul Durand-Ruel visited Manet at his studio in the rue de Saint-Pétersbourg and bought two canvases. To Manet's astonishment, he returned twice over the space of the next few days and bought nearly everything he had (although the astute Durand-Ruel baulked at *Déjeuner sur l'herbe* and *Olympia*) making Manet richer to the tune of more than 50,000 francs.

Although Manet had been able to support himself from private means, this windfall headed off incipient financial pressures and so it was a more solvent painter who spent the summer of 1874 at a property owned by the Manet family in Gennevilliers on the Seine just outside Paris. Nearby, at Argenteuil, Monet had made his home and the two artists painted together during Manet's summer sojourn. They had become friends in the late 1860s when Manet invited the younger painter to join him at the regular gatherings at the Café Guerbois. Monet later said of these evenings 'Nothing could have been more interesting than our discussions.'

Pottering about in boats had become a fashionable pastime and both painters reflected this in their choice of subject matter – Monet turned out a number of views of the river full of sailing boats; Manet painted Monet in his floating studio and he painted this arresting canvas. The gentleman guiding the skiff (resplendent in straw boater) is almost certainly Rudolphe Leenhoff,

Manet's brother-in-law, but the identity of the woman is unknown.

There is no doubt that Monet's preference for painting *en plein air* had a significant influence on Manet's output in 1874. He had painted outdoors before on trips to the Normandy seaside but now, following Monet's lead, he experimented with a much lighter palette, endeavoring to capture the fleeting effects of natural light. Boating is an 'Impressionist' painting from the choice of subject matter (the middle class enjoying their leisure – *la vie moderne*) to the flickering application of paint, seen to particular effect in the young woman's diaphanous summer dress and the eddies of the water created by the passage of the boat.

But although the influence of Monet and Renoir (who also occasionally joined them at Argenteuil) can clearly be seen in this painting, Manet did not consider himself to be part of their rebellious artistic circle. 1874 was notable of course for the first exhibition held in April that year by the *Société anonyme des artistes, peintres, sculpteurs, graveurs etc* in a direct challenge to the power of the Salon. Monet and Renoir, together with many other artists including Pissarro and Degas exhibited paintings, one of which, Monet's *Impression: Sunrise* gave rise, via a sneering review in the satirical magazine *Le Charivari* to the name later adopted by the group. Manet was asked to send canvases but refused, partly it seems because of the inclusion of work by Cézanne, which he could not abide, but also because he still saw the Salon as his best route to success. **GS**

Contemporary Works

1874	Jean-François Millet: *Haystacks: Autumn*, New York, Metropolitan Museum of Art
	James Tissot: *The Ball on Shipboard*, London, Tate
1875	Gustave Caillebotte: *The Floorscrapers*, Paris, Musée d'Orsay

Édouard Manet

1832	Born in Paris, the son of a bureaucrat in the Ministry of Justice.
1850	Enters the studio of Thomas Couture, the academic history painter.
1856	Sets up his own studio.
1860	*The Guitarist* is accepted by the Salon.
1862	*Concert at the Tuileries Gardens* is painted in the open air.
1863	*Déjeuner sur l'herbe* is rejected by the Salon jury but causes a sensation when exhibited at the Salon des Refusés which has been set up specifically to exhibit the many rejections from the official Salon. Marries Suzanne Leenhoff, his piano teacher.
1865	*Olympia* causes another scandal when exhibited at the Salon. The brazen gaze of the naked woman causes particular offense. Saddened and frustrated by the reception of *Olympia*, Manet decides to visit Spain.
1867	In the face of public hostility, Émile Zola publishes an article praising Manet in the *Revue du XIX siècle*.
1870	Manet serves as a lieutenant in the National Guard during the Siege of Paris.
1872	Paul Durand-Ruel buys a large quantity of canvases from Manet relieving him of increasing financial pressures. Visits the Netherlands where he is much influenced by the paintings of Frans Hals.
1874	Manet's friendship with Claude Monet grows closer and the two paint together on the banks of the Seine at Argenteuil.
1875	Travels to Venice.
1880	Manet holds a one-man exhibition at the premises of the periodical *La Vie Moderne*.
1882	Exhibited his last great work, *A Bar at the Folies Bergère* at the Salon.
1883	In early April his left leg becomes gangrenous. This is amputated but he dies soon afterwards.

Pierre-Auguste Renoir

Madame Georges Charpentier and her Children 1878

The Metropolitan Museum of Art

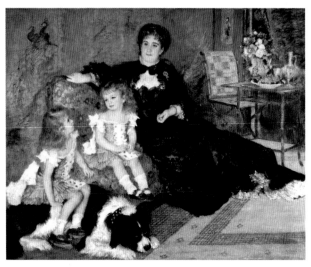

Marguerite-Louise Lemonnier married Georges Charpentier in 1872 and very soon the couple were blessed with a daughter, Georgette-Berthe, followed three years later by a son, Paul-Émile-Charles. Georges was a wealthy publisher who counted Flaubert, Zola, Maupassant and the Goncourt brothers among his authors. They both became keen supporters of the Impressionists and in 1879 Georges founded a magazine, *La Vie Moderne*, which championed their cause (a gallery was opened on the ground floor of the magazine's offices devoted to exhibiting works by the Impressionist circle).

Mme Charpentier held a salon every Friday to which she invited artists, writers and politicians; Renoir and Manet received invitations but it was Renoir who became a particular favorite. Through her he was introduced to an affluent and fashionable circle where he found a ready supply of patronage, not least from the Charpentiers themselves for whom he painted five portraits, this wonderful piece, finished in 1878, being the most celebrated. He integrated into this milieu with ease and (perhaps choosing solvency over penury) he decided to submit this painting together with a portrait of the actress Jeanne Samary to the 1879 Salon rather than take part in the Fourth Impressionist Exhibition. And indeed this seems to have been a wise choice as the jury, possibly mindful of the influential principal subject of the painting, chose to hang *Mme Charpentier and her Children* in a prominent location. The critics were by no means unanimous in their praise, one reviewer damning it as a 'slack, transparent sketch' in which 'there is a complete absence of perspective' but there is no doubt that, in general, the painting was hailed as a success, especially in regard to Renoir's gifts as a colorist.

Renoir's brother Edmond tells us that the picture was 'painted at home. None of the furniture was moved from its usual place.' This feeling of informality suffuses the work. Madame Charpentier, resplendent in an elegant and fashionable Worth dress, reclines on a sofa next to her young son Paul who, in

of modernism precipitated a steep decline in his posthumous reputation although his work attracted the attention of Giorgio de Chirico and later the Surrealists.

It is not difficult to appreciate the psychological link between Böcklin and de Chirico – the sense of dreamlike foreboding, the profound stillness and the presence just below the surface of a disturbing anxiety. Böcklin said that 'a picture should tell a story, make the spectator think, like a poem, and leave him with an impression like a piece of music.' This painting is an admirable exemplar of those principles. *GS*

Contemporary Works

1880	Paul Cézanne: *Still Life with Fruit Dish*, New York, MOMA
1881	Édouard Manet: *Lady in a Fur Wrap*, Vienna, Belvedere

Arnold Böcklin

1827	Born in Basel.
1846	Attends the Düsseldorf academy.
1848	Böcklin is in Paris, remaining there throughout the revolutionary uprisings which engulf the city during the year. He is influenced by the work of Couture and Corot.
1850	Leaves Paris for Rome.
1853	Marries Angela Pascucci, the daughter of a papal guard, in Rome.
1857	Leaves Rome to work on a short-lived commission in Hanover.
1858	Moves to live in Munich.
1859	Böcklin's painting *Pan in the Reeds* is purchased by King Maximilian II of Bavaria.
1862	Returns to live in Rome.
1863	Visits Pompeii and studies the wall paintings there.
1866	Takes up residence again in Basel where he works on commissions at the museum there.
1870	Böcklin is in Paris but with the advent of the Franco Prussian war he returns to Basel.
1871	Returns to Munich.
1874	Böcklin leaves Munich at the onset of cholera and settles in Florence.
1885	Returns with his family to Switzerland and settles in Zurich.
1890	His love of Italy leads him to leave Switzerland and he moves to live in Viareggio.
1892	Böcklin suffers a stroke.
1894	He purchases the Villa Bellagio in San Domenico near Fiesole.
1901	Dies at San Domenico.

John Singer Sargent

Madame X 1884

The Metropolitan Museum of Art

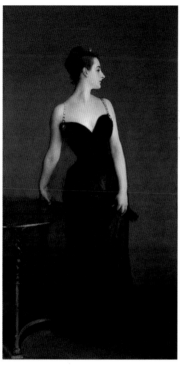

John Singer Sargent was born in Florence in 1856 to expatriot American parents and studied at the École des Beaux-Arts in Paris and in the studio of the preeminent portraitist in France, Charles Carolus-Duran. He practiced as a modestly successful portrait painter in Paris until this particular work caused such controversy that he determined to resettle in London where he soon became the leading portraitist in the British capital.

Virginie Amelie Avegno was born in New Orleans but married Pierre Gautreau, a French banker and became a celebrated beauty in the Parisian haute-monde, her legendary complexion being maintained by the covert application of copious amounts of rice powder.

Sargent probably met Mme Gautreau in 1881 and, obviously impressed, asked if he could paint her. After a number of preliminary studies, a full size sketch was completed before work on the portrait began. This went slowly with Sargent, who usually painted with some alacrity, constantly reworking the canvas. At one point he wrote to his friend Vernon Lee that he was 'struggling with the unpaintable beauty and hopeless laziness of Madame Gautreau.' So it was not until 1884 that the portrait was unveiled at the Salon entitled *Portrait of Mme*

The pose is striking and unconventional; her head is turned somewhat awkwardly in profile, emphasizing a nose which perhaps some sitters would have preferred to remain as a rather less prominent feature; her torso is aligned

more frontally. Her right arm twists round to enable her hand to grasp the edge of an occasional table – again there is a degree of awkwardness – her thumb seems to be buckling under pressure from the weight of the right side of her body. She wears a black satin dress which accentuates her hour-glass waist as well as the considerable dimensions of her charms above it. The dress also features an unusually revealing décolletage leaving large expanses of flesh exposed to the gaze. Sargent has imparted a curious lavender cast to all this flesh but this was not some fanciful invention of the painter – rather it seems to have been the product of the sitter's idiosyncratic skin care regimen.

The picture was unveiled at the 1884 Salon to almost universal hostility. The critics were offended by what they saw as the provocative stance of the sitter and the indecently low cut of the bodice as well as alighting on the rather odd flesh tone. Sargent's decision to show one of the spangled straps as if it had just fallen off the right shoulder played into the hands of those who saw the painting as a lascivious affront. He obviously regretted this 'provocation' as he immediately overpainted the offending detail, in favor of a strap that was firmly in place on the shoulder, as soon as he recovered the painting from the walls of the Salon.

It is probable that Sargent had set out to create a sensation (the matter of the loose shoulder strap seems to confirm this) but the fervor of the outrage which greeted this painting surprised and shocked him. His reputation, which had been on the rise during his years in Paris was now in tatters. However, Sargent would later find fame in London and America. Mme X was not so lucky: the scandal destroyed her reputation and she was forced to withdraw from polite society. *GS*

Contemporary Works

1884	James A. M. Whistler: *Milly Finch*, Washington, Freer Gallery of Art
	Georges Seurat: *Bathers at Asnières*, London, National Gallery
	Alfred Sisley: *Riverbank in Saint-Mammés*, Saint Petersburg, Hermitage

John Singer Sargent

1856	Born in Florence to wealthy expatriate American parents.
1874	Enters the studio of Charles Carolus-Duran in Paris.
1877	His portrait of *Miss Fanny Watts* is accepted by the Salon.
1884	His portrait of *Madame X* is attacked on grounds of being decadent. This minor scandal persuades Sargent he should move to London.
1885–6	Spends the late summer of both years at Broadway in the Cotswolds, the guest of an American doctor.
1886	Settles in London permanently following encouragement by his friend Henry James.
1887	Visits the USA (his second trip) where he is fêted, receiving numerous commissions.
1894	Accepts a commission to paint a series of murals at the Boston Public Library.
1907	At the height of his fame as the preeminent portrait painter in both Britain and the USA, Sargent announces that he will accept no further portrait commissions. Exceptions were in fact made for friends.
1916	Begins work on murals for the Boston Museum of Fine Arts. Visits the Rocky Mountains.
1918	Visits the Front in France and produces watercolors and other works such as *Gassed*.
1925	Dies in London.

Mary Cassatt

The Metropolitan Museum of Art

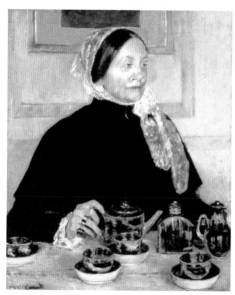

Mary Cassatt was exceptional in many ways; one of the few successful female artists of the era she was also the only American member of the French Impressionists. From a wealthy Pennsylvania family, Cassatt first came to Paris in 1865 to study painting and ended up making Paris her home for much of the rest of her life. After mastering academic painting and exhibiting at the Paris Salon, she was drawn to the avant-garde trends of Impressionism and in 1879 was invited by her friend and mentor, Edgar Degas, to exhibit with the Impressionists (she would exhibit at four of their eight exhibitions, in 1879, 1880, 1881, and 1886). 'I accepted with joy,' Cassatt told her biographer. 'At last, I could work with absolute independence without considering the opinion of a jury. I had already recognized who were my true masters. I admired Manet, Courbet, and Degas. I hated conventional art'.

But while she embraced the techniques and influences of Impressionism she developed her own unique artistic language that often explored themes rarely touched on by male artists: the contemporary lives of middle-class women. Her choice of subject was somewhat inescapable as, like the women she portrayed, Cassatt's social life was limited. A middle class woman in late 19th-century Paris was chaperoned wherever she went in public, be it a park, theater or shop, and she could not enter without serious social consequences the bars, musical halls and brothels which served as the subjects and inspiration for many male artists. Cassatt thus depicted the world she knew; recording with insight and originality, women like herself, writing letters, sewing, reading or engaging in other domestic or social activities. She became known for her intimate portrayal of mothers and their children, but also for individual portraits such as this rather commanding-looking lady with a tea set.

Her name is Mrs Robert Moore Riddle (died 1892) and she was a cousin of Mary

Cassatt's mother. Mrs Riddle sits at a table with one hand on the teapot of an Asian-looking blue-and-white gilded porcelain tea service, which her daughter had given to the Cassatt family. Her cool blue eyes, which echo the blue of the tea set, gaze out of the picture frame. Looking crisply refined, she is elegantly dressed in expensive fabric and lace and appears about to pour tea for unseen guests. However, she does not appear to be a particularly lively companion. Almost iconic in her stillness, she seems rather intimidating, which may partially explain why Mrs Riddle's daughter refused the painting (she also thought her mother's nose looked too big). Thus Mary Cassatt ended up putting this painting aside until 1914, when a friend saw it and encouraged Cassatt to exhibit the portrait. It was shown later that year at the Durand-Ruel gallery in Paris and created a sensation.

Despite the Riddle family's negative response, the painting is nonetheless a superb reflection of Cassatt's fascination with figure composition and Japanese art. Cassatt shared with Degas and other Impressionists an appreciation of Japanese prints which emphasized outline, silhouette, and flattened space. Here Cassatt was clearly inspired by Japanese artists' use of solid colors within stylised outlines and by their emphasis on the surface pattern of the print rather than the illusion of space. The foreground and background surfaces are similarly colored, creating ambiguous spatial relations and Mrs Riddle is framed in a series of rectangles that become more defined as they recede and that are abruptly cut off at the top of the picture. Not only was Cassatt inspired by the technique and composition of Japanese prints, she discovered fresh approaches to the depiction of women's everyday lives, which were commonly depicted in Japanese art.

Mixing these exotic influences with Impressionism and with her own unique, female interpretation of what modern life looks and feels like, Cassatt captured a segment of late 19th-century life that otherwise might have gone unrecorded. *DM*

Contemporary Works

1883	Edward Burne-Jones: *The Wheel of Fortune*, Paris, Musée d'Orsay
1885	Vincent van Gogh: *The Potato Eaters*, Amsterdam, Van Gogh Museum
	Paul Cézanne: *The Bather*, New York, MOMA

Mary Cassatt

1844	Born in Pittsburgh (then Allegheny City), the daughter of a banker.
1860	Attends classes at the Pennsylvania Academy of Fine Arts in Philadelphia.
1866	Leaves for Europe, studying in Paris and Rome.
1868	A painting is accepted for exhibition at the Paris Salon.
1870	Exhibits paintings at the Paris Salon. Returns to the United States at the outset of the Franco-Prussian War.
1871	Again in Europe visiting Madrid, Seville, Antwerp, and Rome.
1874	Settles in Paris.
1875	Her work is rejected by the Salon.
1877	Her parents and sister settle in Paris and Mary joins them to live in their spacious apartment. She meets Edgar Degas.
1879	Sponsored by Degas, she exhibits with the Impressionists at their fourth exhibition.
1891	Her first individual exhibition is held at Galerie Durand-Ruel.
1894	Her success enables her to buy the Château de Beaufresne at Le Mesnil-Théribus.
1895	Durand-Ruel mount a retrospective exhibition of her work in Paris and New York.
1904	She is awarded the Légion d'Honneur.
1926	Dies at Le Mesnil-Théribus.

Georges Seurat

Circus Sideshow (La Parade) **1888**

The Metropolitan Museum of Art

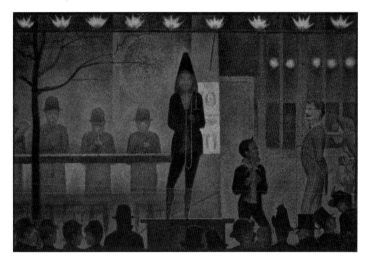

I n this painting we are party to a *parade de cirque* – a sideshow or taster designed to whet the appetite of passers by and persuade them to part with their entrance fee in order to see the full performance of the circus within. Our attention is caught initially by the figure of a mysterious trombonist who stands at the center of the stage, elevated on a plinth which may also project forward into the small crowd of onlookers. His stance is at once passive (perhaps one might detect a note of effeminacy) but also confrontational, even faintly sinister. To a considerable extent this effect stems from the musician's choice of headgear – a very peculiar conical hat which could be an indication of secondary duties as a magician.

To the left of this singular musician three more members of the ensemble accompany him (with the instrument and left arm of a further player just visible on the extreme left), each standing at an exact distance from each other, each dressed the same: were it not for a difference in height they could be taken for clones. To the right of the central figure, in front of the cash kiosk the ringmaster struts, his cane held firmly under his arm in military style. The heads of the crowd are either seen directly from behind, chiming with the frontal orientation of the band, or in profile like the ringmaster. This rigorous arrangement reminds one of an Assyrian relief – flat, alien, pregnant with unknowable mysteries.

This picture is very different from Seurat's earlier sun-drenched compositions such as *Bathers at Asnières* and *Sunday on la Grande Jatte*. Whereas these two masterpieces depict the escape of city dwellers to the cooling airs of the river Seine's suburban reaches during a summer weekend, *Circus Sideshow* is unremittingly urban and wintry, the scene lit by the glow of gas lighting. Although a link remains with these earlier pictures in that Seurat is illustrating the pastimes of ordinary people, this piece also represents a further development in his researches into optics and it is the first time he had used

the technique which later came to be called 'pointillist' to represent the effects of artificial light. (It seems that the impetus for this may have come from the publication by the poet Stéphane Mallarmé of a paper by Whistler on the problems associated with the depiction of artificial light.)

Seurat's working method, which he rather clumsily called chromo-luminarism, resulted from his interest in color theory and led him into the study of a number of scientific disciplines. Essentially this involved the application of small juxtaposed dabs (or points) of pure but complementary color which, when viewed from a distance mix within the viewer's eye to give the impression of another color. Here the dominant blue–orange–yellow spectrum of dots fuse to give a range of greens, purples and darker colors.

This is not the only circus scene Seurat painted – his unfinished work in the Musée d'Orsay (*The Circus*) depicts the scene once we have paid and passed into the arena. It might be seen as a companion piece to *Circus Sideshow*, introducing us to the delights awaiting us, transporting us from the cold, foggy street to an entrancing domain of light, movement, glamour and excitement. The circus was a very popular part of social life in *belle époque* Paris and not just for the lower classes – the patrician Degas was a devotee (one of his most memorable pictures is of the trapeze artist Miss La La) as were many of those in the Impressionist circle. But there can be few more strange and memorable images to emerge from the circus milieu than this hauntingly enchanting if slightly unsettling painting. *GS*

Paul Gauguin

Ia Orana Maria 1892

The Metropolitan Museum of Art

In March 1892, Gauguin wrote to a friend in France describing a painting he had recently completed, which he considered his best work since arriving in Tahiti a year earlier. 'A yellow angel points out Mary and Jesus to two Tahitian women. Mary and Jesus are likewise Tahitians and naked, except for the paréo, a flowered cotton cloth tied to suit one's fancy. In the background very dark mountains and blossoming trees. Foreground emerald green. To the left bananas…'

Entitled *Ia Orana Maria* (Tahitian for 'Hail Mary'), the painting embodied Gauguin's life-long fascination with the exotic. He had traveled to the South Pacific hoping to find artistic inspiration in 'primitive' cultures living in harmony with nature and unsullied by European values. Instead, he found a world already transformed by colonial rule and Christianity. Gauguin probably learned the term 'Ia Orana Maria' from the Catholic missionaries who had converted Mataiea – the region where Gauguin painted this image – long before the artist arrived. But in his paintings Gauguin created the world he sought, interweaving the mythologies and imagery of the islands with that of the West and his own imagination.

Gauguin himself had a relatively exotic background – brought up in Peru, educated in France, Gauguin had traveled the seas as a merchant marine and later became a successful stockbroker in Paris. He started painting in the 1870s, studying with his friend Pissarro and after he lost his job in the 1882 stock market crash, took up painting full time. He exhibited with the Impressionists but by the late 1880s, he had begun his nomadic search for a simpler, more meaningful way of painting and of life. He first traveled to remote Brittany, where, inspired by local folklores and customs, he painted images of flattened, simplified forms and bold color imbued with symbolic meaning.

He employed this same Symbolist vocabulary in Polynesia in works like this one, in which he transforms a Christian subject into a tropical dream. Gauguin derived the scene's unusual composition from a photograph of a bas-relief from the Javanese temple of Borobodur. Mary is depicted as a beautiful, Tahitian girl wearing a red print sarong with the Christ child, a naked, sturdy-looking toddler, sitting on her shoulder. Both have gold halos and Christ leans his cheek on his mother's head, looking directly at the viewer. The fruit at Mary's feet is laid out in a 'fata,' a platform used by the Polynesians to make offerings to the gods. Further back, two young girls, naked from the waist up, hold their hands in prayer as if worshipping. Beside them, partially obscured by tropical leaves and flowers, is an almost Botticelli-like angel with colorful wings and long black tresses who seems to act as their intercessor with the holy pair.

Gauguin would produce numerous paintings of his exotic paradise, despite his less than idyllic life there. Short of funds, he returned to Paris briefly in 1893 to raise money, selling this painting for 2000 francs. Returning to Polynesia, he continued to paint but descended into poverty and morphine addiction, dying of syphilis in 1903. *DM*

Contemporary Works

| 1892 | Frederic, Lord Leighton: *The Garden of the Hesperides*, Port Sunlight, UK, Lady Lever Art Gallery |
| | Henri de Toulouse-Lautrec: *Jane Avril Dancing*, Paris, Musée d'Orsay |

Paul Gauguin

1848	Born in Paris. After the revolution of this year his father decides to move with his family to Peru. His father dies before arrival in Lima.
1854	Gauguin's family returns to France to enable his mother to claim a legacy.
1865	At the age of 17 Gauguin enlists in the Merchant Navy.
1867	Gauguin's mother dies leaving her children under the guardianship of the financier, photographer and art collector, Gustave Arosa.
1871	Gauguin learns of his mother's death.
1872	Returns to France where Arosa has arranged a position for Gauguin in the Paris Stock Exchange. Becomes an enthusiastic amateur painter.
1873	Marries a young Danish woman, Mette-Sophie Gad.
1874	Visits the First Impressionist Exhibition. Later meets Camille Pissarro who becomes his mentor.
1876	Exhibits a landscape at the Salon.
1881	Gauguin, Pissarro and Cézanne paint together in Pontoise.
1882	The French stock market crashes and Gauguin loses his job.
1883	Deciding to make a living through his art, Gauguin moves with his wife and five children from Paris to Rouen.
1884	Mette and the children leave for Copenhagen. Gauguin eventually follows.
1885	Gauguin works as a salesman in Copenhagen but in June returns to Paris.
1886	Paints in the Breton village of Pont-Aven for five months.
1887	Leaves Paris for Panama and Martinique. Becomes ill and returns to Paris.
1888	Leaves Paris in February for Pont-Aven. In October Gauguin joins Vincent van Gogh in Arles, sharing tiny lodgings. Two months later van Gogh severs part of his left ear and Gauguin flees back to Paris.
1891	Gauguin travels to Tahiti but does not find the paradise he is looking for.
1893	Returns to Paris. An exhibition of Tahitian work elicits a muted response.
1895	Depressed by his lack of success, Gauguin returns to French Polynesia.
1897	Hearing of the death of his daughter Aline, Gauguin attempts suicide.
1899	Takes a job as a journalist on a local satirical paper, *Les Guêpes* (The Wasps).
1901	Leaves Tahiti for Hiva Oa in the Marquesas, seeking a world unspoiled by European influence. He paints with renewed enthusiasm.
1903	Dies at Atuona, Marquesas Islands.

Thomas Eakins

The Thinker: Portrait of Louis N. Kenton **1900**

The Metropolitan Museum of Art

This large canvas, well over six feet (two meters) tall, presents us with a near life-size full length portrait of a man in a dark suit, feet set squarely apart standing in an unadorned and unexplained space. No extraneous object is allowed to deflect us from our contemplation of the subject of the portrait who is himself deep in thought, hands in pockets, head tilted downwards, his face serious and introspective. A sense of profound quietude drifts from the canvas slightly tinged with melancholia – this latter response perhaps reflecting the subject's difficult personal circumstances.

This is a portrait of Louis Kenton, Eakins' brother-in-law who had married Elizabeth Macdowell, sister of Eakins' wife, in 1889. Elizabeth had studied at the Pennsylvania Academy of Fine Arts where Eakins had been director. She had enjoyed some modest success as an artist but her marriage to Kenton was apparently unhappy and short-lived.

When the painting was exhibited it was much admired – something of a novelty for Eakins who had received scant recognition from all except a few supporters throughout his career as a painter. Now, in the last decade of his life this slowly began to change; two years after this painting was completed he was at last made a member of the National Academy of Design, the association of American artists founded earlier in the 19th century by Thomas Cole and others.

This lack of acclaim meant that Eakins spent most of his life teaching while always working on his own artistic output. A great many of his portraits were

painted as a result of Eakins inviting the subject to sit for him rather than the more usual arrangement of the client commissioning the artist.

Eakins advised one of his students that the mission of a painter was to 'peer deeply into American life' and he has certainly achieved that aim in this work. There is something here which is quintessentially American; the open relaxed stance, the informal nature of the clothing (especially compared to contemporary middle class Europeans) right down to the high-heeled boots.

All his life Eakins was concerned with the human body – with portraiture in its widest sense, either formally posed or, especially earlier in his career, portrayed against the backdrop of a natural or professional setting. In order to further his understanding of the human form Eakins became an enthusiastic exponent of photography which he took up in the 1870s. He made many photographs of models in various poses, building up a reference resource for his students. But his interest in photography also took him in the direction of research into human movement. In 1884 he assisted Eadweard Muybridge at the University of Pennsylvania with his famous photographic enquiries into the nature of human and animal movement. Later Eakins continued this interest, conducting further research into the anatomy of motion.

Although an innovator in the use of the camera as a servant to his art and his study of the human body, he was technically conservative as a painter but this did not stop him from producing profoundly memorable work such as this portrait. *GS*

Contemporary Works

1899 Gustave Klimt: *Portrait of Serena Lederer*, New York, Metropolitan Museum of Art
1900 Édouard Vuillard: *Madame Hessel on the Sofa*, Liverpool, Walker Art Gallery
 Pablo Picasso: *Moulin de la Galette*, New York, Solomon Guggenheim Museum (Tannhauser Collection)
1901 Ferdinand Hodler: *Spring*, Essen, Folkwang Museum

Thomas Eakins

1844 Born in Philadelphia, the son of a weaver.
1862 Attends the Pennsylvania Academy of Fine Arts. Also enrolls in anatomy and dissection classes at Jefferson Medical College.
1866 Studies in Paris at the École des Beaux-Arts with Jean-Léon Gérôme.
1869 Spends six months in Spain where he makes an intensive study of Velázquez in the Prado.
1870 Returns to Philadelphia.
1881 Eakins purchases his first camera. Studies human movement using multiple exposures.
1882 Becomes director of the Philadelphia Academy of Fine Arts.
1884 Marries Susan Hannah Macdowell. Works with Eadweard Muybridge researching animal and human movement through photography.
1886 The Board of Directors of the Philadelphia Academy of Fine Arts forces Eakins to resign. Travels to Dakota. Meets Walt Whitman. After his dismissal he teaches at a number of other schools.
1902 Eakins becomes a member of the National Academy of Design.
1916 Dies in Philadelphia.
1917 A memorial retrospective of his work is mounted by the Metropolitan Museum of Art in New York and in Philadelphia.

André Derain

The Metropolitan Museum of Art

In the summer of 1904 a series of canvases by Claude Monet, depicting various views of London, were exhibited at the Durand-Ruel gallery in Paris. Unlike Monet's view of the Palace of Westminster shrouded in mist painted some 30 years earlier (the then infamous *Impression; Sunrise*), this new London series was rapturously received. Times had changed.

Among those who were impressed by the exhibition was the young painter André Derain who was on leave that summer from military service. Derain wrote of Monet 'I adore him … even his mistakes teach me valuable lessons.' Another admirer of Monet's London series was the art dealer and rival to Durand-Ruel, Ambroise Vollard who, since his arrival in Paris in 1887 from his remote and romantic birthplace, the Île de la Réunion in the Indian Ocean, had become the most important dealer for new art. He had taken Cézanne and Picasso under his wing and was about to do the same for a new group of painters including Derain.

In 1905 Derain spent the summer painting in the small Mediterranean fishing village of Collioure near the Spanish border with his friend Henri Matisse. Here the two artists developed a new visual language based around color; Matisse wrote that 'we rejected imitative colors … with pure colors we obtained stronger reactions.'

The results of this collaborative effort together with paintings by like-minded artists such as Maurice de Vlaminck and Albert Marquet were displayed in their own room at the 1905 Salon d'Automne. They were greeted with outrage and disbelief. One critic, Louis Vauxcelles thought that an Italianate sculpture by Marquet which had been placed in the middle of the room was like a '*Donatello parmi les fauves*' (a Donatello among the wild beasts). In a direct parallel with the insult aimed by Louis Leroy at *Impression; Sunrise* in 1874, the name stuck and Matisse, Derain and company became known as the 'Fauves.'

A month or two later Vollard, whose prescience at spotting the 'coming thing' was legendary, descended on Derain's studio, bought his entire stock of nearly 90 paintings, and gained the artist's signature on an agreement for future representation. The following year, in a direct response to Monet's London series, Vollard commissioned this new addition to his 'stable' to paint 50 views of the British capital – a somewhat ambitious target. Derain, who eventually completed 30 canvases, visited the city three times between the spring of 1906 and early 1907. He chose similar views to Monet, painting some *in situ* from similar vantage points, but most were painted back in France, using the contents of a number of sketchbooks as the basis for his compositions.

We can see in this work that Derain is using the color theories expounded by Georges Seurat (see page 147), Paul Signac and the Neo-Impressionist masters who had for a time deeply influenced Matisse. The dark blue and blue-green of the Houses of Parliament and the night sky are balanced and complemented by divisionist strokes of dark yellow and light orange in the foreground water and two dark vermillion highlights splashed on two barges. The green and light blue of the water in the middle ground forms a buffer between these dominant fields of color. *GS*

Contemporary Works

1906	Gustave Klimt: *Fritza Riedler*, Vienna, Belvedere
	Pablo Picasso: *Gertrude Stein*, New York, Metropolitan Museum of Art
	Henri Rousseau: *The Merry Jesters*, Philadelphia, Museum of Art

André Derain

1880	Born at Chatou near Paris.
1898	Derain abandons his studies as an engineer to enroll at the Académie Carrière.
1899	He is introduced to Matisse.
1900–1	Shares a studio in Chatou with Maurice de Vlaminck.
1901	Much influenced by the exhibition of van Gogh's work at Bernheim-Jeune in Paris.
1904	Completes three years of national service in the army.
1905	Spends the summer painting in Collioure in the south of France with Matisse. Exhibits with Matisse, Vlaminck and others at the Salon d'Automne. The name 'Fauves' comes into use as a group designation for their work. The dealer Ambroise Vollard buys the contents of Derain's studio.
1906	Develops friendships with Guillaume Apollinaire and Georges Braque.
1907	Moves from Chatou to central Paris. Braque and Derain form a close friendship with Picasso. Sells some work through Picasso's dealer Daniel-Henry Kahnweiler.
1908	Destroys most of the work in his possession. Concentrates on landscapes, in a style heavily influenced by Cézanne.
1912	Signs an exclusive contract with Daniel-Henry Kahnweiler. His style diverges from the avant-garde, reverting to traditional figurative painting.
1913	Three paintings by Derain are shown at the Armory Show in New York.
1914	Derain suffers four years in the army during World War I.
1919	Creates the designs for the ballet *Boutique fantasque* staged by Serge Diaghilev.
1928	Moves to a new studio in rue Douanier. Braque's studio is in the same building. They remain close friends.
1935	Buys a house at Chambourcy.
1943	Creates a series of 400 woodcuts for an edition of *Pantagruel* by Rabelais.
1954	Dies at Garches near Paris.

Otto Dix

The Metropolitan Museum of Art

Max Roesberg, the owner of an engineering firm in Dresden, stands behind his desk returning the gaze of the viewer from the corners of his eyes. His face juts forward from his ramrod-straight neck which looks as if it might swivel within his wing collar like a periscope. He holds a mail order catalog of machine tool parts in an oddly stiff hand which adds to the feeling that we are beholding some sort of semi-automaton – both arms are curiously rigid – his head is a little too large for his body. His slant-eyed gaze, while not overtly malevolent does engender a feeling of some unease. One senses a ruthless personality capable of considerable cunning tempered only by the necessity to moderate these instincts for the sake of best business practice. Would you buy a used machine tool from this man?

However his close-cropped hair, trimmed mustache, neat suit and sober tie all speak of the quiet, understated efficiency of the successful businessman as does the prominence given to the wall clock, calendar and telephone. It was this success that gave Roesberg the means to collect art and, despite his straight-laced appearance, commission a portrait from an avant-garde artist like Dix.

World War I had changed artists like Otto Dix. It had exposed him and his generation to levels of mechanized horror and cruelty which few of us can imagine and as a result his art changed. After the Great War, Dix and fellow artists such as George Grosz and Max Beckmann sought to distance themselves from what they considered the irrationality of the Expressionists

who had led the German avant-garde before the war. Deriding any show of patriotism, rejecting the past and developing a cool, unsentimental style, they sought to portray a distinctive version of objective reality infused with a merciless satirical commentary on the corruption (both financial and social) and political factionalism that paralyzed post-war German society. In 1925 an exhibition of work by Dix, Grosz and 30 other artists entitled *Neue Sachlichkeit* (New Objectivity) was organized in Mannheim, providing a name for this group of disparate artists.

Dix's portraits are never flattering and this picture is no exception – although not as chillingly forensic as many of his other portrayals of lawyers, prostitutes, theatrical personalities and writers, we are nevertheless aware that we are in the company of a man (notwithstanding his activities as a collector of the output of several young Dresden artists, including a number by Dix) whose first allegiance is to his business. *GS*

Contemporary Works

1922	Max Ernst: *Rendez-vous of Friends*, Cologne, Wallraf-Richartz Museum
	Chaim Soutine: *View of Céret*, Baltimore Museum of Art
1923	Marcel Duchamp: *The Bride Stripped Bare by her Bachelors, Even (Large Glass)*, Philadelphia Museum of Art

Otto Dix

1891	Born in Untermhaus near Gera in Thuringia, south-eastern Germany, the son of a railway worker.
1909	Begins to teach himself the techniques of painting.
1914	Joins the army as a volunteer machine gunner.
1919	Studies at the Dresden Academy of Art.
1920	Works by Dix are exhibited at the International Dada Exhibition.
1922	Dix moves to Düsseldorf. Marries Martha Koch.
1923	First solo exhibition in Berlin. *The Trench*, is purchased by the Wallraf-Richartz Museum in Cologne but is later returned as a result of a nationalist campaign portraying the painting as anti-military.
1925	The term *Neue Sachlichkeit* was coined as the title of an exhibition in Mannheim. Dix is among the 32 artists represented. Moves to Berlin.
1926	Dix is appointed as a professor at the Dresden academy.
1933	After the Nazi election victory Dix is immediately dismissed from his teaching post at Dresden. His works in public museums are confiscated.
1934	Leaves Dresden for Schloss Randegg near Singen.
1936	Moves to live in Hemmenhofen on Lake Constance.
1937	His work is included in the famous exhibition of '*Entartete Kunst*' – Degenerate Art in Munich.
1945	Conscripted into the Volkssturm – reserve militia – in the last months of World War II, Dix is captured by the French and becomes a prisoner of war.
1946	Dix is released and returns to Hemmenhofen. He is later appointed to the academies in both East and West Berlin.
1969	Dies at Singen.

Charles Demuth

The Figure 5 in Gold **1928**

The Metropolitan Museum of Art

Though various European art movements influenced Demuth, his style – with its expressive directness, sense of scale and urban, industrial feel – is distinctly American. The artist was part of the Modernist group – whose members including Marsden Hartley and Georgia O'Keeffe – centered around photographer Alfred Stieglitz that in 1920s New York sought to define an authentic American identity in the arts. Demuth helped to do just that with this painting, which is today considered an icon of American Modernism and a forerunner of Pop Art.

It was first exhibited at Stieglitz's gallery 291 and was one of a series of eight abstract poster-portraits – inspired by Gertrude Stein's word-portraits – that Demuth made of friends and colleagues between 1924 and 1929. The subject is the poet and physician, William Carlos Williams, whom Demuth had first met years before when he was an art student in Philadelphia. Williams was also a member of the Stieglitz circle and in this portrait Demuth evokes not only the man but also his poetry.

The portrait contains no physical likeness, but rather is a collage of symbols associated with Williams. There are the rather obvious initials – W.C.W. – and the names 'Bill' and 'Carlos.' Less obvious, for those who have not read Williams' poetry, are references to his poem 'The Great Figure,' which describes a red fire engine with the number 5 painted on it rushing through a New York City night.

> *Among the rain*
> *and lights*
> *I saw the figure 5*
> *in gold*
> *on a red*
> *firetruck*

moving
tense
unheeded
to gong clangs
siren howls
and wheels rumbling
through the dark city.

Williams was an 'Imaginist' poet and sought to express ideas in the most direct, succinct manner possible; an approach that Demuth here approximates in painting. The artist breaks down the space, line and color of the image to their most symbolic components.

With crisp lines and bold colors, Demuth evokes the experience of the poem: slashes of gray, black and white speak of the 'rain/and lights' while striking reds and golds suggest the 'gong clangs/siren howls/and wheels rumbling.' The number 5 seems to both recede and speed forward in the geometric space of Ninth Avenue (the avenue where Williams recalled he had seen the fire engine that inspired his poem). The roundness of the lights, corner arcs and the number 5 play off the straight lines of the fire engine, buildings and rays of light, creating an atmosphere of rushing energy.

Demuth often tailored his style to suit his subject: in paintings of nature his approach is often delicate and lyrical, while his urban subjects, like this one, are treated much like a machine: controlled, clean and hard-edged. This style, called Precisionism, incorporated various influences – such as the splintered planes of French Cubism and the mechanical ethos of Italian Futurism, which Demuth knew from his travels in Europe – however, its uniquely New York subject interpreted through Demuth's literal precision resulted in something decidedly American. **DM**

Contemporary Works

1928	René Magritte: *The Reckless Sleeper*, London, Tate
	Emil Nolde: *Large Sunflowers I*, New York, Metropolitan Museum of Art
1929	Salvador Dalí: *Illumined Pleasures*, New York, MOMA

Charles Demuth

1883	Born in Lancaster, Pennsylvania. A childhood illness leaves him lame and in poor health all his life.
1905	Studies art at the Pennsylvania Academy of Fine Arts where he meets William Carlos Williams, who becomes a lifelong friend.
1907	Travels in Europe; in Paris meets fellow American artist Marsden Hartley, who would introduces Demuth to Alfred Stieglitz.
1912	Again visits Paris to study art; exposed to European Cubism and Dada.
1914	Demuth has his first one-man show at the Daniel Gallery, New York.
1920s	Demuth is part of the Modernist group (including Marsden Hartley and Georgia O'Keeffe) which forms around photographer Alfred Stieglitz in New York.
1924–9	Completes a series of abstract poster-portraits of friends and colleagues.
1925	Subject of a one man show at Stieglitz's Gallery 291 in New York.
1935	Dies, principally from the effects of diabetes, in Lancaster.

Grant Wood

The Metropolitan Museum of Art

In 1928 Grant Wood made the long journey to Munich in order to oversee the manufacture of a stained glass window he had designed for the Veteran's Memorial Building in Cedar Rapids, Iowa. Naturally, during this sojourn he visited the great collection of old masters at the Alte Pinakothek where he was particularly impressed by the paintings of the early Netherlandish school. Munich, at this time, was also one of the principal centers of a movement of German painting dubbed *Neue Sachlichkeit* (New Objectivity – see page 155) – a reaction against abstraction and expressionism, preferring a cool, cynical realism. Wood was attracted to the direct and orderly precision of these two disparate influences and on his return to the United States he incorporated these ideas in his depictions of rural American subjects.

His painting *American Gothic* (in the Art Institute, Chicago) completed in 1930, brought him fame; it is a paradigm of Wood's new style – detached, detailed, quintessentially American. Although the image of the staid, stern-faced farmer (actually Wood's dentist) and his daughter has been frequently parodied and is often seen as a satire on the denizens of the Midwest, Wood actually intended his iconic picture to be understood as a positive affirmation of the values of Middle America, epitomized by hard work (the farmer's pitchfork figures prominently) and the simplicity of vernacular architecture and unadorned clothing.

These were the values celebrated by a group of artists and writers working in the 30s who were known as the Regionalists of which Wood was one. They rejected European modernism and abstraction, and the predominance of New York, in favor of a focus on rural, or at least non-urban, subject matter, painting in an unashamedly figurative style.

In *The Midnight Ride of Paul Revere* Wood's unalloyed realism, rather than bringing us face to face with the actuality of the Midwest, creates a New

England dreamscape – a Disney model village which might have been plucked from the pages of a children's illustrated story book. The scene is presented to us in bird's eye view; a road snakes through the implausible folds of the landscape to a small settlement which clusters around a clapboard church with a beautifully slender spire. Cliffs rise behind the village, half lost in the gloom of the night, resembling giant sandcastles. The uniform trees, all shaped into perfect spherical crowns, look like those used in a model train layout.

The eponymous hero is shown galloping past the church, on his way from Boston to Lexington, his arm pointing behind him, warning of the imminent arrival of British forces. Lights have been lit, throwing precisely delineated shafts from windows as the inhabitants rush from their houses to investigate.

This picture could hardly present a starker contrast with the output of the modern movements that held the stage in Europe. But one's attention is attracted by the sheer charm of this painting, one of the beacons proudly maintaining the flame of figurative painting in America – a torch which would later be passed to Andrew Wyeth and Edward Hopper. *GS*

Contemporary Works

1930	Piet Mondrian: *Composition No. 1*, New York, Guggenheim Museum
	Salvador Dalí: *The Invisible Sleeping Woman, Horse, Lion etc*, Paris, Musée National d'Art Moderne – Centre Georges Pompidou
1931	Pierre Bonnard: *The Breakfast Room*, New York, MOMA

Grant Wood

1891	Born in Anamosa, Iowa.
1901	Wood's father dies and the family moves to Cedar Rapids, Iowa.
1910–11	Studies at Minneapolis School of Design and Handicraft.
1912–13	Wood takes short courses at the University of Iowa.
1913	Studies at the Art Institute of Chicago.
1920s	Visits Europe four times.
1923	Enrolls at the Académie Julian in Paris.
1928	Visits Munich where he is influenced by the *Neue Sachlichkeit* movement and by Netherlandish works he saw at the Alte Pinakothek.
1930	Completes his best known work – *American Gothic*.
1932	Co-founds the Stone City Art Colony near Cedar Rapids which lasts for two years.
1934	Moves to Iowa City to teach at the School of Art at the University of Iowa.
1942	Dies in Iowa City.

Anselm Kiefer

Bohemia Lies by the Sea **1996**

The Metropolitan Museum of Art

For Kiefer, art has always been about the big questions: truth, meaning and mankind's place in the cosmos. As a young man, he studied law but after three weeks in a Dominican monastery, where he had gone to 'think quietly about the larger questions,' turned instead to art. Four decades later, Kiefer continues to question and create paintings, sculptures and installations of great visual power and profound intellectual analysis. He is deservedly considered one of the most important artists of his generation.

'I'm interested in reconstructing symbols,' Kiefer has stated. 'It's about connecting with an older knowledge and trying to discover continuities in why we search for heaven'. In style, he draws on the formal heritage of Abstract Expressionism but in his preference for mythic themes and epic scope he demonstrates his debt to the long tradition of northern European Romanticism. His work references literature, history and politics, giving his art layers overflowing with symbols, metaphors and overlapping interpretations.

Kiefer has never shied away from difficult subjects, particularly about his own heritage. Born in Germany months before the end of World War II, Kiefer grew up as a witness to the fall-out from German nationalism. As a young artist, he studied informally in Düsseldorf with Joseph Beuys (1921–86), whose use of unusual materials, allusions to history, mythology, religion and art, and direct response to the Holocaust in his imagery, greatly influenced Kiefer. For many years, Kiefer's work unblinkingly explored the connection of German mythology and history and the rise of Fascism and the Third Reich. However since moving to southern France in 1992, he has explored new themes, and while still pondering weighty issues his art has taken on a more lyrical mood.

Bohemia Lies by the Sea revisits a frequent theme in Kiefer's art: the land, which the artist uses as a foundation for exploring the connection between landscape, human history and dreams of utopia. The image's masterful command of scale, deep perspective and rich impasto surface are characteristic of Kiefer. However, unlike the barren landscapes of post-war Germany, which often appeared in his earlier work, this painting features a blooming field of flowers.

A rutted country road passes through fertile fields of pink-orange flowers, identified by the artist as poppies. From antiquity, poppies have been associated with dreams, sleep and death and more recently with military veterans; a reference suggested by the occasional splash of blood-red paint. The textured surface and lines of luminous shellac create a shimmering dream-like atmosphere. Kiefer's choice of materials – a combination of oil, emulsion,

shellac, charcoal and powdered paint on burlap – are a mix of traditional media and natural elements and are as symbolically charged as his imagery.

It is the title – *Böhmen liegt am Meer* (*Bohemia lies by the sea*) – written receding into the horizon on the left, that helps explain the landscape's elegiac beauty and vague nostalgia. The title is taken from a well-known poem by the Austrian writer Ingeborg Bachmann (1926–73) that explores the irreconcilable longing for utopia with the understanding that it can never be found, just as the former kingdom of Bohemia, landlocked in central Europe, can never lie by the sea (a reference no doubt inspired by Shakespeare's stage direction in his play *The Winter's Tale*, Scene III – Bohemia: 'A desert country near the Sea').

Life in the south of France seems to have relieved some of the weight of history that Kiefer seemed to bear for so long, yet he continues in his search for meaning and truth in images like this, full of irony, contradiction and epic beauty. *DM*

Contemporary Works

1996	Beatriz Milhazes: *Succulent Eggplants*, New York, MOMA
	Rachel Whiteread: *Untitled (Ten Tables)*, New Haven, Yale Center for British Art
1997	Rodney Graham: *Vexation Island*, Toronto, York University Gallery

Anselm Kiefer

1945	Born in Donaueschingen, Germany.
1965	Studies law in Freiburg.
1966	Switches to study art.
1969	Continues his studies in Karlsruhe. During travels through Switzerland, Italy and France he produces a series of photographic works called *Occupations* which show Kiefer imitating a Nazi salute.
1970	Studies with Joseph Beuys at the Düsseldorf Kunstakademie.
1971	Moves to live in Hornbach where he works on large landscape paintings.
1980	Represents Germany at the Venice Biennale.
1984	Visits Israel.
1992	Moves to live in Barjac, France where he has created a huge studio comprising glass buildings, storerooms, archives and subterranean chambers.

After an extensive renovation by celebrated architect Yoshio Taniguchi, the MOMA reopened in 2004 with over 630,000 square feet of exhibition space featuring high ceilings, natural light and an urban garden. This elegant work of architecture houses one of the most comprehensive holding of modern art in the world. Its amazing permanent collection – which includes 150,000 paintings, sculptures, drawings, prints, photographs, etc., as well as approximately 22,000 films and four million film stills – continues to grow covering works from the Impressionists to the latest in contemporary art.

The original impetus for an institution devoted solely to modern art came from three influential patrons of the arts, Miss Lillie Bliss, Mrs Cornelius Sullivan, and Mrs John D. Rockefeller, Jr. The Museum of Modern Art was founded in 1929 and its first Director, Alfred H. Barr, Jr, wanted the museum to help people understand and enjoy the visual arts of their own time. During the next ten years, the museum moved three times due to the need for more space but in 1939 it finally arrived at its present location on 53rd Street in midtown Manhattan. The museum continued to expand – Philip Johnson renovated the MOMA in 1950s and 1960s and Cesar Pelli doubled the museum's gallery space in the 1980s.

Today it remains the number one destination for modern art fans in New York.

The Museum of Modern Art (MOMA)

11 West 53rd Street,
between Fifth and Sixth avenues
New York, New York 10019-5497
Tel: 212-708-9400
www.moma.org

Opening Hours

10.30am – 5.30pm Saturday, Sunday, Monday, Wednesday, Thursday
10.30am – 8.00pm Friday (free entry 4.00pm to 8.00pm)
Closed Tuesday. Also closed Christmas Day and Thanksgiving Day.

Admission

$20 adults; $16 senior citizens (65 and over); $12 full time students.
Children (16 and under) are free.

How To Get There

Subway: E or V to Fifth Avenue/53rd Street; B, D, or F to 47th-50th Streets/
Rockefeller Center.

Buses M1, 2, 3, 4, 5 to 53rd Street.

Access for the Disabled

All public areas of the museum and all entrances are wheelchair
accessible.

MOMA Stores

Flagship Store – 11 West 53rd Street. In the renovated museum building.
Open Saturday – Thursday 9.30am – 6.30pm
Friday 9.30am – 9.00pm

MOMA Design Store – Directly across the street from the museum at
44 West 53rd Street stocking design objects, gifts, jewelery, personal
accessories, furniture, and lighting.
Hours are the same as the Flagship Store.

MOMA Design Store, Soho – 81 Spring Street, New York, NY
Monday – Saturday 11.00am – 8.00pm
Sunday 11.00am – 7.00pm

Vincent van Gogh

The Starry Night **1889**

The Museum of Modern Art

Van Gogh painted this celebrated 'Starry Night' in June of 1889 while confined to an asylum in the monastery of Saint Paul de Mausole near St-Rémy-de-Provence. He had come to Provence a year and a half earlier, looking for artistic inspiration and solace for his already troubled mind. He found his inspiration in the brilliant color and light of the region, capturing in painting his deep affinity for nature. However, peace of mind was more elusive. Following a dispute with his friend Paul Gauguin, van Gogh suffered a mental breakdown, ending with the now infamous ear incident in which van Gogh cut off part of his own ear and gave it to a local prostitute. A few months later he voluntarily entered the asylum at St-Rémy.

While there, during lucid periods, van Gogh was permitted to paint in the surrounding countryside and one of his favorite subjects was the Provençal night sky. 'This morning I saw the country from my window a long time before sunrise,' he wrote in one of his many letters to his devoted brother Theo, 'with nothing but the morning star, which looked very big'. For van Gogh, the stars and sky were filled with metaphysical meaning and to paint them was a means of redemption. 'Looking at the stars always makes me dream,' wrote van Gogh, 'Why, I ask myself, shouldn't the shining dots of the sky be as accessible as the black dots on the map of France? Just as we take the train to get to Tarascon or Rouen, we take death to reach a star'.

In this fantastic night sky van Gogh depicts a highly charged mixture of imagination and memory, an expression of his own mental landscape. The sky is like a churning wave, swirling with frenetic energy – the stars and moon shimmer like cosmic fireworks. Connecting the land and the sky is a characteristic Provençal cypress that reaches up like a flame into the night. The village, particularly its soaring spire, recalls the Dutch communities van Gogh would have known as a youth; however the natural setting is pure Provence filtered through the turbulent mind of the artist. The entire scene is imbued

with intense emotion, articulated with bold, interacting color, wild brushwork and expressive lines. 'The emotions are sometimes so strong that one works without being aware of working,' van Gogh wrote, 'and the strokes come with a sequence and coherence like words in a letter or speech.'

Though largely self-taught as an artist, van Gogh had spent time in Paris before coming to Provence where he absorbed numerous influences: the bold color and direct effect of Japanese prints, the techniques of the Impressionists and the approach of artists like Gauguin and the Pont-Aven Group who believed an artist should be free to invent subjects and to stylize. However, van Gogh adhered to no one stylistic approach; he once wrote 'I think the search for style is prejudicial to the true sentiment of things.' For above all, he wanted people to 'see' what he saw in the Provence landscape, which he thought others had missed: 'Good Lord, I have seen things by certain painters which do not do justice to the subject at all. There is plenty for me to work on here.' So well did van Gogh succeed in capturing the quintessence of Provence, that today local tourist boards promote the region using his images. And so well did he express his inner vision, his art became a touchstone for all subsequent Expressionist painting and much of early 20th-century art. However, in his lifetime, van Gogh sold only one painting and was supported both emotionally and financially by his brother Theo. And though he painted prolifically – during his year in St-Rémy van Gogh produced over 150 paintings – he found neither critical success nor consolation and a year after completing this work took his own life at the age of 37. *DM*

Contemporary Works

1889 Paul Gauguin: *La Belle Angèle*, Paris, Musée d'Orsay
 Giovanni Segantini: *The Fruits of Love*, Leipzig, Museum der bildenden Künste
 Camille Pissarro: *Apple Picking at Eragny-sur-Epte*, Dallas, Museum of Art

Vincent van Gogh

1853 Born at Grooot-Zundert in the southern Netherlands, the son of a pastor.
1869 Becomes an apprentice at the French art dealers Goupil & Co. in The Hague.
1873 Van Gogh is transferred to the firm's London branch. He falls in love with the daughter of his landlady but is rejected – a bitter personal blow.
1875 He is transferred to the head office of Goupil & Co. in Paris.
1876 Increasingly obsessed with religion, van Gogh is sacked. Travels to England and works in church schools in Ramsgate and West London.
1877 Returns to the Netherlands and decides to become a minister but fails to gain a place in the Theological Faculty at Amsterdam.
1878 Becomes a lay preacher in a mining area of Belgium.
1879 His contract is not renewed. Decides to become an artist.
1880 Studies drawing in Brussels. Becomes dependent on the financial support of his brother Theo who works for Goupil & Co. in Paris.
1881 Returns to live with his parents. In December moves to The Hague where he lives with a prostitute Clasina (Sien) Hoornik.
1883 Leaves Sien and after a spell in the province of Drenthe returns to live with his parents in Nuenen where he paints peasant life.
1885 His father dies. In November he moves to Antwerp.
1886 Joins his brother Theo in Paris who introduces him to the Impressionist circle.
1888 In February he leaves Paris for Arles. Gauguin is persuaded to join him but soon announces that he wants to leave. Van Gogh cuts off a small part of his ear. He is committed to the Hôtel Dieu in Arles but discharges himself.
1889 After suffering further hallucinations and attacks of paranoia he is admitted to the asylum near St-Rémy-de-Provence.
1890 In May he leaves the asylum and travels to Auvers-sur-Oise. Vincent shoots himself on 27 July. Two days later he dies.

Paul Cézanne

Château Noir **1903-4**

The Museum of Modern Art

Today Paul Cézanne is admired as one of the greatest artists of the late 19th century; which makes it all the more surprising to recall that in his own time, few people liked Cézanne's work. In fact, when Cézanne offered his hometown, Aix-en-Provence, a large collection of his paintings they responded with a firm 'non.' However, his fellow artists thought differently and it was Claude Monet who first purchased this painting of the *Château Noir* from Cézanne for his home in Giverny.

The painting depicts the Provençal landscape that so entranced Cézanne. The son of a well-to-do banker, Cézanne spent an idyllic childhood amidst Provence's ancient history and natural beauty. He dropped out of law school to become an artist and spend much of the 1860s and 1870s as a struggling painter in Paris where he was part of the same circle as Manet, Monet and Pissarro. But he always felt most inspired in Provence and returned to Aix permanently in 1886. 'When one is born there [Aix],' wrote Cézanne, 'that's it, nothing else appeals'.

Despite his early association with the Impressionists Cézanne's art is considered 'Post-Impressionist,' – by the 1880s he and contemporaries like van Gogh and Gauguin had moved beyond the Impressionist's aims of representing modern life, to look for deeper, more personal meaning. This search took on several forms but for Cézanne it was an all-absorbing study of nature. He spent most of his days painting out in the countryside around Aix, attempting to capture what he saw and felt. 'To paint from nature is not to paint the subject,' he wrote, 'but to realize sensations'. Yet Cézanne approached these 'sensations' analytically on canvas – he once instructed another painter to 'treat nature by means of the cylinder, the sphere, the cone' – an approach that foreshadowed and greatly influenced early 20th-century Cubist and Abstract Art.

Cézanne would occasionally rent rooms at the Château Noir, a 19th-century Neo-gothic estate five kilometers east of Aix-en-Provence on the rue du Tholonet, where he based himself while he painted the surrounding

countryside. He also painted the château itself many times from the 1880s, including numerous watercolors and four paintings.

In these pictures, he attempted to work out various pictorial problems, such as creating depth and using color to create form. Here, the foreground is filled with green wind swept pines set before the ochre-colored château (made of stone from the nearby Bibémus quarry, which Cézanne also painted), an unsettled cerulean sky and limestone hills. Uninterested in the laws of classical perspective, Cézanne presented each thing independently within the pictorial space, emphasizing each object's relations to another, rather than adhering to one-point perspective. He also experimented with subtly gradated tones to create dimension in his objects, painted with what he called 'constructive brushstrokes.' Cézanne wrote: 'Shadow is a color just like light, but less brilliant; light and shadow are nothing but the relationship of two tones.' The result of all this technical experimentation is a shimmering, evocative and startlingly modern vision of the warm light and color of Provence.

By the time of this painting, 64-year-old Cézanne was finally gaining some recognition in the art world. However, fame, he claimed, was not his goal: 'All my life I have worked to be able to earn my living, but I thought that one could do good painting without attracting attention to one's private life. Certainly, an artist wishes to raise himself intellectually as much as possible, but the man must remain obscure. The pleasure must be found in the work.' *DM*

Contemporary Works

1904	Pablo Picasso: *The Blind Guitarist*, Chicago, Art Institute
	Henri Matisse: *Luxe, Calme et Volupté*, Paris, Musée d'Orsay

Paul Cézanne

1839	Born in Aix-en-Provence the son of a prominent businessman.
1852	At school, he meets Émile Zola who becomes a close friend.
1857	Enrolls at the École Municipale du Dessin in Aix.
1859	Under pressure from his father he studies law at the university in Aix.
1861	Moves to Paris after abandoning university. Attends the Académie Suisse.
1863	Fails the entrance exam for the École des Beaux-Arts. Exhibits at the Salon des Refusés (in company with Manet and Pissarro).
1869	Meets Hortense Fiquet, a 19-year-old model who becomes his mistress.
1870	At the outbreak of the Franco-Prussian war he quits Paris for L'Estaque .
1871	Returns to Paris after the fall of the Commune.
1872	Hortense gives birth to a son (Paul). Moves his family to Pontoise where he works outdoors with Pissarro whom he thought of as his master.
1873	Stays in Dr Gachet's house in Auvers-sur-Oise. Meets van Gogh.
1874	Exhibits at the First Impressionist Exhibition where his paintings come in for particular criticism from the press.
1877	Shows 16 works at the Third Impressionist Exhibition. The critics are again scornful and he resolves not to take part in further group shows.
1878	Moves to live in L'Estaque but makes annual trips to Paris.
1881	Works with Pissarro again in Pontoise.
1886	Falls out with Zola after the publication of the latter's novel *L'Ouvre* in which Cézanne recognizes himself as the main character, a failed artist. Marries Hortense in April. His father dies in October.
1892	Buys a house near the forest of Fontainebleau.
1894	Visits Monet at Giverny where he meets Rodin and Georges Clemenceau.
1895	Ambroise Vollard shows 150 works by Cézanne.
1899	Sells Jas de Bouffan and moves to Aix; his wife and son remain in Paris.
1903	Exhibits seven pictures at the Vienna Secession.
1904	At the Salon d'Automne Cézanne's paintings fill a room.
1906	Dies at Aix-en-Provence.

Pablo Picasso

Les Demoiselles d'Avignon **1907**

The Museum of Modern Art

In the late autumn of 1907 Picasso unveiled a huge new painting at his studio in Montmartre, but only for the eyes of a few fellow artists, friends and patrons. According to the critic André Salmon, who was member of this charmed circle, 'It was the ugliness of the faces that froze with horror the half-converted.' Most, including Braque and Derain were appalled by what they saw. The painting remained in Picasso's studio until 1916 when it was exhibited in a commercial gallery in Paris; it was at this time that André Salmon conceived the title by which it is still known, *Les Demoiselles d'Avignon* – referring to a brothel in the Calle Avigno in Barcelona. It then disappeared back into Picasso's studio until it was sold to a private buyer a few years later. The painting was not exhibited again for 21 years when it was shown at the Petit Palais in Paris in 1937.

Les Demoiselles d'Avignon is one of the most important and influential paintings of the 20th century so it is curious that it was not until just before the outbreak of the Second World War, when it was acquired by the Museum of Modern Art in New York, that it was at last put on permanent display. Its importance lies in its position as a watershed in the development of Picasso's art, and in the birth of Cubism. Even now after 100 years, the violent clashing forms within the painting still have a visceral effect on the shocked viewer.

Five figures confront us, inhabiting a narrow space filled with jagged forms which may represent a backdrop or may, as the critic Robert Hughes suggests, denote a distortion of space itself. These angular, dysmorphic harpies are prostitutes who are displaying themselves in the parade – the moment when the visitor to a brothel makes his choice from a number of women. Picasso made a great many preparatory sketches for this composition and it is clear that initially he intended to include two men – a medical student and another figure which may have been a sailor. Their exclusion from the finished picture means that the (male) viewer now finds himself in the position which would have been occupied by the client. The hard, fixed stares of the central pair of

women who glare directly out of the canvas convey the harsh reality of their situation and accentuates the tensions at play within the painting.

We know from the preparatory sketches that one of the two male figures which failed to make it into the final version was holding a skull. This link with the allegorical *vanitas* paintings of earlier centuries, in which the skull was an important motif reminding us of the transience of life, takes us to the core of the work. Because of this painting's modernity we sometimes need to remind ourselves that Picasso was inhabiting the same city which had been portrayed not long before by Toulouse-Lautrec. It was the City of Light, the capital of hedonistic excess and Picasso's studio in Montmartre was surrounded by the same brothels, bars and cafés, which Toulouse-Lautrec had delighted in patronizing. The downside of this heady mix of available sex, alcohol and license was an enveloping sense of anxiety and doom caused by an epidemic of syphilis. In such an atmosphere fear stalked those who sated their sexual desires by making a choice at the parade.

The two women to the right of the composition are certainly a daunting sight – enough to make most men think again. They were repainted quite late in the gestation of the piece, after Picasso visited an exhibition of African art. He became fascinated with his discovery of the art of Africa and the faces of the two women owe their disturbing physiognomy to his new found enthusiasm for African masks. But the eclectic mix of influences to be found within the picture are many; top of the list is Paul Cézanne whose late series of compositions portraying monumental female bathers are obvious precursors. El Greco's attenuated bodies and startling palette have also been seen as an influence as well as early Iberian and Cycladic sculpture. All these elements have been fused with Picasso's genius to produce a disturbing, groundbreaking masterpiece. *GS*

Contemporary Works

| 1907 | Gustav Klimt: *Portrait of Adele Bloch-Bauer I*, New York, Neue Gallerie |
| | Henri Rousseau: *The Snake Charmer*, Paris, Musée d'Orsay |

Pablo Picasso

1881	Born Pablo Ruiz in Málaga, 25 October.
1895	The family move to Barcelona.
1900	Picasso and his friend Casagemas leave for Paris.
1901	He starts to sign his works using his mother's surname, Picasso.
1904	Picasso rents a studio at *Le Bateau-Lavoir*. Meets Guillaume Apollinaire.
1909	Picasso and Braque develop Cubism.
1912	Picasso produces the first collage, *Still Life with Chair-caning*.
1915	His current companion Eva Gouel dies.
1916	Meets Jean Cocteau who introduces him to Diaghilev.
1917	Designs the sets for the Ballets Russes production of *Parade*.
1918	Marries the dancer Olga Koklova.
1927	Meets Marie-Thérèse Walter who later becomes his mistress.
1931	Picasso's marriage to Olga breaks down.
1933	Designs the cover for the first edition of the Surrealist periodical *Minotaure*.
1935	Marie-Thérèse Walter gives birth to Picasso's daughter.
1937	In a reaction to the Fascist bombing of the Basque town during the Spanish Civil War, Picasso produces the huge iconic painting *Guernica*.
1940	Picasso continues to live in Paris during the Nazi occupation.
1944	Joins the Communist Party after the liberation of Paris.
1950	The Vollard Suite, 100 etchings produced in the 1930s goes on sale.
1958	Buys the Château de Vauvenargues near Aix-en-Provence.
1967	Refuses the Légion d'honneur.
1973	Dies at Mougins, France.

Ernst Ludwig Kirchner

Street, Dresden **1908**

The Museum of Modern Art

While visiting Munich in 1903 Kirchner saw an exhibition of Post-Impressionist paintings which had been mounted by a group (The Phalanx) led by Vasily Kandinsky. The work of Paul Signac, Vincent van Gogh, Henri de Toulouse-Lautrec and others, which he saw at this Munich exhibition had a profound effect on Kirchner, an influence which was equalled by the advent of the Fauves a couple of years later, whose use of color is an obvious inspiration for this painting.

In the same year that Matisse and Derain were at work in Collioure on the Mediterranean coast of France, producing the first color-saturated Fauvist pictures, many miles to the north, in Dresden, not far from a much colder sea, Kirchner and three friends (Fritz Bleyl, Erich Heckel and Karl Schmidt-Rottluff - all four were architecture students) were forming an influential group which they called *Die Brücke* – the Bridge. The name was symbolic of a bridge to a new art, direct and youthful, an art which was presented to the Dresden public for the first time in 1906 at an exhibition mounted in the showroom of a lamp factory.

The members of *Die Brücke* may have used Fauve-like color in their work but the results are markedly different. Whereas the Fauves use of color creates a feeling of warmth and well being (one thinks of Matisse and Derain working in their Mediterranean arcadia at Collioure), here the clashing colors induce a sense of angst. Apart from a startling expanse of pink representing the Dresden street, the canvas is packed with a predominantly female crowd. A number of these women are sporting huge belle-époque hats which seem to add to the latent claustrophobia. The tram track rears upwards at an acute angle creating an uncertain perspectival space and increasing the general sense of unease. The tram, seen in a central position at the top of the picture, blocks our line of sight (in a similar way to all those hats) and looks as if it might topple towards the child in the center of the composition. Three women stare disconsolately

out of the picture – they seem apprehensive, uneasy, infected by the anxiety inherent in city life.

The work of the *Brücke* group came to exemplify all that is understood when we speak of Expressionism – an art which is searching for emotional impact through deliberate exaggeration of outline and color, and where traditional ideas of beauty are sacrificed in order to emphasize the expression of emotion.

Kirchner's experiences in the army during First World War resulted in a nervous breakdown; his recovery necessitated a lengthy spell in sanatoriums in Switzerland where he subsequently settled. The Alpine scenery, a far cry from the crowded streets of Dresden, inspired a shift to a more serene style in which Kirchner painted landscapes. But in the late thirties the angst returned and he committed suicide. *GS*

Contemporary Works

1908	Odilon Redon: *Ophelia among the Flowers*, London, National Gallery
	Georges Braque: *Houses at L'Estaque*, Berne, Kunstmuseum
	Pierre Bonnard: *La Loge* (The Box), Paris, Musée d'Orsay

Ernst Ludwig Kirchner

1880	Born at Aschaffenburg.
1901	Kirchner's parents do not support his plans to become a painter and he enrolls in the *Königliche Technische Hochschule* in Dresden to study architecture but also undertakes clandestine studies in painting.
1903	Kirchner interrupts his studies to spend a term in Munich.
1905	Qualifies as an engineer. Takes up painting full time. In June Kirchner founds *Die Brücke* with three other architecture students – Fritz Bleyl, Erich Heckel and Karl Schmidt-Rottluff.
1906	Sets up a studio in a former butcher's shop in Dresden. Meets Emil Nolde and Max Pechstein who both join the group. First *Die Brücke* show in Dresden.
1908	Members of *Die Brücke*, including Kirchner visit Berlin and see an exhibition of paintings by Matisse at Galerie Cassirer.
1910	Paintings by *Brücke* artists are exhibited at one of Dresden's most prestigious galleries – Galerie Arnold.
1911	Kirchner follows other members of the group who relocate to Berlin, joining Max Pechstein who has been there since 1908.
1913	*Die Brücke* dissolves partly because of friction between Kirchner and the other members.
1914	Kirchner is conscripted into the army.
1915	Suffers a complete nervous breakdown and receives a provisional discharge.
1917	Still suffering from depression Kirchner moves to live in Frauenkirch near Davos in Switzerland. His style gradually changes and he produces more landscapes.
1922	Collaborates with a weaver to produce tapestries.
1923	An exhibition of his work is mounted at the Kunsthalle in Basel.
1925-9	Makes several trips to Germany where he gradually gains recognition.
1937	Kirchner's work is included in the 'Degenerate Art' exhibition mounted by the Nazis. Hundreds of his paintings and other work in German museums are confiscated and many destroyed.
1938	Commits suicide in Frauenkirch.

Vasily Kandinsky

The Museum of Modern Art

Today, considered a central figure of 20th-century art, Kandinsky spent most of his early career searching for his artistic voice. It wasn't until 1908, when he was a 42-year-old art professor in Munich living with a former student, the artist Gabriele Münter, that Kandinsky had his first artistic breakthrough. He and Münter began to spend time in Murnau, a village near the Bavarian Alps, and the area's bucolic beauty became an inspiration for both of them. The exuberant *Picture with Archer* dates from this period and it suggests everything Kandinsky would become as an artist.

It is a heady mix of nostalgia, excitement and promise. Evoking the romantic atmosphere of a dream or folk tale, the scene is set in an abstracted landscape of multi-hued mountains and trees with a small house and an onion-domed tower. In the left foreground stand a cluster of men in Russian dress and, adding a dash of chivalric drama, to the right is a galloping horse and rider, who turns and points a bow at some unseen target.

In this painting Kandinsky merges the natural splendor of the Murnau countryside, the influences of Bavarian folk art (particularly glass painting) and his own memories of the iconic art of his native Russia with a palette of vibrant hues. The intense color was partially inspired by the Fauves and other French artists who he and Münter had encountered while living in Paris from 1906-07, and in part by Münter herself, who favored high color, rough brushwork and unusual viewpoints. While still figural, *Picture with an Archer* points towards abstraction with its patchwork of masterful color and pulsating energy, creating an effect almost like music. And indeed, within a few months of completing this canvas, Kandinsky would be the first modern artist to paint an entirely abstract work.

From the time of this painting, Kandinsky stripped away descriptive detail, reducing forms and figures to calligraphic lines and color. Kandinsky often spoke

of painting like music (he was greatly influenced by the avant-garde composer Schönberg) and believed re-occurring motifs, even abstract ones, and brilliant color could trigger emotion (or as he put it, an 'inner sound'), just as a piece of music does. In abstraction, Kandinsky felt art could put aside material concerns and reveal a spiritual truth, which would be more powerful for not being tied to reality. For Kandinsky, painting thus became a sort of music for the eyes.

The horse and rider motif was one that Kandinsky came back to again and again. The theme was inspired by St George, the heroic Christian saint often depicted killing a dragon while on horseback, who was a central character in both Russian and Bavarian folk art. For Kandinsky, the rider symbolized his own crusade against conventional values and his belief that art could lead the way to spiritual renewal. The rider first appeared in Kandinsky's art in Russia at the turn of the century and was a reoccurring motif in his Bavarian landscapes from around 1909-10. The theme would become central to the group Kandinsky founded in 1911 with Franz Marc: *Der Blaue Reiter* (The Blue Rider). And indeed, the horseman was incorporated into the cover designs of Kandinsky's theoretical manifesto *On the Spiritual in Art* (1911) and the *Blue Rider Almanac* (1912). **DM**

Contemporary Works
1909 Pablo Picasso: *The Factory, Horta de Ebro*, Saint Petersburg, Hermitage
 Gustav Klimt: *Judith II (Salome)*, Venice, Galeria d'Arte Moderna

Vasily Kandinsky

1866 Born in Moscow but grows up in Odessa.
1886 Attends Moscow University studying economics and law.
1892 Marries his cousin Anya Shemyakina (divorced 1911).
1896 Decides to become an artist; studies at an independent art school in Munich where he meets Alexei Jawlensky.
1900 Studies at the Akademie in Munich with Franz von Stuck.
1902 While teaching art in Munich he meets Gabriele Münter, one of his students, who becomes his lover.
1905 Kandinsky and Gabriele Münter are in Tunisia.
1906-7 They travel in France. Sees works by the Fauves and Gauguin. Kandinsky responds by introducing more brilliant color into his paintings.
1908 Spends time in the Bavarian mountains at Murnau.
1909 Co-founder of the *Neue Kunstlervereinigung München*. Paints his first 'Improvisation.' Moves towards abstraction.
1911 Completes *On the Spiritual in Art*. Kandinsky is instrumental, with Franz Marc, in the formation of *Der Blaue Reiter* group. First group exhibition at Galerie Thannhauser in Munich.
1912 *Der Blaue Reiter Almanac*, a seminal manifesto, edited and largely written by Kandinsky and Marc, is published. Second group exhibition.
1914 On the outbreak of the First World War Kandinsky is forced to leave Munich for Switzerland. Then stays in Sweden.
1917 Travels to Moscow. Meets and marries Nina von Andreyevskaya.
1919 Kandinsky becomes director of museums in Russia.
1921 Walter Gropius offers Kandinsky a professorship at the Bauhaus.
1923 One man show in New York.
1925 Shares a house with Paul Klee who is also teaching at the Bauhaus.
1926 60th birthday exhibition of his work travels to several German cities.
1932 The Nazis force the closure of the Bauhaus.
1933 Kandinsky and his wife move to Neuilly-sur-Seine near Paris.
1937 Kandinsky's work is included in the Nazi exhibition of Degenerate Art in Munich.
1939 He is granted French citizenship.
1944 Dies in Neuilly-sur-Seine.

Oskar Kokoschka

The Museum of Modern Art

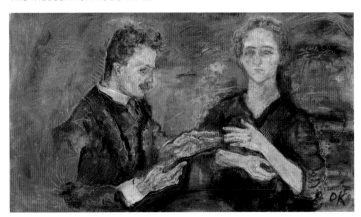

Kokoschka was a classic 'angry young man'. He stormed into the rarefied artistic world of haute bourgeois Vienna and set out to shock; a goal he achieved in 1908 when he was expelled from the Vienna School of Fine Arts for his explicit contributions to the Vienna Kunstschau. However, the avant-garde architect Adolph Loos befriended Kokoschka and helped the impoverished 23-year-old find his first commissions among members of the Viennese intelligentsia. The young rebel ironically found himself earning a living from perhaps the most bourgeois of all artistic genres: portrait painting. However in Kokoschka's hands a portrait was not simply a display of position or wealth: it was a picture of the soul.

Kokoschka – who would become a leader of the Expressionist movement – stated that his portraits from this time (circa 1908-1915) came from his own feelings of alienation. He threw himself into portrait painting, he said, in an attempt to connect with others; to discover and illustrate their essence or consciousness in a bid to understand his own (this was, after all, the age of Freud). Kokoschka's obsession with interior states was in pointed contrast to many of his successful Viennese contemporaries, like Gustav Klimt, who were fascinated by the two-dimensional beauty of surface ornament. Kokoschka wanted to transcend surfaces and, in his own words, 'to render the vision of people being alive', penetrating the sitters' 'closed personalities so full of tension'; an ambition that is undoubtedly attained in this pulsating double portrait of husband and wife, Hans Tietze (1880-1954) and Erica Tietze-Conrat (1883-1958).

The young couple – both art historians who were prominent in Vienna's avant-garde art circles and later helped organize the city's Society for the Advancement of Contemporary Art – commissioned this marriage portrait for their mantelpiece from Kokoschka in 1909. Despite the static medium, the pair appears animated. 'A person is not a still life' stated Kokoschka and he often kept his sitters moving and talking to better capture their spirit: 'From their face, from the combination of expression and movement,' he wrote, 'I try to guess the nature of the person, recreating with my own pictorial language, what would survive in memory'.

Erica Tietze-Conrat recalled that Kokoschka painted she and her husband separately; a fact supported by their individual poses and lost-in-thought gazes. Despite this autonomy, the pair occupy the same shimmering, multi-hued atmosphere. Kokoschka rarely included any background detail in his portraits; the ambience was to be created by the sitter's psyche, or, as in this case, by the electric interaction between two individuals. Both seem to radiate a crackling energy or light, an effect enhanced by the thin layers of vibrant color and the scratches Kokoschka made (according to Tietze-Conrat) with his fingernails all over the surface. The result is that the couple – whom Kokoschka referred to 'the Lion' (Hans) and 'the Owl' (Erica) – seem to inhabit the same spiritual space; one feels that if their hands, which seem to reach towards each other, were to touch, there would be a spark, no doubt a symbolic reflection of their personal and intellectual relationship. For all his youthful anger and alienation, Kokoschka here creates a perceptive and surprisingly tender evocation of two kindred, yet independent, spirits.

The couple had married in 1905. As there were no academic positions for women at the time, the two worked together as a research team; for most of their lives their desks faced each other so they could more easily discuss ideas. Each, however, published separately as well as together. Many years later, after the Nazi annexation of Austria, the pair were forced to emigrate (both were of Jewish heritage). They settled in New York City where they would continue their art history work (Tietze-Conrat taught at Columbia) and, in order to fund their new life, they sold this portrait to the MOMA in 1939. *DM*

Contemporary Works

| 1909 | Georges Braque: *Château de La Roche-Guyon*, Stockholm, Moderna Museet |
| | Albert Marquet: *The Port of Hamburg*, Saint Petersburg, Hermitage |

Oskar Kokoschka

1886	Born at Pöchlarn in Austria.
1904-9	Studies at the Kunstgewerbeschule in Vienna.
1908	Exhibited at the Kunstschau, organized by Gustav Klimt.
1909	Again exhibits at the Kunstschau. Conservative critics are outraged.
1910	Herewath Walden engages Kokoschka to provide illustrations for *Der Sturm*
1912	An intense love affair develops between Kokoschka and Alma Mahler, the widow of Gustav Mahler.
1913	Paints *Bride of the Wind* an intense expression of his love for Alma.
1914	Alma severs the relationship with Kokoschka. She later weds Walter Gropius. Kokoschka volunteers for service in the army.
1915	He is wounded while serving in the Ukraine.
1919	Appointed professor at the Kunstakademie in Dresden.
1923-34	Leaves Dresden and travels widely visiting many European cities. He paints views of London, Lyons, Paris, Madrid, Vienna and Venice among others.
1934	After settling for a short period in Vienna, Kokoschka moves to Prague because of the increasingly authoritarian political regime in Austria.
1935	Becomes a citizen of Czechoslovakia. Meets his future wife Olda Palkovská.
1938	The Nazi seizure of Czechoslovakia prompts Kokoschka and Olda to flee to London.
1947	After spending the war in Britain he becomes a British citizen.
1953	Settles in Villeneuve on Lake Geneva.
1955	Designs sets for Mozart's *Magic Flute* at the Salzburg Festival.
1960-62	Designs sets and costumes for productions at the Burgtheater in Vienna.
1975	Becomes an Austrian citizen again.
1980	Dies at Montreux.

Henri Rousseau

The Museum of Modern Art

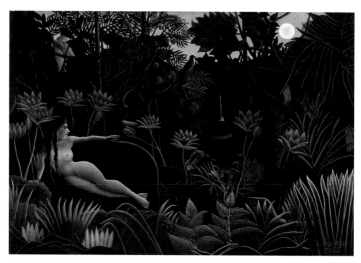

Like many of his contemporaries, Rousseau was fascinated by the exotic and foreign. The late 19th century was a time of colonial expansion and information about the world beyond France became part of popular culture. Rousseau read adventure and travel books and visited colonial exhibitions that presented people and goods from distant lands. He was also a frequent visitor to Paris' Jardin des Plantes, where he sketched tropical trees and plants and marveled at the exotic animals in its zoo.

Yet for all his fascination with the foreign, Rousseau never once set foot outside France. His seductive and sometimes unsettling paintings of faraway places, like *The Dream*, were just that: the fantasies of a man who had spent much of his life as a lowly paid customs clerk on the outskirts of Paris (thus his sobriquet *Le Douanier* – the customs agent).

Rousseau was 49 when he turned to painting full-time after retiring in 1893. A self-taught artist, he produced the conventional genres of the artistic establishment – landscapes, portraits, allegories and erotic scenes – however his interpretations were far from traditional. His references were that of popular culture, not the French Academy. Illustrated magazines, photographs and postcards inspired his strong graphic quality and love of drama. With no formal training he did not hesitate to mix the exotic with the domestic, a highly unconventional approach that mystified audiences.

However, the same qualities thrilled the avant-garde. Rousseau's unique perspective and odd juxtapositions found enthusiastic acceptance with a whole generation of avant-garde artists, including Delaunay and Picasso. In his naïve visions they could see a reflection of the desires and fears of the new modern world. When *The Dream* was first exhibited the poet and critic Guillaume Apollinaire championed Rousseau who had previously been mocked by art critics: 'The picture radiates beauty,' Apollinaire wrote, 'that is indisputable. I believe nobody will laugh this year.'

The Dream brings together the studio and the jungle, depicting a nude woman lounging on a sofa (modeled on one in Rousseau's studio) in the middle of a dense jungle dotted with wide-eyed animals – lions, birds, a snake, a monkey and an elephant – as well as a dark-skinned man in a colorful loincloth playing a pipe; a stereotypical image of the era of the exotic other. The entire canvas is painted with Rousseau's characteristic bold lines, solid colors and precision with human, animal and foliage rendered with equal weight.

Though Rousseau's imaginary jungles were based on first-hand observations at the Jardin des Plantes (he probably transferred his sketches onto the canvas with a pantograph, a simple copying device), he freely mixed flora and fauna from different environments and often altered them to the point of abstraction: for Rousseau vegetation was a decorative motif and no actual species of plant can be identified in his pictures. His animals are depicted with almost human characteristics, like human stand-ins staring out at the spectator in mock aggression or surprise, such as the curious lion who peers out of the scene or the second lion who seems surprised to find a nude woman on a sofa in the jungle. Naïve and bold, beautiful and startling, with a dash of the surreal, *The Dream* is among Rousseau's best works. **DM**

Contemporary Works

1910	Henri Matisse: *Dance*, Saint Petersburg, Hermitage
	Gwen John: *Girl with Bare Shoulders*, New York, MOMA
	Vasily Kandinsky: *Sketch for Composition II*, New York, Guggenheim Museum

Henri Rousseau

1844	Born at Laval. Later attends the lycée in Laval but receives no artistic training.
1871	He is working by this date for the Paris municipal toll service, collecting dues at the entry gates to the city. This gave rise to his later nickname of *Le Douanier* but he never rose to the rank of customs officer.
1884	He is known to have had a permit to copy works in the Louvre by this date.
1885	Showed two works at the Salon, both derided by the critics.
1886	Paul Signac encourages Rousseau to exhibit at the Salon des Indépendants. Thereafter, he exhibits regularly at this annual show.
1893	He retires in order to spend more time painting.
1905	Exhibits his work at the Salon d'Automne (the year of Les Fauves). Meets Picasso, Robert Delaunay and the poet and critic Guillaume Apollinaire.
1908	Picasso holds a banquet in Rousseau's honor.
1910	Dies in Paris (September).
1911	The Salon des Indépendants holds a retrospective of his work.

Marc Chagall

The Museum of Modern Art

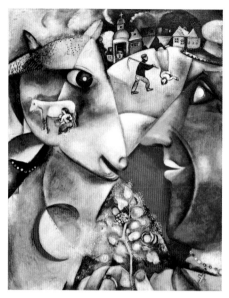

In 1910 Moishe Segal (or Mark Shagal to use his Russified name) left the Belarusian town of Vitebsk and arrived in Paris, the undisputed capital of the art world. The city was a crucible of creativity, witnessing at that time an extraordinary explosion of innovation. The Fauves led by Matisse and Derain had built on Post-Impressionist foundations to create a new language of color. Picasso and Braque had just invented Cubism. Artists were flocking to the French capital from far and wide in an attempt to experience this extraordinary zeitgeist. It was not just artists; critics, writers and philosophers such as Guillaume Apollinaire engaged in the intellectual ferment. And then there were the dealers, most importantly Ambroise Vollard who had established himself as the preferred route to market for many of the avant-garde. Chagall (as he came to be known) soon counted both Apollinaire and Vollard as friends.

Chagall entered this maelstrom of ideas and welded a very personal style which then remained more or less immutable for the rest of his life. In *I and the Village* we can see the influence of the Fauves in his use of color and of Cubism but these elements are fused with his memories of daily life in his native Hasidic Jewish community in Belarus. A huge green face dominates the right half of the composition, topped with the archetypal hat of the Russian peasant. This is balanced by a sheep's head, divided into zones of mid blue, gray, grayish pink and white; a vignette of a cow being milked is interposed on the cheek of the sheep. A peasant with a scythe is confronted with a woman who has flipped through 180 degrees as have two houses in the row of dwellings at the top of the picture. A central circular motif which incorporates sections of the two dominant heads is clearly indebted to the circular, pioneering, semi-abstract compositions of Chagall's friend Robert Delaunay.

Chagall never traveled down the path to abstraction – his paintings were at this time rooted in a mystical nostalgia. 'For me,' he said 'a painting is a surface covered with representations of things.' Many of these representations were assigned symbolic meanings. The central circle in *I and the Village* is a symbol of divinity and wholeness, performing here a unifying function, linking peasant and animal (who were mutually dependent in a rural economy) but also representing the orbit and phases of the moon – appearing as a waning crescent in the lower left corner. To the right of the moon, occupying the lower segment of the central circle, we can see a curious flowering twig held delicately in the large hand of the peasant. This would seem to represent the tree of life – another reference to the interdependence of man and nature in the bucolic context of rural Belarus.

Chagall's magical naturalism creates a beguiling, nostalgic vision of his home village in which scale, color and form morph and shift. The influence of Fauvism and Cubism are clear but were clearly of secondary importance to Chagall who wrote: 'Personally, I do not think a scientific bent is good for art. Art seems to me to be a state of the soul'. *GS*

Contemporary Works	
1911	Egon Schiele: *Girl with Black Hair*, New York, MOMA
	Karl Schmidt-Rottluff: *Norwegian Landscape*, Munich, Staatsgalerie Moderner Kunst

Marc Chagall

1887	Born in Vitebsk, Belarus.
1907	Begins three years of studies at St Petersburg.
1910	Moves to Paris where he meets Amedeo Modigliani.
1912	Exhibits at the Salon des Indépendants.
1914	A retrospective exhibition of Chagall's work is mounted in Berlin by the German gallery owner Herwath Walden.
1914	Travels from Vitebsk intending to stay for a month or two, but the outbreak of war prevents his planned return to Paris.
1915	Marries Bella Rosenfeld.
1917	After the Bolshevik Revolution Chagall is appointed as Commissar for the Arts at Vitebsk.
1920	He is commissioned to design sets for the State Kamerny Theatre in Moscow.
1922	Leaves the Soviet Union for Berlin. His wife and daughter join him there.
1923	Moves back to Paris where Ambroise Vollard commissions him to illustrate fine art books.
1935	Visits Poland where he notes the rise of anti-Semitism.
1937	Becomes a French citizen.
1941	After a period of imprisonment in Vichy France he seeks asylum in the USA.
1942	Commissioned to create backdrops for the New York Ballet Theater.
1944	Chagall's wife dies suddenly from a viral infection.
1946	The Museum of Modern Art in New York puts on a retrospective exhibition of his work.
1948	Returns to France with his partner Virginia Haggard.
1950s	Creates a cycle of biblical paintings now housed in a dedicated museum in Nice.
1950	Settles in St-Paul-de-Vence.
1960s	Starts to design and paint stained glass – one of his first windows is installed in Metz Cathedral.
1964	Paints ceiling decorations for the Paris Opéra.
1967	Creates stage designs for a production of Mozart's *Magic Flute* at the Metropolitan Opera, New York.
1985	Dies at St-Paul-de-Vence, France.

Henri Matisse

The Museum of Modern Art

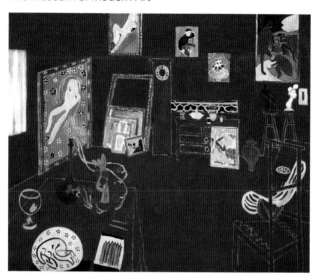

'Modern art, spreads joy around it by its color, which calms us.' – **Matisse**

In 1909, Matisse, feeling financially flush thanks to a new patron, created a studio for himself near Paris. The actual studio was white but in this painting the artist depicts it as a field of sensuous, all-enveloping red. For Matisse, color was a feeling – an expressive element. He often changed colors until they felt right to him as he did in this image: traces of yellow and blue can be seen beneath the red. 'Where I got the color red – to be sure, I just don't know,' he once remarked, 'I find that all these things … only become what they are to me when I see them together with the color red.'

Like a mini retrospective of Matisse's recent work, this *Red Studio* is dotted with his paintings, sculptures and ceramics. All are multicolored and detailed, unlike the rest of the room and its furnishings which are only suggested by pale lines traced in the red surface. The minimalist grandfather clock in the center has no hands, adding a timeless quality; a wine glass suggests a certain *joie de vivre*; an open box of crayons in the foreground seems to invite the viewer into the picture, as if they too could pick up a crayon and create.

Angled lines are used to give the room depth and the blue-green light of the window emphasizes the interior space. Yet the omnipresent red and lack of vertical lines in the corner of the room create a flattened perspective, an effect reflective of Matisse's love of pattern and interest in Islamic art; he had in fact traveled to Munich to see an exhibit of Islamic art the year before he completed this painting.

The unrealistic, abstract elements of the image combine to suggest an almost magical place, an artistic oasis beyond a troubled world, which was how Matisse thought of his studios, whether in Paris or southern France. There, regardless of world events, for 60 odd years, Matisse unabashedly produced images of joyful color and gracious beauty. Unlike many of his contemporaries,

famed for their modernist angst and revolt (such as Matisse's friend and rival, Picasso), Matisse is considered, sometimes disapprovingly, as a painter of happiness – he once said that he wanted his art to have the effect of a good armchair on a tired businessman.

His work was grounded in tradition, rather than rebellion: as a youth he had studied at the École des Beaux-Arts and admired the works of Manet and Cézanne (a small 'Bathers' by Cézanne which he bought in 1899 became his talisman). Around 1904 he became interested in the colorful pointillism of Seurat and Signac and the transforming effects of the light of southern France, which led him to Fauvism. From there, his art continued to evolve but always remained true to the goals he stated in his *Notes of an Artist* (1908): to discover 'the essential character of things' and to produce art 'of balance, purity and serenity.' While in a lesser artist this contentment might add up to mere decorativeness, with Matisse it reveals a profound essence that evokes both pleasure and reflection. *DM*

Contemporary Works

1911	Robert Delaunay: *Eiffel Tower*, New York, Guggenheim Museum
	Pablo Picasso: *Ma Jolie*, New York, MOMA
	Lovis Corinth: *Lady by a Goldfish Tank*, Vienna, Belvedere

Henri Matisse

1869	Born at Le Cateau-Cambrésis, near Cambrai, Picardy.
1887	After working in a solicitor's office he begins to study law in Paris.
1889	On returning to Picardy, he attends drawing classes.
1891	Studies painting at the Académie Julian in Paris.
1892	Gustave Moreau invites Matisse to join his classes at the École des Beaux-Arts even though he has not passed the entrance exams.
1894	A daughter is born to Matisse's mistress Caroline Joblaud.
1895	Passes the entrance examination for the École des Beaux-Arts.
1898	Marries Amélie Parayre. The couple honeymoon in London.
1902	Unable to sell his work the family returns from Paris to Picardy.
1904	A one-man exhibition is mounted by Ambroise Vollard. It is not a success. Stays with Paul Signac at St Tropez in the summer.
1905	Spends the summer at Collioure near the Spanish border with André Derain.
1906	Good sales at a second one-man exhibition enable Matisse to visit Algeria. Also paints again at Collioure. Meets Picasso.
1908	Publishes *Notes d'un peintre*.
1909	The Russian businessman Sergey Shchukin commissions two of Matisse's masterpieces, *Dance* and *Music*.
1910	Travels to Munich for an exhibition of Islamic art. Travels to Spain to see more Moorish architecture.
1911	Visits St Petersburg and Moscow.
1917	Stays in Nice which will become his home base for much of the rest of his life.
1920	Serge Diaghilev invites him to London to work on the set designs for a Stravinsky ballet.
1930	Travels to Tahiti via New York and San Francisco.
1933	Completes murals for the Barnes Foundation in Pennsylvania.
1941	Matisse undergoes an operation for a tumor which leaves him in poor health.
1948	Begins work on designs for stained glass, and decoration for the Chapelle du Rosaire at Vence. This commission occupied him until his death.
1954	Dies in Nice.

Giorgio de Chirico

The Song of Love **1914**

The Museum of Modern Art

M. de Chirico has recently purchased a glove of pink rubber, one of the most extraordinary objects that one can find. It is destined, once copied by the artist, to render his future works even more striking and disconcerting than his past ones. If one asks him as to the terror that this glove is capable of inciting, he will speak to you immediately of the still more terrifying toothbrushes just invented by the dental art, the most recent and perhaps the most useful of all arts. **Guillaume Apollinaire** (from a short article in the *Paris Journal* for July 4 1914)

Leaving aside the matter of toothbrushes, the rubber glove turned up a few weeks later, as predicted by Apollinaire (an inspirational friend to de Chirico), having been given a starring role in this picture. It is pinned to a centerally positioned construction of uncertain utility or provenance – a board or a piece of theatrical scenery perhaps? Next to the glove hangs a plaster head of Apollo Belvedere. The central structure to which glove and head are attached appears to abut a building to the right which imparts to it and its attachments a gigantic scale. A green ball in the foreground is of unresolved size and uncertain stability – looking like it might roll away towards the left at any moment. Strong shadows are cast by an unseen sun.

The schematic building sports the trademark de Chirico loggia or colonnade – the openings reveal only the density of nightmare darkness within, harboring the possibility of an unknown menace. To the left another favorite motif is utilized – the steam locomotive behind a brick wall emanating a single puff from its chimney. Steam trains held an exalted place in de Chirico's personal pantheon of objects to which he attached special meaning. Like the futurists, he held them to be emblematic of modernity, power and speed; they were also the instruments of melancholy partings at railway stations. But, more

personally, they triggered memories of childhood – his father was a railway engineer and trains did indeed pass behind just such a brick wall at the end of his childhood garden in northern Greece.

Apollo is the sun god, the god of beauty, music and poetry, but in the writings of Nietzsche (a powerful influence on de Chirico) he presides over the world of dreams. De Chirico also considered Apollo to be symbolic of the plastic arts – his art, what he called metaphysics, a term coined by Apollinaire (who later also came up with the term 'Surrealist').

Through his metaphysical paintings de Chirico sought to unmask the mysterious truth behind apparent reality. In this he was influenced by the enigmatic work of the Symbolists and especially Arnold Böcklin (see page 140). But de Chirico went much further. In his paintings he constructed a world where everyday objects take on a new significance merely by their unexpected juxtaposition with articles which, in another context would remain unremarkable. These objects are placed in a superficially illusionistic space which he then subtly undermines – floors are tilted, lines of perspective pitch away from the viewer creating an unsettling instability. All this combines to give de Chirico's paintings a disturbing air of anxiety and foreboding – providing the surrealist painters with a rich source of inspiration when they later discovered his work, a debt which even extended to the adoption by Dalí and Ernst of similarly inscrutable titles. *GS*

Contemporary Works

1914	Francis Picabia: *I See Again in Memory My Dear Udnie*, New York, MOMA
	Walter Richard Sickert: *Ennui*, London, Tate
	Oskar Kokoschka: *Bride of the Wind*, Basel, Kunstmuseum

Giorgio de Chirico

1888	Born in Vólos in northern Greece, the son of an Italian railway engineer.
1903	Begins three years of studies at the Higher School of Fine Arts in Athens.
1906	After the death of his father in 1905, the family move to live in Munich.
1911	After studying in Munich he joins his family who are in Milan, but de Chirico and his mother then move to live in Paris.
1912	Exhibits three paintings at the Salon d'Automne in Paris.
1913	Sells his first paintings at the Salon d'Automne. Meets the critic Guillaume Apollinaire and through him Picasso, Derain, Brancusi and others.
1915	De Chirico is conscripted into the Italian army as Italy enters the war. He is based in Ferrara, a city which inspired him to continue painting despite the demands of military life.
1917	Meets Carlo Carrà in a military hospital. Together they found *Pittura Metafisica*.
1918	First one-man show at the Galeria Bragaglia in Rome.
1924	Returns to Paris where he meets the Surrealists who have, during his absence, enthusiastically received his early work. However they are less keen on his more recent output.
1931	His marriage to his first wife Raissa ends and he later marries Isabella Pakszwer Far.
1935	De Chirico travels to New York where he stays for two years. He is now producing work in a new 'classical' style which provokes hostility from former supporters.
1942	Paints a portrait of Mussolini's daughter.
1946	Declares the contents of an exhibition of his metaphysical paintings to be fakes.
1950s	It becomes clear that de Chirico has been making copies of his own early work, selling them as originals. He defends this by saying that the concept is his and the time of execution is of no consequence. He campaigns against Modernism.
1978	Dies in Rome, active to the end.

Claude Monet

Reflections of Clouds on the Water Lily Pond **c1920**

The Museum of Modern Art

In 1883, Monet rented a house in Giverny, about 18 miles from Rouen. Seven years later his financial position was such that he felt able to buy the property enabling him and his second wife Alice to continue with the creation of a magnificent garden which, in 1893, they extended through the acquisition of a further parcel of land across the road. He obtained permission to dam a stream which ran through this new plot enabling him to greatly enlarge an existing small pond and to begin the cultivation of the famous Nymphéas – a variety of white water lily. At one end of the pond he constructed a bridge based on a Japanese design. This garden increasingly became central to his art, providing the defining motifs for his work during the last two decades of his life.

Monet eventually emerged from a period of acute depression following the death of his wife in 1911 with a determination (although by now well into his seventies) to embark on a series of huge canvases depicting the water lilies in his garden pond. At the outset, he conceived these 'Grandes Décorations', as he called them, to be a project on such a scale that it would only be possible for them to be properly displayed in a public space. In this conviction he was encouraged by his friend Georges Clemenceau who at the inception of the project was minister of war and later prime minister of France. Without Clemenceau's coaxing and constant support, which was forthcoming even in the darkest hours of the Great War, it is doubtful that Monet would have continued with the Grandes Décorations or that they would have eventually been suitably displayed by the state. As it was, Clemenceau's influence ensured that, a year after Monet's death, the Nymphéas cycle was triumphantly installed in purpose-built rooms in the Orangerie in Paris.

After Monet's death in 1926 this water lilies triptych was one of the works which remained in the studio which he had constructed specially for his grand project. In the process of creating the (22) panels which eventually ended up in the Orangerie, Monet had painted a number of canvases which did not feature in the final installation, some of which he destroyed, but this triptych is one that mercifully survived.

It is a breathtakingly beautiful work, its dominant size demanding that the viewer immerse themselves in its resonant color. Monet said that his aim was

to create 'the illusion of an endless whole, of water without horizon.' The poet and dramatist Paul Claudel wrote that Monet, 'by addressing himself to the element that is in itself the most docile and penetrable he concentrates on the almost invisible, spiritual surface that divides light from its own reflection. The blue of the sky imprisoned in liquid blue. The only evidence of a surface is the flowers … The light is beaten into blue through the chemistry of water.'

What we see here is Monet, the 20th-century artist, pursuing his own vision towards a personal approximation of the abstract. Unconcerned with the myriad groups and 'isms' of the Paris avant-garde, he nevertheless arrived, via a very different route, at a place not so far away from those younger painters who had simultaneously experimented with abstraction and new ways of representing reality. As Clement Greenberg wrote, Monet 'arrived at a shadow of the traditional picture, the Cubists arrived at a skeleton.' Indeed one could argue that with the creation of rooms at the Orangerie in which his Nymphéas series are installed so that they completely surround the viewer he went even further, heralding the 'installations' of the later 20th century. *GS*

Contemporary Works

| 1920 | Frantisek Kupka: *The Colored One*, New York, Guggenheim Museum |
| | George Grosz: *Republican Automata*, New York, MOMA |

Claude Monet

1840	Born in Paris.
1845	Monet's family moves to Le Havre, his father joining a family grocery business.
1857	Monet's mother dies but his aunt encourages his interest in painting.
1859	Enrolls at the Académie Suisse in Paris where he meets Camille Pissarro.
1860	Called up for military service and posted to Algeria for a year.
1862	Discharged from the army due to illness. Meets Renoir and Sisley at the studio of Charles Gleyre in Paris.
1867	Camille Doncieux, Monet's mistress gives birth to their first son.
1869	Monet and Renoir work together at La Grenouillère, on the Seine. Their paintings are of great importance in the formation of Impressionism.
1870	Marries Camille. At the onset of the Franco-Prussian War they move to London.
1871	Monet's father dies leaving him a modest inheritance. Returns to France where the family rent a house at Argenteuil near Paris.
1873	The Société Anonyme Co-opérative d'Artistes-Peintres, Sculpteurs, Graveurs etc. is formed. The nucleus of the group are later labelled as Impressionists.
1874	The first group exhibition takes place. The critic Louis Leroy coins the word 'Impressionist' in a sarcastic review of Monet's *Impression, Sunrise*.
1876	Meets Ernest Hoschedé who commissions panels for his château.
1878	Monet's patron Ernest Hoschedé is declared bankrupt. The Hoschedé and Monet families set up house together at Véteuil.
1879	Camille dies.
1883	Monet, Alice Hoschedé and their eight children move to Giverny.
1890	Monet is able to purchase his house in Giverny.
1892	Following the death of Ernest Hoschedé, Monet and Alice are married.
1893	Buys more land to extend his garden at Giverny where he builds a 'Japanese' bridge over a pond and plants water lilies.
1894	The Durand-Ruel Gallery exhibit Monet's Rouen Cathedral series.
1904	Exhibition of paintings resulting from Monet's recent visits to London.
1911	Alice dies.
1916	A large studio is completed at Giverny which Monet uses to work on his huge water lily decorations which are designed to surround the viewer.
1918	Monet announces that he will donate his water lily decorations to the state.
1926	Dies at Giverny.
1927	The water lily decorations, in the Orangerie are opened to the public.

Paul Klee

The Museum of Modern Art

Swiss-born Paul Klee's *Twittering Machine* was one of many artworks confiscated by the Nazis from the Nationalgalerie in Berlin in 1937 and labeled as 'degenerate art.' The picture, much like Klee himself, was everything the Nazi's hated: subtle, cerebral, avant-garde. Luckily, while the Nazi's could not see its artistic worth, they could see its monetary value and the picture was not destroyed but sold by the Propagandaministerium to an art dealer who in turn sold it to the MOMA in 1939.

A versatile artist who produced some 9,000 paintings, drawings, and watercolors, Klee was associated with various modern art movements in his lifetime – Expressionism, Dadaism, Surrealism and the Bauhaus – yet his idiosyncratic style is always recognizable. His pictures tended to be small in scale but with remarkable nuances of line, color and tonality, almost like a piece of sheet music. Raised in a family of musicians (he himself played the violin), Klee's art almost always has an innate lyricism and rhythm. Inspired by the art of children, whom he considered closer to the true sources of creativity, Klee rarely planned out an image but instead engaged in a free play of imagination until he found a balance, or 'rightness.' But while his art can have a childlike simplicity, his subjects are sophisticated, mixing irony and a sense of the absurd with an intense awareness of the mystery and beauty of nature. For Klee, the role of the artist was not to produce reality but rather to make visible a deeper inner truth. 'Art does not reproduce what we see'; Klee once stated, 'rather, it makes us see.'

Klee created the *Twittering Machine* in the early 1920s when he was an influential art teacher at the avant-garde Bauhaus school of modernist art and architecture (Klee's colleagues included Walter Gropius, Vasily Kandinsky and Lyonel Feininger). The school's motto was 'art and technology – a new

unity,' which could be an ironic subtitle for this image. It presents a chorus of wiry, stick figures, birds upon a roost set against a background washed in shadowy blue and pink. Klee once stated that he considered layers of color over drawing to be comparable to polyphonic music and here he seems to be evoking pastoral images of birdsong at dawn or dusk.

However the 'twittering' birds, lined up like notes on a musical scale, perch upon (or are they attached to?) a 'machine,' as if part of a monstrous music box. The contraption is both amusing and sinister: what would happen if someone turned that hand crank? Certainly not the gentle sound of chirping: the birds' mouths open as if to sing but their nervous, agitated forms suggest a silent scream or a fiendish cacophony. The picture walks a fine line between humor and monstrosity, tragedy and comedy, nature and technology. At one level, it is simply a clever, dark humored, visual joke; but it is one that questions blind faith in technology as well as naïve sentimentality of nature. With wit and empathy, Klee presents the bird's futile struggle as a metaphor of man and nature's impotence in the face of larger cosmic forces. *DM*

Contemporary Works

1922	Chaim Soutine: *View of Ceret*, Baltimore, Museum of Art
	Max Ernst: *Rendezvous of Friends*, Cologne, Wallraf-Richartz Museum
	Fernand Léger: *Still Life with a Beer Mug*, London, Tate

Paul Klee

1879	Born in Münchenbuchsee near Berne.
1898	Decides to study art in Munich.
1900	Studies under Franz von Stuck at the Munich Academy.
1901	Travels to Italy.
1902	Returns to live in Berne.
1906	Marries the pianist Lily Stumpf. They move to Munich.
1911	Meets Alfred Kubin, August Macke and Vasily Kandinsky and is welcomed into the *Blaue Reiter* group. Starts to catalog his work.
1912	Travels to Paris and meets Robert Delaunay whose work is highly influential on Klee's output.
1914	Travels to Tunisia with Macke.
1917	Klee is called up for military service but is spared the terrors of the Front and is given a job as a clerk.
1920	Publishes a treatise on graphic art entitled *Schöpferische Konfession*. Walter Gropius appoints Klee to a lectureship at the Bauhaus in Weimar.
1924	An exhibition of Klee's work is mounted by the Société Anonyme in New York.
1925	Klee's work is included in the first Surrealist Exhibition in Paris.
1928	Travels to Egypt.
1931	Klee leaves the Bauhaus and begins teaching at the art academy in Düsseldorf.
1933	With the rise of the Nazis Klee is dismissed from his post in Düsseldorf. He leaves Germany with his wife to live in Berne.
1935	Klee experiences the first symptoms of an incurable skin disease.
1937	His work is included in the Nazi 'Degenerate Art' exhibition and his paintings are removed from German museums.
1940	Dies at Muralto near Locarno.

Max Ernst

Two Children are Threatened by a Nightingale **1924**

The Museum of Modern Art

In a world before Hitchcock, birds were rarely seen as objects of fear. However, in the Surrealist world of Max Ernst – steeped in Freudian metaphor, private mythology and childhood memories – birds appear frequently as sinister presences. In this image, a tiny nightingale appears to menace two girls: one runs in fear, brandishing a knife; the second has fainted. When asked to explain the scene, Ernst gave two possible autobiographical sources: the death of his sister in 1897, and a fevered hallucination he recalled in which the wood grain of a panel near his bed took on 'successively the aspect of an eye, a nose, a bird's head, a menacing nightingale, a spinning top, and so on.'

Adding to the hallucinatory sense of unreality, a man carrying a baby seems to balance on the roof of a hut and reach towards a (relatively) huge knob, almost as if it were an alarm or bell. The hut and the knob, like the open fence on the opposite side, are disproportionate, three-dimensional elements added to the flat painted surface. Here Ernst mixes two mediums: painting and collage, the latter he considered a useful medium to express the 'irrational.'

The image also employs elements of traditional European painting, including a sense of depth and perspective, the classical architecture in the background, and the figures' formal poses, which are derived from Old Masters. However Ernst's composition breaks all the rules. Whereas a painting usually presents a unified world, Ernst blurs the line between art and viewer, between one- and multi-dimensional spaces; for example, the fence seems to open into the spectator's space. The usual concepts of scale and function are thrown out and the rational mixes with the bizarre; nothing and no one act as expected. Nothing makes sense yet there is a palpable impression of anxiety. Ernst has

captured that elusive, half-forgotten feel of a dream, or nightmare, where subconscious fears manifest themselves.

Ernst created this image in Paris in 1924, the same year the Surrealist movement, of which Ernst was a founding member, was officially consecrated with the publication of André Breton's *Surrealist Manifesto*. Like many of his generation, Ernst had returned from the Great War disillusioned and looking for deeper meaning in both life and art. As a painter, sculptor, graphic artist and poet, he was first drawn to the creative irrationality of Dadaism and by 1922 was part of Breton's avant-garde circles in Paris. Surrealism, inspired by Freud's methods of free association, drew upon dreams and the unconscious to attempt to reveal a deeper reality, a way to release the unbridled imagination of the subconscious. Ernst expressed these concepts in cerebral, irrational images like this one that could be whimsical, clever and deeply unsettling and in the process became one of the most influential avant-garde figures of the early 20th century. *DM*

Contemporary Works

| 1924 | Joan Miró: *The Tilled Field*, New York, Guggenheim Museum |
| | Pierre Bonnard: *Signac and his Friends Sailing*, Zurich, Kunsthaus |

Max Ernst

1891	Born in the town of Brühl near Cologne the son of a keen amateur painter.
1909–12	Attends the University of Bonn where he studies philosophy, psychology and art history.
1914–18	Serves in the German Army but continues to paint.
1918	After demobilization, disillusioned by his experiences, he joins the Dada movement. Marries the art historian Louise Strauss.
1921	The Parisian Dada group mount an exhibition of Ernst's collages. Paul Eluard and his wife Gala visit him in Cologne.
1922	Leaves his wife and moves to Paris where he lives with the Eluards.
1924	Eluard travels to the far east. Ernst and Gala meet him in Saigon. Ernst stays as the Eluards return.
1925	Back in Paris he moves into his own studio.
1926	Ernst develops the frottage technique. Designs sets for Diaghilev's production of Prokofiev's *Romeo and Juliet*.
1927	Marries Marie-Berthe Aurenche.
1928	Exhibition of his work at the Galerie Georges Bernheim.
1934	Stays near St Moritz in Switzerland with Alberto Giacometti.
1938	Moves to St Martin d'Ardeche with the English painter Leonora Carrington.
1939	Ernst is interned as an enemy alien on the outbreak of war.
1941	After suffering a mental breakdown he escapes to New York.
1942	Marries Peggy Guggenheim but the relationship does not last.
1946	Ernst marries the surrealist painter Dorothea Tanning and settles in Sedona, Arizona.
1948	Becomes a American citizen.
1953	Returns to live in Paris.
1954	Wins the Grand Prix at the Venice Biennale.
1955	Ernst and his wife move to live near Chinon in France.
1958	Becomes a French citizen
1964	Moves to the Var region in the south of France.
1975	Major retrospectives of his work are held in New York and Paris.
1976	Dies in Paris.

Joan Miró

The Birth of the World 1925

The Museum of Modern Art

According to writer and critic André Breton's *Surrealist Manifesto* (1924), there were two main routes to the 'marvelous': via dreams or through 'pure psychic automatism.' The latter concept, inspired by Freud's psychoanalytical theory, suggested that 'the real functioning of the mind' could be only expressed in 'the absence of any control exercised by reason.' *The Birth of the World*, by Catalan artist Joan Miró, who was a member of Breton's avant-garde circle in Paris, is one of the most ambitious attempts to put this theory into practice.

It is the largest of Miró's 'dream paintings', a series of over 100 canvases produced between 1924 and 1927 which feature simple signs, somewhere between drawing and writing, in an atmospheric pictorial space. While not explicit, the signs are evocative: the amorphous swirl of blotches and smudges suggests limitless space while the lines and shapes evoke various interpretations: shooting stars, a kite or a tree, a red balloon, sperm or perhaps a fruit, a white-headed figure, etc.

Inspired by Surrealism's free invention and openness to the subconscious, Miró developed a style that drew from highly personalized and psychological references. With a large canvas such as this one, he often began with studies on paper in which he would allow his hand to move freely across the surface in response to the smudges and cracks on his studio walls or to knots and grains of wood; later he transferred his 'spontaneous' ideas to the canvas. He then transformed his subjects through whimsical color and a free play of form. 'Rather than setting out to paint something,' Miró once stated, 'I begin painting and as I paint, the picture begins to assert itself … The first stage is free, unconscious.' But, he added, 'The second stage is carefully calculated.'

In *The Birth of the World* the spectator can immediately appreciate Miró's

'unconscious' approach to the painting: he applied paint freely – pouring, flinging, brushing or spreading with a rag – onto an unevenly primed canvas to allow the paint to absorb differently across the surface. Yet despite this seeming randomness, Miró's art suggests a sensibility highly tuned to subtleties and small beauties; he can make a line feel sensuous or a circle on a stick appear alert. These abstracted, expressive forms invite a play of the imagination and the title, added by a poet friend of Miró, suggests an interpretation.

Miró himself once described this painting as 'a sort of genesis,' an abstract beginning from which life could spring. And in fact, there is a fairly exact pencil study of *The Birth of the World* to demonstrate that Miró had begun with the idea of a scene of innocence, a moment before the Fall, showing a figure beneath a tree bearing a single fruit, that became more and more abstract. The final image is at once primal and poetic; daring in its metaphysical scope and ambition. It was the first of many Surrealist works to metaphorically link artistic creation and the creation of a universe and was admired by Breton and his circle; Miró had clearly discovered a route to the 'marvelous.' **DM**

Contemporary Works

1925	Chaim Soutine: *The Side of Beef*, Minneapolis, Institute of Art
	Paul Signac: *The Lighthouse, Groix,* New York, Metropolitan Museum of Art
	Edward Hopper: *House by the Railroad*, New York, MOMA

Joan Miró

1893	Born in Barcelona, the son of a goldsmith.
1907–10	At his parents insistence he studies business at the Escuela de Comercio in Barcelona.
1911	Miró abandons his business course after contracting typhus.
1912–15	Studies art with Francesc Galí.
1918	A one-man show of Miró's work is held in Barcelona.
1919	Visits Paris.
1920	Moves to live in Paris.
1921	The first exhibition of his work in Paris is held but results in no sales. Returns to the family property outside Tarragona for this and many future summers.
1925	Galerie Pierre shows Miró's paintings and also hosts a Surrealist exhibition. Although influenced by Surrealism, Miró does not join the group officially.
1928	Visits The Netherlands.
1929	Miró marries Pilar Juncosa in Palma de Mallorca. The couple live in Paris.
1934–36	Produces a series of *Wild Paintings*.
1937	Designs posters supporting the Republican cause in the Spanish Civil War.
1939	Moves to live in Varengeville in Normandy.
1940–1	Works in Palma de Mallorca and Montroig near Tarragona.
1941	The first major retrospective of his work in mounted by the Museum of Modern Art in New York. Creates his first ceramic works.
1944	Produces a series of 50 monochrome lithographs entitled *Barcelona*.
1949–50	Working in Barcelona.
1958	Illustrates a volume of poetry by Paul Eluard with 77 woodcuts. In the next two decades he works on a large number of illustrations for books.
1960	Harvard University commissions a large ceramic mural.
1970	Completes ceramic murals at Barcelona Airport.
1983	Dies at his home in Palma de Mallorca.

René Magritte

The Menaced Assassin **1927**

The Museum of Modern Art

I n a room devoid of comfort the naked corpse of a young woman lies on a chaise longue, blood issuing from her mouth. Within the same space, a smartly dressed man, presumably the eponymous assassin (although no signs of blood besmirch his immaculate suit) interrupts his getaway to listen with insouciant nonchalance to a gramophone record. His hat, coat and case are nearby, awaiting his delayed flight. However, we can see that this course of action will be met with instant interception for in an adjoining vestibule, extending towards the viewer, but hidden from the inner room behind partition walls, await two identically dressed men, armed with hilarious incongruity, one sporting a club more suited to a caveman, the other holding a net of the type used by gladiators.

Also unseen by the murderer (if that is his true status) three heads appear above the ironwork of the window balcony like fairground coconuts. As with the twins in the foreground, their features are identical. Oddly, their attention is not directed at the killer; nor do they seem concerned with the naked body, staring instead directly over the corpse to meet the gaze of the viewer. In this way we are drawn into the drama both as witness to what is happening inside the house and also by the worrying challenge implicit in the blank but direct stare of the triplets just outside the window.

After studying at the Académie des Beaux-Arts in Brussels, Magritte had at first been interested in Futurism but in 1922 he saw a reproduction of Giorgio de Chirico's *Song of Love* (also in MOMA – see page 182) and, as with so many painters who later espoused Surrealism, his encounter with de Chirico changed everything. He was instrumental in the foundation of the Belgian Surrealist group in 1926 and this painting was finished a year later.

We can see here that Magritte has learned from de Chirico the secrets behind the older artist's ability to create an atmosphere of foreboding – the

feeling that the carefully constructed equilibrium – the stasis – within the painting is about to be broken in a manner which may not be wholly expected and furthermore will probably not be welcome. But the resolution of the narrative will hang forever unresolved. Of course the venue for this picture is shifted from de Chirico's agoraphobic piazzas to Magritte's world of northern European bourgeois interiors, albeit stripped down to bare floorboards and plaster walls. However the window gives us a glimpse of an exterior almost as threatening as de Chirico's – an inhospitable lunar landscape redolent of isolation and hostility.

The cast of characters employed by Magritte owe much to his fascination with detective novels and films, and the twin detectives (if that is what they are), complete with bowler hats and starched collars, became a standard type used by Magritte in many subsequent paintings, but making a debut appearance in this picture. *GS*

Contemporary Works

1927	Fernand Léger: *Woman Holding a Vase*, New York, Guggenheim Museum
	Marc Chagall: *The Dream*, Paris, Musée d'Art Moderne de la Ville de Paris

René Magritte

1898	René Magritte is born at Lessines, Hainault, Belgium.
1912	René's mother commits suicide, drowning herself in the river Sambre. The young Magritte is present when his mother's body is recovered.
1916	Enters the Académie des Beaux-Arts in Brussels.
1919	Magritte's first posters are exhibited. He later takes on advertising work.
1922	Magritte marries Georgette Berger. Sees a reproduction of de Chirico's *Song of Love* – a seminal influence on his art.
1926	Magritte is a founder member of the Belgian Surrealist group. He is able to devote himself to painting as a result of an agreement with two Brussels galleries.
1927	Magritte's first one man show is mounted at Le Centaure in Brussels. Moves to live in Paris.
1929	Stays with Salvador Dalí in Cadaquès.
1930	Returns to Brussels.
1931	The need for income leads to the establishment of Studio Dongo with his brother Paul. The business provides services for advertising and publicity firms.
1933	The Palais des Beaux Arts in Brussels mounts a one man show of Magritte's work.
1937	Magritte takes part in a group show at the Palais des Beaux-Arts in Brussels with Man Ray and Yves Tanguy. Completes multiple works for the British collector Edward James.
1948	First one-man show in Paris at Galerie du Faubourg. Produces drawings for an illustrated edition of *Les Chants de Maldoror* by the Comte de Lautréamont. Reaches agreement to produce work for the New York dealer Alexandre Iolas.
1956	Produces his first brief Surrealist film.
1965	The Museum of Modern Art in New York put on a retrospective of Magritte's work. He travels to New York. Also travels to Rome.
1967	Produces a series of wax sculptures based on his paintings. Dies at Schaerbeek, Brussels.

Salvador Dalí

The Museum of Modern Art

Dalí adored fame, money and, above all, himself; he once declared, 'Every morning when I awake, the greatest of joys is mine – that of being Salvador Dalí ...' The son of a notary in small town Spain, Dalí never lacked ambition: 'When I was three I wanted to be a cook. At the age of six I wanted to be Napoleon. Since then my ambition has increased all the time.' With a flair for drama and self-promotion, a hyperactive imagination and a distinctive waxed mustache, Dalí lived up to his own hype and today his Surrealist images, like these metaphorically melting watches, are part of modern consciousness.

Although he had collaborated in 1928 with Luis Buñuel on the iconic Surrealist film, *Un chien andalou*, it wasn't until 1929 when Dalí moved to Paris and became involved with the Surrealist circle which formed around André Breton, that he made his first Surrealist paintings, what he called his 'hand painted dream photographs.' *The Persistence of Memory* is a fantastic vision of time set in a bleak, limitless dreamscape that contains only one realistic element: distant cliffs that recall the coast of Catalonia, where Dalí was born. The rest is pure Surrealist fantasy. Watches melt like cheese – Dalí called them 'the Camembert of time' and claimed to have been inspired by watching a Camembert melt on an August afternoon. Ants swarm over a metal pocket watch as if it was putrefying flesh. The flaccid central object draped with a limp watch resembles the artist's own face with long insect-like lashes and a snail or tongue-like object oozing from its side. As with most of Dalí's art, sexual overtones abound, from the vaguely phallic face to the swarming ants, which Dalí considered symbols of both decay and his own overpowering sexual desire. This is a landscape where both time and flesh literally dissolve and rot, like a Surrealist update on a classic art theme: 'vanitas,' i.e., all is organic, decaying, and impermanent.

How did Dalí invent such visions? Inspired by Magritte's dream imagery, Dalí developed what he called his 'paranoiac-critical method,' in which he would self-induce psychotic episodes (achieved by doing things like standing on his head until he was delirious) and then paint the resulting hallucinatory, often erotically charged, visions with a meticulous and unsettling clinical matter-of-factness. Dalí stated that he mastered 'the usual paralyzing tricks of eye-fooling,' so he could paint with 'the most imperialist fury of precision' in order 'to systematize confusion and thus to help discredit completely the world of reality.' Yes, some did call Dalí crazy. However, his response was: 'the difference between a madman and me, is that I am not mad.'

Dalí first achieved his sought-after fame around the time of this painting, which the MOMA bought in 1934. The museum organized a retrospective of Dalí's work in 1941, helping to establish his international reputation. However by that time, Dalí had broken with the Surrealists – André Breton began to call him 'Avida Dollars' – an anagram of Salvador Dalí and a comment on what Breton saw as Dalí selling out his artistic principles. Sell-out or not, he continued to paint until the 1980s. *DM*

Contemporary Works

1930 Pablo Picasso: *Seated Bather*, New York, Guggenheim Museum
1931 Diego Rivera: *Agrarian Leader Zapata*, New York, MOMA

Salvador Dalí

1904 Born in Figueres in Catalonia, the son of a notary.
1921 Enters the Real Acadamia de Bellas Artes de San Fernando in Madrid where he meets the poet Federico Garcia Lorca and the film maker Luis Buñuel.
1925 Dalí has his first one-man exhibition at the Galeria Dalmau in Barcelona.
1926 Expelled from the Acadamia. Visits Paris for the first time.
1929 Dalí collaborates with Luis Buñuel in making the famous Surrealist film *Un chien andalou*, shot in Paris and le Havre. André Breton, René Magritte and Paul and Gala Eluard visit Dalí at Cadaqués in Catalonia. The Galerie Camille Goemans mounts his first show in Paris. Accepted as a member of the Surrealist group. Travels to Paris where he and Gala begin a lifelong relationship.
1933 Shows eight pieces at the Exhibition of Surrealist Objects in Paris.
1934 Exhibits at the Zwemmer Gallery in London. Visits the USA.
1936 Takes part in the International Surrealist Exhibition in London giving a lecture dressed in a diving suit complete with helmet.
1938 Visits Sigmund Freud in London.
1940 After the fall of France, where he has been living, he flees to the USA.
1941 A rift with the Surrealists is formalized when he is attacked in print by André Breton. Retrospective at MOMA New York.
1948 Returns to Europe but continues to spend some time each year in the USA.
1958 Marries Gala in Spain.
1964 Dalí is awarded the Grand Cross of Isabella, Spain's highest decoration.
1979 A major retrospective takes place at the Centre Georges Pompidou in Paris.
1982 Gala dies.
1984 He suffers severe burns as a result of a fire in his current home, the castle of Púbol.
1989 Dies in Figueres where his body is buried in the Teatre-Museu Dalí.

Pierre Bonnard

The Bathroom 1932

The Museum of Modern Art

Te greater part of Bonnard's later output is concerned with capturing moments of intimate domesticity. In this body of work he seemed happy to limit his horizons to the bounds of his modest property near Cannes, which became his main residence after 1927 (although he retained homes in Normandy and Paris). His wife appears in most of these paintings either as the principal subject or peripherally – her fugitive figure sometimes cut by the edge of the canvas. Her ubiquitous presence mirrors the increasingly claustrophobic relationship which had evolved between them.

Bonnard met Maria Boursin (always known as Marthe) in 1893. By the time they married in 1925, she had developed a number of ill-defined health problems which came to dominate her life and that of her husband. These concerns, perhaps accentuated by hypochondria, fed a reclusive tendency – visits by friends and fellow artists were discouraged, which, not unnaturally, resulted in a negative appreciation of her by Bonnard's acquaintances who saw her as 'an uneasy, tormenting sprite' or as a jailer. Other idiosyncrasies accentuated this negative perception – her speech was 'weirdly savage and harsh' and she had a penchant for bizarre clothing and very high heeled shoes, upon which she can be seen tottering in many of her husband's canvases.

But there is little doubt that Marthe was genuinely ill. It has been established that she suffered from tubercular laryngitis (from which she eventually died). The prescribed regime for this in France at the time was frequent immersion in water. This explains why, in addition to her special dietary requirements and other health related routines she was constantly taking baths. And Bonnard has faithfully recorded these daily bathroom rituals in a great number of paintings, of which this is one of the finest.

There is a palpable sense of confinement – the walls of the small room crowd in on us – the clutter on the table by the bath and the presence of Marthe's pet dog accentuate this feeling of claustrophobia. As does Bonnard's extraordinary use of color, filling every corner of the canvas with a vivid profusion of different hues, setting up unusual and intense interactions which delight the eye but which serve to further minimize our reading of the volume within the room.

Marthe is bent over, one hand on a stool, one on the sink – her face is obscured as it generally was in most of these intimate scenes. One of her breasts is picked out in white, a mid blue is used as a highlight on her right shin, tying in with the color scheme of the tiles on the floor and walls. The area of pink in the right foreground links with some parts of Marthe's body and with the grouting which outlines each tile. Of course it is unlikely in the extreme that these pictures are a guide to the reality of Bonnard's bathroom – pink grouting would be an interesting but novel choice; in another similar work painted within months of this one, the same pattern of floor tiles are a mixture of black, white, red and yellow.

Perhaps we may be forgiven if we surmise that Bonnard sublimated the frustrations inherent in the difficult circumstances of his home life (which he outwardly bore with a resigned fatalism) in a constant search for fresh pictorial resolutions, transforming the mundane into a kaleidoscope of flashing facets of color. *GS*

Contemporary Works

| 1932 | Oskar Schlemmer: *Bauhaus Stairway*, New York, MOMA |
| | Salvador Dalí: *The Birth of Liquid Desires*, Venice, Peggy Guggenheim Foundation |

Pierre Bonnard

1867	Born at Fontenay-aux-Roses near Paris.
1887	Attends law school at the behest of his father but also enrolls at the Académie Julian where he meets Paul Sérusier who has already painted with Gauguin in Brittany.
1889	Sworn in as a lawyer. Becomes a member of the Nabis, a group founded by Sérusier and dedicated to furthering the aims of Gauguin's art.
1891	First Nabis group exhibition is held in the château of Saint-Germain-en-Laye. Bonnard produces a poster, *France-Champagne* which is well received; the income from this persuades him to give up the law and become an artist.
1893	Meets Maria Boursin (Marthe), who becomes his companion and muse.
1896	Bonnard, other Nabis members and Toulouse-Lautrec design sets for the Théâtre d'Art. First one-man exhibition at Durand-Ruel.
1901	Travels to Portugal and Spain with his friend Vuillard.
1903	He is a founding member of the Salon d'Automne.
1906	Exhibits at both Vollard's gallery and Bernhein-Jeune.
1911	Buys his first automobile. Motoring becomes an important part of his life.
1912	Purchases a house at Vernon in Normandy.
1913	Visits Hamburg with Vuillard.
1916	Visits the Somme battlefields.
1925	Marries Marthe who suffers from ill health and becomes increasingly paranoid, discouraging visits from friends and fellow artists.
1926	Purchases a small villa 'Le Bosquet' at Le Cannet in the south of France. Travels to the USA to serve on the jury of the Carnegie International Exhibition.
1927	Le Bosquet becomes his main home. He keeps properties in Normandy and Paris.
1942	Madame Bonnard dies.
1947	Bonnard dies at Le Cannet.

Max Beckmann

Departure 1932–3

The Museum of Modern Art

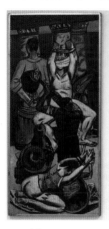

'We must participate in the great misery to come … the sole justification for our existence as artists, superfluous and egotistic as we are, is to confront people with the image of their destiny.' **Max Beckmann (writing in 1920)**

In January 1933 Adolf Hitler was appointed Chancellor of Germany. The Nazis had become the largest party in the Reichstag in the two elections of the previous year, a year marked by street battles between Nazis and Communists which left nearly 100 dead and over 1,000 seriously injured. Shortly after his elevation to the Chancellorship Hitler used the Reichstag fire as an excuse to suspend civil liberties. The first concentration camp was established at Dachau. Hitler assumed dictatorial powers; trade unions and political parties other than the Nazi party were suppressed.

This is the political environment within which Max Beckmann began to work on *Departure*, the first of nine triptychs on which he worked in the coming years. He could see what was coming. The Nazis wasted no time in declaring him a 'degenerate' artist, confiscating all works by him in public museums and forcing his dismissal from his professorial position at the Kunstinstitut in Frankfurt. He moved to Berlin where he sought anonymity and it was there that he completed this picture in 1935.

Beckmann had already been traumatized by his experiences in the Great War. He had joined the medical corps in 1914 but had been discharged a year later due to his failing health. Beckmann's work, much of which had been, since 1915, disturbing and psychologically charged was now given a new horrifying edge by the political and social upheavals associated with the rise of Hitler.

In the two outer panels of the triptych Beckmann presents us with a terrifying vision of torture and savagery. The victims within these havens of sadism are blindfolded, gagged and bound in a number of ingenious ways. The bonds of one detainee restrain arms which are now nothing more than pathetic bloodied stumps. A woman, arms trussed above her head as though a pleading supplicant, is left kneeling, head balanced, eyes down, over some sort of ball. In the right hand panel a man and a woman are bound together

head to toe – somehow they remain upright. They may be aided in this by a man who looks like he is wearing the uniform of a hotel bell hop who carries a fish. In the foreground, a man walks, we assume, on another level, with a bass drum. The images of suffering are interspersed with a personal lexicon of symbols most of which remain opaque – fish, fruit etc. Beckmann was somewhat dismissive when asked to explain – 'if people cannot understand it of their own accord … there is no sense in showing it'.

These scenes are depressingly prophetic of what was to come not only in the various haunts of Gestapo and SS thugs but also within the cellars of the Lubianka and indeed Beckmann's hell has continued to be reinvented in more recent times from Chile and Argentina to Africa and Iraq; the universality of Beckmann's images is a chastening reminder of the darkest recesses within the human psyche.

However, the central section of the triptych, entitled *Homecoming*, contrasts with the dark horror of the side panels. A small boat is rowed by a hooded oarsman across a calm blue sea; the other occupants are a king and queen – she carries a young child. Beckmann tells us that the child represents 'Freedom.' So, setting aside some of Beckmann's obtuse symbolism, his message is clear – deliverance from cruelty and brutality are possible no matter to what depths of barbarism the world has currently descended. *GS*

Contemporary Works

| 1933 | Balthus: *Alice*, Paris, Musée National d'Art Moderne - Centre Georges Pompidou |
| | Marc Chagall: *Solitude*, Tel Aviv, Museum of Art |

Max Beckmann

1884	Born in Leipzig.
1900	Enrolls at the Kunstschule in Weimar.
1906	Beckmann marries Minna Tube. Exhibits for the first time at the Berlin Secession.
1910	Becomes the youngest member of the committee of the Berlin Secession.
1914	At the outbreak of war Beckmann joins the medical corps and works as a hospital orderly.
1915	He is discharged from the army because of the deterioration of his mental health.
1917	Settles in Frankfurt am Main.
1925	Exhibits with the *Neue Sachlichkeit* movement in Mannheim. Divorces his first wife and marries Mathilde von Kaulbach. Appointed professor at the Städelsches Kunstinstitut in Frankfurt.
1932	Begins work on *Departure*, the first of his triptychs.
1933	Declared a 'degenerate' artist by the Nazis; he is dismissed from his academic post and all works by him in museums are confiscated.
1937	Leaves Germany to live in Amsterdam.
1947	Moves to the USA.
1950	Dies in New York.

Frida Kahlo

Self-Portrait with Cropped Hair **1940**

The Museum of Modern Art

Frida Kahlo was her own favorite subject; about 55 paintings (about a third of her work) are self-portraits. 'I paint myself because I am so often alone,' she once said, 'because I am the subject I know best.' She hid nothing in her portraits, frankly depicting her own sorrows and indignities: miscarriages, physical suffering and, as in this painting, betrayal.

Kahlo was 33 years old and had recently discovered that her husband, the painter Diego Rivera, had been carrying on a long-term affair with her younger sister. The couple had married in 1929 when Kahlo was 21 and Rivera, who had been married twice before, was 43. It was a tumultuous marriage and Rivera, a self-confessed philanderer, had already had many affairs (as had Kahlo with both men and women – one of her lovers was said to be the Russian revolutionary, Leon Trotsky) but this was the final straw. They divorced in 1939 and Kahlo created several paintings expressing her anger and pain, few more affecting than *Self-Portrait with Cropped Hair*.

Kahlo, who had frequently portrayed herself in traditional Mexican dress with abundant dark hair, here paints herself in a man's shirt, shoes and oversized suit (presumably her portly ex-husband's) and with scissors in her hand with which she has shorn her hair. Her freshly cut locks, surreally animated, seem almost to crawl over the floor and chair. At the top of the painting are the lyrics of a Mexican song: 'Look, if I loved you it was because of your hair. Now that you are without hair, I don't love you anymore.' There is a dream, or rather nightmare -like quality to the scene, fueled by Kahlo's grief over her estrangement with Rivera. The image is both an act of mourning and of defiance. 'I suffered two grave accidents in my life,' Kahlo once said, 'One in which a streetcar knocked me down … The other accident is Diego.'

It was both of these 'accidents' that were the focus of much of her art. Kahlo had begun to paint while recovering from the horrific accident that left her in pain and in and out of hospitals all her life. She depicted her often harrowing physical and psychological suffering in intense images of naïve, bright color and flattened forms, a style inspired by Mexican folk art, in particular the small votive pictures called 'retablos' that the pious dedicated in Mexican churches.

Her unique art was embraced by the Surrealists: André Breton, admiringly described her art as 'a ribbon around a bomb' and also arranged for Kahlo to exhibit in Paris in 1939; a critical success, the Louvre bought one of her self-portraits, making Kahlo the first Latin American woman to have a painting in that museum. However, Kahlo never considered herself a Surrealist: 'They thought I was a Surrealist but I wasn't. I never painted dreams. I painted my own reality'. Certainly, her pictures are more about her own rather surreal life and her style owed more to her strong identification with her Mexican heritage (perhaps even stronger as a result of her mixed parentage: her father was a Hungarian Jewish immigrant, her mother was of Spanish-Mexican descent) than European Surrealism.

Not long after completing this painting, Kahlo reconciled with Rivera and they remarried, remaining together until Kahlo's death in 1954. Despite their tumultuous relationship, each always considered the other Mexico's greatest artist. Rivera once wrote to a friend: 'I recommend her [Frida] to you, not as a husband but as an enthusiastic admirer of her work, acid and tender, hard as steel and delicate and fine as butterfly's wings, loveable as a beautiful smile, and profound and cruel as the bitterness of life.' *DM*

Contemporary Works

1940	Edward Hopper: *Gas*, New York, MOMA
1941	Vasily Kandinsky: *Various Actions*, New York, Guggenheim Museum

Frida Kahlo

1907	Born in Mexico City.
1925	Begins to paint while recovering from serious injuries incurred during a bus accident. She undergoes many operations and is often in a great deal of pain. The extent of her injuries means that she is subsequently unable to have children.
1929	Shows her work to Diego Rivera. Later the same year she marries him. Their marriage is famously tempestuous with both indulging in extra-marital affairs, including Frida's with Leon Trotsky.
1939	Kahlo and Rivera are divorced. Her unhappiness is expressed in her painting *The Two Fridas*. An exhibition of her work is mounted in Paris.
1940	They remarry.
1950	Spends a year in hospital undergoing a series of spinal operations.
1953	Her right leg is amputated at the knee due to gangrene. Turns to drugs and alcohol in order to relieve her suffering.
1954	Dies in Mexico City, her death is probably as the result of suicide.

Piet Mondrian

Broadway Boogie Woogie 1942-3

The Museum of Modern Art

*B*roadway Boogie Woogie is Mondrian's American masterpiece, an abstract vision that captures the jazz-fueled buzz of 1940s New York City. The 68-year-old Dutch artist arrived in New York in 1940, after war had forced him to leave Paris, where he had lived for over two decades. In New York, Mondrian joined the group 'American Abstract Artists' and his late style evolved in response to his new city.

He immediately fell in love with New York, especially its architecture and jazz music. On his first night in New York, Mondrian (who was also a good dancer) discovered boogie-woogie music and soon began, he said, to put some boogie-woogie in his art. He had become a fan of jazz in 1920s Paris but here in New York Mondrian found the very embodiment of its irreverent, can-do spirit. For him, jazz – with its syncopated beat, improvisation and irreverent approach to melody – was analogous to his own 'destruction of natural appearance; and construction through continuous opposition of pure means – dynamic rhythm.'

As a young artist Mondrian had worked his way through various styles from Pointillism to Cubism until in the late 1910s he developed his own independent abstract style, a geometric abstract language that he called 'Neoplasticism.' In 1917 he was a founder of the Dutch abstract art movement, *De Stijl,* and over the next decades in Paris Mondrian developed his Neoplasticist style in numerous non-figurative canvases composed of black vertical and horizontal lines and blocks of primary color. For Mondrian, who as a young man had been interested by Eastern religions, abstract art was in many ways a spiritual mission: a metaphysical desire to reconcile the distance between the material world and the spirit. His artistic goal was to depict 'absolute reality,' which he thought was to be found in a world of pure geometric forms – straight lines and pure spectral color – which he felt underpinned all existence.

In this painting he uses similar forms to evoke the bustle of New York's skyscraper-lined, grid plan streets. However, he leaves out his usual black outline and transforms his customary bands of uniform color into multihued sections. The canvas is criss-crossed with paths of red, yellow and blue, which seem to pulsate like a jazz beat or the blinking lights of Broadway, while sporadic gray areas suggest the city's non-stop traffic.

Mondrian's earlier work had often had an architectural feel of stability and strength but in *Broadway Boogie Woogie* the primary feel is lively, colorful movement, almost like visual music. Mondrian, inspired by the randomness and repetition of a city filled with people and traffic in perpetual motion, surrounded by bright lights and spectacular, soaring architecture, was never freer and more colorful in his art. The colors seem to bounce off one another creating a vibrant rhythm, like a modern bird's eye view of a busy New York intersection. Despite the bustle and potential for chaos, the shapes and colors work together, reacting off one another, forming a coherent, if lively, universe. It is an affectionate Neoplasticist metaphor of the city Mondrian loved. **DM**

Contemporary Works

1942	Max Ernst: *Europe After the Rain*, Hartford, Wadsworth Atheneum
	Paul Delvaux: *The Phases of the Moon III*, Rotterdam, Museum Boymans-van Beuningen
1943	Jackson Pollock: *Guardians of the Secret*, San Francisco, Museum of Modern Art

Piet Mondrian

1872	Born in Amersfoort, Netherlands.
1889	Mondrian qualifies to teach drawing in lower schools.
1892 – 4	Studies art in Amsterdam.
1895 – 7	Attends evening classes in drawing whilst making a living as a book illustrator, drawing teacher, decorator and copyist among other things.
1898	Enters work for the Prix de Rome but is unsuccessful (as he is again in 1901).
1908	Stays at the artists' colony of Jan Toorop on the island of Walcheren.
1909	Exhibits work at the Stedelijk Museum in Amsterdam.
1912	Moves to live in Paris but spends some time each year in the Netherlands, often at Domburg on Walcheren Island. Meets and befriends Diego Rivera and Fernand Léger who occupy nearby studios.
1914	With the outbreak of World War I Mondrian returns to the Netherlands.
1917	Theo van Doesburg founds the periodical *De Stijl*. Mondrian writes articles relating the development of his work.
1919	Returns to Paris.
1920	A booklet entitled *Néo-plasticisme* containing a series of articles which first appeared in *De Stijl* is published in Paris. It is at this time that Mondrian develops his signature geometric style.
1922	A 50th Birthday retrospective is shown at the Stedelijk Museum in Amsterdam.
1924	Another retrospective in Rotterdam cements his international reputation.
1925	He has a one man show in Dresden.
1926	His work is seen for the first time in the USA at the Société Anonyme in New York.
1934	Meets Ben and Winifred Nicholson.
1937	Publishes *Plastic Art and Pure Plastic Art*, his first article in English.
1938	Winifred Nicholson and English friends find a studio for Mondrian in London as the political situation in Europe deteriorates.
1940	Moves to live in New York.
1944	Dies in New York.
1945	MOMA organize a retrospective of his work.

Francis Bacon

Painting 1946

The Museum of Modern Art

Apparently Bacon once observed that nobody had ever purchased one of his paintings because he or she liked it. But his work has a mesmeric intensity which draws one to it (perhaps in spite of the viewer's initial repulsion) triggering a ghoulish inquisitiveness like the sheepish glance when passing a car crash.

A huge carcass of beef hangs in an indeterminate space – perhaps some strange butcher's shop – the walls adorned with what looks like blinds – color coded with the blood-red marbling of the meat. (In one of his rare interviews Bacon declared that 'there is this great beauty in the color of meat.') Despite the artist's protestations to the contrary he was clearly influenced by Rembrandt's *Slaughtered Ox* (in the Louvre) and he would also have been aware of the allusive connections of such a motif with the Crucifixion – a subject that had occupied his mind for a number of years and had culminated in his triptych *Three Studies for Figures at the Base of a Crucifixion* (see *100 Best Paintings in London*). With Surrealist incongruity Bacon places a dark suited figure in front of the crucified carcass, eyes and forehead unseen within the impenetrable shade of a black umbrella. The top lip is bloodied – it may have been cut away – we can see no teeth to match the full set protruding from beneath the lower lip. The mouth is open in a silent exhalation of pain. Or perhaps the figure is merely giving a speech, dressed as he is in the uniform of the politician complete with a yellow flower in his buttonhole. This interpretation would gain credence if one accepts the suggestion that the vertical white objects to either side are microphones.

These 'microphones' are attached to an apparatus which encloses the figure, cutting him off from the viewer and restraining him within the claustrophobic confines of the butcher's shop. Two further slabs of meat are balanced on, or pinioned by, this peculiar tubular construction, a simplified form of which would later imprison Bacon's terrified but still sinister popes.

The artist maintained that the process of painting this picture had been accidental or 'automatic.' 'It came to me as an accident. I was attempting to make a bird alighting on a field. And it may have been bound up in some way with the three forms that had gone before, but suddenly the line that I had drawn suggested something totally different and out of this suggestion arose this picture. I had no intention to do this picture; I never thought of it in that way. It was like one continuous accident mounting on top of another.'

Francis Bacon is the portrayer-in-chief of anguish, pain and isolation, all on show in this painting. He presents us with a pictorial year zero – a visceral vision of humanity stripped to its violent and abject essence. *GS*

Contemporary Works

1946	Andrew Wyeth: *Winter 1946*, Raleigh, North Carolina Museum of Art
	Mark Rothko: *Vessels of Magic*, New York, Brooklyn Museum
	Pierre Bonnard: *Nude in the Bath*, Pittsburgh, Museum of Art

Francis Bacon

1909	Born in Dublin to English parents. He is brought up in Ireland. Because of ill health he receives very little formal education.
1924 – 6	At school in Cheltenham
1926	Living in London.
1927	Lives in Berlin (then the capital of European decadence) and in Paris.
1929	Returns to London. Tries his hand at interior decoration and painting but the next ten years are characterized by drift.
1940	Bacon's father dies.
1943	Commits himself to becoming a full-time artist having been excused military service as a result of his asthma.
1945	*Three Studies for Figures at the Base of a Crucifixion* causes a sensation when first exhibited at the Lefevre Gallery in London.
1948	Bacon is a founder member of the Colony Room, a drinking club in Soho, in central London, which had obtained a licence for drinking from 3.00 pm to 11.00 pm. This club becomes the centre of Bacon's social life as it did for a number of other artists such as Lucian Freud and Frank Auerbach.
1950s	Gains an international reputation.
1952	Meets Peter Lacey at the Colony Room – they become lovers.
1953	Paints *Study after Velázquez's Portrait of Pope Innocent X*.
1964	Begins a relationship with George Dyer who Bacon claims he met when Dyer burgled his apartment. Dyer becomes the subject of many paintings.
1971	Dyer dies the day before the opening of a major retrospective of Bacon's work in Paris.
1974	Meets John Edwards who becomes his lover.
1992	Bacon dies during a visit to Madrid.

Jackson Pollock

The Museum of Modern Art

I want to express my feelings, not illustrate them. – **Jackson Pollock**

To Jackson Pollock, the act of painting (not the painting itself) was the artwork. The expression of the creative instinct was in the action; the physical painting was merely a by-product, a pure and abstract expression of his mind. To this end, Pollock developed a radical new painting technique in which he moved around a huge canvas laid on the floor, pouring and flinging paint over the surface. At 1.7 m x 2.7 m (5.5 ft x 8.8 ft) this painting is among the largest of these 'drip' or 'pouring' works (sometimes called action painting), which earned Pollock the epithet 'Jack the Dripper.'

A pioneer of American Abstract Expressionism, Pollock is considered as the most important and influential painter of the mid-20th century. His work from 1947-1952 revolutionized painting, creating art the critics loved but that audiences often found incomprehensible. The public, however, was nonetheless intrigued by Pollock himself, who had a reputation as a wild, hard-drinking, macho cowboy. His legacy as the quintessential tortured, 20th-century artist was assured in 1958 when, drunk, Pollock wrapped his car around a tree, killing himself and one of his passengers.

Pollock's art theories had their roots in Surrealism, considering accident as a way to bypass the conscious mind: Pollock once said that when he was 'inside' his paintings, he didn't know what he was doing. Yet though his works have no single point of focus or any obvious patterns, there is an overall sense of underlying order. Through trial and experience, experimenting with the chance effect of gravity and momentum on paint, he had learned how his materials worked, how they fell if he used a certain consistency or motion. Pollock himself insisted that his abstract work had order. 'No chaos, damn it' – was his telegraphed response to *Time* magazine after they wrote of his 'chaotic' paintings. Pollock's process of creating is thus sometimes compared to choreography and indeed his physical approach to painting was a bit like a dance.

Pollock (who was filmed at work), tossed house paint straight from the bucket, flicked paint with a brush or stick like some mad conductor, and used his body to spread the paint: in this work, you can see his hand prints in the top right corner. *Number 1A, 1948* has a sense of swirling energy that is balanced by the almost lacelike delicacy of the strings and skeins of matte and glossy color – tans, blues, grays, black and white – that form an intricate web of lines across the surface. It is monumental, lyrical and passionate but what, many have asked, does it all mean?

In the 1940s, Abstraction had to deal with the problem of subject: in particular, the audience wanted one. Some said Pollock's work represented the nervous intensity of the modern city, others the primal rhythms. One reviewer said it was 'a leap into the void.' But Pollock was having none of it: to avoid the definition implicit in a descriptive title, he, like Mondrian before him, gave his paintings numerical titles, opening them up to a sort of creative ambiguity. 'I decided to stop adding to the confusion,' Pollock explained in 1950. 'Abstract painting is abstract. It confronts you.' Nevertheless, the debate over meaning has continued ever since. *DM*

Contemporary Works

1947	Marc Chagall: *Flayed Ox*, Paris, Musée National d'Art Moderne - Centre Georges Pompidou
1948	René Magritte: *The Flavor of Tears*, Birmingham, Barber Institute of Fine Arts

Jackson Pollock

1912	Born in Cody, Wyoming, the youngest of five sons. The family moves constantly around the western states.
1928	Pollock studies at the Manual Arts High School in Los Angeles.
1930	Moves to New York where he studies at the Art Students League.
1933	Works for subsistence wages on the Federal Art Project.
1934	Moves to live with his brother Sanford in Greenwich Village.
1936	Joins an experimental workshop run by the Mexican muralist David Alfaro Siqueiros.
1938	Spends four months in hospital receiving treatment for alcoholism.
1942	The painter Lee Krasner moves to live with Pollock in his studio.
1943	First one-man show at the Art of This Century Gallery in New York.
1945	Pollock and Krasner marry; they settle in East Hampton, NY.
1947	The first major 'poured' paintings created. Pollock uses numbers for his titles.
1951	Begins to drink heavily again.
1956	Dies in a car accident in East Hampton.

Andrew Wyeth

Christina's World **1948**

The Museum of Modern Art

Andrew Wyeth is the fifth child of a well known American illustrator and artist Newell Convers Wyeth who illustrated well loved editions of *Treasure Island*, *Robin Hood* and the *Last of the Mohicans* among many other books. Andrew was a sickly child who was educated at home and his father, to whom he was very close, gave him a secure grounding in draughtsmanship. The subsequent death of his father in 1945 in a tragic accident when a train struck his car at a level crossing had a deep effect on Wyeth, intensifying the melancholic vein already noticeable within his work.

This picture was painted three years after the death of Wyeth senior. A young girl sprawls in a slightly odd pose in the midst of a prairie-like expanse of grassland. She has her back to us and she gazes up a steady incline to a house and a barn which occupy the crest of the hill. A track makes its way from the house and exits the scene to our right; the occupants of the house have erected a desultory fence around a small part of their land and they have mowed some of the grass to create the feeling of an enclosure for the buildings. But apart from this nothing impinges upon the smooth rise of the land and the texture of the grass which covers it. This featureless domain separating girl from house creates a tension which deepens when certain details concerning the young woman who modeled for the girl become apparent.

Christina Olsen lived near to the Wyeth family summer home in Cushing, Maine. She had suffered from poliomyelitis or some other unspecified muscular disorder in infancy because she was paralyzed from the waist down – this accounts for the strange pose she has adopted and it also heightens our perception of the physical gulf which she has to overcome if she is to regain the crown of the hill.

It is tempting to make some sort of connection between her physical inability to move far from the environs of her home and the artist's almost hermetic attachment to the homes in Pennsylvania and Maine where he was

brought up and where he has continued to live all his life. He rarely traveled outside these twin personal centers and he drew his inspiration from the people and farms local to his homes.

The feeling that Wyeth is in some way 'a man apart' is strengthened by his lifelong use of tempera – the use of egg yolk as a binding medium for the pigment rather than oil. This technique militates against a speedy execution and gives his paintings the fine but 'dry' finish that characterizes his work. His style and subject-matter remained almost immutable throughout his career – a rock like adherence to figurative painting in the face of the enthusiasm of the American avant-garde for the abstract and the innovative. But the popularity of his work in the United States has never been in doubt (although critical approval has been less than unanimous). His portrayal of a rural America rooted in the past has struck a chord in an increasingly urban – or suburban – country. *GS*

Contemporary Works

1947	Henri Matisse: *Dahlias and Pomegranates*, New York, MOMA
1948	Paul Delvaux: *Leda*, London, Tate
1949	Mark Rothko: *Untitled (Violet, Black, Orange, Yellow on White and Red)*, New York, Guggenheim Museum

Andrew Wyeth

1917	Born at Chadd's Ford, Pennsylvania, the youngest of five children. As he is not a strong child he is taught at home by his parents.
1937	First one man exhibition of watercolors at the Macbeth Gallery in New York. The exhibition sold out on the first day.
1940	Marries Betsey James.
1940s	Begins to use egg tempera as a medium.
1943	Wyeth turns down an offer to paint cover images for the *Saturday Evening Post*.
1945	Wyeth's father dies in a railway accident.
1971	Begins a series of drawings and paintings, extending to some 240 works, including some nudes, of his neighbor Helga Testorf. All were executed in secret.
1976	A major retrospective exhibition of his work is mounted at the Metropolitan Museum of Art in New York, the first time that a living artist has been so honored.
1977	Becomes the first American since John Singer Sargent to be elected to the Académie des Beaux-Arts in France.
1985	The secret series of paintings featuring Helga Testorf is brought to a close.
1987	An exhibition of the 'Helga' pictures is held at the National Gallery of Art, Washington DC.

Cy Twombly

The Museum of Modern Art

In *Leda and the Swan*, Cy Twombly offers a mischievously novel interpretation of a classic Greco-Roman myth. The story recounts how Zeus, lord of the gods, took the form of a swan in order to ravish the beautiful Leda, wife of the king of Sparta (who subsequently gave birth to the equally ill-fated beauty, Helen of Troy). In Twombly's pictorial telling, Zeus and Leda's coupling is an orgiastic explosion of feathers, flesh and fluid, like some Baroque cloudburst run amok. The scene is a confusion of energies that thrash in layers of scribbles and smudges of crayon, pencil and paint, evoking a furious passion reinforced by a few recognizable signs – hearts, a phallus. The only other figurative mark is a window-like rectangle to the top of the canvas; a stabilizing mark amidst the chaos.

The painting is typical of Twombly's work in the 1960s: subjective, erotic and featuring lively color against a white background. The choice of subject – a classical myth that had been a favorite subject of Italian Renaissance artists – was highly unusual for a modern American artist but characteristic of Twombly; the ancient world had become a touchstone for him since travels (with his friend Robert Rauschenberg) in Italy, Spain and North Africa in 1952–3 and even more so after Twombly settled permanently in Italy in 1957. His fascination with the epic narratives and history of Ancient Rome shaped his art in various ways; the classical allusions and graphic quality of this image even feels a bit like the ancient graffiti found on the walls of Roman architecture.

Like much of Twombly's work, *Leda and the Swan* inspires contradictory sensations. The scene delights with its playful sensuality yet verges on the comic with its cartoon-like explosiveness. However, it is a bit too primal to be altogether comfortable. This is, after all, a tale of violation. The subject mixes

high culture and the base mechanisms of sexuality – Twombly's canvases often feel Rabelaisian, full of impolite splatters and ejaculations. This same complexity is part of Twombly's style. His canvases combine impulsiveness and obsessive systems, mixing words, geometry, ideographs, counting systems and abstract finger work as well as drawing, painting and writing. The result can feel epic, like lines of poetry on canvas. Art historian Simon Schama has written: 'I have always thought "Twombly" ought to be (if it isn't already) a verb, as in twombly: To hover thoughtfully over a surface, tracing glyphs and graphs of mischievous suggestiveness, periodically touching down amidst discharges of passionate intensity. Or, then again perhaps it should be a noun, as in twombly: A line with a mind of its own.'

Twombly's style, so utterly original and deeply personal, was influenced by many, but doesn't fall easily into any one category. He studied with Abstract Expressionists Robert Motherwell and Franz Kline who interested him in calligraphy and the automatic drawing technique of the Surrealists, which Twombly mixed with the expressive gestures of Jackson Pollock. He was a part of the New York artistic circle of fellow southerners Rauschenberg (with whom he shared a studio in Manhattan from 1952-57) and Jasper Johns. However his first exhibits offered none of the bold graphic qualities of his Pop Art contemporaries and were not well received. It was only after his move to Italy that his mature style emerged, producing artwork like this one: sparse, enigmatic canvases of lyrical scrawls, sensual smudges and epic themes. *DM*

Contemporary Works

1962	Ben Nicholson: *May 1962 (Urbino – footsteps in the dust)*, London, Tate
1963	Roy Lichtenstein: *Whaam!*, London, Tate

Cy Twombly

1928	Born in Lexington, Virginia.
1948 – 51	Studies at Washington and Lee University in Lexington and also at the Art Students League in New York.
1951 – 2	Spends some time at Black Mountain College and becomes friendly with Robert Rauschenberg. Travels to North Africa and southern Europe.
1953	Serves in the army as a cryptologist.
1955	Moves to New York where he is a prominent member of the group which forms around Rauschenberg and Jasper Johns. Works in chalk and pencil giving his output a graphic character.
1957	Twombly settles in Rome. Produces some abstract sculptures.
1964	Exhibits at the Venice Biennale.
1976	Again working with sculpture, influenced by classical forms.
1988	A retrospective of his work is mounted by the Musée National d'Art Moderne in Paris.
1994	MOMA shows a retrospective.

Andy Warhol

Gold Marilyn Monroe 1962

The Museum of Modern Art

Movie star Marilyn Monroe was an ideal subject for the celebrity-obsessed Andy Warhol, whose art was fueled by popular culture and commercial processes. The Pittsburgh-born son of Slovak immigrants, Andrew Warhola dropped the 'a' from his name soon after arriving in New York where his first assignment as a commercial artist for *Glamour* magazine was prophetically entitled, 'Success is a Job in New York.' His first solo exhibit in 1952 featured 'Fifteen Drawings Based on the Writings of Truman Capote,' indicative of what would be one of Warhol's perennial favorite subjects, the rich and famous.

Around 1960 he made his first artworks based on objects from mass culture, mostly comics and ads, which he enlarged and transferred onto canvases with a projector. With growing success, he established a studio at 231 East 47th Street, which became known as the 'Factory,' where Warhol replaced hand painting with a commercial silkscreen process and, working with numerous assistants, produced series of images based on everything from Campbell soup cans to celebrities.

After Monroe committed suicide in August 1962, Warhol created a series of works using a single publicity still from her 1953 film, *Niagara*. He would paint a canvas a single color – turquoise, green, blue, yellow and, here, gold – and then silkscreen Monroe's face on to it, sometimes several times or, as in this image, only once. Warhol places her smiling face in a burnished gold field, presenting the troubled movie star like a Byzantine icon. However this pseudo-canonization is no more than a comment on the illusion of stardom.

With brash ruby lips, turquoise eye shadow and yellow hair, Monroe is a caricature of 1950s high gloss glamour. The image, with it commercial

artificiality and deliberately off-registered lines, blatantly presents Monroe as a constructed image, a product of the movie industry; beautiful, stylized and elusive, she seems to be sinking into her golden environment, fading out like the end of a film. Warhol simultaneously seems to acknowledge the dark side of fame while reveling in its morbid fascination.

As the ultimate Pop artist, Warhol has both fans and critics. In light of German theorist Walter Benjamin's writings on art in the age of mechanical reproduction (Benjamin posited that the endlessly reproduced images of original artworks – e.g. a postcard of the *Mona Lisa* – lack the 'aura' or authenticity of the original), Warhol is often given the dubious distinction of being the first artist to completely eliminate 'aura' from art; there is no original, only copies, shallow mirror images endlessly reproducing themselves. Some criticize Warhol for his emotional and, frequently physical, distance from his art. Warhol himself admitted: 'I find it easier to use a screen. This way I don't have to work on my objects at all. One of my assistants or anyone else, for that matter, can reproduce the design as well as I could.'

However, others consider Warhol, with his '15 minutes of fame,' as a visionary prophet of contemporary media and celebrity culture and the equation of the celebrity as a consumer product. Marilyn Monroe, to Warhol, was interchangeable with Coca-Cola bottles or Elizabeth Taylor – she was a commodity that he sold for profit. His silk-screens produced in a 'Factory' erased the old-fashioned concept of personhood and replaced it with a market object to be disseminated, sold and made famous. Entirely rational and utterly promiscuous, the same logic can be applied to anyone or anything. Warhol, as energetic a self-promoter as he was an artist, even applied the same principles to his own detached, laconic persona, making Andy Warhol as illustrious as his art. *DM*

Contemporary Works

| 1962 | Francis Bacon: *Three Studies for a Crucifixion*, New York, Guggenheim Museum |
| 1963 | Bridget Riley: *Fission*, New York, MOMA |

Andy Warhol

1928	Born in Pittsburgh.
1945	Begins his studies at the Carnegie Institute of Technology in Pittsburgh.
1949	Moves to New York working as a commercial artist and illustrator.
1956	An advertisement campaign for a shoe manufacturer results in an award for his work.
1960	Inspired by the art of Jasper Johns and Robert Rauschenberg, Warhol determines to become a painter.
1962	Warhol uses screenprinting techniques, adding graphic or photographic images to painted backgrounds. These are produced at his studio which becomes known as the 'Factory.'
1963	Starts to make experimental films.
1964	Exhibits 'sculptures' replicating retail packaging at a show which looks like the interior of a small supermarket.
1965	Announces that from now on he is devoting himself to film.
1968	A follower, at the margins of the 'Factory' scene, shoots and nearly kills Warhol.
1970s	Warhol devotes much of his time to producing portraits commissioned by the rich and famous.
1980s	Regains a measure of critical success after the 1970s.
1987	Dies in hospital in New York after routine surgery.

Roy Lichtenstein

Drowning Girl

1963

The Museum of Modern Art

The term Pop Art was first used in the late 1950s by a group of British artists, notably Richard Hamilton, Peter Blake and Eduardo Paolozzi, to describe the output of the popular arts (such as advertising and science fiction illustration), as opposed to fine art at the 'high' end of the artistic spectrum. They used these popular arts as the inspiration for their output. At the same time, Jasper Johns and others were thinking along the same lines in the United States. Hamilton defined Pop as aimed at the youth market, low cost, transient, sexy, witty and glamorous and despite the fact that Lichtenstein's work was painstakingly manual, during the early sixties he celebrated the ephemeral world of the popular comic strip. In this regard *Drowning Girl* hits all the buttons on Hamilton's list right down to the heroine's seductively rouged lips.

In 1960 Lichtenstein started teaching at Rutgers University in New Jersey. There he met a number of artists who were involved in performance art (or 'happenings' in sixties parlance). It seems that it was these contacts which awakened Lichtenstein's interest in comic strips and he began to produce work which mimicked the printing techniques used in the world of mass market advertising, magazines and comics.

This was the Benday Dot process, named after a printer from New Jersey who developed the technique, one Benjamin Day. The use of small dots printed in one of four process colors (cyan, magenta, yellow and black) and used in varying combinations and proximity resulted in the optical illusion of many colors and varying tones. If the dots overlap then the illusion of secondary color (such as purple and green) is produced, if the dots are widely spaced then a lighter tone results. The pointillist painters achieved similar effects when

214 100 Best Paintings in New York

juxtaposing differing dabs of color.

Lichtenstein now sought to reproduce the mechanized Benday process by manually painting dots onto his canvas. Combined with the use of strong outlines, a necessarily restricted palette and of course a shift in scale, the result is a body of work with an arresting visual impact which also challenged the aesthetic near monopoly of Abstract Expressionism as the accepted orthodoxy of the New York art world during the early sixties.

The source for this particular painting has been identified as 'Run for Love' published in 1962. The original artwork included the girl's boyfriend who is shown hanging onto an overturned boat. However Lichtenstein crops this image to focus the melodrama of the original strip exclusively onto the girl who is seriously threatened by the waves that surround her. Lichtenstein's use of enlarged scale emphasizes the banality of his source material but the presence of an ironic sense of humor together with his undoubted genius as a draughtsman conspires to create a Pop Art classic. *GS*

Contemporary Works

| 1963 | Mark Rothko: *No. 14 (Browns over Dark)*, Paris, Musée National d'Art Moderne - Centre Georges Pompidou |
| | Hans Hartung: *T1963-R6*, London, Tate |

Roy Lichtenstein

1923	Born in New York.
1939	Studies at the Art Students League on a summer course.
1940	Begins a fine arts course at Ohio State University.
1943	Military service in the army during World War II interrupts his university course.
1946	Lichtenstein continues his studies as well as doing some teaching at Ohio State University.
1949	Completes a masters degree.
1957	Teaches at the State University of New York at Oswego.
1960	Begins teaching at Rutgers University, New Jersey.
1961	Breaks with his earlier Abstract Expressionist style and starts to mimic commercial printing techniques.
1962	A one-man exhibition takes place at the Leo Castelli gallery in New York.
1970s	Produces parodies of Cubism, Futurism and Expressionism. Also works on large scale public sculptures.
1980s	Continues to attract commissions for monumental sculptures.
1997	Dies of pneumonia in New York.

The Neue Galerie is devoted to early 20th-century German and Austrian art and design displayed on two exhibition floors. The second floor galleries are dedicated to art from Vienna circa 1900, looking at the relationship that existed then between the fine arts (of Gustav Klimt, Egon Schiele, Oskar Kokoschka and others) and the decorative arts (created at the Wiener Werkstätte by figures such as Josef Hoffmann and Koloman Moser, and by such celebrated architects as Adolf Loos and Otto Wagner).

The third floor galleries feature German art representing various movements of the early 20th century: the *Blaue Reiter* and its circle (Vasily Kandinsky, Paul Klee, August Macke, Franz Marc, Gabriele Münter); the *Brücke* (Erich Heckel, Ernst Ludwig Kirchner, Max Pechstein, Karl Schmidt-Rottluff); the Bauhaus (Lyonel Feininger, Paul Klee, László Moholy-Nagy, Oskar Schlemmer); the *Neue Sachlichkeit* (Otto Dix, George Grosz, Christian Schad); as well as applied arts from the Werkbund (Peter Behrens) and the Bauhaus (Marianne Brandt, Marcel Breuer, Ludwig Mies van der Rohe, Wilhelm Wagenfeld).

Neue Galerie was conceived by art dealer and museum exhibition organizer Serge Sabarsky and businessman, philanthropist, and art collector Ronald S. Lauder. They shared a passion for the German and Austrian art of this period and dreamed of opening a museum to display the finest examples of this work. After Sabarsky died in 1996, Lauder carried on the vision of creating Neue Galerie as a tribute to his friend.

The museum is now housed in a 1914 mansion commissioned by industrialist William Starr Miller. It was later occupied by Mrs Cornelius Vanderbilt III. It was purchased by Ronald S. Lauder and Serge Sabarsky in 1994.

Neue Galerie New York

1048 Fifth Avenue at 86th Street
New York, New York 10028
Tel: 212-994-9490
www.neuegalerie.org

Opening Hours

11.00am – 6.00pm Saturday, Sunday, Monday and Thursday
11.00am – 9.00pm Friday
Closed Tuesday and Wednesday

Admission

$15 adults; $10 senior citizens and students. Children under 12 are not admitted. Children aged 12 to 16 must be accompanied by an adult.

How To Get There

Subway: 4, 5, or 6 Train to 86th Street (at Lexington Avenue), B or C train to 86th Street (at Central Park West).

Bus: M86 to 86th Street (at Fifth Avenue) M1, M2, M3, or M4 to 86th Street (at Madison Avenue).

Access for the Disabled

All three levels of the building are wheelchair accessible; three wheelchairs are available for loan on the Gallery level.

Book Store, Design Shop

11.00am – 6.00pm Saturday, Sunday, Monday, Wednesday and Thursday
11.00am – 9.00pm Friday
Closed Tuesday

Café Sabarsky

Do not miss this. The museum's café, which bears the name of Neue Galerie co-founder Serge Sabarsky, draws its inspiration from the great Viennese cafés that served as important centers of intellectual and artistic life in *fin-de-siècle* Vienna. The menu is authentically Viennese especially the fine patisserie, such as strudel and Linzertorte, as is the decor including lighting fixtures by Josef Hoffmann, furniture by Adolf Loos, and banquettes that are upholstered with a 1912 Otto Wagner fabric.

Gustav Klimt

Adele Bloch-Bauer I **1907**

Neue Galerie

This breathtakingly beautiful painting, encrusted with gold leaf like a Byzantine icon, embellished with myriads of swarming devices from his personal lexicon of decorative forms (some raised from the surface in low relief, built up with layers of gesso), is one of Klimt's most celebrated works, produced at the apogee of his powers – his most sumptuous portrait and the best example (together with *The Kiss*) of his 'gold' period.

The subject is Adele Bloch-Bauer, the wife of Jewish Austrian industrialist Ferdinand Bloch-Bauer and, according to rumor, the lover of Klimt, an infamous womanizer (who nevertheless lived most of his life with his mother).

Adele's head, shoulders and hands emerge from the mesmerizing surface, a focus of feminine reality, perhaps at risk one feels, of becoming subsumed once more within the welter of sinuous decoration, enveloped, suffocated, by the encroaching gilding, almost as if she were a victim of the same god who granted King Midas his wish. There is no attempt to place the sitter in any meaningful three dimensional space – the line of her dress has become just another element in the compositional scheme with its references to earlier conspicuous consumers of precious materials, the civilizations of Egypt and Mycenae and Rome.

Presenting Adele like some Byzantine treasure was not only artistically intriguing, it was also a clear reference to the wealth, affluence and taste (in both art and women) of Adele's spouse, Ferdinand, who would later commission another portrait of his wife from Klimt and also owned several of his landscapes.

Were Adele and Klimt lovers? It is impossible to say for certain. They met at about the time of her marriage to Ferdinand. She was the only woman to sit twice for a portrait by Klimt. Some point to *Judith and Holofernes* painted in 1901, in which the features of Judith, depicted in a state of sexual arousal, bear

a striking resemblance to Adele's. As if the facial similarity was not enough, the prominent gem encrusted gold choker worn by Judith seems to be the same as that worn by Adele in this portrait.

This painting entered the Neue Galerie's collection in June 2006 when it was purchased at auction in New York for a record $135m. For years earlier the portrait had hung in the Belvedere Gallery in Vienna, the city which was home to both artist and sitter. However in February 2006, after a long court case, the portrait was among five paintings by Klimt returned to Maria Altmann, the Los Angeles-based niece of Adele Bloch-Bauer.

Adele had died in 1925 but her husband Ferdinand retained the painting until he was forced to flee Vienna after the Nazi annexation in 1938. Ferdinand lost everything, his huge art collection was looted, some paintings, including this picture finding their way into Austrian galleries.

After World War II, legal moves to secure restitution of the estate of Ferdinand Bloch-Bauer for his surviving heirs were unsuccessful but in the late 1990s further efforts were made to gain possession of paintings stolen from Ferdinand's collection. Finally, in 2006 several works by Klimt were transferred to the ownership of Maria Altmann, Adele's niece who then made the decision to sell this portrait.

The sensational bidding in New York saw Klimt overtake Pablo Picasso as the 'holder' of the record price paid for a painting. It is interesting that in the same year Klimt was at work applying the glittering gold surface to this picture, Pablo Picasso was in Paris grappling with *Les Demoiselles d'Avignon*, that shockingly heretical icon of avant-garde severity. They had taken very different directions in their search for a new art but they are now linked as the two painters who command the heights of the art market at the beginning of the 21st century. *GS*

Contemporary Works

| 1907 | Pablo Picasso: *Les Demoiselles d'Avignon*, New York, MOMA |
| | Henri Matisse: *Le Luxe I*, Paris, Musée National d'Art Moderne |

Gustav Klimt

1862	Born at Baumgarten near Vienna.
1876	Enters the School of Applied Art (Kunstgewerbeschule) in Vienna.
1883	Completes his studies and forms the Artists' Company (Kunstlercompagnie), opening a studio with his brother Ernst and Franz Matsch.
1888	The Artists' Company work on the staircase of the Burgtheater in Vienna.
1891	The Company works on the decoration of the staircase at the Kunsthistorisches Museum in Vienna.
1892	Klimt's brother Ernst dies.
1894	Klimt and Matsch are commissioned to paint the ceiling of the grand auditorium at Vienna University (known as the 'Faculty Paintings').
1897	The Vienna Secession is founded with Klimt as first president.
1898	The First Secession exhibition takes place.
1900	Exhibits one of the unfinished paintings for the university, representing Philosophy, to a storm of protest .
1903	Klimt visits Ravenna and is entranced by the gold mosaics he sees there.
1905	Klimt renounces the contracts for the 'Faculty Paintings' and buys them himself. He resigns from the Secession.
1908	Exhibits 16 paintings at the Kunstschau in Vienna. His iconic work, *The Kiss* is bought by the Austrian State Gallery.
1911	The Villa Stoclet is completed in Brussels with a frieze designed by Klimt for the dining room combining mosaic and painted panels.
1918	Suffers a stroke in January and, weakened by this, succumbs to influenza, one of the many killed in the pandemic.

Egon Schiele

Neue Galerie

When Egon Schiele died at the age of 28, he was already considered the leading artist of his generation. Something of a prodigy, he began art school at 16 in Vienna, where he soon came to the notice of Vienna's most celebrated artist, Gustav Klimt; when asked if Schiele showed talent, Klimt reportedly replied, 'Yes, much too much.' Klimt purchased some of Schiele's drawings and introduced the young artist to collectors and to the Wiener Werkstätte (the arts and crafts collective associated with the Viennese Secession). By the age of 20, Schiele's edgy, provocative Expressionist style had marked him as Klimt's successor.

But early on Schiele embroiled himself in controversy, mostly relating to his explicit, erotic images, frequently of young girls. In 1912, he was arrested for 'immorality' and 'seduction' and spent 24 days in prison. He nevertheless continued to paint prolifically; narcissistic self-portraits, intense allegories of life, death, and sex as well as some of the most fascinating Expressionist landscapes ever produced.

Like most of Schiele's townscapes, *Town among the Greenery* was inspired by the twisting, narrow streets and contiguous medieval houses of Krumau in southern Bohemian (today known as Český Krumlov in the Czech Republic, and a UNESCO World Heritage Site). Picturesquely set around the bends of the Vltava River, Krumau was Schiele's mother's hometown and the artist frequently went there to paint and even considered settling there permanently. However, the townspeople – shocked by Schiele openly living 'in sin' with his girlfriend and reports of young girls posing nude in his studio – had other ideas. He was forced to leave town in 1911 though he would return for short periods in the future to paint.

Seen from a bird's eye view, the town is composed of tightly packed, irregular rooflines surrounded by deep greenery. With his characteristically agitated line,

Schiele depicts the architecture with technical precision and in contrast to the more organic forms of the surrounding trees. He adds texture with thick daubs of paint; at other points the canvas can be seen.

Many of Schiele's earlier townscapes had a gloomy atmosphere but this scene has a lighter air with multi-hued pastel houses accented with splashes of red and orange. For all his aggressive modernity, Schiele captures the crumbling medieval essence of the city; the shimmering building surfaces have the patina of age suggesting an organic place filled with generations of lives and memories. The romantic landscape had been a staple of 19th-century art but Schiele expunges the format of any traces of sentimentality; his is an Expressionist landscape that amalgamates Modernist style and medieval imagery – a vision of animate nature and a dream-like city.

The relative optimism of this work perhaps reflects Schiele's improving fortunes around the time. In 1918, a solo show at the Vienna Secession brought him critical acclaim and financial success and his new wife was expecting their first child. However, the post-war influenza epidemic would kill him and his wife within days of each other that same year. **DM**

Contemporary Works

1917	Fernand Léger: *The Cardplayers*, Otterlo, Kröller-Müller Museum
	Amedeo Modigliani: *Nude*, New York, Guggenheim Museum
	Oskar Kokoschka: *Portrait of the Artist's Mother*, Vienna, Belvedere

Egon Schiele

1890	Born at Tulln an der Donau, near Vienna.
1906	Enters the Akademie der Bildenden Künste in Vienna.
1907	Meets Gustav Klimt.
1909	Schiele and other students leave the Akademie and form the *Neukunstgruppe*. Shows four paintings at the Kunstschau.
1910	Paints portraits for a number of patrons he has met due to his participation at the Kunstschau. Starts to develop his angular, taut style.
1911	Moves to live in Krumau in the spring but is forced to leave in the summer and lives in Neulengbach near Vienna. Sends work to the *Blaue Reiter* exhibition in Munich.
1912	Schiele is arrested on suspicion of seducing an under age girl. This is not proven but he imprisoned on a lesser charge. After this he moves to Vienna.
1915	Separates from his long-term girlfriend Wally Neuzil and marries Edith Harms. He is conscripted for military service and is posted to Prague. He sees no fighting being given guard duties overseeing Russian prisoners of war. He is able to continue his artistic activities.
1917	Schiele is back in Vienna.
1918	Dies in the influenza pandemic three days after the death of his pregnant wife.

The Whitney Museum houses one of the world's foremost collections of 20th-century American art. The permanent collection of some 12,000 works encompasses paintings, sculptures, multimedia installations, drawings, prints, and photographs – and is still growing. The museum was founded in 1931 with a core group of 700 art objects, many of them from the personal collection of founder Gertrude Vanderbilt Whitney; others were purchased by Mrs Whitney at the time of the opening to provide a more thorough overview of American art in the early decades of the century.

Although the Whitney's acquisition budget was always rather modest, the museum made the most of its resources by purchasing the work of living artists, particularly those who were young and not well known. It has been a long-standing tradition of the Whitney to purchase works from the museum's annual and biennial exhibitions, which began in 1932 as a showcase for recent American art.

In 1956, a group of supporters formed the Friends of the Whitney Museum of American Art. This organization was led by ardent collectors and benefactors of American art.

From the 1960s donations of important works have continued to enrich the collection.

Whitney Museum of American Art

945 Madison Avenue at 75th Street
New York, New York 10021
Tel: 1 800 WHITNEY
www.whitney.org

Opening Hours

11.00am – 6.00pm Wednesday and Thursday; Saturday and Sunday
1.00am – 9.00pm Friday
Closed Mondays and Tuesdays

Admission

$15 adults; $10 senior citizens (62 and over) and students.

How To Get There

Subway: 6 train to 77th Street and walk two blocks west to Madison
Avenue.
Buses M1, M2, M3, M4 to 74th Street.

Access for the Disabled

The museum's main entrance is accessible on Madison Avenue between
74th and 75th Streets. The public areas, including the galleries, restrooms,
main elevator, Sarabeth's Restaurant, and the Museum Store, are
accessible to people who use mobility aids. The museum offers visitors
wheelchairs free-of-charge at the coatcheck area on a first-come, first-
serve basis.

Whitney Museum Store

11.00am – 6.00pm Wednesday and Thursday; Saturday and Sunday
11.00am – 9.00pm Friday
11.00am – 4.30pm Tuesday
Closed Mondays

Sarabeth's Restaurant at the Whitney

11.00am – 4.30pm Wednesday and Thursday
10.00am – 4.30pm Saturday and Sunday
11.00am – 4.30pm Friday
11.00am – 3.30pm Tuesday
Closed Mondays

Edward Hopper

Early Sunday Morning **1930**

Whitney Museum of American Art

From the other side of the street we look, straight at an unremarkable row of shops. Above the store fronts windows stare blindly back, curtains drawn against an implacable early light. A cloudless sky, perhaps betraying the remnants of some mist, presides over the terrace. The just-risen sun casts long shadows down the street – its rays illuminate most of the building but consign the shop doorways into deep gloom. One is reminded of Giorgio de Chirico's sun drenched piazzas bounded by loggias of unfathomable darkness harboring nightmarish foreboding. But here the shadows are more benign – one doorway is already open, the first sign of a new day – the dark shielded windows above provide refuge only to the last prosaic dreams of a now vanished night.

The nightmare which stalks this painting is not the haunting, hidden terror of de Chirico but the suffocating presence of a crushing ennui – it is interesting that Hopper has chosen to tell us via the title that we are witnessing a Sunday morning; not a weekday, when the exigencies of work might brush aside any brooding unease, or a Saturday when release from work might engender a mild euphoria, but Sunday, that dread day of childhood boredom, forced worship and the ticking of the clock towards another Monday. The nightmare is an enveloping claustrophobia caused by the blocking presence of the terrace confronting the viewer – a claustrophobia intensified by the absence of any human figures. The repeated patterns of windows and doors mirror the dreary routine of city life offering no prospect of a release from the constrictions imposed by a cramped architectural environment – no prospect of the sort of bucolic idyll which Hopper himself was experiencing that summer in Cape Cod.

This first summer in Cape Cod led to the decision to build a second home there which became Hopper's regular summer escape from New York (he occupied his apartment in Greenwich Village from 1913 until his death in 1967). But his paintings of coastal Massachusetts maintain the same note of melancholic alienation which pervades his urban settings.

Hopper's world is a domain of detachment, a province where forces conspire to stifle human intercourse. In this picture the loneliness is the viewer's – no one moves in the soundless street – but even when Hopper introduces a meager cast of players they almost always fail to connect – cocooned in a mood of introspection. The famous *Nighthawks* is a good example. Three customers sit at the bar of an otherwise empty diner; it is late – outside the city is deserted. One customer sits with his back to us, head lowered, obviously lost in his own world. A couple sit opposite him but they do not converse, they are both similarly, perhaps momentarily, preoccupied with their own thoughts. The attendant behind the bar stares into the empty street. The painting induces a powerful response in the viewer – a mixture of alienation and aching loneliness. Hopper commented `I didn't see it as particularly lonely … Unconsciously, probably, I was painting the loneliness of a large city.' *GS*

Contemporary Works

| 1930 | Salvador Dalí: *The Invisible Sleeping Woman, Horse, Lion etc,* Paris, Musée National d'Art Moderne - Centre Georges Pompidou |
| | Pablo Picasso: *Seated Bather*, New York, Guggenheim Museum |

Edward Hopper

1882	Born in Nyack, NY.
1899	After leaving school he studies commercial illustration.
1900	Attends the New York School of Art where he studies both illustrations and painting.
1906	After working part time as an illustrator Hopper travels to Paris to study European trends. Produces paintings in an Impressionist manner.
1907	Visits London, The Netherlands, Berlin and Brussels before returning to New York where he again works as an illustrator, an occupation he detests.
1908	First exhibits his work in a group show in New York.
1909	Visits Paris for four months.
1910	Makes another visit to France and Spain.
1913	Moves to live in Washington Square, New York which remains his principal home throughout his life. Exhibits at the Armory Show where he sells his first painting.
1920	Hopper holds his first one-man show at the Whitney Studio Club. Neither sales nor critical reviews are forthcoming. However he is gaining a reputation as an illustrator.
1924	Marries Josephine Nivison. Exhibits watercolors at a second one-man show selling everything.
1925	*House by the Railroad* becomes the first work to be acquired by the new Museum of Modern Art in New York.
1930	Hopper and his wife spend their first summer in Cape Cod.
1933	A retrospective exhibition of Hopper's work is mounted by MOMA.
1934	Hopper and his wife build a house at Truro on Cape Cod in Massachusetts.
1942	Paints *Nighthawks*, his most celebrated work.
1950	Hopper's second retrospective at the Whitney Museum, held at the height of the vogue for Abstract Expressionism, attracts some criticism.
1964	A third retrospective is held at the Whitney Museum when his work is hailed by a new generation.
1967	Dies in New York.

Mark Rothko

Blue, Yellow, Green on Red **1954**

Whitney Museum of American Art

A large yellow rectangle dominates the painting, floating on a pale red ground. Above this yellow field hovers a horizontal blue strip of equal width which is balanced by a similar green shape beneath. The intersections between blocks of color are irregular, sometimes blurring and fading into the adjacent area.

This bald description – although accurate enough – does nothing to convey the powerful effect which these simple arrangements of color have on the viewer. Rothko's work possesses a profound spirituality. His juxtaposed areas of color create a complex relationship within the picture – the soft edges helping to create a remarkable feeling of depth. Scale is also a key factor but the monumentality of his work does not conspire to overwhelm, rather it draws the viewer in, compelling him or her to stand and meditate. Rothko usually applied his paint in thin layers, building up washes in such a way that the uneven surface of the color created an inner intensity – a luminosity, as though lit in some way from an internal source of energy. To look upon his paintings is to engage with the sublime.

Professor Robert Rosenblum sees a parallel here with the struggle of the Romantic painters of 19th century northern Europe to capture the sublime. But Rothko was also following in the footsteps of one of his great heroes, J. M. W. Turner.

In the late 1960s Rothko donated a number of works which had originally been destined to adorn the walls of the Four Seasons restaurant in New York to the Tate Gallery in London primarily because he wanted them to enter the collection which was the preeminent repository of Turner's work. There

is a direct parallel between this painting and some of Turner's late, intensely ethereal, works which verge on the abstract, their washes of lucent golds, yellows and reds evoking an overpowering sensation of looking directly into the sun.

Like Turner, Rothko was not interested in color for its own sake, even though his pictures (from the mid 1940s onwards) depict nothing more than expanses of color. Like Kandinsky he felt that pure color provided a direct route to the soul. 'I'm interested only in expressing basic human emotions – tragedy, ecstasy, doom …'

Unfortunately Rothko's depressive character (exacerbated towards the end of his life by alcoholism) precipitated his own premature doom in the form of his suicide in 1970 – on the very day that his 'Four Seasons' murals arrived at their destination in London. *GS*

Contemporary Works

1954	Robert Motherwell: *Elegy to the Spanish Republic 34*, Buffalo, Albright-Knox Art Gallery
1954 – 5	Alberto Giacometti: *Portrait of Jean Genet*, London, Tate
1955	Friedensreich Hundertwasser: *The Large Path*, Vienna, Belvedere

Mark Rothko

1903	Born Marcus Rothkowitz at Dvinsk in Russia (now Daugavpils in Latvia).
1913	He emigrates to the USA with his mother and sister arriving in Portland, Oregon where his father and the rest of the family had settled.
1921	Begins his studies at Yale University.
1923	Leaves Yale in his third year without taking a degree and moves to New York where he begins to paint.
1933	First one-man exhibition at the Portland Art Museum.
1935	Co-founder of The Ten, a group of Expressionist artists.
1940	First starts to use the shortened version of his name.
1942-7	His work is influenced by Surrealism, in particular Ernst and Miró. Works extensively in watercolor.
1947	Teaches at the California School of Fine Art in San Francisco. Turns to abstraction, painting compositions with large soft-edged areas.
1959	Legally changes his name to Mark Rothko.
1964-67	He works on a commission for John and Dominique de Menil to produce murals for a chapel at the University of St Thomas in Houston, Texas.
1968	Ill health means that for a time he is unable to work on large works. Becomes depressed.
1970	Commits suicide in New York in 1970 on the very day that the murals originally destined for the Four Seasons Restaurant are delivered to the Tate.

Jasper Johns

Three Flags 1958

Whitney Museum of American Art

In New York in 1955, an aspiring artist named Jasper Johns began to make art featuring familiar, commonplace objects; what he called the 'things the mind already knows.' He created a series of pictures featuring the American flag, a quotidian but symbolically charged object, which stunned the art world. *Three Flags* is the culmination of these works and was made the year of Johns' first solo exhibit at the Leo Castelli Gallery. The show was attended by the director of the MOMA who bought three paintings, an extraordinary vote of confidence for a virtually unknown 28-year-old painter, who from that point on would be considered one of American's most original and important artists.

Born in Augusta, Georgia, Johns showed artistic talent from an early age. However he didn't enjoy art school (he left the Parsons School of Design after one semester) and after serving two years in the army during the Korean War, he returned to New York where he became friends with fellow Southerner and artist Robert Rauschenberg. The two began a tumultuous personal and professional relationship and together, from 1954 to 1961, they led a new generation of artists who broke from the dominant style of the day, Abstract Expressionism, and began to integrate the signs, symbols and images of mass culture into their works. And while their subject matter may have been mundane, their approach wasn't.

Johns has been described as having a compulsive curiosity; his art always seems to ask why something has a certain meaning and what would happen if that meaning was altered? In this picture he divests the American flag of its conventional use and significance – as a patriotic symbol – and transformed it into a question; or rather numerous questions about perception, visual ambiguity and the meaning of art itself.

Unlike his earlier flag images, *Three Flags* is less a picture of an object, than an object itself. The painting, featuring three American flags of diminishing size superimposed one onto the other, is five inches deep. The interplay of

the three flags creates an inverse perspective and the flags seem to project outward, invading the real space of the viewer. The image is an odd mix of deadpan reticence – these flags do not fly, but seem tacked to a wall – and an unexpected sensuality; the latter enhanced by the artist's use of a rich painterly technique and encaustic, a wax medium first used by the Greeks to give paint a thick, relief-like surface. The result, created by Johns' seductive handling of materials and his enigmatic, intellectual approach to the most ordinary of subjects, is a picture of haunting beauty that transforms the banal into art.

When asked why he chose the American flag as a subject Johns has replied: 'Well, it certainly wasn't out of patriotism. It was about something you see from out of the side of your eye and you recognize it as what it is without really seeing it. It is the thing itself, but there's also something else there.' In interviews Johns had said he was amused and sometimes frustrated that his flag paintings are often taken as patriotic symbols and points out that when first exhibited in the 1950s in the age of McCarthyism they were considered subversive. But Johns, who today continues to paint from his home in Connecticut, is notoriously reticent about assigning definite meaning to his art, so its ultimate interpretation remains open to debate. *DM*

Contemporary Works

1957	Clyfford Still: *1957-D, No. 1*, Buffalo, Albright-Knox Art Gallery
	Paul Delvaux: *Evening Train*, Brussels, Musées Royaux des Beaux-Arts
1959	Kenneth Noland: *Song*, New York, Whitney Museum of American Art

Jasper Johns

1930	Born in Augusta, Georgia.
1947 – 8	Studies at the University of South Carolina.
1949	Moves to New York and studies for a short period at the Parsons School of Design.
1952 – 3	During military service he is stationed in Japan.
1954	Back in New York, Johns lives in the same building as Robert Rauschenberg who introduces him to the composer John Cage.
1955	Completes his iconic painting *Flag* which is made using thick encaustic.
1958	Leo Castelli organizes a one-man show for Johns at his New York gallery. Alfred Barr, the director of MOMA buys three paintings. Begins to make sculptures of everyday objects.
1959	Meets Marcel Duchamp.
1972	Johns begins to paint in a new style using cross hatching.
1980	The Whitney Museum pays $1m for *Three Flags*.

Jean-Michel Basquiat

Hollywood Africans 1983

Whitney Museum of American Art

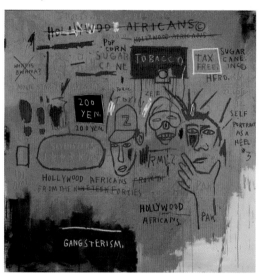

One of the most exciting American Neo-Expressionist artists to emerge in the 1980s, Basquiat is today considered as something of a visual precursor of hip-hop with his artistic samplings, stuttering words and free-flowing phrases and his focus on the experience of black urban America. He is also emblematic of the excesses and burnouts of 1980s New York. A precocious talent, he was an international star by the age of 22 and dead of a drug overdose at 27, which, in the logic of the era's inflated art market, made his work even more sought after. As art critic Robert Hughes has written: 'The only thing the [Eighties'] market liked better than a hot young artist was a dead hot young artist, and it got one in Jean-Michel Basquiat.'

Basquiat, who grew up in a middle-class home in Brooklyn, showed artistic talent early and as a child, his mother gave him a copy of *Gray's Anatomy*, which began a lifelong interest in the human figure; labeled depictions of the human body, usually black and male, became a staple of his art. At 15, he ran away from home, living in abandoned buildings or with friends and started doing graffiti art, spray-painting buildings around SoHo and the Lower East Side with cryptic poems and witty statements which he signed 'SAMO' (a compression of 'same old shit'). He soon gained an underground following but his big break came in 1981 at an underground art show where his 15 artworks – edgy, urban images on foam rubber and found lumber – garnered critical praise and sold out. Basquiat was soon the hottest young artist in New York with a huge demand for his art. Smart, charismatic and outrageous, Basquiat was as famous as his art and people would come to his studio just to watch him work. Fueled by drugs, he worked non-stop, sometimes producing eight painting a week.

With its African-American iconography and references to racism, capitalism and urban street life, *Hollywood Africans* is an iconic example of Basquiat's

brash, bold graffiti art-style that set the New York art scene ablaze. Words – like 'MOVIE STAR,' 'AFRO.ISM,' GANGSTERISM,' etc. – written and crossed out all over the surface, evoke themes frequent in Basquiat's art: fame and the experience of being black in America. He often referenced famous African Americans; athletes, jazz musicians, and here, as the title suggests, actors. Basquiat also included himself with his characteristic spiky hair and enigmatically labeled 'SELF PORTRAIT AS A HEEL.'

Though he had no formal training, Basquiat had a natural talent for color, line, language and composition and he drew inspiration from various art movements; his dynamic handling of paint reveals the influence of Abstract Expressionism while his cartoon-like figures and pop culture references reflect Pop Art. He used vivid color and fragmented images and words to draw the viewer in, challenging them to puzzle out his intentions. *Hollywood Africans* is a collage of ideas, conversations and emotions that flow over the spectator like a stream of consciousness, as if meant to evoke the performance of creating it, as Basquiat jumped from thought to thought.

Some critics have called Basquiat all hype and no substance and Basquiat himself – influenced no doubt by his hero and sometime collaborator, Andy Warhol – stated that all he wanted was to be famous; he could learn to draw later. But while he got his wish regarding fame, he maintained an antagonistic relationship to the elite art world that embraced him. At his memorial service, Basquiat's friend, Keith Haring, summed up his brief career: 'He disrupted the politics of the art world and insisted that if he had to play their games, he would make the rules. His images entered the dreams and museums of the exploiters, and the world can never be the same.' *DM*

Contemporary Works

1982	Gerhard Richter: *Korn*, New York, Guggenheim Museum
1983	Peter Blake: *The Meeting* or *Have a Nice Day, Mr Hockney*, London, Tate
	Richard Hamilton: *The Citizen*, London, Tate

Jean-Michel Basquiat

1960	Born in Brooklyn to a middle-class family who take him to the New York museums at an early age.
1968	While hospitalized after a car accident, Basquiat is given a copy of *Gray's Anatomy*; the diagrams in the book inspire his further interest in art.
1976	Attends an alternative high school where he is influenced by various drama groups.
1977	Invents 'Samo' (Same Old Shit), a fictional character who appears in graffiti sprayed on trains passing through lower Manhattan.
1978	Drops out of school and leaves home, supporting himself by selling T-shirts and postcards on the street.
1979	Comes to the notice of the East Village art scene.
1981	First one man exhibition at the Annina Nosei Gallery, New York.
1982	Meets Andy Warhol with whom he collaborates.
1984	His drug use starts to cause concern among his friends just at the time when his international success is at its height.
1988	Dies of a drug overdose in New York.

Acknowledgments

The Publishers would like gratefully to acknowledge the generosity of Neue Galerie New York in granting us permission for the two images from their collection (pages 218 and 220).

Constable, John *Salisbury Cathedral from the Bishop's Garden* Copyright The Frick Collection, New York; 54

Corot, Jean-Baptiste-Camille *The Boatman of Mortefontaine* Copyright The Frick Collection, New York; 59

Courbet, Gustave *Woman with a Parrot* © 2008 Image Copyright The Metropolitan Museum of Art / Art Resource / Scala, Florence; 128

Cranach, Lucas the Elder *The Judgment of Paris* c1528 (tempera & oil on panel) by Cranach, Lucas, the Elder (1472-1553) © Metropolitan Museum of Art, New York, USA / The Bridgeman Art Library; 96

Crivelli, Carlo *Madonna and Child* © 2008 Image Copyright The Metropolitan Museum of Art / Art Resource / Scala, Florence; 86

Dalí, Salvador *The Persistence of Memory* 1931 (oil on canvas) by Dalí, Salvador (1904-89) ©Museum of Modern Art, New York, USA / The Bridgeman Art Library; 194

David, Gerard *Virgin and Child with Four Angels* © 2008 Image Copyright The Metropolitan Museum of Art / Art Resource / Scala, Florence; 94

David, Jacques-Louis *Antoine-Laurent Lavoisier and his Wife* © 2008 Image Copyright The Metropolitan Museum of Art / Art Resource / Scala, Florence; 114

de la Tour, Georges *The Fortune Teller* c1625 (oil on canvas) by Tour, Georges de la (1593-1652) © Metropolitan Museum of Art, New York, USA / The Bridgeman Art Library; 104

Degas, Edgar *Dance Class* © 2008 Image Copyright The Metropolitan Museum of Art / Art Resource / Scala, Florence; 132

Demuth, Charles *The Figure 5 in Gold* The Metropolitan Museum of Art, Alfred Stieglitz Collection, 1949. (49.59.1) Image © The Metropolitan Museum of Art; 156

Derain, André *The Houses of Parliament at Night* Robert Lehman Collection 1975 Acc.n 1975.1.168. © 2008 Image Copyright The Metropolitan Museum of Art / Art Resource / Scala, Florence;152

Dix, Otto *The Businessman Max Roesberg* © 2008 Image Copyright The Metropolitan Museum of Art / Art Resource / Scala, Florence, © DACS, London 2008; 154

Duccio di Buoninsegna *Temptation of Christ on the Mountain* Copyright The Frick Collection, New York; 24

Dyck, Anthony van *James, Seventh Earl of Derby, His Lady and Child* Copyright The Frick Collection, New York; 40

Eakins, Thomas *The Thinker: Portrait of Louis N. Kenton* © 2008 Image Copyright The Metropolitan Museum of Art / Art Resource / Scala, Florence; 150

Ernst, Max *Two Children are Threatened by a Nightingale* Digital Image © (2008) Ernst, Max *Two Children are Threatened by a Nightingale*. The Museum of Modern Art / Scala, Florence © ADAGP, Paris and DACS, London 2008; 188

van Eyck, Jan *Virgin and Child with Saints and Donor* Copyright The Frick Collection, New York; 26

Fragonard, Jean-Honoré *The Progress of Love: The Meeting* Copyright The Frick Collection, New York; 50

Gainsborough, Thomas *The Mall in St James's Park* Copyright The Frick Collection, New York; 52

Gauguin, Paul *Ia Orana Maria* © 2008 Image Copyright The Metropolitan Museum of Art / Art Resource / Scala, Florence; 148

Giotto di Bondone *The Epiphany* The Metropolitan Museum of Art, John Stewart Kennedy Fund, 1911 (11.126.1) Image © The Metropolitan Museum of Art; 76

Giovanni di Paolo *The Creation of the World and the Expulsion from Paradise* (oil on panel) by Giovanni di Paolo di Grazia, (1403-83) ©Metropolitan Museum of Art, New York, USA / Giraudon / The Bridgeman Art Library; 80

van Gogh, Vincent *The Starry Night* Digital Image © (2008) van Gogh, Vincent *The Starry Night*. The Museum of Modern Art/Scala, Florence; 164

Goya, Francisco *Duchess of Alba* Courtesy of The Hispanic Society of America, New York; 72

El Greco *Portrait of a Cardinal* © 2008 Image Copyright The Metropolitan Museum of Art / Art Resource / Scala, Florence; 102

Hey, Jean *Portrait of Margaret of Austria* Robert Lehman Collection 1975 Acc.n 1975.1.130. © 2008 Image Copyright The Metropolitan Museum of Art / Art Resource / Scala, Florence; 90

Holbein, Hans the Younger *Sir Thomas More* Copyright The Frick Collection, New York; 32

Hopper, Edward 1882 - 1967 *Early Sunday Morning* 1930 oil on canvas, Overall 35 3/16 x 60 1/4 in (89.4 x 153 cm) Framed 68 1/2 x 43 in (174 x 109.2 cm) Whitney Museum of American Art, New York; Purchase with funds from Gertrude Vanderbilt Whitney 31.426; 224

Ingres, Jean-Auguste-Dominique *Comtesse d'Haussonville* Copyright The Frick Collection, New York; 56

Johns, Jasper *Three Flags* 1958 (encaustic on canvas) by Johns, Jasper (b.1930) ©Whitney Museum of American Art, New York, USA / The Bridgeman Art Library © Jasper Johns / VAGA, New York / DACS, London 2008; 228

Kahlo, Frida *Self-Portrait with Cropped Hair* Digital Image © (2008) Kahlo, Frida *Self-Portrait with Cropped Hair*. The Museum of Modern Art / Scala, Florence. © Banco de Mexico Diego Rivera & Frida Kahlo Museums Trust, Mexico D.F. / DACS 2008; 200

Kandinsky, Vasily *Picture with an Archer* Digital Image © (2008) Kandinsky, Vasily *Picture with an Archer* The Museum of Modern Art / Scala, Florence © ADAGP, Paris and DACS, London 2008; 172

Kiefer, Anselm *Bohemia Lies by the Sea* The Metropolitan Museum of Art, Purchase, Lila Acheson Wallace Gift and Joseph H. Hazan Foundation Purchase Fund, 1997 (1997.4ab) Image © The Metropolitan Museum of Art © Anselm Kiefer; 160

Kirchner, Ernst Ludwig *Street, Dresden* Digital Image © (2008) Kirchner, Ernst Ludwig *Street, Dresden* The Museum of Modern Art / Scala, Florence, © by Ingeborg & Dr. Wolfgang Henze-Ketterer, Wichtrach / Bern; 170

Klee, Paul *Twittering Machine* Digital Image © (2008) Klee, Paul *Twittering Machine*. The Museum of Modern Art / Scala, Florence © DACS, London 2008; 186

Klimt, Gustav (1862-1918) *Adele Bloch-Bauer I* 1907 Oil, silver, and gold on canvas, Neue Galerie New York. This acquisition made available in part through the generosity of the heirs of the Estates of Ferdinand and Adele Bloch-Bauer; 218

Kokoschka, Oskar *Hans Tietze and Erica Tietze-Conrat* Digital Image © (2008) Kokoschka, Oskar *Hans Tietze and Erica Tietze-Conrat* The Museum of Modern Art / Scala, Florence; © Foundation Oskar Kokoschka / DACS, 2008; 174

Lawrence, Thomas *Elizabeth Farren, later Countess of Derby* © 2008 Image Copyright The Metropolitan Museum of Art / Art Resource / Scala, Florence; 116

Leutze, Emanuel Gottlieb *Washington Crossing the Delaware* 1851 (oil on canvas) (copy of an original painted in 1848) by Leutze, Emanuel Gottlieb (1816-68) © Metropolitan Museum of Art, New York, USA / The Bridgeman Art Library;122

Lichtenstein, Roy *Drowning Girl* Digital Image © (2008) Lichtenstein, Roy *Drowning Girl*. The Museum of Modern Art / Scala, Florence. © The Estate of Roy Lichtenstein / DACS 2008; 214

Lippi, Fra Filippo *Portrait of a Woman with a Man at a Casement* .1440 (tempera on panel) by Lippi, Fra Filippo (c.1406-69) © Metropolitan Museum of Art, New York, USA / The Bridgeman Art Library; 78

Magritte, René *The Menaced Assassin* Digital Image © (2008) Magritte, René *The Menaced Assassin*. The Museum of Modern Art / Scala, Florence © ADAGP, Paris and DACS, London 2008; 192

Manet, Édouard *Boating* 1874 (oil on canvas) by Manet, Edouard (1832-83) © Metropolitan Museum of Art, New York, USA/ The Bridgeman Art Library; 134

Marc, Franz *Yellow Cow (Gelbe Kuh),* 1911, Oil on canvas, 140.5 x 189.2 cm (55 3/8 x 74 1/2 inches) Solomon R. Guggenheim Museum, New York, Solomon R. Guggenheim Founding Collection 49.1210; 66

Matisse, Henri *The Red Studio* Digital Image © (2008) Matisse, Henri, *The Red Studio*. The Museum of Modern Art / Scala, Florence, © Succession H Matisse / DACS 2008; 180

Memling, Hans *Tomasso Portinari* © 2008 Image Copyright The Metropolitan Museum of Art / Art Resource / Scala, Florence; 84

Memling, Hans *Maria Portinari* © 2008 Image Copyright The Metropolitan Museum of Art / Art Resource / Scala, Florence; 84

Miró, Joan *The Birth of the World* Digital Image © (2008) Miró, Joan *The Birth of the World* The Museum of Modern Art/Scala, Florence © Succession Miro / ADAGP, Paris and DACS, London 2008; 190

Mondrian, Piet *Broadway Boogie Woogie* Digital Image © (2008) Mondrian, Piet *Broadway Boogie Woogie*. The Museum of Modern Art/Scala, Florence. © 2008 Mondrian/ Holtzman Trust c/o HCR International, VA USA; 202

Monet, Claude *Reflections of Clouds on the Water Lily Pond* Digital Image © (2008) Monet, Claude *Reflections of Clouds on the Water Lily Pond*. The Museum of Modern Art / Scala, Florence; 184

Moreau, Gustave *Oedipus and the Sphinx* © 2008 Image Copyright The Metropolitan Museum of Art / Art Resource / Scala, Florence; 126

O' Keeffe, Georgia *Ram's Head, White Hollyhock - Hills* 1935 (oil on canvas) by O'Keeffe, Georgia (1887-1986) © Brooklyn Museum of Art, New York, USA / Bequest of Edith and Milton Lowenthal / The Bridgeman Art Library © ARS, NY and DACS, London 2008; 16

Picasso, Pablo *Les Demoiselles d'Avignon* 1907 (oil on canvas) by Picasso, Pablo (1881-1973) © Museum of Modern Art, New York, USA / Lauros / Giraudon / The Bridgeman Art Library; © Succession Picasso/DACS 2008; 168

Piero della Francesca *St John the Evangelist* Copyright The Frick Collection, New York; 28

Piero di Cosimo *A Hunting Scene* The Metropolitan Museum of Art, Gift of Robert Gordon, 1875 (75.7.2) Photograph © The Metropolitan Museum of Art; 92

Pollock, Jackson *No. 1A 1948* Digital Image © (2008) Pollock, Jackson *No. 1A 1948*. The Museum of Modern Art / Scala, Florence © ARS, NY and DACS, London 2008; 206

Rembrandt *Self Portrait* Copyright The Frick Collection, New York; 44

Renoir, Pierre-Auguste *Madame Georges Charpentier and her Children* 1878 by Renoir, Pierre Auguste (1841-1919) © Metropolitan Museum of Art, New York, USA / The Bridgeman Art Library; 136

Reynolds, Joshua *General John Burgoyne* Copyright The Frick Collection, New York; 48

Ringgold Faith *Tar Beach* © Faith Ringgold 1988 Acrylic paint on canvas bordered with printed, painted, quilted and pieced cloth 189.5 x 174 cm (74 5/8 x 68 ½ inches) Solomon R. Guggenheim Museum, New York, Gift, Mr and Mrs Gus and Judith Lieber, 1988 88.3620; 68

Rothko, Mark 1903 - 1970 *Blue, Yellow, Green on Red* 1954 oil on canvas, Overall 77 3/4 x 65 1/2 in (197.5 x 166.4 cm) Whitney Museum of American Art, New York; Gift of the American Contemporary Art Foundation Inc., Leonard A. Lauder, President 2002.261; 226

Rousseau, Henri *The Dream* Digital Image © (2008) Rousseau, Henri. *The Dream* The Museum of Modern Art/Scala, Florence; 176

Rubens, Peter Paul *Rubens, his Wife Helena and their Son* © 2008 Image Copyright The Metropolitan Museum of Art / Art Resource / Scala, Florence; 106

Sargent, John Singer *Madame X* © 2008 Image Copyright The Metropolitan Museum of Art / Art Resource / Scala, Florence; 142

Schiele, Egon (1890-1918) *Town Among the Greenery (The Old City III)* 1917 Oil on canvas Neue Galerie New York. In memory of Otto and Marguerite Manley, given as a bequest from the Estate of Marguerite Manley; 220

Seurat, Georges *Circus Sideshow (La Parade)* The Metropolitan Museum of Art, Bequest of Stephen C. Clark, 1960 (61.101.17) Image © The Metropolitan Museum of Art; 146

Tintoretto *The Miracle of the Loaves and Fishes* The Metropolitan Museum of Art, Francis L. Leland Fund, 1913 (13.75) Photograph © 1986 The Metropolitan Museum of Art; 98

Titian *Pietro Aretino* Copyright The Frick Collection, New York; 34

Turner, Joseph Mallord William *Venice, from the Porch of the Madonna della Salute* © 2008 Image Copyright The Metropolitan Museum of Art / Art Resource / Scala, Florence; 118

Twombly, Cy *Leda and the Swan* Digital Image © (2008) Twombly, Cy *Leda and the Swan*. The Museum of Modern Art/Scala, Florence © Cy Twombly; 210

Velázquez, Diego *Juan de Pareja* 1650 by Velásquez, Diego Rodriguez de Silva y (1599-1660) © Metropolitan Museum of Art, New York, USA / The Bridgeman Art Library; 108

Vermeer, Johannes *Young Woman with a Water Pitcher c.*1662 (oil on canvas) by Vermeer, Jan (1632-75) © Metropolitan Museum of Art, New York, USA / Giraudon / The Bridgeman Art Library; 110

Veronese, Paolo *The Choice between Virtue and Vice* Copyright The Frick Collection, New York; 38

Vuillard, Edouard *Place Vintimille* 1908-10, Distemper on cardboard, mounted on canvas Two panels, 200 x 69.5 cm (78 3/4 x 27 3/8 inches) and 200 x 69.9 cm (78 3/4 x 27 ½ inches) Solomon R. Guggenheim Museum, New York, Thannhauser Collection, Gift, Justin K. Thannhauser, 1978, 78.2514.74; 64

Warhol, Andy *Gold Marilyn Monroe* Digital Image © (2008) Warhol, Andy *Gold Marilyn Monroe*. The Museum of Modern Art / Scala, Florence © Licenced by the Andy Warhol Foundation for the Visual Arts, Inc / ARS, New York and DACS, London 2008; 212

Watteau, Jean-Antoine *Mezzetin* .c1718-20 (oil on canvas) by Watteau, Jean-Antoine (1684-1721) © Metropolitan Museum of Art, New York, USA/ The Bridgeman Art Library; 112

Whistler, James Abbott McNeill *Symphony in Flesh Color and Pink: Portrait of Mrs Frances Leyland* Copyright The Frick Collection, New York; 60

Wood, Grant *Midnight Ride of Paul Revere* © 2008 Image Copyright The Metropolitan Museum of Art / Art Resource / Scala, Florence, © Estate of Grant Wood / DACS, London / VAGA, New York 2008; 158

Wyeth, Andrew *Christina's World,* 1948, tempera, © Andrew Wyeth, Digital Image © (2008) Wyeth, Andrew *Christina's World*. The Museum of Modern Art/Scala, Florence; 208

Index